The
BIG, BAD BOOK
of
BEASTS

ALSO BY MICHAEL LARGO

NONFICTION

God's Lunatics

Genius and Heroin

The Portable Obituary

Final Exits

FICTION

Southern Comfort

Lies Within

Welcome to Miami

The World's

Most Curious

Creatures

The
BIG, BAD BOOK
of
BEASTS

MICHAEL LARGO

Illustrations by
Jesse Peterson and Christopher David Reyes

WILLIAM MORROW
An Imprint of HarperCollins*Publishers*

For those dedicated to preserving the diversity of life

Animals come into being in earth
and in liquid because there is water in earth,
and air in water, and in all air is vital heat
so that in a sense all things are full of soul.

—Aristotle, *On the Generation of Animals*, Book III, Part 11

CONTENTS

INTRODUCTION

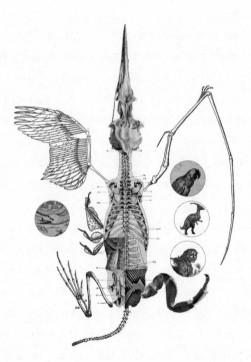

The first bestsellers were medieval encyclopedias called "bestiaries" that described strange and fascinating facts and lore about animals, real and imagined. Often gorgeously illustrated, they were less products of close observation than works of imagination, myth, or the rare traveler's tales of far-off lands populated with seemingly fanciful creatures. Griffins and unicorns thus were comfortably included alongside eagles and lions.

Beasts were studied to see what lessons they could teach us—about daring and sloth, loyalty and cowardice, good and evil. Early naturalists and philosophers looked to animals as a way to measure our differences, defining ourselves by similarities or by observing the wide range of peculiarities found in nature. Then, as now, animals spurred our imaginations, occupying our dreams and nightmares. Real and mythical creatures were anthropomorphized, given human qualities as a means of making points about mortality and ethics. Eventually, the study of animals spurred serious scientific inquiry and helped establish an understanding of biological laws and principles.

Attitudes toward animals changed throughout history, although we primarily believed they were here for our usage, which has led to a great deal of regrettable mistreatment and exploitation of our fellow creatures. The idea that an animal is an individual, or a sanctioned being, was never universally popular. However, everyone who cares for a pet knows that each animal has its own personality. A dog is a dog, but all are different. The same for eagles or insects. Are there introverted sponges or extroverted ants? Is there a mean-spirited termite or a butterfly who is frightened of flying?

Without animals, there would be no human civilization. We would have been among the multitude of trial-and-error species that came and went—gone in a bleep of time—without them. They were our food and clothing. We imitated how they hunted; animals, birds, and even insects showed us where to collect fruits and grains and provided raw materials to make our shelters. Our first roads were their migratory paths; they were the engines that built cities. But who are they, these millions of creatures that live with us? Do they think the way we do? How do they feel? How is it that they live and die? Did two-headed beasts actually exist and what of the myriad species that were here and are now gone? What clues can we learn from the myths from which they sprang or of their fossilized bones?

We try to imagine how animals see the world, but even our pets are mysterious to us. However, understanding the way their eyes work or their sense of smell, for example, helps us to appreciate them even more

and adds a measure of empathy, if nothing else. Appreciating the vastness of these individual lives, from the smallest microbe to the greatest whale, makes us more human. Shamans of old looked for the spirit of an animal, believing all creatures had special powers. Each animal was either an instructor or a link to an ancestor that would speak through it and reveal an unknown universal language. In this book, I hope to return to that momentary wonder we had as children. I remember when I first learned of a giraffe's preposterously long neck, or heard the incredible roar of a lion, or observed the organized and ever busy trail of ants—I was amazed by the wonderful strangeness of things. I also look at the beasts we created with our imaginations and the ones long gone. How incredible to think of the very first birds that learned to fly, or what it was to exist as a 10-ton dinosaur. Mythical creatures that breathed fire or burned themselves to become immortal are intensely compelling. Did they truly live? In our need to understand, and with our creative resourcefulness, they did—and who really knows that they didn't.

Science and technology have proved that what was once thought impossible can, in fact, become probable. Nothing is constant, as many things in science are discovered, refuted, and reevaluated again and again. Who knows what it is that makes us essentially human and at the same time so similar to animals. What separates us from creatures and beasts—real, mythical, and extinct—might be only the trace of a tail line left in the sand. As philosopher Herbert Spencer said, in a variation on a William Paley quotation, "There is a principle which is a bar against all information, which cannot fail to keep a man in everlasting ignorance— that principle is contempt prior to investigation."

The
BIG, BAD BOOK
of
BEASTS

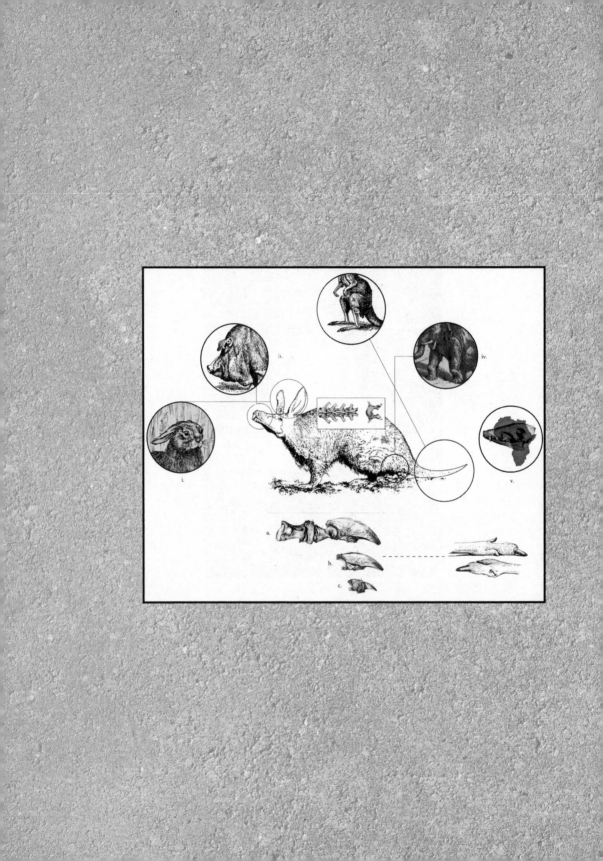

AARDVARK
"Earth Pig"

One of a kind.

With rabbit ears, a pig snout, a kangaroo tail, and mini-elephant legs, an aardvark seems put together from nature's spare parts department. The aardvark is actually completely unique—the only surviving member of its own distinct order, Tubulidentata, which means "tube-teethed mammal." It is also classified as an *afrotherian* animal, which is a small group of beasts with ancient African origins, including shrews, elephants, and sea cows. Today, aardvarks live only in Africa, in a range below the Sahara Desert to Cape Town. Most people believe an aardvark is the size of beaver, but it weighs more than 150 pounds, growing to over 4 feet in length, not including a 2-foot-thick tail. Its hind limbs have hooves, while its front feet are padded paws with sharp claws. Within minutes, it can dig a tunnel to fit the size of its body, making it faster than five men with shovels and picks.

Animated Fossil

Aardvarks existed for more than ninety million years and lived when dinosaurs roamed. The aardvark was there when all sorts of strange creatures appeared in the wake of the dinosaurs' extinction and probably heard the first songbirds sing. In fact, it certainly witnessed the rise of primates and saw the first upright walking hominid emerging from the forests. Yet, today the aardvark is exactly as it was then. With its unique chromosomes and distinctive physical characteristics, the aardvark is a living animal relic.

Hire an Aardvark

If animals were listed under categories of employment, aardvarks would without doubt work in pest control, specializing in termites. Their

The aardvark somersaults, has a tongue of glue, and an extraordinary sense of smell, though it is nearly blind during daylight. It is a quiet, nonaggressive, and typically unpretentious nocturnal beast.

Aardvark *was the name given to it by South African Dutch settlers, meaning "earth pig." In the mid-1800s, Dutch explorer and naturalist Robert Gordon introduced the aardvark to Europe and convinced biologists the animal was not related to an anteater or a warthog. In 1869, the London Zoo was the first to show an aardvark—before that, most thought rumors of such a creature were imaginary. It was not even listed in English language dictionaries until the 1920s, but after that it always made the first page, due to its double A—an alphabetical plus the aardvark taught small businesses trying to get top billing in the phone book.*

appetite for this insect is insatiable, and they never seem content until stuffed with them. Aardvarks are omnivores like us, eating insects, fruits, and roots found along their paths.

Every night of the year, an aardvark shows up for work, making a zig-zag line from one mound to another, able to identify the faintest termite pheromone, or scent; it often travels more than 15 miles from its burrow searching for its preferred delicacy. An aardvark punches a hole through a termite mound's hard, mud-caked exterior. It then inserts its sticky 12-inch tongue deep within the termite nest, trapping hundreds of insects at a time. The aardvark is anatomically qualified for the job.

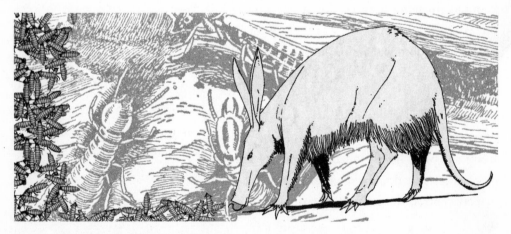

How It Works

When an aardvark smells termites, its saliva glands produce a sticky resin that is stronger than the adhesive side of duct tape. It rolls and coats its tongue in this thick pool of specialized spit before probing it into the nest. The aardvark also has a distinctive flaplike design that can seal its snout as it munches face-first into termite mounds. This prevents swarms of frantic termites from entering the aardvark's nostrils, filling up its lungs, and suffocating it.

In one year, a single aardvark eats more than eighteen million termites. That amount of wiggling bugs would fill four large bathtubs to the brim.

To solve the problem of all the dirt that inevitably gets caught on its tongue, an aardvark has rows of perpetually growing teeth located on the roof of its mouth and protruding from its cheeks. It has a gizzard stomach, the same as birds and earthworms, made of contracting and crunching muscles that work better when pebbles or stones are also swallowed to aid the digestive process. An aardvark's stomach is half filled with sand and soil much of the time, though this causes no undue grief, heartburn, or upset stomach.

Does It Play Well with Others?

Aardvarks are loners by temperament, though they join briefly once a year for mating. They usually give birth to only one naked and blind offspring each season, which the mother cares for diligently. Female cubs, or slow-learning males, are sometimes allowed to stay with the mother until the following mating season. After spending six months to a year with her, though, and while still nearly hairless, the young aardvark must leave to dig its own burrow. Afterward, the aardvark begins its existence of solitude, often never socializing with its parents again. From fourteen weeks old, an aardvark begins to eat termites, and like its parents, it will not stop searching for this particular food source for the rest of its life. An aardvark tolerates and avoids other animals that cross its path and rarely picks a fight. However, if provoked or eyed as a meal, it will defend fiercely by planting its backside to the ground, and then

Magic Animal

The Hausa people of West Africa consider the aardvark an admirable beast, respected for its unstoppable quest for food and its apparent fearlessness: aardvarks seem unafraid when challenged by deadly swarms of soldier ants, which often nestle near, and supposedly guard, termite mounds. Hausa shamans and medicine doctors use the aardvark's heart, along with powder made from a dead aardvark's strong claws, for magical concoctions. Aardvark amulets make a person invisible, capable of flying, and able to walk through walls.

"Hey, Aardvark, Where Are You?"

Though no one knows exactly how many aardvarks remain in the wild—they are hard to count due to the animal's extremely shy personality, underground homes, and nocturnal foraging—the aardvark population is estimated to be 50,000.

start swiping and swiveling at its attacker with lightning-quick claws. As awkwardly shaped as it seems, the aardvark can make a ninja-style somersault to change positions during a fight. Aardvarks usually try to avoid water, as lions do, but can swim skillfully if needed. The Tswana tribe of Africa has said that in the wild an aardvark rarely looks a human in the eye, but if it does, this is extremely bad luck.

An aardvark does not make a suitable pet, since if kept in a backyard pen, for example, it could quickly dig a hole to escape. Feeding an aardvark a sufficient supply of termites would be a greater challenge, though zoos feed captive aardvarks a mushlike substitute consisting of hash, eggs, oatmeal, and milk. The claws of an adult aardvark can slice off a leopard's nose; aardvarks must be handled with caution, if at all.

Life Cycle

On average, an aardvark that learns to fend off pythons, hyenas, and leopards can live in the wild for twenty years. Pythons are the biggest threat to young aardvarks, but all the large cats and hyenas frequently attempt to eat them, too. Aardvarks also die from snakebites. Where roads intersect terrains, they are regularly found as roadkill, as is the case with many nocturnal animals. Aardvarks are not prone to acquiring any specific diseases, though they tend to become slower, arthritic in old age, and more vulnerable to predators. Most expire in their burrows during the noontime heat due to hunger, too feeble to move. Having a solitary life—unlike wild dogs that feed their elderly—aardvarks usually die alone.

AFANC
Legendary Lake Monster

According to Welsh mythology, this creature lived in the dark, cold lakes of the British Isles. It was crocodilelike, over 10 feet long, and had a large beaver tail. However, centuries-old legends describing this beast differ, with some accounts claiming it had a humanoid face. Others portray the afanc as a dwarf-man-beast with a strange tail. Nevertheless, it stalked with an intelligent craftiness and watched people sitting near the banks, lurking close by undetected for days at a time to observe their every detail. When it finally showed itself, it spoke in humanlike noises and mimicked speech, sometimes even calling out to its intended target by name. Afterward, it usually devoured the stunned onlookers with one bite.

How It Works

The afanc's tail was multidirectional and had the ability to slap the water flat or swish it back and forth like a canoe paddle. When populations grew too crowded around its secluded lake regions, numerous afanc grouped together and agitated the surface so furiously that flash flooding occurred,

destroying villages. According to Welsh myths, the afanc's powers were useless on land. However, in water, the creature was at its stealthiest best, rarely fooled by conventional fishing methods and impossible to coax from its hiding place.

How to Survive It

Welsh folktales describe how the afanc was finally subdued, after its vulnerability was discovered; the beast seemed mesmerized by the sight of beautiful women, and at first it approached meekly and tried to talk to them softly. The afanc had a quick temper, however, and became frustrated when damsels were horrified by its presence. Records show how towns plagued by this creature actually coerced charming village girls to bait the afanc from its hiding place by having them pretend to picnic near the shore. The girls had to remain calm and look unafraid, encouraging the brute to come closer. Once the beast fell asleep on the maiden's lap, the afanc was then roped and dragged away. The last one, which legends say was captured by King Arthur, lived in a whirlpool of the river Conway located in North Wales.

Was It Real?

Accounts of dangerous creatures living near remote lakes in Britain were so ingrained in oral history that it was presumed that something weird, in fact, once lived there. Stories of such beasts appeared in numerous written accounts during the early 1500s. The mountains of northern Wales were shaped during the last Ice Age, ending about ten thousand years ago. Humanoid species lived in this area for hundreds of thousands of years. The seas were lower then, and land bridges connected Britain and Ireland to Europe. In 2004, archaeologists discovered twelve-thousand-year-old remains of a hobbit-sized people that once thrived on the island of Flores, Indonesia, and confirmed that bands of homi-

nids no taller than 3 feet, once considered fable, did in fact exist. It is unclear whether the afanc was purely imaginary or an extinct humanlike genus. Other more far-fetched theories suggest it was an anomaly birthed from Jurassic-period eggs of an extinct dinosaur and hatched during the 1500s, when Britain experienced a period of global warming.

Fifty million years ago, there was a real animal, a hairy 2-pound creature called a *Castorocauda* that had an oversized beaverlike tail and, with its large teeth, feasted ravenously on fish. The afanc might have been such a creature thought extinct, though whatever this beast was, none have been seen in more than four hundred years.

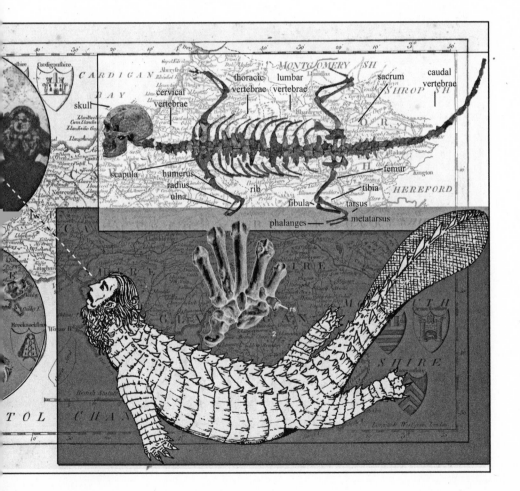

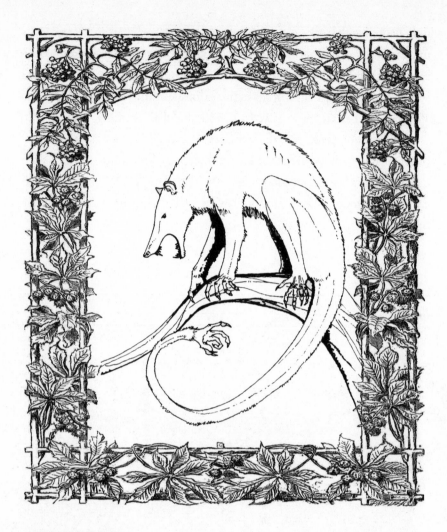

AHUIZOTI
Five-Armed Dog

Christopher Columbus attempted to take inventory of all things found in the New World, including native animals. As indicated by drawings of fantastical creatures adorning antique maps, even the most rationally minded members of the time believed in sea monsters. There was a widely accepted theory that a parallel universe existed, where every animal on land had its counterpart in the sea, though oftentimes with physical characteristics exaggerated or mutated by the unfathomable laws

of the ocean. During Columbus's fourth voyage in 1503, he happened to be stranded in Jamaica for more than a year. In correspondence, he described a strange beast known as King of the Lakes, or "Sun Dog." Some called it an "ahuizoti," apparently named after the Aztec emperor Ahuizotl. The creature was the size of a dog with a humanlike or monkey face. It had five hands, with one growing from the end of its tail. It was incredibly strong and according to writings attributed to Columbus, it attacked a Jamaican wild boar with a berserk fury, using its tail-hand to grab the pig by the throat and strangle it.

The beast was also cataloged in a book called the *Florentine Codex*, written by a Franciscan monk between 1540 and 1585, which described various aspects of Aztec life. This dog-size animal lived either in the water or in damp caves or alcoves and was notorious for being savagely territorial. If people came to fish in the area it claimed, it tangled nets and capsized vessels. The victims of the Sun Dog were dragged below the surface and overpowered by the grasp of the superstrong hand on its tail.

The creature lived in Mexico, in and around Lake Texcoco, but was also observed in Nicaragua. It has not been seen in recent times, though reports of drowning victims in the area found with fingernails missing persist.

> *The one it has drowned no longer has his eyes, his teeth, and his nails; it has taken them all from him. But his body is completely unblemished, his skin uninjured.*
> —FLORENTINE CODEX

Was It Real?

It's hard to imagine what this creature was, or the actual animal it was mistaken for, yet it is described in numerous verifiable historical records. It is speculated that the ahuizoti was perhaps a type of extinct, fiendish monkey or even a hermitic hominid, though most probably it was a type of prehistoric otter since vanished.

Nevertheless, a creature with an extra hand on its tail certainly would have its advantages.

Geographically, Lake Texcoco, before it was drained and modified to conform to the urban sprawl of nearby Mexico City, was once a large natural lake connected to five other lakes that were all more than 7,000 feet above sea level. During the period when different mammals developed, the region and these waters were isolated, not connected to the sea or any rivers, which theoretically could help to give rise to unusual creatures; consider the unique animals that evolved on Madagascar or the Galápagos Islands.

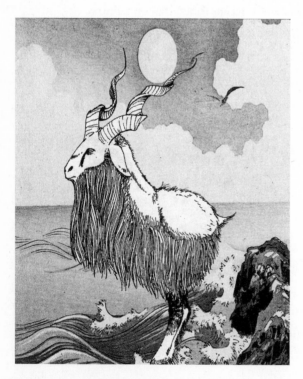

AJA-EKAPAD
Lightning Goat

This mythical one-footed goat lived in India. It had spiraling horns and long, matted fur, with a beard under its chin that extended the full length of its body. It favored mountainous regions and was rarely seen, though, in early Vedic texts (Hindu sacred books, written around 500 B.C.), the beast was represented as a god of floods and a deity that lived somewhere in the sky. The beast was often seen during thunderous lightning storms, perched on cliffs, its sil-

houette remaining motionless against the storm's flash of light. Legend believed the one-footed animal caused lightning every time it stomped its foot or when its hoof struck a rock. Vedic writings that mentioned this beast used a combination of words to form the creature's name, including *goat, serpent,* and *unborn,* such that no clear notion of the actual animal meant to be described remains. Aja-ekapad came to symbolize the fundamental energy required to bring inanimate objects to life—or the spark behind creation.

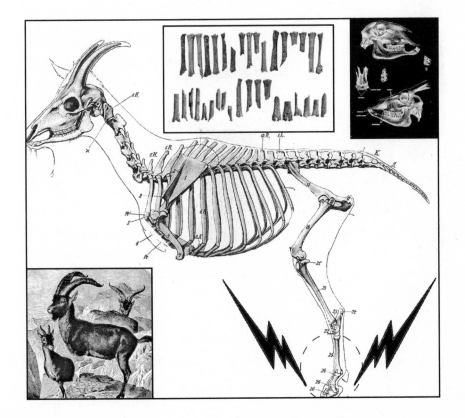

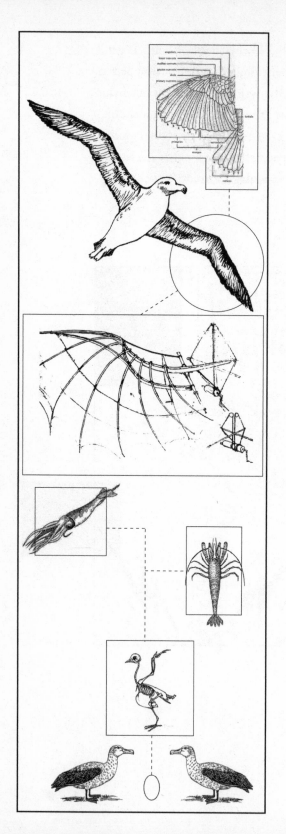

ALBATROSS
Perpetual Flying Machine

An albatross has the largest wings of all living birds, with an average wingspan of over 11 feet. The albatross prefers the wide-open ocean, only touching land and gathering in prodigious numbers on the remotest outcroppings during mating season. The albatross lays a single egg, which both parents take turns incubating. The parents remain married, so to speak, for a few years and acknowledge the commitment by a ritualized head-bobbing dance, first doing a comic mock sword fight with their beaks. They guide their single offspring until it can take to the wind on its own. The fledgling year-old albatross typically will not touch the ground again, remaining in constant flight for ten years, until it finally touches down on land only after becoming mature enough to breed. There are more than twenty known species of albatross, with the majority found in the southern oceans or near the North Pacific, favoring remote areas void of civilization.

It eats squid, small fish, and shrimp and does not need to drink freshwater to survive. Unlike people,

whose salt levels become unbalanced after drinking seawater, an albatross has a built-in desalinizing system and specialized salt-removing glands at the back of its beak. To make freshwater from seawater, the excess salt is extracted and expelled from its nostrils.

The albatross is an expert at surfing the lower air currents, able to glide vast distances without a single flap of the wings. It can circumnavigate the globe in less than two months.

Lucky Charm

In the early seafaring days, spotting an albatross was a blessing and brought good luck, since the birds were considered harbingers of fair winds and smooth sailing ahead. However, this popular perception changed over time. During the 1960s, after a resurgence of interest in Samuel Taylor Coleridge's poem *The Rime of the Ancient Mariner*, the albatross came to signify an unshakable curse. In that poem, a sailor kills the bird with a crossbow and is then made to wear the carcass of the heavy bird around his neck as a penance. The ship and all the sailors meet a tragic fate, and the Old Mariner remains destined to live forever, telling his tale of woe to whoever would hear it.

Life Cycle

Since they prefer colder air, albatross are less susceptible to diseases than tropical birds, though many do get cholera and various pathogenic bacteria, which usually affect newborn chicks. The new hatchling, after being so carefully tended, frequently dies from these diseases only after a few minutes outside its egg. While airborne, albatross have few natural

An albatross has no need for a nest, except when breeding, since, for most of its life, the sky is its bed. It sleeps in the air while in flight and has the ability to turn off one-half of its brain at a time.

enemies, but if albatross rest on the ocean, which they regularly avoid, some whales or sharks will snatch or attack the birds when these ocean predators come to the water surface to feed.

True to its majestic spirit, and as a symbol of boundless freedom, an old albatross will take a final flight, if it can, and die while riding the trade winds before tumbling into the sea. An albatross has a long life of more than sixty years. There are about 500,000 pairs of albatross still flying.

AMMONITES
"Snake Stones"

When the Roman naturalist Pliny the Elder examined fossils of ram-horn-shaped shells, he assumed they were once pieces of jewelry belonging to the ancient Egyptian god Amun, a deity that was a primeval creator who made the sky and earth, and fashioned creatures from his thoughts. Ram horns were often associated with this deity, and thus the creatures were called "ammonites." These fossil shells actually belonged to nautilus-like invertebrates, which had been long gone by Pliny's times, though they had lived in the world's oceans for over two hundred million years. They disappeared along with dinosaurs about sixty-five million years ago.

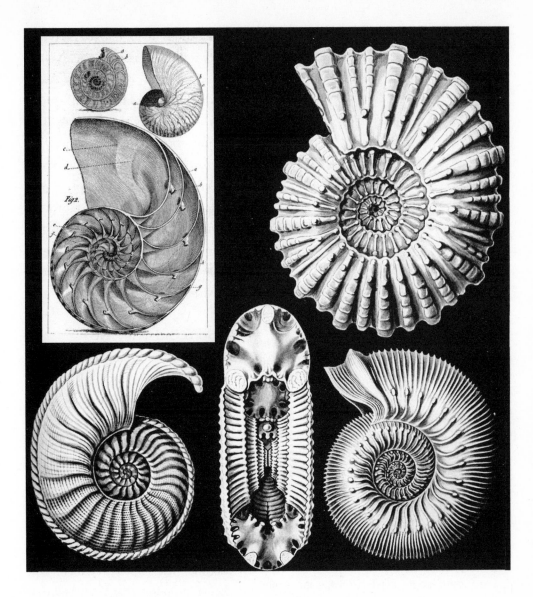

These ancient marine animals were so numerous they literally clogged the oceans during their long reign. Many of the fossilized shells remain abundant and intact even to this day.

How It Lived
Life as a prehistoric ammonite was relatively worry-free, despite finding itself in an ocean rife with dangerous beasts, since few thought of it as

In medieval times, scientists disagreed with ancient historians and said the ammonite fossils were once coiled snakes that had been transformed into stone for their evil deeds and relationship with the devil, and they called them "snake stones."

From Many to No More

Extinction is a substantial, fatalistic word. The exact reasons why some species survive and others perish are matters of speculation. Ancients explained the loss of individual animals, such as ammonites, with the principle of "miraculous interposition," suggesting that God (or one of many gods, as Egyptians believed) simply no longer had a plan for the creature. Scientist Jean Baptiste Lamarck was one of the first to ponder why organisms seemed to disappear. Lamarck was an eighteenth-century naturalist and a curator of a museum in Paris that held many specimens of invertebrates. Lamarck believed that nothing actually became extinct but that the less than "perfect'" moved to a more complex and better organism suited to its environment. There are fossil records, considered the most tangible evidence, of more than 250,000 species that no longer exist. More than 90 percent of all the species that once lived on earth are gone; viewed long term, extinction rather than survival appears to be the rule of the natural world.

a nutritious food source, especially since it was encased in a hard shell. In addition, it had another secret weapon and could ward off persistent predators by shooting ink at its enemy, sort of like an underwater smoke bomb, clouding the water, which gave it time to escape. It propelled by tentacles that protruded from its disk-shaped shell, which moved in pulsating unison to gain momentum and allowed it to move to where it wished.

Where Did They Go?

Ammonites had numerous shell designs that grew from less than 1 inch to more than 7 feet in diameter. Most ate plankton, but the largest species likely consumed smaller fish as well. They possibly became extinct because of unusual reproductive habits, since many types of ammonites only gave birth to a giant cluster of eggs once in their lifetime, just before they died. One theory proposes that if an environmentally abrupt change occurred, the total global specimens of egg clusters could have perished during a particularly devastating climatic event. In addition, plankton populations were thought to have

diminished drastically due to a blanket of atmospheric volcanic ash that had darkened the skies during the period immediately preceding the ammonites' elimination. When this primary food source for ammonites dwindled, it likely abetted this creature's disappearance forever from the oceans.

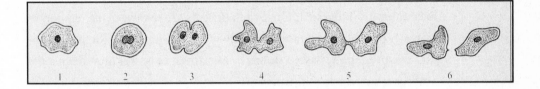

1 2 3 4 5 6

AMOEBA
Microscopic Immortal Being

Amoebas live all around us, but they are usually too small to see without a microscope. The largest grows to 700 micrometers, which is smaller than the period at the end of this sentence. However, at any given moment, hundreds are hitching rides on dust particles floating in the air. In a single drop of pond water, there are typically more than one thousand, which, if coerced to stand in a straight line, would measure less than 1 inch. Amoebas have jellylike bodies or cytoplasm held in loose form by a membrane. An amoeba can change shape and look like an ink splat; it can be oval or form into a shape with a number of peninsula-like extensions. Inside it has a nucleus, its brain, of sorts, but it has no eyes, ears, arms, legs, or mouth. Although it does not hear or see—or so we think—it is fully equipped to survive and even flourish to the point of being almost immortal. An amoeba strives to find a moist environment—a stagnant puddle of water would do—where its whole being entwines with its fluid mini-universe and nearly becomes part of the substances around it. Once in a watery locale, its eternal endurance of riding on dust specks or blowing in the wind pays off and it becomes keenly sensitive and active.

How It Works

When an amoeba feels things bumping against its body, such as minuscule bacterium (its food source), it immediately sends a feeler out, breaching the membrane, to capture it.

These feelers (called "pseudopodia") are kind of like backhoes with a scoop bucket. They emerge to capture the bacterium and then retract with it back into the amoeba's body. A sack is formed around the yummy bacterium until digested. Once the nutrients are removed, the temporary stomach pouch, then containing only waste, is ejected by the pseudopodia. Even though it has no stomach, intestines, or bowel movements, the amoeba is extremely self-sufficient.

When food is plentiful and the amoeba eats to excess, it does not remain chubby for long. Instead, it divides in two, and an identical amoeba is born. An amoeba has no parents, yet, unless squashed, boiled, or dried out, an amoeba, in theory, can live forever. If eaten by a fish or ingested by a bird, the amoeba will outlast it several times over. An amoeba never grows old or ages in any way.

Are Amoebas Animals?

From the time of Aristotle (ca. 300 B.C.) until the late 1800s, all life was divided into two kingdoms, with everything classified as either animal or plant. In the late 1600s, scientist Antonie Van Leeuwenhoek urged the scientific community to add a third kingdom for unseen single-cell creatures that he "discovered" after perfecting magnifying lenses and ultimately inventing the first microscopes. He originally called these single-cell beings, including amoebas, "animalcules," which are now classified as microorganisms. These animalcules were added to zoological classification in 1674, but they were categorized in either the plant or animal kingdom. The third kingdom of Protista, which is where amoebas are now placed, was made distinct in 1866 under the urging of biologist Ernst Haeckel. As an innovative scientist, Haeckel also proposed the idea that the evolution of an individual species could be observed by studying an organism's changes during gestation. To demonstrate, he showed how a single-cell sperm and egg transformed from a fishlike embryo and then eventually developed into a human baby. Haeckel said a baby's embryonic development was a mirror of our evolutionary path.

Friend or Foe?

There are thousands of different kinds of Amoebozoas, many of which inhabit our bodies without ill effect. A number are particularly dangerous and potential killers. The *Naegleria* amoeba lives in freshwater lakes where water temperatures exceed 80 degrees Fahrenheit. These enter through a swimmer's nostrils or mouth and find their way to the brain. They feed on nerve endings and trigger headaches, stiff necks, and fevers within weeks. Hallucinations and abnormal behavior follow until deadly brain swelling results. It is unclear how long those particular amoebas can live, or if they also die, forfeiting their immortality by killing their hosts.

AMPHIVENA
Two-Headed Lizard-Bird

According to Greek mythology, this half-bird, part-reptilian creature had two heads of unequal sizes. Its larger head faced forward, while the smaller second head looked backward and grew from the tip of the amphivena's whiplike tail. When the amphivena hatched from an egg, the little head had to awaken the oversized head from its embryonic state or else the creature would die. Both heads were fully functional, and each ate and drank independently as needed. It had two sharp talons for claws, a leathery snake skin, and feathers only on its wings. These creatures grew typically to about 6 inches, or the size of a sparrow, but with longer, hairless necks. Other witnesses claimed to observe amphivena that were 2½ feet tall. They took to cold climates well and were the last to hibernate and the first to reappear in spring. Many ancient writings described this creature as some sort of strange worm, or as a combination lizard-bird, a missing link between the two, which gave a harmless pinching sting similar to a flea. It was difficult to sneak up on these animals or capture them; each head took turns sleeping. They had eyes that literally turned off to get black as marbles or alternately glowed emerald bright and sparkled like mirrors.

Amphivenas' hides were used in medicines to reduce "cold shivers." If a pregnant woman crossed paths with an amphivena, it was common knowledge that she would probably miscarry. It was unknown whether this adverse event was caused by the amphivena itself, or from sheer fright after stepping on such an extraordinarily odd creature.

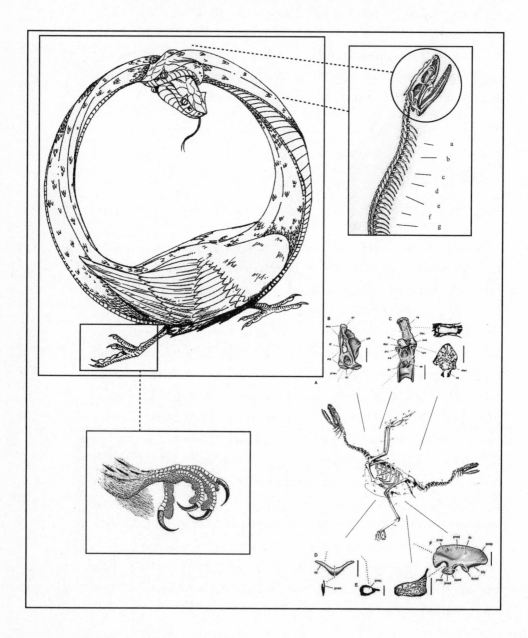

Were They Real?

In the 1570s, John Gorraeus, a French physician, tried to explain why references to the two-headed amphivena had appeared extensively in both ancient Greek and Roman books, though no living specimens could be found. He believed multiple-headed creatures were isolated incidents and mentioned a snake then recently born in Ceylon that had four heads. Gorraeus interrogated witnesses who described how each head of the snake faced north, south, east, or west, and no matter how it was turned, it would not rest until each darting tongue indicated the four points of a compass. More likely the amphivena could have been a hoop snake that lies with it head to its tail and is easily mistaken for a bicycle tire.

ANDEAN CONDOR
Nature's Trash Man

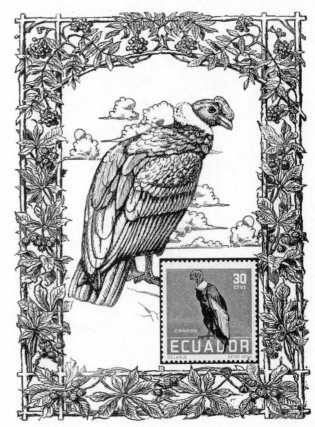

The 4-foot-tall Andean condor is a lofty bird weighing over 30 pounds. According to the principles of aerodynamics and the laws of gravity, the bird is so bulky it should require a long runway before it is capable of achieving flight. Andean condors live in a range that spans the entire Southern Hemisphere. They prefer mountainous areas but are also found near oceans and even in deserts; they need regions where strong thermal-air currents allow them to stay airborne. Most condors are now concentrated along the west coast of South America.

Condors build nests as high as 15,000 feet above sea level and like to perch where they can simply jump off and be immediately in the wind streams.

—

Vultures can eat anthrax, botulism, and other deadly diseases without ill effect.

—

Plutarch, a first-century Greek historian, wrote about the vulture: "For it is a creature the least hurtful of any, pernicious neither to corn, fruit-tree, nor cattle; it preys only upon carrion, and never kills or hurts any living thing; and as for birds, it touches not them, though they are dead, as being of its own species, whereas eagles, owls, and hawks mangle and kill their own fellow-creatures."

Once airborne, a condor glides in wide circles, as high as 3 miles above the ground, sometimes not flapping its wings, and only shifting the end tips of its wing feathers for direction.

Waste-Removal Experts

Like all varieties of condors, the Andean condor is a vulture, with a black feathered body, white under its wings and tips, and a bald head. Male condors have white collar bands, and all have hooked, strong beaks designed to rip open the carcasses of dead animals. They can go for a few days without eating, but once they locate a fallen animal, they gorge until so stuffed they are barely able to obtain liftoff. In nature, vultures are the chief hazardous waste removers, eliminating the dead that would spread diseases and contaminate water supplies.

With their bald, featherless heads, condors wear a sort of permanent rubbery mask, which prevents oozing bacterium from infecting them. Throughout history, condors and all vultures were looked upon with disdain for their appetite of eating the dead, and more so for sensing death's close approach. However, when considered as an effective recycler, doing a job that few find attractive or are as equipped for, the condor leads the animal kingdom's sanitation patrol.

Life Cycle

Condors usually only lay one egg per year. They breed in July, and both male and female warm and guard the egg and take care that it does not fall from its rocky ledge. Since the nests usually lack soft bedding,

tending the egg and not cracking it against the rocks until it hatches sixty days later is no easy matter. Both parents stay with the chick for another six months, teaching it all they know about being a vulture until it can keep up with the flock and circle to impressive heights. When the young condor turns five or six years old, it will choose a mate and remain faithful to it for its entire life. Some vulture couples have been together for over fifty years, and there are records of condors living for more than one hundred years.

ANGLERFISH
Deep-Sea Oddity

Nature can have a surrealist flair when fashioning some creatures. The anglerfish, a bottom-dwelling species found in the deepest oceans, would win any contest for the most innovative and perhaps the craziest of animal designs. It lives in the lightless environ of the ocean floor, as far as 1 mile deep, in regions known as the abyssal zone. Its range extends from the Arctic through the North Atlantic Ocean and down to Africa and even into the Mediterranean Sea. Anglerfish are also found in the Mariana Trench, the legendary abyss southeast of Japan.

The female anglerfish is always fishing for food. It has a thin, bony dorsal spine that extends from between its eyes and arches out in front of its mouth. The end of this permanent fishing rod is baited with a wad of tissue that is covered with a bioluminescent bacterium that glows and attracts prey—a tiny, electrically charged fishing lure. When small fish fall for it, the anglerfish snatches the curious. The anglerfish has a pail-sized

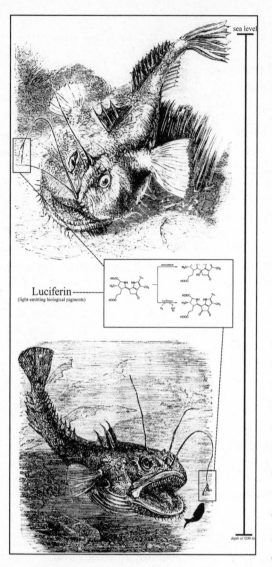

mouth that snaps shut like a steel trap, capable of capturing fish twice its size. Its neon fishing lure also attracts mates, which are not eaten, but are enticed, perhaps, into accepting an even worse fate.

It's a Woman's World

In this dark ocean world, at least among anglerfish, the female is the only one who can fish for food. The male does not have the built-in fishing pole and must find a female that allows him to become a sort of pilot fish, at first trailing her wake and catching her scraps. Eventually, the male anglerfish physically attaches himself to the body of the female and hitches a ride by biting into her flesh. Soon thereafter, the male loses the ability to see or open his mouth, and in due course, all the male's internal organs disappear, with the exception of his testes. By fusing

The anglerfish's lower jaw protrudes and looks similar to a gobbling Pac-Man video icon, though with horrifically sharp and jagged teeth. There are two hundred different species of anglerfish that grow in size from as little as 8 inches to over 3 feet.

to the female, the male then receives all his nutrients from her shared bloodstream. A dominant female anglerfish can have as many as a dozen of these freeloading males permanently attached as she swims, providing the day's food for her collection of leeches. As for a benefit in reproduction, the female never has to go far to get one of her males to fertilize her eggs.

Life Cycle

Some anglerfish live in schools; others are solitary, though often they gather in the vicinity of underwater thermal vents, where a strange kaleidoscope of creatures exists. The superheated water reaches temperatures of over 500 degrees Fahrenheit, though heat dissipates rapidly in the surrounding near-freezing water to make it habitable. Anglerfish thrive in this nearly sci-fi environment and have been known to live for more than one hundred years.

Relationship Counseling

As human couples often do, animals in nature sometimes engage in what are called "symbiotic relationships." There are three basic types: first is *mutualism,* when both parties benefit from each other's company; second is *commensalism,* when one party is benefited while the other is neither harmed nor rewarded; and third is *parasitism,* when one gains all to the detriment of the other—and among humans, at least, this often leads to divorce. As for anglerfish, with its seemingly inequitable arrangement where the females do the bulk of the work, its relationship actually qualifies as a sort of dysfunctional mutualism. For her labors, the anglerfish has an unbreakable hold over a harem of lovers who are always at her beck and call, but with an assurance that her eggs will be fertilized and her lineage survive.

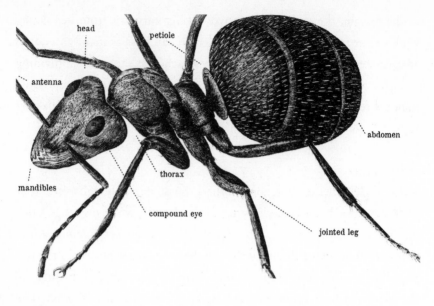

head — petiole
antenna
abdomen
mandibles
thorax
compound eye
jointed leg

ANTS
Nine Trillion Strong

Ants lack ears and lungs. They hear by vibrations and breathe through holes in their bodies. They use chemical scents called "pheromones" to communicate and identify other members of their colony, as well as a way to mark a trail once they find food, telling others where to go and how to bring it back to the nest. An ant has the power to lift an object more than forty times its body weight, such that if it were the size of a human, an ant could pick up a city bus and carry it a mile. All ants in a colony, with the exception of the queen, are considered expendable and are sacrificed to save the nest without hesitation. Soldier ants are so tough, they will join forces and use their heads as a barricade to plug the colony entrance. When a worker returns, it knows how to knock or bang on the heads of the solider ants in such a way as to gain entry.

You'll never see an ant out in the rain—they know when inclement weather is approaching before a cloud appears in the sky.

When ants form a line to carry crumbs, they are reluctant to pass their loads to other ants and usually insist on taking them back to the nest themselves. They persist at finishing whatever job is assigned. When ants collect seeds or grains, they are careful not to bring them back to the nest if the seeds have the potential to germinate, since once sprouted, they could destroy the ants' underground tunnels and chambers. Specialist ants take the responsibility of temporarily arresting seed germination by eating only a certain portion of a seed, then removing the harder part of it from the nest where it is dispersed and then blooms. In this way, ants are efficient forestry managers. If any of their stored food gets wet, ants take their inventories back aboveground and dry them off before restocking.

Art of Ant War

Some ants plan attacks on neighboring colonies and use different tactics to achieve victory. The Argentina ants, with supersize colonies, will move through a territory they wish to acquire, laying waste to more than a million enemy ants within one day. Other ants have been known to encircle an adversary's nest and simply wait, letting no ants in or out. When the colony under siege loses its wits and starts running around in a disorganized frenzy, the attacking ants move in for an easy win.

Ant Society

There are more than 12,000 species of ants found all over the world—with the exception of Antarctica, Iceland, and Greenland. They live in rock, sand, soil, trees, wood, and in man-made items like airplanes, cars, and electrical panels, as well as, reportedly, even inside of living people. There are stories of how ants can crawl inside a sleeping picnicker's ear and form a colony in the brain, eventually killing their host. However, due to the anatomy of our ear canals, protected with earwax, such a feat would be difficult even for the most persistent ant.

For every one human alive today, there are 1.5 million ants crawling

around at this very moment—approximately 9 trillion total ants. Since there are so many types of ants, certain habits vary, but all ants are social animals and can survive only as a colony. Thief ants are the smallest ant, no bigger than ⅟₁₆ inch, while sausage ants (named for their overbloated abdomens) are the biggest, growing to over 2 inches. The largest colony of ants belongs to the Argentine ants, with one colony stretching for 3,700 miles.

Ants come in three varieties: the queen; winged male soldiers, which also might be assigned as mates for the queen; and worker ants, which are all females. Although particular habits of ant species differ—some colonies, for example, have more than one queen—ant society is broken down into castes, wherein individual ants are assigned very specific roles and duties. An ant rarely has a chance to change its status within the colony and must perform the function it was given for the remainder of its life. If ants attack another colony and win, they transport the enemy's eggs as war booty back to their nest, hatch them, and make the captured

Farmer Ants

Fossil evidence suggests that ants flourished for 150 million years and were underfoot when dinosaurs ruled. They also have practiced a form of farming for 70 million years, long before people thought plant cultivation was the most reliable way to obtain food. Ants plant seeds of various plants that have sweet sap or contain nutrients specialized to their diet. They can also produce chemicals to ward off fungus and kill mold to protect their crops. In addition, ants designated to be farmers are assigned to a variety of fertilizing duties, and they know how to use their own waste or manure from other animals, which is spread around to nourish seedlings. Ants even employ sap-sucking insects and aphids, carrying them on their backs to harvest their crops. After the aphids suck the plants' fluid, the ants eat them.

ants their slaves. A queen, once so enthroned, has only one job—lay eggs. She can produce one million eggs in her typically three-year life span. Males allowed to mate with the queen die shortly after. When the queen herself dies, the colony is doomed, and all workers and soldiers perish within a few months. Some queen ants have incredibly long lives—over thirty years—while a typical worker ant lives for about three months.

Ant-Lion

Ancient books on natural history describe a prehistoric species of large antlike insect that had mated with a lion. It was supposedly the size of a dog. It had the face of a lion, but all other body parts resembled that of an ant. The females of the species ate grain, while the males ate meat. It was reasoned that this creature disappeared due to its differing appetites, which never allowed for a harmonious union.

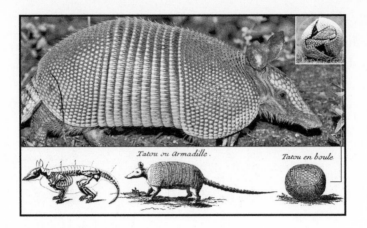

Tatou ou armadille. Tatou en boule

ARMADILLO
"The Little Armored One"

There are 20 different types of armadillos—ranging in length from only 1 foot to more than 5 feet long, and weighing from 8 ounces to 130 pounds. They are found naturally in the southern parts of North America and throughout Central America and South America; most prefer warm weather since they freeze easily. This animal descended from an order of mammals of which anteaters and sloths are fellow members. Armadillos live in burrows and are equipped with sturdy, sharp digging claws designed to hunt for their food of insects, ants, and termites. They sleep most of the time and only rouse at sunrise and again at dusk.

The shell is made of bones and a hornlike material that is divided into flexible sections, which if necessary can enable it to form into an almost perfect sphere. The armor also allows the armadillo to escape into thorny patches to evade predators. It also defends itself by confusing enemies with a sudden leap; when an armadillo gets frightened, it suddenly jumps 2 feet off the ground before scurrying away. Some armadillos live alone; others live in pairs or in arrangements of a few, though they usually only come to gather in cold weather so they can share body heat inside burrows.

The armadillo's distinctive protection of body armor gave it its name, which is Spanish for "the little armored one."

Armadillos often are killed while crossing roads. Instead of lying flat when they see headlights approaching, they jump up, just high enough to reach the car fender. They are also one of the few animals that get leprosy, a disease that eats away at the flesh. Armadillos are unusually susceptible to this human disease due to their lower-than-normal body temperature. Even so, armadillos typically live for about four years, but some luckier individuals have reached the age of twenty years.

Armor Patrol

Porcupines, although not at all related to armadillos (they instead rank as the third-largest rodent), also developed a form of armor. A porcupine's elongated hairs are encased in keratin, the protein that makes our fingernails hard. Its 6-inch quills are barbed and release upon contact, but it cannot shoot them at will. By way of contrast, the armadillo's armor is made of dermal bone, the same type of bone found in human skulls.

The most tanklike body armor of all time belonged to the ankylosaurus. It was a squat, 35-foot-long dinosaur, with a clubbed tail. It had a back or shell made of hard bony plates, topped with spikes. The armor bones were pleated in a way similar to an armadillo's shell and could withstand a chomp from a T. rex, though the ankylosaurus could not roll into a ball. It became extinct sixty-five million years ago. Soon after, relatively speaking, about sixty million years ago, the new and improved model, the armadillo, appeared, so it is nearly as old as dinosaurs.

ARCHAEOPTERYX
First Bird?

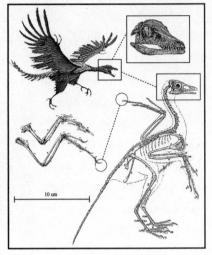

10 cm

During the days of dinosaurs, there weren't many creatures that we would recognize as birds. Most creatures were reptilian, though one well-persevered 150-million-year-old fossil of a birdlike beast, the archaeopteryx, shows how the transition from earthbound to sky-roaming creature might have taken place. The archaeopteryx was small, only as tall as a modern-day crow. It had teeth and three claws on the outer part of its wings, features that birds today do not have. Its bones were hollow, making it light enough to take to the air—though its limb structure was not developed for long flights or high-altitude soaring. It had a hornlike bill and was most likely an omnivore. By strict definition, the archaeopteryx is not classifiable as a bird, according to most scientists, yet it can be appreciated for being the earliest known animal to achieve flight.

What Makes a Feather Fly?

For anything to fly, it must adhere to the four basic principles of aerodynamics and compensate for lift, thrust, weight, and drag. Simply, a bird's feathers (and wing shape) do most of the calculations needed to achieve flight. Like fingernails (and animal claws and lizard scales), bird feathers are made from the protein keratin. Birds usually have at least three types of feathers: interior down feathers, which are fluffy and aid in insulation; filoplumes or sensory feathers, which are primarily only a stem with a tuft of fibers on the end; and contour feathers, which are responsible for flight. Although feathers come in many shapes, lengths, and designs, flight is achieved as rows of tightly arranged feathers provide lift and thrust. Feathers are symmetrical, with an identical feather found in an equal place on the opposite wing. However, it is the complete wing structure that determines if the bird must be a constant flapper or is able to glide.

ASPIDOCHELONE
Legendary Living Island

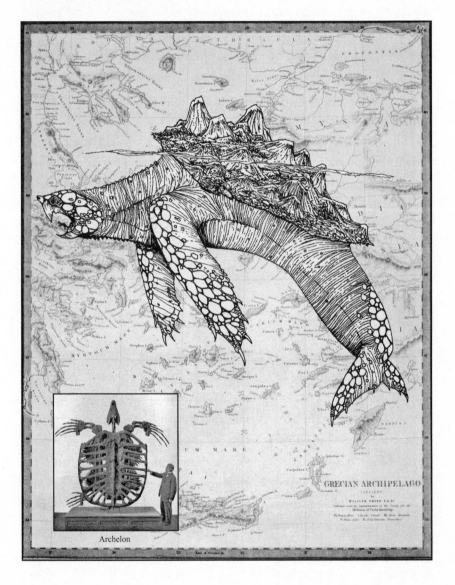

Archelon

GRECIAN ARCHIPELAGO

Early sailors who returned to tell tales of their adventures at sea frequently mentioned sightings of a giant creature that was as big as an island. The fabled beast was exceedingly cunning and deceived the unwary by camouflaging itself as a small outcropping of rocks. A legend popular

in ancient Greece described how sailors encountered the monster in waters far beyond the Strait of Gibraltar or in the deep oceans. These sailors navigated their ship close to what appeared to be a sturdy island and anchored. Eager to stretch their legs on land, the crew disembarked and lit fires on the beach. As the fires blazed, the entire island began to shudder when the heat suddenly aroused the sleeping beast into a crazed frenzy. The aspidochelone then latched on to the ship and pulled it and all the men down to the bottom of the sea.

Though some speculated it could have been a whale, the aspidochelone is thought to be a type of monster turtle. Those who claimed to have seen it (and survived) said it had a hard, stony hunched back similar to an enormous snapping turtle shell. It waited at the surface, remaining stationary for days at a time, appearing to ships in the distance as a haven to rest or gather supplies. The aspidochelone was so artful, it even dredged up sand from the ocean floor and made itself appear as a landmass with tranquil beaches.

Was It Real?

Today the largest turtle, the leatherback sea turtle, can grow to 9 feet, but enormous specimens have emerged from the fossil record, suggesting it's not impossible some living relic was encountered. There was a primitive giant turtle called an archelon. It was immense as far as turtles are concerned, measuring 13 feet long and about 16 feet wide. This oversize turtle likely disappeared sixty-five million years ago and roamed the ocean that covered parts of North America. Another prehistoric animal, a whale named *Basilosaurus,* was far larger, reaching a length of 60 feet, but this creature was (in all likelihood) extinct long before the earliest humans took to the sea in boats.

AYE-AYE
Knock, Knock, Who's There?

The aye-aye is a rain forest tree dweller that forages at night and rarely ventures far from its leafy seclusion. Native to the biologically diverse island of Madagascar, located off the southeast coast of Africa, the aye-aye is a primate (thus related to chimps and humans) that looks more like a rodent—with big eyes, bone-thin fingers, and a fluffy tail that is longer than its 15-inch body. It also uses a unique method to get food.

With its pointy ears pressed to a tree, an aye-aye listens for insect activity inside or for a hollow sound. After gnawing a small hole at that spot, the aye-aye inserts its middle finger into the gap to gather its feast. This is easy for the aye-aye since its middle finger is three times the length of its other fingers.

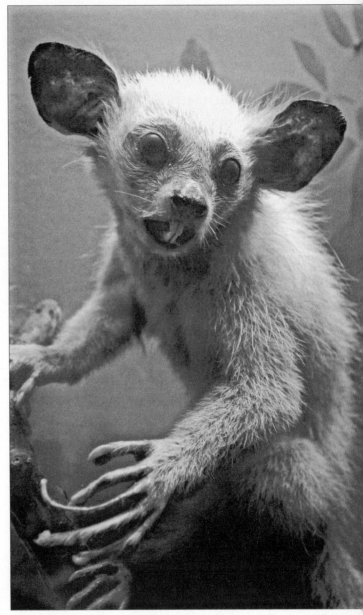

By tapping its knuckles on a tree, the aye-aye finds its favorite food of grubs and insects that hide under bark.

Are They Evil?

Due to the aye-aye's outrageous appearance and physical oddness, many native peoples believed seeing one would bring instant bad luck. According to legend, the aye-aye was the reason why some people died during the night in their sleep, for the nocturnal animal would creep into huts and pierce sleepers' hearts using its long middle finger like a knife. Because of this superstition, aye-ayes were killed on sight, historically. Now there are laws to protect them. Although their numbers are difficult to calculate, it's estimated that fewer than 10,000 aye-ayes remain in the wild. When left alone, an aye-aye can live for about ten years.

AXOLOTL
"Mexican Water Monster"

From the prehistoric subterranean lakes and caverns that once swirled in darkness under Mexico City, and from the high-altitude Lake Xochimilco of central Mexico (now drained), a special type of tiger salamander emerged. The axolotl is unlike other salamanders that metamorphose from egg to tadpolelike larvae and then to a fully formed land-dwelling amphibious adult. Instead, this creature halts development perpetually at the larvae stage, unable to live terrestrially for long. Called everything from

The axolotl has a distinctly round, grotesquely cartoonish face with six feathery antennae-looking feelers, which are actually gills, protruding from its neck.

a "walking fish" to "Mexican water monster," it averages 6 to 9 inches in length (though it can grow to 1½ feet) and weighs less than ½ pound.

Even though the axolotl has lungs, it breathes through its gills and skin. In addition, it has unique regenerating properties that allow it to grow back lost limbs or parts of its tail at will. In contrast to many creatures that modified and evolved in a forward path, the axolotl is an example of an animal that devolved. At one time, these salamanders lived on land and in water like frogs, but for reasons unknown (though presumably it found an advantageous niche back in the water), the axo-

lotl returned to an aquatic existence. Unfortunately, axolotls are nearly extinct in the wild. As pets, sold as wooper roopers, they survive in freshwater tanks, and if fed a steady diet of worms and mollusks, they can live for an astounding ten to fifteen years.

De-evolved vs. Re-evolved

It is not fully understood why some animals revert anatomically to an earlier evolutionary state. From a genetic standpoint, a genome can switch off or on as a result of a variety of factors. In all animals, genes that are not in use can lie dormant for about six million years, yet still carry the overall genetic makeup of the species. It is assumed that if the gene is not switched on within ten million years, then its functionality will be lost. In theory, dolphins could regrow legs, and humans might be able to grow a tail.

Human

Baboon

BABOON
Red-Rumped Monkeys

Baboons are the largest species of Old World monkeys. They are distinguished physically from related primates, such as chimpanzees and apes, by their longer, muzzled snouts. There are five different types of baboons, also called Old World Monkeys, which are found primarily in Africa below the Sahara Desert and on the Arabian Peninsula. The mandrill, famous for its brilliantly colored face, was previously classified biologically as a baboon. Now mandrills belong to a distinct genus, or subfamily of primates, although they are still commonly referred to as baboons.

Nature's Most Colorful Face (and Bottom)

The name *mandrill* means "man-ape" (though baboons are not apes). The mandrill is the largest of all baboon varieties, known for its furrowed and vividly blue cheeks, crimson nose, and sharp canine teeth. It has a yellow tuft of hair below its chin, and the males grow a mop of head hair that eventually looks like a cape. About the size of a pit bull dog, mandrills stand 3 feet tall at the shoulder (when on all fours) and weigh about 60 pounds. Both males and females have nongripping tails, and they are excellent tree climbers with ten toes and ten fingers. Most striking to us is how they have zero embarrassment when it comes to parading about and showing off their conspicuously red bottoms, which for females, at least, change from gray to pink when in heat. For

the baboon, its soft bottom is like carrying around its own pillow that adds to its sitting comfort.

Baboons make up to thirty different vocal sounds and use body language, like shrugging, but the mandrill's face is its most expressive form of communication, one that makes for a truly scary countenance, especially when angry.

However astonishing their crazy clown faces appear to us, they are signs of beauty and power among mandrills. Males with the most wildly vibrant colored cheeks and noses are often considered the most attractive to the females of the species. In fact, the face coloring of a male mandrill, with its long, red nose and puffy light blue cheeks, often matches the colors of its private parts. Since they make the densely vegetated rain forest their primary habitat, baboons' faces stand out and mark them immediately as a member of their species and instantly recognizable by their troop. Baboons survive the dangerous jungles by banding together. As social primates, it is important to know who was friend or foe, which remains an essential element of the baboon's survival. Its face not only makes it an easy way to identify another member, but also serves as a unique visual defense. Most baboons would rather flee than fight, but mandrills show no fear and stand upright to face off with a leopard, for example, if attacked. When flushed in rage, and baring their long canine choppers, mandrills have a maniacal appearance.

Adult males use cooperative war strategies, their faces signaling to one another as they surround, decoy, and deploy, making even larger predators think twice before challenging a troop of mandrills.

Pick and Comb Your Way to the Top

Baboons and mandrills form strong bonds among the members of their troops and spend hours at social networking. Troops are led by a dominant male, who (if adept at his job) attempts to bring harmony whenever possible by stopping infighting, often quelling potential mayhem with a look. Each boss male leads as many as thirty females, along with their young offspring. The larger troops are broken down into complex hierarchies, with certain males ruling separate, offshoot families, though all are under the direction of the top monkey. Living as a baboon is similar in many ways to how street gangs operate. In addition to strength and aggression, status is often gained by baboons' almost fetishlike activity of grooming each other and trying to appease the leading baboon. Many hours of their days are dedicated to picking bugs and dry skin and stroking matted fur. This is done to demonstrate affection and compliance, and although sometimes it appears as an obsessive habit, it nevertheless ultimately makes for strong bonding.

Everyone likes to be massaged and groomed, but baboons make it an essential part of their societies.

If a weak baboon is proficient at grooming, for instance, even the toughest male will not want to lose his masseuse and protects his favorite groomer more than other members that are less skilled. Among primates, mandrills rank only second to humans in the size of their congregations—one troop was counted to have more than thirteen hundred gathered at one time.

Life Cycle

All the big cats and hyenas hunt baboons. Baboons usually bed in treetops or amid high cliffs, but while foraging during the day and traveling on the ground for fruits, plants, and small animals, they are exposed to many dangers, with females and young baboons usually suffering the greatest fatalities. Most deaths caused by predators occur during rainy seasons, when baboon foraging routes are restricted and more predictable.

The baboons have a dark side—their propensity to commit infanti-

cide and eliminate a baby (of a rival male) that is still nursing to make the mother capable of mating. Those males new to the troop, or ones trying to gain status, do this if they desire a female, which cannot go into heat while she is still caring for her young.

A female that has made a male friend by grooming often calls upon him to protect her baby, which he will often do by snatching the baby away in his arms and taking it to safety.

This lifestyle of constantly trying to maintain acceptance and status among peers actually causes baboons to acquire diseases considered, among humans at least, to be stress related, such that baboons often die of factors from a weakened immune system, including heart disease, tuberculosis, liver disease, seizures, and venereal infections. Baboons can live for about forty years, but the average life span for a mandrill in the wild is only about twenty years.

BADGER
Natural-Born Prizefighter

Badgers are stocky, short-legged burrowing mammals. There are eight kinds of badgers found in North America, Europe, and Asia. Most have black-and-white-striped faces, weigh about 7 pounds, and grow to 30 inches in length. They are omnivores and eat roots, plants, insects, frogs, snakes, and mammals. Since they do not run exceptionally fast (reaching speeds of 10 to 15 miles per hour), they prefer to hunt for smaller animals by digging into a burrow and capturing their prey underground. They have extremely sharp claws and can bulldoze through the ground at a rapid pace.

Some badgers are partial to rotting fruit, especially pieces that cause them to become intoxicated. The badger is one of the few animals that seek out fermented fruit for the sole purpose, it seems, of getting buzzed. Groups of badgers, called "cetes," often gather at places where there is rotting fruit and are seen staggering about, heading topsy-turvy back to

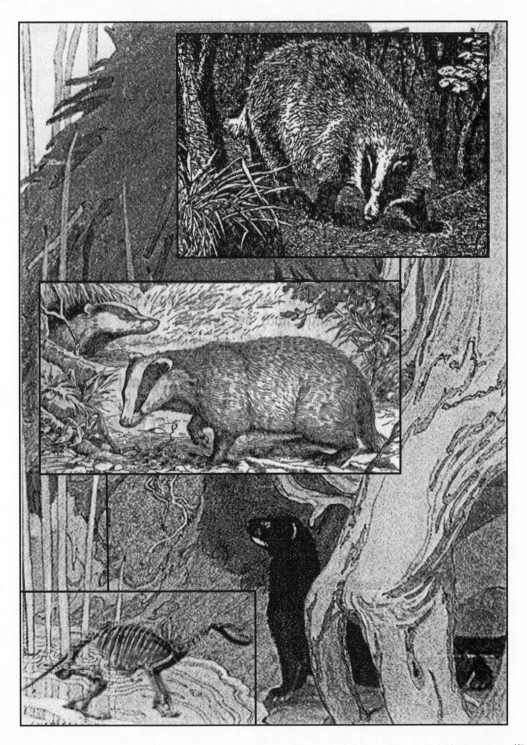

their dens. Some badgers are solitary, but most live among ten or more family members. They excavate elaborate burrows called "setts," with chambers for sleeping, hanging out, storage, and designated restrooms. One badger sett discovered in England was something of an underground mansion that had over fifty rooms and was ½ mile long. Badgers have such strong forearms that when one builds its home, dirt and rocks are seen flying out as if exploded by ministicks of dynamite. They keep these setts clean, changing straw and cushioning it with moss. Setts are decorated by the badger's family tastes, and they keep them functional and maintained for long periods, passing over the homestead from one generation to the next.

Life Cycle

As much as they seem to enjoy a good stiff drink and are tidy housekeepers, badgers are especially noted as fierce fighters and have no qualms taking on a wolf or larger predator. They are quite vicious when attacking, using their powerful, muscular arms and swiping claws. Once they lock down with their sharp teeth, their jaws set like a vice, which no amount of shaking will seem to loosen. Only the largest predators, such as bears or cougars, consider taking on a badger. Coyotes will try to eat them, but oftentimes get eaten themselves. The young might be picked off by eagles. Badgers have reached the age of twenty-five, but depending on the species, they usually live for about twelve to fifteen years in the wild.

The phrase "Don't badger me" comes from the animal's dogged persistence when hunting or fighting. Badgers also are famous nags and pester other badgers to keep their burrows clean.

The word badge *appeared in the English language during the 1300s, meaning a special insignia or a symbol of alliance to a clan. So the badger probably got its name from the badge of white fur on its face.*

BAGWORM
Snug as a Bug

The North American bagworm is a black moth that got its name for its larva and pupa stage. The female spends her entire life inside the safety of an interwoven fibrous bag of her own making. When attaching to evergreen trees, bagworms produce a cocoon that passes for a replica of a pinecone. On leafy, deciduous trees, they fashion cocoons that look like seedpods or teardrop-shaped brownish-pink paper bags. Eggs laid in autumn lie dormant in these cocoons until spring, but once the larva hatches it fashions another bag for itself that it drapes around its hind parts. It only sticks its head out to eat. From June to August the bag-

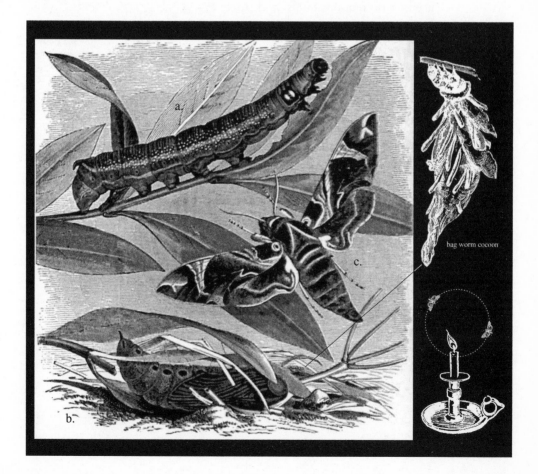

bag worm cocoon

worm, a black, eleven-segmented caterpillarlike insect, is a hungry little beast, devouring large sections of foliage seemingly overnight. It grows to 2 inches long and frequently resizes its bag as it gets larger.

The female remains in her bag sending out scents, called "pheromones," that attract males to her. She will then lay one thousand eggs, seal the bag as she departs, and fall to the ground dying in the knowledge that she had completed her life's mission. The male bagworm moth will spend the rest of its life attracted to light, flying into headlights, or singeing it wings on outdoor bulbs, and surely expires with the first frost.

When the summer starts to close, the larva will face head down into its bag, seal it, and wait for about four weeks until it breaks free and, if a male, flies away as a moth during September and October.

Why Moths Are Attracted to Light

The female bagworm's pheromones are released during the night, oftentimes when the moon is full. Adult males flying at night have a better chance of avoiding the array of birds ready to eat them. Although it's still mysterious to scientists, moths have an involuntary instinct, called "phototaxis," which makes them positively drawn to light. (Insects like cockroaches have negative phototaxis and are repelled by bright lights.) Moths might be programmed to use the low-frequency light of the moon as guidance. Once they have met their reproductive requirements, the moonlight and artificial lights still draw them. A moth's eyes are such that once filled with light, it cannot fly away; for once it does, it is totally blinded, thus returning to the source of brightness to see. No matter how many times it breaks away from the light, the need to go back is too compelling, even if doing so leads to its ultimate demise.

BANSHEE
A Scream in the Night

To define something is to make it clear, but a banshee is an amorphous creature yet to be fully comprehended. There are no fossils or partial specimens of the fabled banshee, a mysterious creature that populates Irish folklore and is said to be encountered only at night. A banshee was primarily identified by its distinct wailing screech, which was so shrill and humanlike it was capable of cracking glass. Banshees are mentioned in several historical references in which many people swore to have seen them in person, including James I, king of the Scots in 1432. Sometimes eyewitnesses described the banshee as a foggy, ghostlike form that took shape as a beautiful woman, always holding a brush in her hand to stroke her silvery hair. Others said she was an old hag. Sound frequencies can cause hallucinations; it is not certain if the banshee was a creature that employed a type of sonic camouflage, or if it was simply a fabulous legend. It was noted that verifi-

able deaths occurred within earshot every time a banshee's strange cry was heard. Similar sonic techniques are currently used in combat. Banshees appeared more frequently during the Middle Ages, although a few people in Ireland still claim to hear them.

Was It Real?

Though obviously a product of folklore, the banshee may have been confused by late-returning pubgoers for a real animal: a barn owl. The barn owl is a large nocturnal bird, with ghostly white feathers underneath. It emits a "long, harsh screech in flight," according to BirdWatch Ireland, and has "a beautiful heart-shaped face [and] long legs." Instead of a hairbrush, it can be seen clutching mice, its favored food.

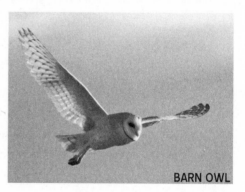

BARN OWL

BATS
The Only Flying Mammal

People once thought bats were furry night-flying birds, which was an honest mistake, since no other animals beside birds actually have wings and fly. Medieval bestiaries described a bat as a mouselike bird that fed its young

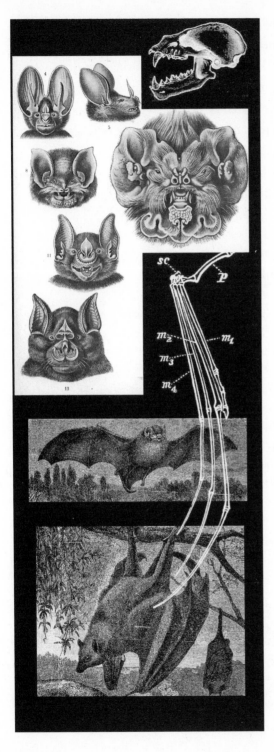

milk. There are other animal gliders, such as certain squirrels, but a bat, due to its unique anatomy, is the only mammal that can take off and land where it wishes (without the aid of a mechanical device, as human use). Bat wings are made of skin stretched between the bat's four long fingers, thumb, and arms. The bat does not flap its arms or limbs as birds do. Instead, it uses its fingers to grab a fistful of air with each wing beat. Bats have extremely long fingers.

In addition to flying, a bat can also use its lengthy fingers to hold on to an insect or to carry a piece of fruit. There are more than 1,000 species of bats, with the majority eating only insects, while some eat only fruit or fish. Bats are found on all the continents, except Antarctica. They range in size from the Thailand bumblebee bat, growing to only 1½ inches, to the hefty flying-fox bat that is 1 foot tall, with a wingspan over 4 feet.

Origin Story

Bats first appeared around fifty million years ago, a time when the earth was warm with rain forests reaching as far north as New York City, and when the current tropics were a steaming cauldron of jungle. The earliest bat fossils from this period indicate that bats were already well adapted to flying and always seemed to prefer sleeping upside

B 🐾 53

down. From this primordial era to today, most bats are social mammals and roost together in great numbers. They prefer to sleep during the day in caves, or in abandoned buildings, attics, under bridges, or hang from concealed tree branches. Sometimes they cling to one another like a cluster of grapes, and they seem to prefer overcrowding to solitude.

Since bats developed when the earth was warm, they crave the body heat of one another and will either migrate as winter approaches or hibernate in massive clusters or colonies.

Meet the Real Dracula

Vampire bats do not eat insects or fruit and prefer warm, fresh blood as their sole nourishment. They drink at least an ounce of it every night. They target large animals like cows, landing behind a cow's head, near the neck, not to be shaken off or bitten itself. A vampire bat has thermoreceptors in its nose that help locate an artery or good vein. It then makes sharp cuts or bites into the animal's skin and drools a special anti-coagulating saliva into the wound. It does not suck the blood like a furry Dracula; rather, it laps up its meal as do cats drinking milk from a bowl. It might take up to twenty minutes for the vampire bat to get the ounce of blood it needs from its host. Bats bite in such a precise manner, they can also get their blood from sleeping people without waking their victims. Vampire bats are found in Mexico, the Caribbean Islands, and in Central America and South America.

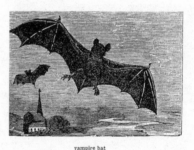

vampire bat

The Bracken Cave in Texas is home to the most bats of any other place in the world, with a population of more than 20 million. The Congress Avenue Bridge in Austin, Texas, has 1.5 million bats hanging from its underbelly of metal trusses.

Living Upside Down

As with anything that flies, lift-off is the first problem to overcome. Bats, by perching upside down, simply have to let go and they are already airborne. Bats wrap themselves in the blanket of their own wings, making them difficult for predators to see. In addition, bats roost in unlikely places that are hard to reach. At night bats are superactive, but for sleep they remain nearly motionless, except during mating, which they also do while upside down.

If we hung upside down for any length of time, we would get headaches as blood pooled in our brains, eventually killing us from hemorrhages. However, bats have less volume of blood than many mammals and proportionally stronger venous hearts that rhythmically pulsate throughout all their arteries, even in the wing membranes, which keep bats' blood flowing uniformly as they sleep.

Bats have talons that do not require muscles to constrict, the way our hands work, but go into a lock mode activated by the weight of their own bodies.

Life Cycle

A bat often dies while roosting and can remain hanging until another bat senses it no longer has body heat and nudges it loose from its upside-down perch. Bats do not have many natural predators, though owls, with their superb night vision, can catch them easily; bats fly less frequently when the moon is full. Death rates for young bats are high during the first few weeks after birth, since they cannot fly well and often meet their end by falling, captured by any number of ground predators. If a bat survives the learning curve of youth, it has a long life span for a mammal of its size. Brown bats, for example, can live for thirty years.

Thinking in Sonar

The phrase "blind as a bat" is partially true—bats' eyes are practically worthless in daylight, though they can gauge distance and avoid objects during low-light conditions. However, at night, many types of bats hunt for flying insects by emitting an ultrasonic sound from their mouths, at a frequency we cannot hear. The bat listens for the echo of its sound, which bounces off its prey. This echolocation, or biosonar, is a method used by whales, dolphins, and shrews. The bat sees the world in a sonicscape, the night turning into a rippling picture of echoes.

BEARS
Gluttonous Goliaths

There are eight species of bears, recently up from seven (it was once believed that the giant vegetarian panda bear was a big version of a raccoon): Asiatic black, American black, brown, panda, polar, sloth, spectacled, and sun bears. All bears are thickset mammals, with small tail stubs, stocky, short legs, paws with five clawed toes, and canine-shaped snouts. All have keen eyesight, sensitive hearing, and a terrific sense of smell. Each species has adapted to a variety of habitats, from tropical forests to living on frozen glaziers. They are found in North America, South America, Europe, and Asia. Most bears are omnivores, eating everything, though the panda has a specialized diet of bamboo leaves, while the polar bear is strictly a carnivore (though in recent years it has adapted to scavenge trash). Bears, generally, live for about twenty-five years.

Origin Story

Bears' earliest ancestors appeared around fifty million years ago, but they were extremely small and looked more like badgers. The first large variety of primitive bear emerged out of Asia around twenty million years ago and was a precursor more closely related to modern bears. The prehistoric cave bear of Europe was slightly larger than modern bears, and it was an important animal to man's early development, not only as a creature competing for habitat, but for supplying us with life-sustaining food and clothing.

The cave bear died out between fifteen thousand to twenty-five thousand years ago. Today, the worldwide populations of bears are varied, with the numbers for the North American black bear at approximately 550,000, to the low end, with 22,000 polar bears and only 1,000 pandas remaining in the wild.

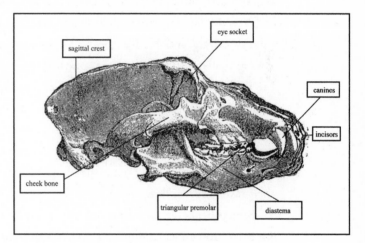

Many early religions, even among nonhuman Neanderthals, worshipped bears and displayed bear skulls as totems. Star constellations, namely Ursa Major (Latin for "Great Bear") and Ursa Minor, appear as gigantic bears in the North Hemisphere's night sky; these were godly symbols and held mystical significance to many ancient cultures.

Black and Brown Bears

As is the case with most bears, the male black bear would not qualify for a father-of-the-year award, while a mother bear is a dedicated and ferocious protector of her young. Males are solitary and often travel up to 80 miles in less than a week in search of food. They join only briefly with females for mating; not only will they never acknowledge their offspring, but they will often kill young bears found unprotected by mothers. Black bears, more than other species, have acquired a taste for human junk food. They regularly raid garbage cans and have been known to break into houses and have been found rummaging through kitchen pantries. The males can weigh nearly 500 pounds; females average around 300 pounds.

Brown bears are larger than black bears, including the subspecies of mighty grizzly and Kodiak bears, weigh up to 1,700 pounds, and are among the largest land predators on the planet. They have a lighter color fur than black bears and a pronounced muscular hump between their shoulders. Their tremendously strong paws can rip fallen trees into shreds or dig out burrowed animals with ease. They eat roots and insects in addition to moose, caribou, and salmon; as true omnivores, they will eat anything, even snatching handfuls of moths that flutter around a lamp in their ravenous search for food.

Brown bears do not climb trees in the way black bears do skillfully. And the brown bear male is an even worse father than the black bear; a grizzly mother will do all she can to keep her cubs from his reach. His temper is more than unpredictable, and he will kill a female over food. Grizzly bears have long been heralded as symbols of the wilderness.

Black bears can eat 30 pounds of food each day, while brown bears, when beefing up for winter, consume more than 70 pounds, or the equivalent of 280 quarter-pound hamburgers.

Sweet Dreams

Bears are legendary for being hibernators, known to sleep through the winter, but, in fact, bears never enter a true hibernation state. Hibernation is defined as drastically reducing body temperature, but a bear's temperature drops only a small amount. Instead, it relies on its ample stored fat to supply its body necessary nutrients. It does lower its metabolic system by 75 percent, such that a wintering bear can survive on nothing more than air. Bears actually enter a profoundly deep sleep—an envy of insomniacs—that allows them to go for as long as seven months without the need to rouse, eat, drink, or urinate. They can come out of the sleep quickly if disturbed, though their dreams must be good because they rarely do.

A brown bear mother does not need to wake up when giving birth and often finds her cubs sleeping on her chest when spring arrives. The black bear mother, however, does arouse to give birth in January or February, even if she nurses her cubs while half asleep. Some bears take a seventh-inning stretch of sorts, and they might even poke their noses outside to check the weather, but they can return to a slumber state quickly.

Predictably Unpredictable

The "star" of the Werner Herzog documentary *Grizzly Man,* Tim Treadwell was a dedicated bear enthusiast and amateur naturalist, spending thirteen summers living among the grizzlies at Alaska's Katmai National Park and Reserve. Getting close and filming his observations on home-style video, he came to know the bears well, saying, "If I show weakness, I'm dead. They will take me out, they will decapitate me, they will chop me up into bits and pieces." In 2003, Treadwell and his girlfriend were brutally killed by a grizzly.

The Polar, Panda, and Sun

Polar bears actually do not have white fur; rather their hair is transparent and merely reflects the color of snow and glaciers. A polar bear's fur hairs are hollow tubes that act as solar receptors, trapping the sun's heat and helping to keep its body at 98 degrees, even in frigid temperatures. Polar bears are the largest bears, with the biggest on record reaching 2,200 pounds. Unique to this species, their front paws are slightly webbed, allowing them to swim for long distances. The bottoms of their paw pads are like sandpaper, which prevents them from slipping and sliding on slick ice.

Polar bears' favorite food is seal; they will park nearly motionless for days at a seal airhole, waiting for a seal to pop out its head. But polar bears will also jump in the frigid water to hunt. Their fur is oily and has a natural water repellent and, with a quick shake, can dry off and thwart ice from forming. Because of their specialized diet, most polar bears—

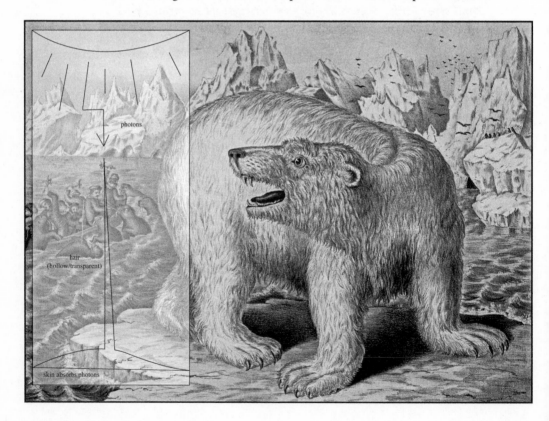

photons

hair
(hollow/transparent)

skin absorbs photons

seven out of ten cubs—never make it past three years old. Polar bears are found in Greenland, the United States (Alaska), Canada, Russia, Norway, and on ice in the Arctic Circle.

Panda bears are the most endangered bears due to their special diet. They need more than 50 pounds each day of bamboo leaves; the bamboo plant does not contain abundant nutrients, thus requiring pandas to eat quite a bit of it to stay full. Pandas look very cuddly, with their distinctive black-and-white fur pattern, but they can easily throw their weight around and become seriously aggressive if disturbed. Pandas weigh about 225 pounds and are 5 feet tall.

Pandas seem to be laid-back and slow but can sprint up to 30 miles per hour, climb a tree rapidly, or swim at a fast stroke when they want to.

Unlike other bears, pandas have thumbs on their front paws and part of the wrist, which help them peel leaves from bamboo stalks. Pandas live in the Tibetan plateau and the western temperate, mountainous forest ranges of China.

Sun bears, with their distinct yellow or white fur bibs, live in the thick, low-lying forests of Southeast Asia, China, and parts of India. Their snouts are shorter than most bears' and their faces resemble dogs'. They also are smaller than their brethren, growing to about 150 pounds and 4 feet in length. This compactness gives them greater agility moving through their dense forest homes. They prefer to build nests in trees, which is also an anomaly among bears. Even though they are called "sun" bears, they choose to come out only at night. Their claws are sharper and longer than most bears', at over 4 inches. All eight bear species are known to enjoy honey, but the sun bear is best equipped for the job. With its long tongue, it takes delight probing into beehives, holding a hive like a swarming honey pot in its lap, seemingly oblivious to stings while licking out the honey until the nest is dry.

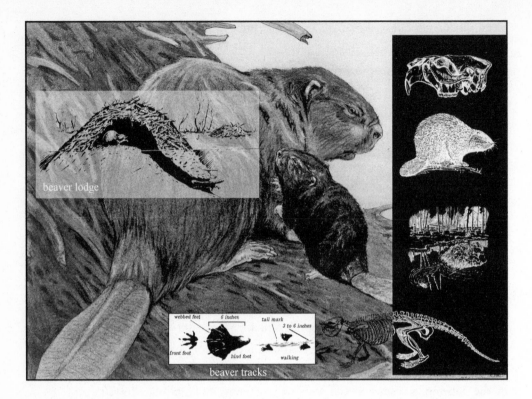

beaver lodge

webbed feet 6 inches tail mark 3 to 6 inches

front foot hind foot walking

beaver tracks

BEAVERS
Brethren of the Lodge

Beavers are found in North America, Europe, and parts of Asia, but no matter where they live, beavers are one of the world's largest rodents. Hailed for centuries as the animal kingdom's superior engineers and for never being idle, beavers, like humans, are one of the few animals that actively transform an environment to suit its needs. Without blueprints or surveying equipment, beavers will select a location where a brook or stream is found and begin to construct a dam from logs, twigs, and mud, slowing the water flow until a reservoir is created. This flooding of land has often conflicted with human plans, but beavers' ponds are a welcome source of food and water for other animals.

There were an estimated 90 million beavers in North America in 1700.

Beaver fur was called the "soft gold" of the New World. European markets paid top dollar for beaver pelts to supply a fashion trend of hats, coats, belts, and clothes. America's first millionaire, John Jacob Astor, arrived penniless in the United States; however, from capital he garnered from the beaver pelt trade and then invested in real estate, he was worth over twenty million dollars and owned nearly half of Manhattan by the time he died in 1848. At that time, beavers were hunted and trapped to the brink of extinction. Today, there are about 12 million beavers living in North America.

Beavers still create ponds that are beneficial. Once a pond is formed, they build a dome-shaped lodge, consisting of chambers and tunnels, big enough to house the whole family. Beavers choose only one mate for life; mother, father, last year's offspring, and the new brothers and sisters, called "kits," live in peace in their spacious home.

A beaver can hold its breath for more than fifteen minutes and when submerged it can open its eyes, which are equipped with transparent eyelids that work better than goggles.

Oh No!

Since ancient times, a male beaver's private parts were considered a necessary ingredient for medicines and as a cure to nearly all ailments. A Roman book about animals called *Physiologus* described how smart beavers found a way to conceal their organs when pursued by hunters; the beaver stopped, raised his arms, and showed he had nothing of use, and was then allowed to escape intact.

Equipped for Construction

Beavers grow to about 3 feet and weigh over 60 pounds. Though cumbersome waddlers on land, they have rear webbed feet that make them agile swimmers. They are herbivores, eating leaves, tree bark, twigs, and aquatic plants.

A beaver's teeth are as sharp as an ax and never stop growing, since they must constantly gnaw trees to prevent breaches in their dams and to make regular updates and renovations to the lodge. Although they have strong teeth, they do not like to bite each other or attack other animals, and they are not particularly aggressive creatures.

Toolbox in a Tail

The beaver's 15-inch tail is an extremely versatile tool. It has several purposes, from being a rudder and flipper while the beaver is swimming, to working as a scoop that digs up mud like a shovel, and then as a trowel to apply earthen mortar to seal dams and lodges. In addition, this wonder tail is a signaling device that with a firm slap on the water surface can alert family members when dangerous intruders approach. It also serves as a depository for the fat a beaver needs during winter.

Seasonal Workers

Beavers do not hibernate, and even when a lake freezes over, they dive to the warmer and deeper parts of their pond throughout winter to collect plants for nourishment. They prefer the dim light of their lairs and usually venture out only at night to build dams and gather food. During spring, summer, and autumn, beavers are truly busy and prefer work as opposed to an idle life. During these months, they are at their job for more than twelve hours each night or more. In the winter, they kick back and might leave the lodge only once or twice a week to fix a drafty hole in the lodge. Beavers never go on vacation.

BEES
Busy Buzzers

There are an amazing 20,000 different species of bees. Fifty types are famous for gathering pollen from flowers and transforming it into sweet honey. The oldest fossil of a bee is dated to a remarkable one hundred million years ago. It displays an insect trapped in amber that physically appears as bees do now, though slightly more wasplike. The encased bee is almost as old as the first flowering plants.

However, the bee has a long history, admired by our earliest civilizations for its industry, its social complexity, and the symmetry of its hexagon-shaped honeycomb cells. In ancient times, it was believed bees emerged from the corpses of oxen or other large animals, though what people were observing were not bees but maggots (fly larvae). The first naturalists thought bees had a king who formed army battalions. Now we know bees are matriarchal, led by a queen. The earliest Greeks believed worker

The question of which came first—the bee to pollinate a flower or a flower that gives a bee nutrients and food—remains a mystery.

bees were all males, which at birth had their privates removed, thus making them less distracted and focused on their job. Unlike human societies that often chose rulers by chance and cunning, the bee was held up as an example of an ideal society, with only the most benevolent bee allowed to lead. It was said that a bee monarch allowed all members of the hive to fly about at will and shared its rich honey equally among all. Honeybees originated in Europe, but bees are now found everywhere, with the exception of Antarctica.

The Honey Hive

Within a colony, there are three types of bees, defined by their jobs and functions. The queen bee's only role is to lay eggs, and she has no say in how the rest of the colony is run. Worker bees are all sterile females who are in charge of cleaning the hive, collecting pollen, feeding members of the

colony, and rearing offspring. Drone bees are males who exist solely to breed with the queen and have no other purpose. Each year the queen lays thousands and thousands of eggs, though she chooses to fertilize only some. A single egg is placed in each honeycomb cell. The unfertilized eggs become the males. Fertilized eggs will develop into females, but only a very select few are fed a special blend of nectar called "royal jelly," which allows a larva to develop into an egg-laying queen. Only the female worker bees have stingers, which are part of the undeveloped reproductive system. The queen has a stinger as well, in addition to its egg-producing organ, called an "ovipositor."

The worker bees are assigned jobs when young, ranging from surveillance to construction of honeycombs; some tend the young, and others are undertakers to remove the dead.

After the phase of hive maintenance is done, bees are sent out to forage for pollen. They gather it in buckets on their legs and collect it on their backs. A summer hive can have as many as 80,000 female worker bees. Male drones never leave the hive and remain in waiting to fertilize the queen or to mate with a new virgin queen before it leaves the colony. A hive contains only about 300 to a few thousand drones. When a community gets too large, a newly impregnated queen will take a few thousand workers with her and move in a swarm, building a new nest in a spot previously scouted out by worker bees.

Royal Jelly

A special blend of nectar mixed with secretions from the nursing bee's head produces a milky colored substance called "royal jelly." Containing potent B vitamins, it is sought by certain humans as a fertility supplement. All bees are at first fed a dose of this potent jelly, but only for three days. If a queen is old, or it was killed, a few larvae are selected to continue with an exclusive diet of royal jelly, which activates the bee's reproduction capabilities and transforms her into a potential queen.

Bee Communication

Bees exchange information via a dance that is often used to indicate where best to find flowers thick with pollen. If they perform a round dance motion, it means the flowers are within a close circle to the hive, and the bees somehow know how to calculate the distance by the number of turns. A trembling motion means that a bee departing the hive must meet up with a pollen-laden bee and transfer or carry part of the load. Bees see in all colors, except red.

A bee returning to the hive will give directional advice to the other bees. By doing what is called a "waggle dance," or by making certain zigzag patterns, bees communicate where to find pollen-rich flowers.

Life Cycle

The queen usually lives for three to five years. Of course, she is given the best honey and a protein-rich concoction of pollen and nectar called "beebread." During the winter, the queen is kept warm as all workers cluster around her. The workers are in continuous shivering motion, flapping their wings to generate heat to keep the monarch warm.

If they are called to defend themselves or the hive, bees will use their venomous stinger, even if they know they will die by doing so. Since the barbed stinger is attached to the lower portion of the bee's abdomen, stinging causes their bottoms to tear apart when the barbed stinger remains behind in the stinging victim. As for male drones, they are only allowed to live during the summer and mating season. Soon after being called upon to mate, they are fatally stung by the queen bee. Unlike other bees, the queen doesn't have a barbed stinger, so she can sting repeatedly and does so to each luckless male called to her chamber.

Female worker bees can live for about four months during winter. Once summer starts they work twenty-four hours a day for about six weeks, until dying from sheer exhaustion.

When winter comes, the drones are of no use and are expelled from the hive. Since they do not know how to gather pollen or feed themselves, they expire soon after.

<div style="border:1px solid">

To Sting or Not to Sting

Wasps belong to the same superfamily as bees, Apoidea, but they do not, in general, have the same complex social network. Wasps make nests from wood. They chew it and excrete it as a papery substance, using their own waste to make their hives. Most wasps couldn't care less about flowers and are meat eaters to the core. While the honeybee must use its stinger as a final act of self-sacrifice, the wasp can sting as many times as it wishes, since its stinger remains attached.

</div>

BOMBARDIER BEETLE
Chemical Warrior

The lowly beetle has many natural predators, everything from larger bugs, birds, reptiles, and amphibians to mammals, which for eons have always considered the beetle to be a quick and crunchy meal. Bombardier beetles, however, developed a complex defense system to survive and employ a surprising and effective way to give themselves a fighting chance. These beetles have a pair of glands that produce the chemicals hydrogen peroxide and hydroquinone, which are stored in reservoirs in their abdomens. When under attack, the beetle constricts its muscles to release the chemicals into mixing chambers, which contain water and special enzymes. Within a fraction of a second, this combina-

The bombardier beetle's chemical mix is lethal to many small creatures and can even cause a painful burning sensation to humans.

In addition to the bombardier, there are more than 500 varieties of other beetles, each possessing varying degrees of toxicity, with some releasing gas and others dispersing a foamy substance.

tion causes what is called an "exothermic reaction," producing energy and a noxious spurt of liquid and gas that nearly reaches the boiling point. The beetle then aims its twin bombardier exhaust pipes and fires this toxic mess, expelling it with a pop.

A cool combatant when under threat, the beetle waits for its attacker to get its face as close as possible before discharging. Some beetles can maneuver their minicannons at different targets, even firing downward between their legs. Their aim is so accurate they can blast enemies approaching from a wide aft range of 270 degrees. Incredible as this is, the beetle also has a flap that seals instantly under pressure, preventing itself from imploding. This allows it to continue on its way, foraging unaffected by the heat and toxic scourge it left in its trail.

The bombardier beetle is found in woodlands and in grassy areas on all continents, except Antarctica. Even with its unique defense, after going from egg stage, to larva, to pupa, the adult bombardier lives for only a few weeks, for enough time to lay more eggs and pass on its bombing skills to the next springtime population.

storage chamber with hydroquinones and hydrogen peroxide

chemical reaction resulting in caustic liquid propellant

mixing chamber with water and catalytic enzyme

BONGO
Elusive Antelope

Even though it is one of the largest species of antelope, the bongo was unknown to scientists at least until the 1960s. Solitary, and as elusive as a unicorn, this nearly 800-pound animal had perfected its camouflage to such an extent that only certain native African tribes knew it existed. It has a reddish coat with twelve vertical creamy-white stripes, and it sports a tufted mane that starts at its head and runs along the spine. Both male and female bongos have long, thick horns that curl one full turn, nearly crisscrossing before ending in a blunt tip. Bongos grow to more than 4 feet at the shoulder, and though they seem to lack the grace of most antelopes, bongos move exceedingly swift through the dense woodland scrub they call home.

These antelope graze at night, feeding at sundown to sunup, and bed down during daylight, remaining totally concealed such that one would

fig. iv

fig. v

fig. iii—antelope

The bongo places its long horns against its back and turns itself torpedo-like to navigate with poise and eye-blurring speed through vegetation too thick for a machete to cut.

—

Boungu, *a Western African word meaning "broad" or "big," is one explanation of how the animal has come to be known as a "bongo." However, since Western African people in Cuba use the same word for a musical instrument that is an open-ended drum played with the hands, the animal's name probably derives from European settlers misunderstanding another African word,* mongu, *meaning "antelope."*

have to step on the animal to see it. They can hear a twig snap 100 yards away. Few people have observed the elusive animal at close range.

Bongos live in the wild for about twenty years. They are found in mountainous forests at altitudes as high as 12,000 feet, primarily in the Republic of Congo, neighboring Central African countries, and in parts of Western Africa and Kenya. Elderly bongos have bald patches on their backs from where they have rested their heavy horns during their long lives. However, oftentimes these marks of longevity become susceptible to disease and infection, eventually causing their death. Males live longer than females, as males are mostly solitary. Leopards, the bongos' primary predator, often attack females traveling with their young. These female herds, consisting of nine or ten bongos, are less elusive to big cats and have decreased their stealth and chances for longevity.

Many Africans believe bongos should never be touched, and as a consequence, they are rarely hunted. In folklore, it's said the animal has the power to cast a magic spell, which will cause a person to convulse and spasm or suffer epileptic seizures. Nevertheless, populations of the bongo continue to dwindle and are estimated to be around 30,000.

Largest and Smallest Antelope

The eland is the world's largest antelope, weighing 1,300 pounds and standing taller than 6 feet at the shoulder. The Dutch called this African antelope "eland," the same name they used to describe the mighty North American moose. Most antelope socialize in coed herds, but elands, similar to bongos, are slightly different in that the elder males choose to live apart. The eland has a life span of about twenty years.

The blue duikers are the smallest antelope and, like the eland, they are native to Africa. Blue duikers are only about 13 inches tall and live in jungle and forest habitats, eating flowers, insects, leaves, and lizard eggs. They follow around monkey troops, waiting for the monkeys to drop fruit and other sweet edibles that the diminutive antelopes are too small to reach.

BONNACON
Flatulent European Bison

In the regions north of ancient Greece, during the first century B.C., there were reports of a thick-boned horse that had the head of a bull and the mane of a lion. Its horns were rounded, turned up, and pointed inward. The horns and head were suitable for butting but not angled correctly for piercing an enemy. Clues from ancient writings seem to describe an animal similar to the European bison, which did once roam throughout Europe, southern England, and Russia.

The first naturalists often described the beast's unique method of defense. Despite its sizable bulk, when frightened the bonnacon preferred to flee rather than fight. However, before bolting away, it turned, paused, and raised its tail. It then released a thunderous fart, which according to Greek legend was strong enough to blow the helmets off an army of men. This noxious gas then settled into a scattered glutinous manure mess and began to sizzle on the ground as if it were acid. The bonnacon emitted a sulfur-smelling gas that became flammable and scorched a wide path as far as 100 yards from the beast's rear end.

What Was It?

Bison and a number of large herd animals often defecate before fleeing. Whether this is caused from fright or to lighten up its load before running is uncertain. The native bison of Europe once gathered into herds of 1,000 or more. In reality, this number—all dropping their deposits in unison—would surely cause a foul line of fresh dung to make anyone's eyes seem as if they were burning.

Prehistoric Bison

Paintings of bison, dating to 15,000 B.C., were found in the Altamira Cave in northern Spain. The ceiling displays a herd of many colored bison in various poses, but none with flame-throwing asses. The earliest strain of bison had a large hump on its neck for storing fat during the Ice Age. Smaller, modern European bison were nearly extinct, down to 50 animals after World War I, but a small herd still exists in Poland.

(Le Papillon Machaon.)

BUTTERFLY
Converted Caterpillar

The metamorphosis of butterflies—transforming from earthbound and ugly wormlike insects to exquisitely beautiful creatures capable of flying—has always intrigued humankind. Egyptian artifacts from as early as 1,500 B.C. were reverently adorned with butterfly imagery. The ancient Greek word for butterfly was *psyche,* which came to be synonymous for "soul" and later morphed into the root word in "psychology." Aztecs thought butterflies were the souls of dead warriors, and they emblazoned war shields with butterfly images. The Japanese saw them as representing femi-

nine vanity; also, white butterflies were considered to be returning souls—their capture was strictly prohibited. Navajos said butterflies were the first creatures to use body paint, while medieval Christianity used the butterfly as a symbol for the Resurrection.

The Celts believed a butterfly was a spirit fluttering about in search of a new mother, and they thought a woman could only get pregnant if she swallowed one.

Four Stages of a Butterfly's Life

Remarkably, there are at least 20,000 species of butterflies found all over the world. That number increases to over 150,000 if moths, which are often mistaken as butterflies and sometimes can be difficult to distinguish, are included. Butterflies and moths belong to the same insect order known as Lepidoptera; butterflies generally differ from moths by their tendency to fly in daylight, while moths normally prefer to fly at night. Butterflies have knobs at the end of their antennae, but moths do not, and butterflies rest their wings in an upright position, while moths nearly always place their wings flat. Both, however, have a four-stage life cycle. A butterfly starts as an egg attached to a leaf, then hatches into a caterpillar (larva), growing and shedding its skin a number of times before finally forming a chrysalis where it seals itself into darkness. At this stage, the pupa transforms its physical structure, breaking down tissues and sometimes even rearranging organs. The process usually takes a winter to complete, and when it is finished, the adult butterfly, with its four pairs of wings made of tiny scales and colored in various patterns, emerges reborn.

Cross-Country on Paper Wings

The monarch butterfly, one of the largest of its kind with a 4-inch wingspan, is common throughout North America, Central America, and South America, though it is also found less frequently in Europe, Australia, New Zealand, Hawaii, and some South Pacific Islands. North American monarchs make the longest migratory flight of any insect, traveling

south in autumn and returning in spring, covering an astounding 2,500 miles in as little as two months.

However, the round-trip migration is never achieved by a single butterfly and takes multiple generations to complete in its entirety. Since the normal life span of a monarch is about two months, only the ones born at the end of summer make the flight south. By entering a hibernating state, they can live seven months or more at their destination. These returning springtime monarchs deposit eggs on their journey northward before dying. At least two generations are born in spring and another in early summer, which each then make part of the trip back to its most northern point. Then, once again, before the first frost, the last monarchs of the season head back south. It remains a mystery how monarchs pass their mapping skills from one generation to the next, returning to the exact location where their great-great-grandparents had roosted, yet according to scientists, it is possible that monarchs navigate by reading the position of the sun or UV light rays. This information is then correlated to some sort of internal body compass. It is also proposed that monarchs have a seemingly mystical, though genetically inherited, way to convey to each generation the recognition of landmarks, such as mountain ranges and rivers.

The butterflies living east of the Rocky Mountains travel each autumn to Oyamel, Mexico, forming winter colonies numbering in the millions.

Life Cycle

From a single egg deposited on the underside of a leaf, the monarch caterpillar is purposefully conspicuous, colored with a striped pattern of bright yellow, black, and white. It prefers to eat various milkweed plants that contain toxins, which make it taste bad to predators. As it is with many insects, the monarch caterpillar warns of its noxiousness with its bright colors. The caterpillar passes the same toxin to the adult monarch, which also advertises its foul flavor by displaying bright orange wings with black veins and white spots. Even with this warning, birds will peck

them for a quick sample, since birds have learned that some butterflies are less toxic and disagreeable than others. Especially while roosting in sizable numbers, many monarchs are stabbed by the beak of birds and die, but are usually not eaten. In addition, since a monarch, once transformed into a butterfly, must wait two or three hours with its wings remaining outstretched to dry in the sun before it is able to fly, it may have an even shorter life span of less than the usual two to three months. The brimstone butterfly, with bright yellow wings that have one orange dot on each, are native to Europe, Asia, and North Africa. This species has the longest life span among butterflies—about one year. However, lepidopterists, scientists who study butterflies, have found that species that eat fruit exclusively live, on average, the longest.

CALADRIUS
Dr. Bird

Caladrius facing *away* from a patient

Caladrius facing *toward* a patient

This all-white bird had remarkable powers to detect human sickness and death, according to Roman legend. Supposedly, caladrius were used by ancient Romans to determine the seriousness of illness. If the bird turned its back on someone sick, all further treatment would be halted, because the patient was destined to die. There apparently were cases when the caladrius hopped along the chest of the infirm until reaching the face. It then plucked a hair from the eyebrows or head, immediately took flight through an open window, and made a beeline straight up into the clouds. It was thought the caladrius took the sickness with it into the heavens and had it burned off by the sun. Caladrius, thus, were the last hope of the terminally ill.

No Free Checkups

Caladrius had special handlers, since it was a rare and an expensive fowl that only royalty could afford. Sellers of the birds kept them under a cloak, for many people came pretending to want to buy a bird but were actually only trying to get a free medical checkup by provoking the bird to look at them. Ancient medical books recommended caladrius droppings as a good salve for the eyes. Although the bird is presented in numerous antique royal coats of arms, and eyewitness accounts of its abilities are recorded, the species with these mortality-predicting properties, for reasons unknown, has not been seen for over three hundred years. Some have variously speculated that the caladrius was really a heron, an albino parrot, a type of dove, a seagull, a white wagtail, or perhaps an extinct species.

CAMEL
Masters of the Desert

Camels come in only two models, the one-humped Arabian camel and the two-humped Bactrian camel. Related to llamas, alpacas, and the South American vicuñas, camels share a distant common ancestor that originated in the prehistoric savannahs of North America around ten million years ago. The first camels migrated to Asia when a land bridge connected continents. They congregated around the northern parts of Africa where they effectively adapted to surviving in harsh desert conditions. Ancient camels were immense and are esti-

mated to have been twice as large as the modern versions. Records show that people of the Middle East and Red Sea regions first domesticated camels around 2,000 B.C. There are only about 1,000 wild camels left in the Gobi Desert, but as a species, there are more than 12 million domesticated.

Sandproof

Adult camels measure around 7 feet high at the hump. They have long legs that can land a kick in four directions. Their two-toed feet prevent them from sinking into sand. They can sprint to speeds of 40 miles per hour and maintain a steady gait of about 25 miles per hour for long distances. Camels have long eyelashes and ear hairs, in addition to sealable nostrils, which make them unperturbed by sandstorms.

A camel can withstand temperatures reaching 106 degrees Fahrenheit without breaking a sweat.

Camels can draw foul-smelling liquid up from their stomachs and spout well-aimed streams of spit through their split lips when annoyed or as a means of defense. The insides of their mouths are so rough they can eat thorny bushes as sharp as coils of barbed wire without a hitch.

Walking Canteens

The hump, believed to be the secret to the camel's unique ability to go without drinking water for long periods, was thought to be an actual reservoir, like a tank filled with sloshing water. It's true that a camel can drink up to forty gallons of water at one time and not need another sip for weeks, but its hump is not hollow. Instead, it's made of fatty tissue that serves as a energy source during long treks. However, the real trick to the camel's ability to survive extreme conditions that would kill almost all other animals rests in its blood cells. Camels are the only mammals with oval-shaped red blood cells, which are also found in some birds,

fish, and lizards. Unlike the circular cells we humans have, these cellular canteens can expand to let the camel consume excessive amounts of water at one time without bursting and they act as effective water regulators, distributing stored water-dense body fats as needed. A camel can live for around forty-five years.

CAPYBARA
World's Largest Rodent

Among the 4,000 different kinds of mammals on the planet, nearly a quarter are classified as rodents. The South American capybara takes the title as largest in its class, growing to 4 feet and weighing about 150 pounds. It looks like a giant guinea pig, though with longer legs and webbed feet. Its hind legs are a bit taller, which makes its rump protrude higher than its head. Capybaras have brown fur and no tail and live in marshy areas or near rivers and lakes, grazing on grasses and aquatic plants. They usually stay in groups of ten or more and are playful with one another, rolling about in mud and communicating throughout the day in a call that sounds similar to a dog's bark.

They also escape big cats and land predators by hiding underwater for long periods. They are much more agile underwater and often sleep there, floating with their noses sticking just above the surface and camouflaging themselves among the reeds and grasses. They mix up their feeding patterns and grazing times and seem to eat whenever they are hungry during both day and night. Ana-

condas, the massive South American snakes, are the capybaras' greatest enemy. Capybaras live for about ten years.

Capybaras have a network of defenses that include sentries, who are young males assigned to keep watch for predators. They sound a warning alarm to the group when danger is near. They all start barking, which makes it seem as if a pack of hunting dogs has infiltrated the area.

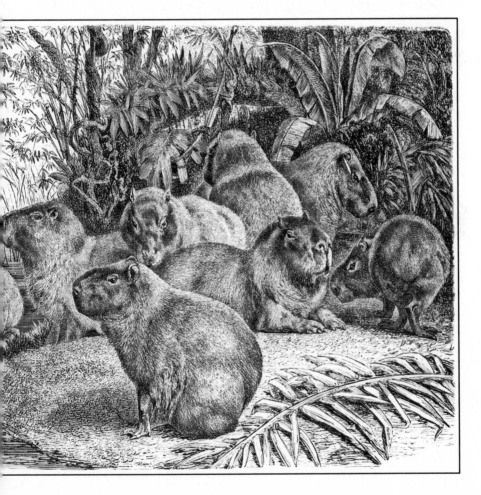

CAT
Favorite Feline

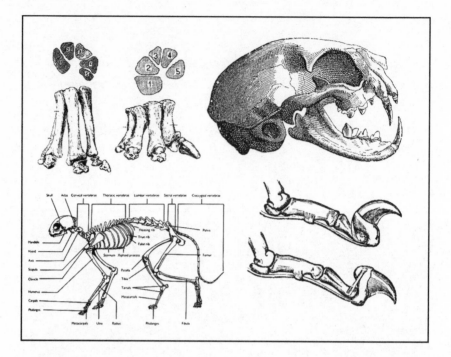

Aloof, primitive, and mysterious, the house cat is the most popular pet in the world. It was first domesticated from the African wildcat more than ten thousand years ago. Early agrarian civilizations of the Middle East, notably the Egyptians, encouraged wildcats to catch mice that plagued their grain stores by leaving treats, until a breed of the cat was tamed enough to live among humans. There are now nearly 80 breeds of domestic cats, and an unknown number of feral cat combinations. None, however, have entirely lost the wildcat instinct. Cats, all 500 million found everywhere in the world, are carnivorous. They are agile and swift, instinctively knowing how to stalk and pounce on a moving object as if it were prey.

> *Cats have retractable claws, sharp teeth, and exceptional hearing that can detect low-frequency sounds, just the kind made by rodents like mice.*

Cats have slit-shaped vertical pupils that can

expand to cover the whole eye, allowing them to see far better in darkness than humans. But their noses, which have ridges like fingerprints, are cats' most important sensory organs. They have scent glands on their cheeks and back—which explains why they curl around your legs, marking territory—and are always sniffing out pheromones and food.

They lick themselves exceptionally clean after every meal, concerned more with odor removal than sanitation. Although instinctively solitary hunters, cats are social animals and express themselves by tail movements, body language, and by verbally using a variety of hisses, purrs,

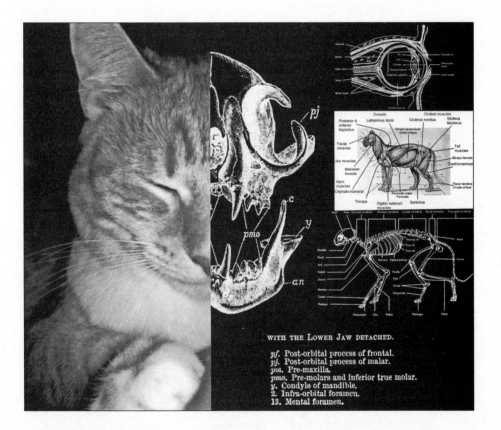

WITH THE LOWER JAW DETACHED.

pf. Post-orbital process of frontal.
pj. Post-orbital process of malar.
pm. Pre-maxilla.
pmo. Pre-molars and inferior true molar.
y. Condyle of mandible.
2. Infra-orbital foramen.
13. Mental foramen.

The scent capabilities of house cats are more than twelve times as sensitive as ours.

growls, and meowing. Most cats weigh about 8 to 10 pounds, but some breeds like the Ragdoll can reach 25 pounds, while the smaller Singapura cat can weigh as little as 4 pounds.

America's Top Ten Pets	United Kingdom's Top Ten Pets
1. Cats	1. Dogs
2. Dogs (More households have dogs, but most cat owners have more than one cat.)	2. Cats
	3. Rabbits
	4. Birds
3. Fish	5. Hamsters
4. Hamsters	6. Horses
5. Mice	7. Snakes
6. Guinea Pigs	8. Gerbils
7. Birds	9. Turtles
8. Snakes	10. Rats
9. Iguanas	
10. Ferrets	

Why Cats Are Loved

Ailurophilia, the love of cats, was a tradition started by ancient Egyptians, who eventually elevated the cat to the status of a god. Egyptians shaved their eyebrows as a mark of grief when a pet cat died, and noteworthy cats were mummified. Many were entombed along with mice, so the cat would have a meal when it revived in the afterlife.

It is the combination of aloof primitiveness and warm empathetic properties the cat is said to possess that attracts cat

Ancient sailors relied on a cat's instinct to sense approaching storms. Cats were welcomed aboard ships (their rodent-hunting skills were appreciated, too) and were subsequently transported around the world via trading routes.

lovers—not to mention their cuteness. Even so, domesticated cat popularity has ebbed and waned throughout history, never more so than during the Dark Ages. In the fifteenth century, Pope Innocent VIII declared that cat lovers were witches fit to be burned at the stake, and Europe purged its cat population, a trend that lasted until the eighteenth century.

Nine Lives

The saying "Curiosity killed the cat" is only partially true, even if a cat's natural prowling instincts often leads it into precarious situations, such as climbing high into trees, traversing roof ledges, or exploring any nook or cranny in which it can fit. Cats have a supple spine and neck bones that enable them to land on their feet if they should fall doing one of their acrobatic stunts. Their ability to survive falls combined with their quick reflexes, which allow them to stay just ahead of danger, feed into the myth that cats have nine lives. Even though the phrase has come to describe a person who seems to narrowly avoid mishap time and again, the cat's legendary "nine lives" myth likely stems from ancient Egypt, where both cats and the number nine were held to be sacred. In reality, the house cat has only one life, of course, but it lives on average from twelve to fourteen years.

CHAMELEON
Master Mimic

There are more than 160 species of chameleons. Chameleons are most famous for their ability to change color and quickly blend into virtually any background. This gift has served them quite well, given that fossil evidence suggests the chameleon has been around for at least fifty million years. Some grow to only 1½ inches long, while others are bigger than 2 feet.

The chameleon has a series of specialized cells in its skin that contain color-modifying pigments, allowing it to simulate the color of its environment and conceal itself from predators or prey. Some change color to show mood, turning darker colors when angry or upset. Others modify

color to attract mates, as they try to show off during this period, often displaying a rainbow of colors. The species of chameleons capable of changing colors seem to love to remain a vibrant green, or a simple understated brown, though they can be blue, red, pink, purple, orange, or yellow, and any partially striped and molted color in between.

Two Worlds in 3-D

Chameleons have two independent stereoscopic eyes, meaning that like us, they can perceive depth, distance, and perception. However, instead of processing this into one image the way we do, a chameleon sees two distinct 3-D views from each eye, giving it a strangely kaleidoscopic picture of reality. Each eye can rotate in different directions, and when the eyes overlap in range, a chameleon can see things in a 360-degree arc above, below, and all around its body.

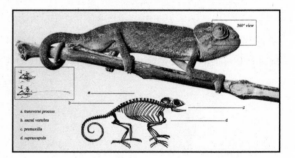

a. transverse process
b. sacral vertebra
c. premaxilla
d. suprascapula

Lightning Licker

Chameleons top the reptile charts for having one of the fastest tongues. Some chameleons have tongues that are twice as long as the length of their bodies and can snatch an insect faster than the human eye can see, or about thirty one-thousandths of a second.

Chameleons have no ears and are most likely

deaf, living in a silent world, though they can sense vibrations through their feet.

Nervous Pets

Chameleons, by their nature, prefer to stay concealed, and would rather not be touched by humans. As pets, however, they usually live from two to three years, if well fed and left unmolested, but some have survived for ten years. In the wild, depending on the species, females usually live for eight years, while males live for only five.

CHUPACABRA
Vampiric "Goat Sucker"

Beginning in the 1950s, reports began to emerge from Puerto Rico of a creature that was attacking livestock in a bizarre manner. Whatever it was, this predator didn't kill its prey for meat but instead left carcasses totally drained of blood. In the mid-1990s, when hundreds of animals were found dead from having their blood drained, the new beast was dubbed *chupacabra,* a Spanish term for "goat sucker." In 1992, the Puerto Rican newspaper *El Nuevo Dia* described the chupacabra as "a raging beast, thirsty for blood, and a servant of the devil."

Eyewitnesses describe a creature that appears half reptilian and half canine.

What It Looks Like

Chupacabras allegedly have been sighted on many Caribbean islands, in Central America, as far north as Maine in the United States, and most recently in Russia. Puerto Rico, however, still has the greatest reports of

chupacabra activity, with more than two thousand attacks on the island's livestock.

It supposedly moves in a hopping manner similar to a kangaroo, though at a much faster gait, and can bound 20 feet horizontally. It is about 3 to 4 feet tall, thick bodied like a bear, and appears greenish, or black gray, in color. It has hornlike protrusions (or spiky quills) on its head that run down its spine to the base of its tail. A chupacabra has a hyena-shaped head and canine snout with sharp incisors, though it screeches and hisses rather than growls. Those who have gotten close enough claim chubacabras have red eyes, though probably from the glare of flashlights, the same way a dog's eyes appear frequently in photos. Chupacabras leave an unpleasant sulfuric, rotten-egg smell that lingers for some time.

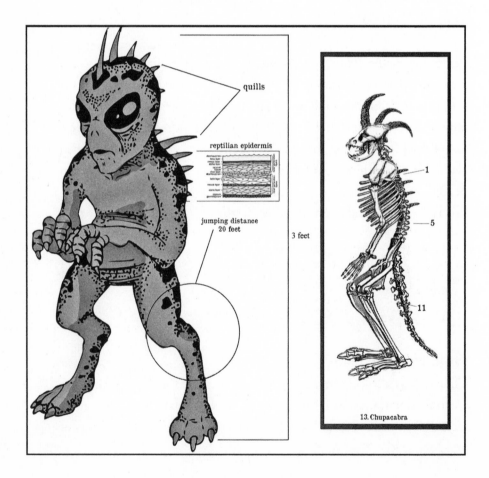

quills

reptilian epidermis

jumping distance
20 feet

3 feet

1

5

11

13. Chupacabra

Methods of Attack

It kills its prey by making three triangularly placed puncture wounds, usually on an animal's chest. The chupacabra is apparently strong enough to overwhelm its quarry by flipping it on its back. It then uses its weight to restrain its catch while draining the animal's blood. Although goat blood is said to be its favorite food, other livestock has been discovered bled dry and with internal organs removed.

Is It Real?

Scientists have attributed chupacabra sightings to stealthy panthers that were introduced illegally into Puerto Rico or to coyotes with parasites and mangy skin that make them look monstrously ugly. One of these predators may bring down a goat, but then abandon the carcass, for some unknown reason, leaving it to bleed to death—and hence creating the appearance that its blood was sucked. Others allege experiments in genetic mutations or cite radioactive fallout or some environmental chemical deviation as the cause for the emergence of this biological abnormality. It is true that Vieques, an island located 8 miles east of Puerto Rico, had been used for numerous military war games for many decades by the U.S. military. The island and surrounding vicinity were used as Cold War bombing ranges and testing grounds, with suspicions that atomic and even nuclear weapons had been discharged there. According to this theory, the chupacabra could be a Caribbean Godzilla, a beast mutated into existence by the atomic age. Still, it remains a mystery exactly why sightings of this new vampirelike beast continue.

Genetic Drifting Goat Sucker

Inherited traits found in a group of organisms often change over time in order to give it a better chance of surviving in an altered environment. Sometimes a mutation produces an organism that is suddenly more suited to rapidly changing conditions. In animals, as evidenced by fossil records, major modifications within a species by and large require eons to take hold, but every so often survival depended on speedy adaptations. In the microscopic world, certain viruses can alter within days. Entire populations, for example, as observed with various strains of staph viruses, can mutate so rapidly they often become resistant, seemingly overnight, to antibiotics that had once killed them easily. Some theorists claimed the chupacabra was a result of secret genetic mutation experiments.

The Beast of Bladenboro

In 1954, the small North Carolina town of Bladenboro made national news. Dogs, goats, and small livestock were found dead, completely drained of blood. The carcasses remained uneaten, though many had their jaws broken or their skulls crushed. Eyewitnesses said the creature responsible was at least 150 pounds and dark colored, though it made an eerie sound like a baby wailing, or to some it sounded like a woman crying hysterically. Its echo carried far through the mountains. These savage killings terrified the community and none dared walk alone without a firearm. Some thought it was a human transformed into a vampire, but further sightings and investigation by trackers indicated it was some type of mysterious large-pawed, catlike beast that had a serpentine tail. Professional big game hunters and sniffing dogs flocked to the area, though bloodhounds curiously refused to follow the scented trail. Nobody could catch the beast. Once the small town became overrun with hunters, the killings stopped. What the beast was—whether a chupacabra, an alien big cat, or another creature—remains a mystery.

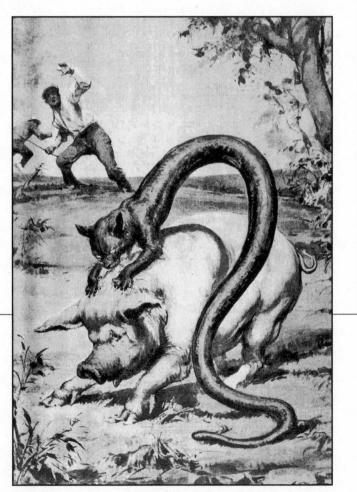

COBRA
Nature's Deadliest Fangs

To be a snake, a creature having only a body without limbs and a mouth to eat with, would seem to be a great disadvantage. While the trend among almost all creatures was toward the development of limbs, the snake's limbless form passed through the maelstroms of environmental change, surviving by seeking rapid shelter underground, where it could hide in the narrowest apertures. As the dinosaurs died off and the age of mammals arose, with rodents abounding, the snake was ready to take advantage of this food source and perfected ways to capture prey and defend itself from predators. The first venomous snakes appeared during the waning years of the dinosaur era. This adaptation gave venomous snakes an even more potent edge that made them serious competitors in the ecosystem. Poisonous snakes were a significant cause of death among primates and early humans. For this reason, many say the fear of snakes, called "ophidiophobia," is embedded in our collective unconsciousness. There are 2,000 species of snakes, with about 400 producing venom dangerous to humans.

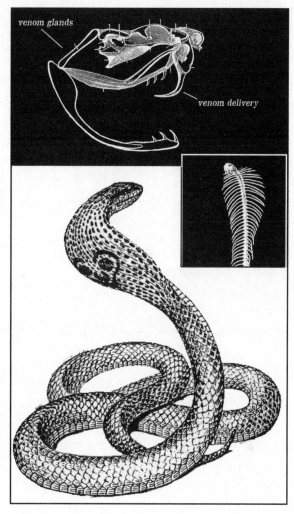

venom glands

venom delivery

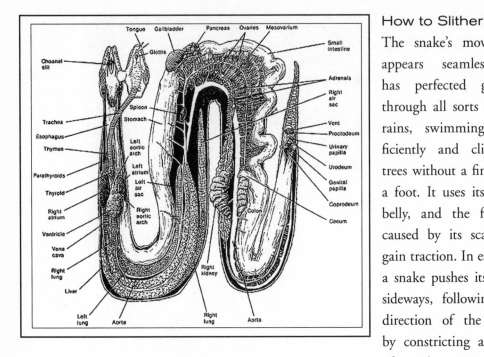

Tongue Gallbladder Pancreas Ovaries Mesovarium
Choanal slit
Glottis
Small intestine
Adrenals
Right air sac
Trachea
Spleen
Stomach
Esophagus
Thymus
Left aortic arch
Left atrium
Vent
Proctodeum
Urinary papilla
Urodeum
Parathyroids
Left air sac
Gonital papilla
Thyroid
Right atrium
Right aortic arch
Coprodeum
Colon
Cecum
Ventricle
Vena cava
Right lung
Right kidney
Liver
Left lung
Aorta
Right lung
Aorta

How to Slither

The snake's movement appears seamless. It has perfected gliding through all sorts of terrains, swimming proficiently and climbing trees without a finger or a foot. It uses its head, belly, and the friction caused by its scales to gain traction. In essence, a snake pushes its body sideways, following the direction of the head, by constricting a series of muscles, a segment at a time, to go forward, thus using this back and forth rippling to achieve thrust. If a snake is on an unstable surface like sand, it must shift its entire body sideways, called "side-winding," since the surface underneath dictates exactly how a snake must ripple or curl its body to achieve locomotion.

In the Hood

There are over 250 types of cobras, classified as Elapidae snakes, which include poisonous coral snakes, mambas, and true sea snakes. They are found in the hotter parts of Africa, Asia, and Australia. Cobras arguably are the most iconic snakes, noted for their threatening posture of raising their hooded heads when angry or disturbed. The hood is actually an extension of the

The second-deadliest venomous snake in the world, the black mamba, is also the fastest, so adept at slithering it can travel 15 feet per second.

snake's ribs and is an evolutionary feature that makes it appear larger and more foreboding. It has two front, elongated fangs, with tubes connected to venom sacs, which are modified saliva glands located behind its eyes. Cobras strike at lightning speed, clocked at 150 milliseconds, which is half the time it takes to blink your eye. The snake then clamps down until the sharpened fang tips inject all the venom with the efficiency of a syringe. Cobras move by wiggling or lateral undulation, as all snakes do, but some cobras can race across the ground as fast as 40 miles per hour.

The cobra's hood—just like the bright color of a coral snake or the rattling tail of rattlesnakes—is an adaptation designed to warn predators of the cobra's potential poison. It's an advertisement that reads, "Don't mess with me." Some animals, notably mongooses and certain birds, have built up an immunity to snake venom, though few living things can survive the bite of a cobra, especially the Egyptian cobra. This cobra can grow to nearly 10 feet and injects a nerve-paralysis toxin, which rapidly impairs breathing and swallowing, leading to suffocation.

The king cobra is the largest venomous snake in the world, growing to 25 feet in length. Despite its girth, it is excellent at climbing trees, swims rapidly, and delivers a bite that kills a person in fifteen minutes. The spitting cobra does not even need to get close to strike and can squirt its venom perpendicularly, with bull's-eye accuracy, from 6 feet away. Being hit in the eye with the spitting cobra's venom will cause blindness.

A cobra dispenses as much as two hundred milligrams (roughly two teaspoons) of venom in a single bite, an amount potent enough to kill a full-grown elephant within a few hours. A person or an animal bitten by a cobra usually has less than a 25 percent chance of survival.

Snake Charmers

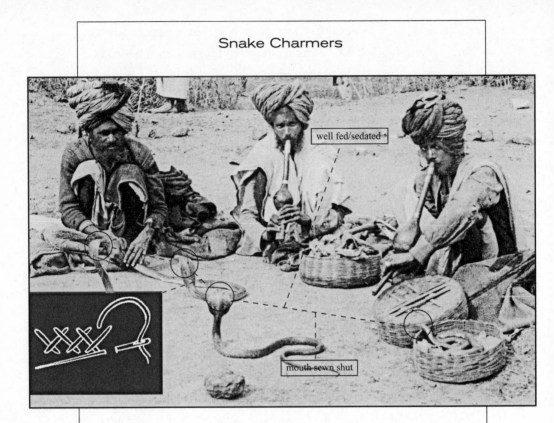

well fed/sedated

mouth sewn shut

Cobras cannot hear the music played by snake charmers in India since snakes are essentially deaf. What captures the Indian cobra's attention is the sway of the flute. It moves its head to keep the flute hypnotically in its vision. Snake charming was a dangerous profession, and during ancient times, it was an art that was passed down from father to son. Since many snakes do not need to eat more than once a week, the snakes used in charming were well fed and sluggish; sometimes the snakes' venom glands were removed or their mouths were sewn closed. Nowadays, Indian snake charmers are like wandering street performers, working for handouts. Some charmers have diversified; for a fee, they perform magic spells and induce healing by using the snake in ritual practices. Others charge for pest control services to rid a house infested with snakes and do so by attempting to lure the invaders out with their flutes.

Life Cycle

The king cobra, unlike other cobras, builds a nest and lays its eggs there. However, the mother abandons it shortly before the eggs are ready to hatch. Were the mother to be present when its eggs hatched, she would eat them. If they survive their mom, young kings, like most cobras, can live for about twenty years.

Cobras eat other snakes, in addition to mammals, birds, and reptiles, and they sometimes sustain injuries during fights that eventually kill them. Some cobras seem capable of digesting snake venom, if they eat a rival poisonous species or consume an animal that they just poisoned with their own venom. But they can die if another venomous snake bites them and injects its poison directly into their bloodstream.

Young cobras are ready to defend themselves within three hours after hatching and are born with venom as potent as the adults'.

CRETO SHARK
Mega "Jaws"

Prowling the world's oceans ninety million years ago, this granddaddy of the great white shark, *Cretoxyrhina,* was a 20-foot marine beast that had as many as 450 teeth in its deadly jaws. Its mouth was like a cutlery store: each of its teeth was 3 inches long and as sharp and strong as the best paring knives. For this reason, this extinct creature has been nicknamed "The Ginsu shark," after a brand of supersharp knives made famous through TV infomercials.

Creto/Ginsu constantly opened and closed its mouth, chopping up anything and everything in its path. It liked to dice prey into pieces before eating, but if something was initially indigestible, Creto would

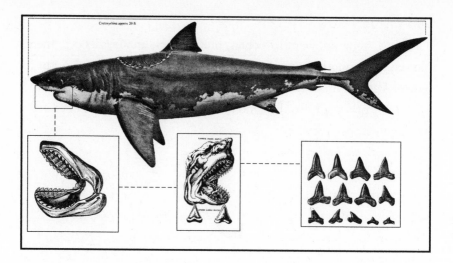

throw up the bad food and try to eat it again. It was menacing to anything that happened in its path as it cut a wide swath of prehistoric oceans.

CRICKETS
Fiddlers of the Fields

Crickets are famous for their distinct musical chirping. Considered one of the best songsters among insects, crickets actually have a repertoire of four distinct tonal rhythms that all males, at least, seem to know how to play from birth. Females are usually silent in the cricket world, while males of the species sing or chirp from dawn to dusk, in a sort of obsessive-compulsive manner, playing the same song as many as eighty times each minute.

Why Do Crickets Sing?
The most familiar and loudest cricket songs are meant to attract females, while others are played to warn fellow males of their territorial rights. Once a female is in sight, a male cricket subdues his tone and plays a

more mellow song, and after successfully courting, he strums out a short victory tune.

The flightless wings have protruding veins containing as many as 250 tiny teeth. The cricket lifts up and rubs one toothed wing against the other, similar to the way melodies are performed by running a comb along a corrugated washboard. Both male

The cricket uses its wings to make sounds, not by rubbing its hind legs together as many believe.

and female crickets can detect the slightest variations of pulse and beat, equipped as they are with an array of sound receptors, or ear holes, located on their front legs, just below the knees. By shifting a leg, they know the direction of sound and can calculate the varying distances to where other crickets are located.

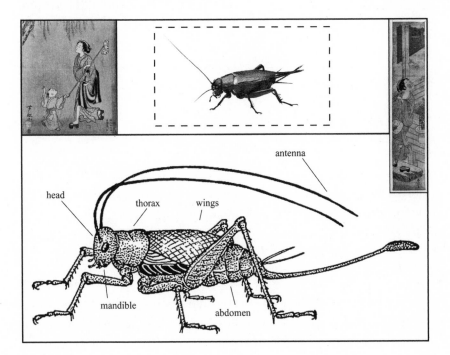

antenna

head

thorax

wings

mandible

abdomen

Music Lessons

Chinese culture has long held a special place for crickets. The Qing dynasty court in the 1600s employed caretakers and music teachers to look after the little singers. An "orchestra" of crickets, kept in golden ornate cages, performed for the emperor and to the delight of visitors on festive occasions. Today, from May to July, Chinese markets still have vendors selling singing crickets, shouting "Jiao Ge-Ge" or "singing brothers." Crickets are sold woven into small bamboo cages, which also serve as their food sources while singing in the buyers' houses.

Cannibal Crickets

Generally, crickets are vegetarians, consuming all types of plants and organic materials. However, they seem to have a darker side, and when food is scarce, they frequently eat their dead. In addition, crickets are fierce fighters. Since the ninth century crickets were bred and trained like prizefighters. Today, the Association for Cricket Fighting in Beijing, China, keeps cricket winning records and sets rules for events. When a champion cricket dies, ceremonies are held, and some famous insects have been buried in their own gilded, miniature cricket coffins.

A Life of Song

Many fables, songs, and poetry characterized crickets as squanderers of their short life, or as hopeless romantics, dedicating their entire existence to the pursuit of song and love. Ancient peasants thought the crickets' songs were messages at the onset of spring, telling the farmers when to plant new crops. Others observed how crickets came into their homes and hid under beds days before the first autumn cold hit; some folktales portrayed them as wise and intelligent creatures. The talking cricket in Carlo Collodi's novel *The Adventures of Pinocchio* (1883) was prudent and had lived in the toymaker Gepetto's house for one hundred years. In Disney's animated version of Collodi's tale, Jiminy Cricket dispensed advice and good judgment as well.

Life Cycle

In the field, most crickets have a short life span of only eight weeks, which might explain why they seem to play a lifetime's worth of songs repeatedly from spring through summer. As winter approaches, crickets try to find their way into houses or burrows and may live longer if kept warm. Many believe that a house cricket will bring good fortune and money, while others call an exterminator.

CROCODILE
Terminator Reptile

CROCODILE DE JOURNU. CROCODILUS JOURNEI. Bory de St Vincent.
a. Le dessus. b. Le dessous ⁴⁄₁₇ᵉ de la grandeur naturelle

A cold-blooded crocodile is consistent in its approach to obtaining food, following the principles of survival long established in its prehistoric mind. It perpetually prowls or lies in wait until it finds something edible, and then it launches a ferocious ambush: be it fish, turtle, antelope, water buffalo, or an unfortunate human, a crocodile sees no difference. Crocs have even been known to attack and kill sharks.

When the *Crocodilia* species emerged over eighty-five million years ago, the earth was warmer than it is now. There were steamy lagoons and shallow seas, and volcanoes erupted everywhere, emitting bursts of deadly gases that choked the atmosphere. The crocodile was a contemporary of dinosaurs, and it is a "living fossil" by many standards, though it was more complex and adaptive than the countless extinct species with which it once competed. A gargantuan crocodile from the dinosaur era called "Super-Croc" grew 40 feet long and weighed 10 tons, as much as a city bus. Among larger primeval creatures, crocodiles were even then dominant in the food chain. The crocodile is encased in a hard, leathery armor, which ancient bestiary books claimed a lance could not penetrate.

Most Man-Eating

The Nile crocodile historically holds the record as the most man-eating reptile on the planet. One notorious crocodile, nicknamed Osama, ruled a portion of Lake Victoria near the village of Luganga for more than a decade. The croc ate a total of eighty-three villagers before it was finally captured. It took fifty men with ropes to wrangle the 20-foot-long beast from the water. Osama was not put down, but, instead, installed as the main attraction of a Uganda wildlife preserve and petting zoo in 2005.

Tricks of Its Trade

Crocodiles are rarely fooled twice by the same trick. They also have the patience of a stone and can remain in the same unflinching position, floating with only their nostrils and eyes above the waterline for more than a day at a time. They even have third eyelids, which are transparent and allow them to blink without giving away their location and swim underwater with their eyes open.

Despite being the croc's legendarily powerful chomping force, its jaws have weak muscles for opening up its mouth, which can be held shut with one wrap of duct tape or by a clenched human grip. Crocodiles have small raised bumps on their jaws that resemble the stubble of a beard but are actually sensors. These detect when water pressure has changed, for example, caused by a potential food source entering a crocodile's lair. These sensors signal when to get in motion and trigger the activation of its deadly force. In addition, a crocodile's eyes are situated to give separate side views or produce binocular-like focus toward objects ahead.

Crocodiles have such powerful immune systems that sickness hardly infects them, and they survive even with severed limbs. They swallow rocks and pebbles to

Jaw Power

The devastating strength of a crocodile's snapping jaws is infamous. Its mouth can clamp shut with over 2,000 pounds of force, the same as a car smashing into a brick wall at 60 miles per hour.

Alligator vs. Crocodile

There are 23 different types of modern crocodiles; some strains such as the dwarf crocodile grow to only 3 feet, while saltwater species have reportedly reached more than 20 feet in length. Crocodiles (their name comes from a Greek word meaning "lizard of the Nile") live in estuaries, where saltwater and freshwater mingle, or in brackish saltwater, found in Florida and the Caribbean, South America, Africa, India, and parts of Asia.

Alligators have blunt snouts, better for pulverizing turtle shells, while the narrower-snout crocodile is more suited to catching fish and tearing into animals. Alligators grow to nearly 15 feet and tolerate only freshwater.

If an alligator and a crocodile squared off in battle, the larger and quicker saltwater croc would have to be the odds-on favorite. First each creature would try to intimidate its opponent by posturing to show its size and ferocity, since it knows that once locked jaw to jaw, neither would show mercy until absolute defeat of its opponent. If both were of equal size, however, the comparably stronger tail of the alligator could deflect the croc's bite. In this scenario, the alligator, with its wider jaw, would likely prove victorious if it was able to inflict the first lockdown grip with its teeth.

Alligator

Crocodile

help their acidic stomachs grind and digest fur, shells, bones, and hooves. If no food is available, the beast can persist for up to a year without eating and yet remain alive and fearsome.

The Crocodile Speaks

Alligators and crocodiles are among the most vocal reptiles and can bark, grunt, hiss, bellow, and growl. From birth, soon after emerging from eggs deposited on shore in mounds of decaying vegetation, hatchlings squeal for their mother. Adults use different calls for hunting, or when feeling annoyed, threatened, or distressed. Adult males can also emit low-frequency sounds that ripple the surface of the water. They do this to scare up turtles or fish—and to attract females.

Life Cycle

In the wild, fully grown crocodiles have no natural enemies and are resistant to most diseases. Since they continue to grow throughout their lives, the length and width of the beasts are the best estimates of how old they are. You also can often tell the age of a wild crocodile by the number of stones and rocks found in its stomach. If not killed for their prized skins, crocodiles live to around seventy years, though some exceed one hundred. One in an Australian zoo was thought to be more than 130 years old.

Crocodile Tears

Legend has it that a crocodile would lure prey by pretending to weep and would eat anyone who came to offer it comfort. Crocodiles do cry, in a way, or are at least capable of producing tears, since they possess what are called "lacrimal glands" in their eyes. Their eyes will moisten involuntarily, especially if they have been on land for some time, in order to keep their eyes alert for the next meal.

DEATHWATCH BEETLE
The Grim Reaper's Tiny Messenger

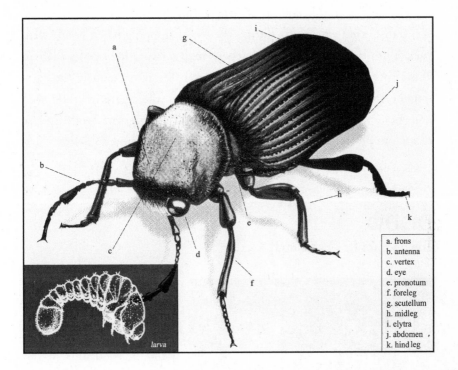

larva

a. frons
b. antenna
c. vertex
d. eye
e. pronotum
f. foreleg
g. scutellum
h. midleg
i. elytra
j. abdomen
k. hind leg

Haunted houses make sounds, such as ticking noises behind walls, squeaky floorboards, and slamming doors. One insect to blame for some of the spookiness in old houses is the ominously named "deathwatch" beetle. This black, ½-inch, bullet-shaped insect eats natural sugars and cellulose found in wood. It doesn't care if it gets its nourishment from a tree in the forest or from beams, rafters, or wall studs in a house.

During summer breeding season, the beetle bangs its head and raps its jaw against wood to locate a mate. It does this head banging in a relentless rhythm, lasting for hours. In medieval times, those keeping vigil with the sick were fearful of the sound, which echoed eerily in the quiet of the night. The tapping sounded like the staff of the Grim Reaper and superstitions arose that this abnormally persistent rapping was an omen and harbinger of death: the beetle was ticking off the minutes left on the

death clock, or deathwatch, and was able to measure the time left before a life would end. As for the beetle, it usually only has a two-year life span before it meets its Reaper.

The deathwatch beetle originated in Europe and northern Asia but was transported worldwide during the era of shipping when goods were packed in wooden crates. It is closely related to two other beetles that are also associated with things that can shorten life span, namely the cigarette beetle and the drugstore beetle. However, the cigarette beetle does not smoke; rather, it eats dried tobacco. And the drugstore beetle doesn't search out pharmaceuticals but instead infests dried, stored goods.

DODO
Too Nice for Its Own Good

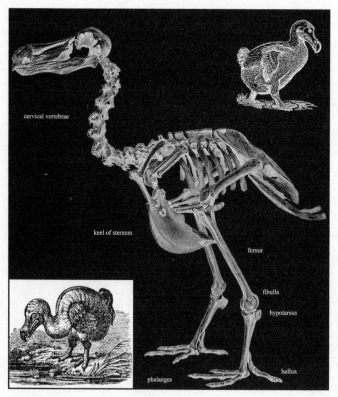

cervical vertebrae

keel of sternum

femur

fibulla

hypotarsus

hallux

phalanges

A pigeonlike bird once flew from India and came to rest on the remote volcanic island of Mauritius in the Indian Ocean, 700 miles from the southeastern coast of Africa. It stayed there, and over many millennia in this isolation, it developed into a large, flightless species of bird that came to be known as the dodo. This stocky bird, similar in body shape to a pelican, with a blunt, hooked beak, stood about 3 feet tall and was as plump as a turkey at 45 pounds. It was brownish

gray with short wings, tufted with yellow feathers; it appeared to have a fleshy, featherless head, though not altogether as bald as vultures. It also had a few long feathers sticking out at odd angles from its rear. Dodos dwelled in rugged, mountainous terrains, made ground nests, ate fruits and seeds, and usually preferred to live in solitude rather than in flocks.

Dead as a Dodo

When Western explorers reached the island in 1581, the birds were seemingly unafraid of their new visitors and did not attempt to seek cover or hide. On Mauritius, the dodo had no natural predators, such that over time, even the need to fly became obsolete. Unfamiliar with the need to worry about predation, they lacked the instinct to fear other creatures. This would prove to be their undoing. The dodo made for an easy catch for hungry settlers and their dogs. As far as wild animals go, the naive dodo seemed to the Portuguese a *doido,* meaning "crazy fool." Within a century after its discovery, the dodo became extinct—and has since become the poster child for humans' regrettably negative impact on wild places and species.

Some paintings and sketches were made of the dodo while it was alive, but exactly how it looked or behaved remained a mystery for some time. For many years, in fact, since no fossils of the dodo were found in Mauritius's volcanic landscape (not a good sediment for fossil preservation), most assigned this so-called dodo bird to the "legendary" category, alongside unicorns. Even natives, when quizzed, said no one had ever known of or remembered seeing such a bird. In 1863, an English schoolteacher living on the island, George Clark, set out to prove that such a rare bird had, in fact, existed. Knowing the island's terrain, he guessed correctly that animal bones never had time to settle and were probably washed off before fossilizing. He searched mud near river deltas and soon found a mother lode of dodo bones. Clark's bones confirmed the dodo was real, and most museums to this day have specimens of the bird assembled from Clark's finds.

Statistically, birds have the poorest chances of species survival. Out of the depressingly long list of extinct animals, nearly eight out of ten are birds.

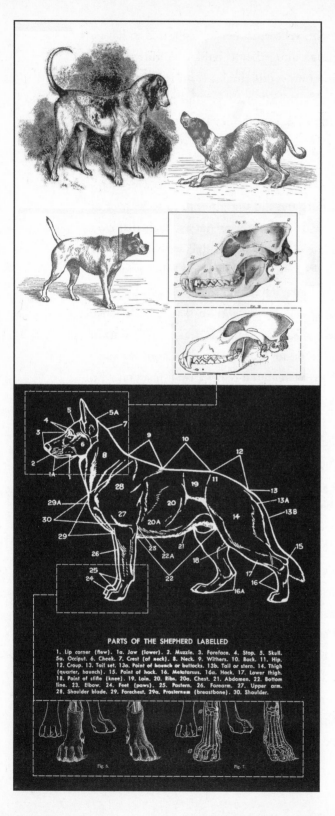

PARTS OF THE SHEPHERD LABELLED

1. Lip corner (flew). 1a. Jaw (lower). 2. Muzzle. 3. Foreface. 4. Stop. 5. Skull. 5a. Occiput. 6. Cheek. 7. Crest (of neck). 8. Neck. 9. Withers. 10. Back. 11. Hip. 12. Croup. 13. Tail set. 13a. Point of haunch or buttocks. 13b. Tail or stern. 14. Thigh (quarter, haunch). 15. Point of hock. 16. Metatarsus. 16a. Hock. 17. Lower thigh. 18. Point of stifle (knee). 19. Loin. 20. Ribs. 20a. Chest. 21. Abdomen. 22. Bottom line. 23. Elbow. 24. Feet (paws). 25. Pastern. 26. Forearm. 27. Upper arm. 28. Shoulder blade. 29. Forechest. 29a. Prosternum (breastbone). 30. Shoulder.

DOG
Most Faithful Friend

Dogs were our first alarm system. When originally tamed from a species of wolves, most likely the smaller East Asian wolf about ten thousand years ago, dogs served as a reliable security system for the caves and camps of our nomadic ancestors. Territorial and loyally devoted to the pack, be it led by dominant wolf or human, certain dog instincts have not changed. They still mark territory with scents, bare their teeth, growl, and bark at intruders or any perceived breach of their space. Some still bury a bone in the dirt from an instinct to preserve food for later, as if paying homage to their past, just as wolves, foxes, and jackals still do. However, most domesticated dogs could no longer survive in the wild.

Instead, many have become (or have been bred to be) specialists, from herding sheep, pulling sleds, sniffing out bombs, guiding people with handicaps, or expertly catching a Frisbee. An ancestral East Asian wolf is about 30 inches at the shoulder and weighs 60 pounds, while dogs now range in size from remarkably small breeds like the 6-

pound, 9-inch Chihuahua to oversize breeds like the mastiff, which can weigh 300 pounds and, when standing on its hind feet, is over 6 feet tall.

How Dogs See the World

It was long believed that dogs are color-blind, seeing the world as images similar to old black-and-white movies on TV. However, even if they do not see in the range of colors that we do, their world is not colorless. Their eyes can register yellows and blues, with all the gray and brown shades in between. In low light, dog eyes work best, another remnant of their predatory past. In the dark, they see four times better than we do. They can recognize detailed features of your face within 20 feet. Beyond that distance, things get fuzzy for dogs, though they can detect the presence of something that's moving or running nearly half a mile away. Another feature a modern dog still possesses from its wild ancestors is its third eyelid, which involuntarily moves up and down over a dog's eyes like windshield wipers, removing dust and keeping its eyes moist. The dog really "sees" or interprets its world with its nose, and it combines these scent signals with visual images to produce a picture of things that would be hard for us to conceive. A dog's olfactory capabilities are legendary, and we all know a dog would rather size up a person and gain information by first sniffing rather than looking at a face. Some breeds, such as the tracking bloodhound, have noses with 300 million scent receptors, while the average person has a mere 5 million.

The Dog's Loyalty

Even in the first medieval texts about dog behavior, many incidents were recorded that described a dog's unmatched loyalty. One such story explained that when one particular knight was held captive, all two hundred of his hounds went out on their own, formed a battle line, and freed their master. Another tells of the time when the Persian king Lisimachus died, and his faithful hound threw itself into the funeral pyre.

Drawing from more recent lore, newspapers covered the story about

The dog's ridged, rippled, and moist nose is as individual as a person's fingerprints and interprets smells about ten thousand times better than we do.

—

In Roman times, the dog of a condemned man waited faithfully for a year outside the prison and howled uncontrollably when his master was finally executed. When the body was thrown in the river, the dog swam against the current to try to lift his lifeless master's head.

Famous Dogs

"Lassie" was a male collie named Pal that became a star in the 1943 movie *Lassie Come Home* and was awarded a star on the Hollywood Walk of Fame. In 1959 he died of old age at age nineteen. Belka was a Russian dog and one of the first earth-born creatures to fly in a rocket ship into space and return alive. (He actually shared the cabin with a rabbit, forty-two mice, two rats, and a fly.) Of the forty-three U.S. presidents, twenty-five had pet dogs with them in the White House. One of the most famous was FDR's Scottish terrier, Fala, which followed the president everywhere. Fala is even cast in bronze, sitting next to the executive chief at the Franklin Delano Roosevelt Memorial in Washington, D.C.

Rudolph Valentino's dog, Kahar. When Hollywood's first matinee idol died in 1926, Kahar waited by the door for two weeks for his master to return, refusing to eat until he too died. Dogs have been known to travel substantial distances to reunite with their lost families. One incident documented how a collie was lost when its human family was on vacation in Indiana in 1923. The family went home by car, but the dog traveled alone on foot, traveling 2,000 miles back to the farm where it was born in Oregon.

Dog Habits

Dogs are omnivores. They prefer meat, but they do eat plants, such as fallen fruit (consumed when they sense a nutrient deficiency or as a cure for an upset stomach). They also have no qualms about eating their own vomit. Dogs also lick themselves and nearly anything else, always willing to give something a sample taste. It was thought that if a dog licked a person's wound it was as good as an antiseptic, but now we know this will only add more bacteria to the cut. Dogs contract all sorts of diseases, from worm infestations to blood diseases to cancer. The average dog lives about twelve to fifteen years. The oldest dog—one tough Australian cattle dog that died in 1939—lived for twenty-nine years.

DOLLY (AKA *DOLICHORHYNCHOPS*)
Prehistoric "Sea Wolf"

There were great schools of sea creatures known as *Dolichorhynchops,* or dollies, living in North America when much of it was covered under a shallow ocean eighty-five million years ago. These air-breathing reptiles looked like a cross between a penguin and a bottlenose dolphin, growing to 15 feet long. Dollies had long, stiff paddlelike front legs that served as fins, and snouts like a dolphins but with sharper teeth. Their rotor-blade-style rear fins revved these creatures up and made them fly through the water. Scientists believe they could shoot down to the ocean bottom like a torpedo and speed back up to the top, breaching the surface and becoming temporarily airborne. Dollies, as seals do now, may have leaped onto rocky outcroppings to sun themselves or hid in shallow inlets, especially when breeding. The first fossil of a full-grown dolly was discovered in the Kansas hill country in 1900.

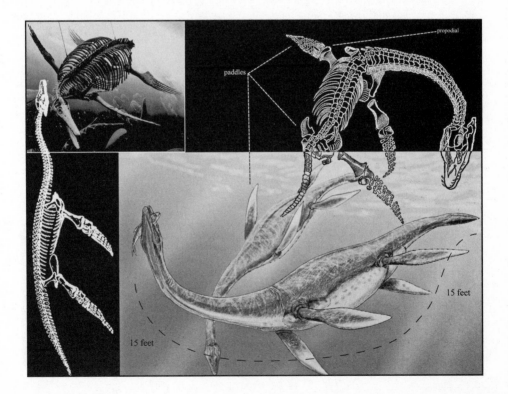

Top Ten Biggest Dinosaurs

1. **Argentinosaurus:** Named after a fossil found in Argentina, this massive vegetarian was 130 feet long and weighed 110 tons. It had a long tail and an equally long neck. Its head was relatively tiny for all its massiveness, even if each of its vertebrae measured 4 feet in length. It lived about 90 million years ago.
2. **Sauroposeidon:** This 100-foot-long, 60-ton beast roamed the woodlands of North America 110 million years ago. Also a plant eater, this dinosaur had a disproportionately bulky body that supported a 60-foot neck. It's speculated that it rarely held its head aloft since doing so would have made it difficult for its heart to pump blood to its brain. Instead, it likely ate low-lying plants and swung its head to and fro to gobble up foliage.
3. **Spinosaurus:** This 7-ton, 50-foot-long brute was the biggest meat-eating creature ever— even larger than the T. rex. It had long legs and small front paws, and a huge flap of skin on its spine that was as big as a ship's sail. It terrorized the African continent until about 90 million years ago.
4. **Quetzalcoatlus:** This dinosaur was the largest creature on earth ever to take to the air. It had a 30-foot wingspan and weighed 200 pounds. It ate fish and meat and lived until 65 million years ago.
5. **Dolly or Liopleurodon:** This species of aquatic monsters weighed in at 30 tons and dominated the ocean from 165 to 150 million years ago.
6. **Shantungosaurus:** This 50-foot-long, 15-ton herbivore had a duck-billed mouth that housed thousands of teeth. It ground up its food supply of plants better than any modern-day juicer machine. It faded away 65 million years ago.
7. **Utahraptor:** This beast looked sort of like a giant chicken, though with massive killing claws on its feet. It was about 23 feet long and weighed about ½ ton.
8. **Moschops:** These fellows lived before that age of true dinosaurs, about 225 million years ago. They looked like a cross between a cow and a toad and weighed 1 ton and were 16 feet long.
9. **Sarcosuchus:** Called a "supercroc," this 40-foot-long, 15-ton terror acted similarly to the modern crocodile, and dominated the world's estuaries and rivers 110 million years ago.
10. **Shonisaurus:** This aquatic beast looked a bulky, girthed whale and a long-nosed dolphin. It was 50 feet long and tipped the scales at 30 tons. It lived about 200 million years ago.

DRACO LIZARD
Diminutive "Flying Dragon"

How scary to be a tiny lizard trying to make a go of it amid the eat-or-be-eaten jungle floor. Many lizards display bright colors to try to

fool predators into thinking they contain poisons, even if they don't. Or they count on camouflage, even changing colors; nevertheless, often none of this is enough to spare them from being consumed. The Draco lizard, found in the Philippines, Southeast Asia, and India, added flying to its survival tactics. The lizard has a yellow throat sac and yellow wings with a brown-freckled body but is only about 8 inches long, including its tail. Dubbed the "flying dragon," the Draco has skin flaps or a membrane attached to its ribs, which grow away from its body and enable it to fly.

As lightweight as they are, some have been carried a mile when the wind is really blowing—carrying them far from any predator that had hoped to catch them. Draco lizards live mostly in trees, eating ants and termites, but the males have learned to use their gliding skills so well that they soar from tree to tree

draco skeleton

draco lizard

contracted

gular sac

sitana minor

expanded

chasing other lizards away from their territories. A Draco female must come out of the trees and down to the dangerous forest floor to lay her eggs. She guards her eggs diligently for twenty-four hours and then abandons them totally before they hatch, never again to return to the nest. She is safer in the trees, and the brief time on the ground apparently scares her motherly devotion right out of her.

Lizard Double Chins

Many of the 400 species of *Anolis* lizards, such as the Draco, have expandable throat sacs, odd-looking skin flaps under their chins, which expand and pulsate seemingly with each breath. However, the sac is not an exterior lung or connected to breathing; it is actually called "gular skin" or a "gullar sac," though commonly referred to as a dewlap. (Dewlaps, by definition, are any flap of dangling chin skin, which even some old men have.) On the Draco, its dewlap expands like a yellow balloon with the intention of making the lizard appear larger. It also acts as a sort of lizard Morse code, used for signaling and for communicating with other lizards. If a male has a bigger dewlap than others', it usually claims more territory and attracts a greater number of females during mating season. The largest dewlap among lizards belongs to the Australian frilled lizard, which can inflate its throat and neck flaps to encircle its head, making it look ferocious and twice the size. The Draco can live for ten years, and the frilled lizard can survive for fifteen years.

After a running start or when perching up on a branch, the Draco unfurls its wing flaps and catches the wind to glide for more than 30 feet.

DRAGONS
Legendary Serpents

World literature is rich with stories and anecdotes about dragons. It was once thought that the "true" dragon was native to Ethiopia and India, or anywhere that had warmer climates. In India, dragons were said to be everywhere, with different species living in marshes, plains, and mountains. According to a Greek writer, Flavius Philostratus, they grew to "thirty cubits," or around 55 feet long. The "marsh" dragon had silver scales, while the "plains" and "mountain" dragons' scales were a golden hue. According to popular depiction, dragons had bony ridges running along their spines, and some had beardlike flaps of skin on their necks. Reptiles with wings, dragons had alligatorlike heads, four limbs (some had only two or none), and all were equipped with exceptionally long, thick tails. The size of tree trunks, dragon tails were used to beat, pummel, and coil around enemies, killing by suffocation. A dragon's favorite food was the elephant, which it captured by tripping. Only some dragons, usually the ones that burrowed, had fire-breathing abilities, though all dragons inflicted the most havoc with their large and powerful tails.

Dragons lived in high, rocky perches, caves, or in deep subterranean caverns, and because of their size and ferocity, they were fearless, showing themselves as they wished in either day or night. Dragons did not fly for

long distances, though they could achieve speeds faster than the swiftest river, and they usually were nonmigratory, staying close to the territory where they were born. They could soar to exceptional heights and usually gained altitude by widening the spiral of ascent. However, when spotting prey, a dragon descended from the clouds with the velocity of a falling boulder.

Dragons' eyes were thought to possess hypnotizing powers.

When Dragons Roamed

Evidence of dragons, a name stemming from the Greek words for "giant water serpent," was frequently observed in the form of fossils or other remnants of huge animal bones, which we now know were from dinosaurs. However, since almost every culture has some reference to eyewitnesses seeing dragons, and with legends claiming they were around since man appeared, many think they were once real. Desmond Morris, a renowned zoologist and ethologist, speculated that what the ancients called dragons could have been various species of dinosaurs not yet extinct, which had, in fact, coexisted with humans.

Famous Dragons

There are thousands of dragons cited in myth, but a few include: **Apalala,** an angry drag-on that lived in the river Swat in Pakistan and was converted by Buddha to his religion of peaceful acceptance. After having killed his nemesis Grendel, Beowulf, an Anglo-Saxon warrior hero, died fighting **an unnamed fire-breathing dragon,** which inflicted a poison-ous bite. **Brinsop Dragon** was a red-colored creature that lived in Duck's Pool Meadow, in Britain, and was slain by Saint George. **Fafnir** was a Norse dragon that was origi-nally a dwarf but was turned into a dragon by a magician. A small 9-foot creature called the **Henham Dragon** was seen flying around a British village in 1669. **Ladon** was a dragon of ancient Greece that guarded a special apple tree. Nessie, or the **Loch Ness monster,** is thought by some to be a type of dragon. **Ou-roboros** is a dragon-serpent that eats its own tail and re-births itself over and over. **Puff the Magic Dragon** lived by the sea and was featured in a song by the folksing-ing trio Peter, Paul, and Mary. **Eingana** is a female Austra-lian Aboriginal dragon that is still alive and hiding; if she dies, the whole world will per-ish. **Shen Lung** is a Chinese good luck dragon and makes appearances at Chinese New Year celebrations.

DUNG BEETLE
Nature's Smelliest Lives

eggs on the underside of a leaf

larva stages

adult

The dung beetle occupies a niche of the animal world few would consider appealing. There are more than 5,000 species of dung beetles found in all parts of the world, though not normally in icy or desert environments. They grow in sizes from $\frac{1}{10}$ to $2\frac{1}{2}$ inches and have metallic, shiny, shell-like bodies in either black, red, or brown, with some featuring one or two horns, plus antennae. Their job is waste removal, and they survive by eating the droppings or dung of larger animals. They do not need water or other food sources, getting all nourishment from excrement.

The dung beetle has an extremely keen sense of smell and can sniff a good, fresh pile of droppings miles away. Some can fly up to 10 miles and be on the dung moments after it splats. A variety of dung beetles hitch a ride on an animal's tail, just waiting there in prime position to alight on a new deposit as it happens. Dung beetles are broadly categorized by the specialized methods in which they handle wastes: rollers, tunnelers, and dwellers.

Dung beetles will eat herbivore or carnivore feces, but they usually prefer the balanced diet offered by omnivore droppings.

The Rollers

This class of dung beetle likes to reshape animal waste and pack it into spherical balls. Rollers take apart animal feces and make one small ball of it and then continue rolling it around and around in the pile of feces, until the ball grows bigger and bigger—similar to how one would make the base of a snowman. Many roller dung beetles are extremely skilled

at fashioning a perfectly round ball out of waste, a technique that allows them to transport their food source back to their nests. No matter where the dung ball is formed, they roll it back home in a nearly straight line, regardless of obstacles or distance, and navigate by moonlight.

The rollers are the strongest of the waste-removal beetles—they are capable of creating dung balls more than fifty times their size. Rollers are a rough crowd, and after a hefty ball is made, their biggest threat is getting it stolen by a larger dung beetle. Even so, the dung beetle will make and roll another ball, sort of like Sisyphus in Greek mythology, and not stop at its task of environmental cleanup for its entire life.

The Tunnelers

Certain dung beetles that have apparently tired of rolling balls instead make one quickly and then dig a tunnel close by and bury their prize. They never seem to forget where they stashed it. Some dung beetles will go into the burrow of animals and collect the waste, often making small tunnels within the burrow to store their dung balls.

Sacred Scarab

Ancient Egyptians admired the untiring dung beetle, called a "scarab," and raised it to the importance of a religious icon. They thought that only male beetles existed and used the ball of dung as the womb for their offspring. Egyptians also thought that the sun was like a dung ball that each night disintegrated and needed to be remade every day. The scarab came to symbolize rebirth, and nearly all Egyptians wore amulets of the beetle. When a person died, jewelry fashioned like the beetle was often placed on the deceased's chest.

The Dwellers

Other dung beetles simply live inside a pile of dung and do not bother to create dung balls or bury them. If manure is plentiful, a dweller beetle changes its dung-pile homes frequently and prefers to live in manure that has the most stench, which indicates it contains the freshest food source.

Life Cycle

Most dung beetles lay their eggs in specially prepared dung balls, which are then buried in chambers underground. Both the male and female

will work together in excavating the breeding tunnels. A dung beetle goes through complete metamorphosis, with the larva eating the dung ball in which it hatched until it becomes a pupa, about three weeks after the egg was deposited. Two weeks later that beetle will breed, make as many balls as it can, and die usually in two months. Some species have life spans of one year, with the longest known to live for about three years.

DUGONG
Sea Cow

Dugong

Found in the warm coastal waters of the Pacific Ocean, Indian Ocean, and more abundantly off the northern Australian coast, the roly-poly dugong is a huge vegetarian marine mammal that resembles a tuskless

walrus. Dugongs belong to the Sirenia family of animals, which has only four living species, including manatees.

It's often argued that dugongs were the source for several mythological creatures, including the Greek sirens and even the mermaid (apparently seen by ancient sailors stricken with poor eyesight or blinded by loneliness). In African folklore, a sea cow was held as sacred, and many thought the animal had once lived its previous life as a human; killing it was considered murder. The 1,000-pound, 10-foot-long beasts claim the forebear of the elephant as their distant ancestor—not cows, though the first types did graze on land. The dugong returned to the sea about fifty million years ago. Manatees are much larger than dugongs, reaching 3,000 pounds and growing to 13 feet. Sea cows' front arms are short and used to paddle, but their rear legs are no more than muscle stubs. Instead they use their flat, wide tails as their primary method for propulsion.

A sea cow has elongated lungs that stretch the length of its spine and, like internal airbags, are used to help regulate buoyancy.

This tail, in addition to its thick bones and blubber, enables a sea cow to appear as if it is casually floating about sort of like an inflatable pool toy. As fat as they appear, sea cows are actually thick with muscle, yet they are incapable of ever leaving the water and cannot even roll themselves free if unexpectedly beached. Dugongs have big suction-cup-like lips, while manatees have more rounded snouts. Neither have biting teeth; instead, they have perpetually growing molars to grind their diet of aquatic grasses and sea plants.

Sea cows swim at a mere 3 miles per hour, but they can do quick sprints reaching 20 miles per hour if they must. They generally can hold their breath for about twenty minutes, though they like to sleep at the surface for longer periods of uninterrupted rest. Sea cows have no particular social hierarchy and prefer solitary lives, although mothers do form small groups and will swim with their young for almost two years. Males seem indifferent to territorial rights, but turn mean and become very aggressive when it comes time for mating. When migrating to find warmer waters, sea cows do loosely group together, but who is in charge seems not

so important, and they play "follow the leader," trailing whichever one decides to take the lead.

Life Cycle

Manatees and dugongs have no means of defense, and yet their size alone deters many predators, even if sharks and crocodiles attack occasionally. In modern times, pollution, red tide blooms of microscopic marine algae, and motor boat propellers are the main causes for the species' dwindling numbers. Sea cows cannot hear the muffled noises made by boats; propeller blades give them fatal wounds by puncturing lungs and affecting buoyancy, thus causing them to drown. Fishing line, when ingested, blocks their digestive tracts and also kills them. When fortunate enough to avoid these hazards, dugongs and manatees can live for about sixty-five years.

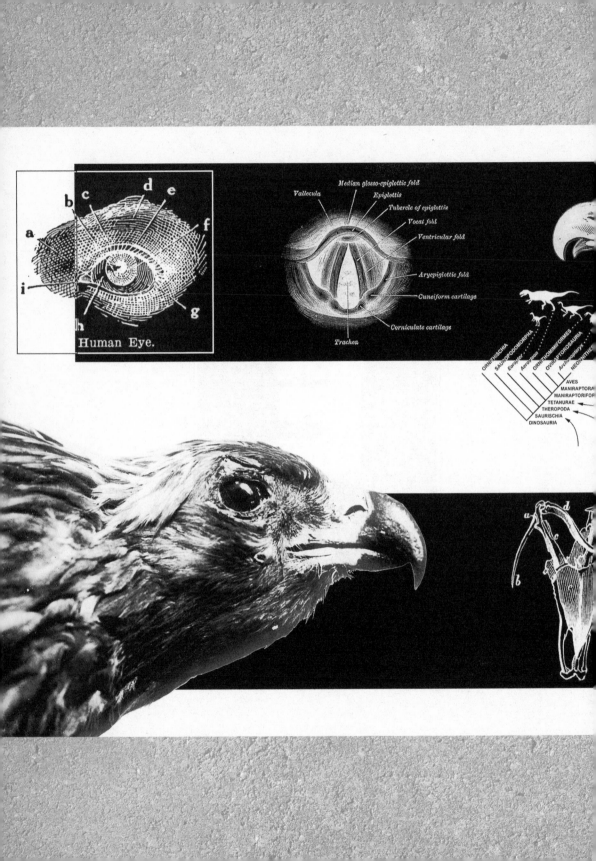

Human Eye.

Vallecula

Median glosso-epiglottic fold

Epiglottis

Tubercle of epiglottis

Vocal fold

Ventricular fold

Aryepiglottic fold

Cuneiform cartilage

Corniculate cartilage

Trachea

ORNITHISCHIA
SAUROPODOMORPHA
Eoraptor
Aerosteon
ORNITHOMIMIFORMES
OVIRAPTOROSAURIA
Archaeopteryx
NEORNITHES

AVES
MANIRAPTORA
MANIRAPTORIFOR
TETANURAE
THEROPODA
SAURISCHIA
DINOSAURIA

EAGLE
King of the Birds

The ancient Greek naturalists believed the eagle strengthened its excellent eyesight by staring into the sun. When an eagle got old, and its vision became misty, it would use the last of its strength to fly directly at the sun and circle it, getting close enough to singe its wings. With its eyes on fire and brilliant from this radiation, it then soared back to earth, dipped three times in a fountain of water, and then rejuvenated itself to its once powerful youth. Eagles, nearly all 60 species, do molt and regrow their seven thousand feathers at various times in their lives to the point of appearing nearly naked, but they are not immortal. However, the ancient naturalists were partially right, since many species of eagles do live long lives, to nearly fifty years. Even if staring at the sun is not the source of their vision, eagles' eyesight is exceptional—ten times better than ours. An eagle can see a brown rabbit in a brown field 2 miles away.

Mascot of Choice

Ancient Egyptians, Persians, Greeks, and Romans all used the eagle as either symbols of war or power. In many Native Mesoamerican mythologies, eagles played roles in creation stories and were said to be responsible for inventing thunder. The Aztecs selected the remote location of their capital city, Tenochtitlan, according to legend, because it was a site where a great eagle was

We have 200,000 light receptor cells in our eyes and see in three basic colors, while the eagle has 1,000,000 receptors and sees in five colors.

once seen perched on a cactus; the Spaniards constructed Mexico City on the same spot.

Nearly a dozen nations still use the eagle on flags or as their official seals. In 1776, one of the first political committees of the newly formed United States of America met to choose the best symbol to represent the nation. Thomas Jefferson, Benjamin Franklin, and John Adams did not pick the eagle from the outset. Franklin liked the rattlesnake and later thought the turkey a better bird, but after six years of debate, the United States made the bald eagle its official seal and national bird. It is commonly depicted holding arrows in one talon and an olive branch in the other. America's neighbor to the south, Mexico, honors the golden eagle at its national bird.

An Eagle's Range

The bald and golden eagles are the only two eagle species native to North America. Most species are found in Europe and Asia. A few make their homes in Australia. The largest eagle is the Central American and South American harpy eagle, which has an 8-foot wingspan and weighs 20 pounds. The most diminutive is the pigeon-sized African crested serpent eagle, which spends most of it time hopping on the ground, hunting for snakes.

Australian Aborigines scared children into behaving by telling them an eagle would come to carry them off if they were disobedient. This cautionary fairy tale might have a basis in truth: a recently discovered fossil found in South Africa shows evidence that an eagle killed a three-year-old primitive hominid child some two million years ago.

Eagles are known for soaring high, some reaching altitudes of 10,000 feet, but a few varieties are adapted for shorter flights in tangled jungles. Eagles are carnivores, eating mammals, fish, and snakes; a few, like the small African fish eagle, primarily eat only palm nuts. Legends of eagles carrying away grown men might have once been true, but the biggest harpy eagle is only strong enough to carry off a fawn-sized deer, and the bald eagle has a mere 4-pound carrying limit.

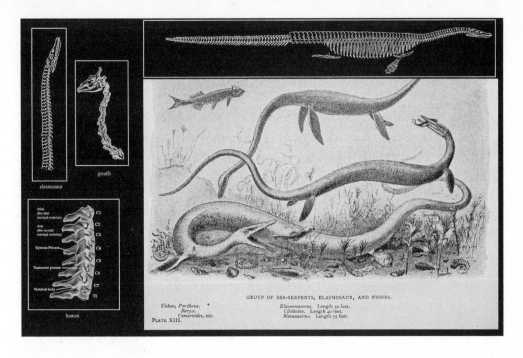

GROUP OF SEA-SERPENTS, ELASMOSAUR, AND FISHES.

Fishes, *Portheus.*
Beryx.
Cimervoides, etc.
PLATE XIII.

Elasmosaurus. Length 50 feet.
Clidastes. Length 40 feet.
Mosasaurus. Length 75 feet.

elasmosaur

giraffe

Atlas
(the first
cervical vertebra)

Axis
(the second
cervical vertebra)

Spinous Process

Transverse process

Vertebral body

C1
C2
C3
C4
C5
C6
C7
T1

human

ELASMOSAUR
Ancient Aquatic Giraffe

When scientists found the first fossils of this creature, they attempted to reassemble its bones. However, they incorrectly placed its skull on the end of its tail, believing its short tail was the neck. It was hard for paleontologists to imagine a marine reptile that had a neck that was more than 25 feet long. The elasmosaur roamed the world's oceans for thirty million years, until the end of the dinosaur era, some sixty-five million years ago. Elasmosaurs' remains have been unearthed in North America, New Zealand, and Antarctica. This reptile had a massive body, weighing 2 tons, with four seal-like flippers it used for swimming in a slow, treading-water fashion. Its flesh was smooth; it breathed air and ate small schooling fish and squid. Its neck was four times longer than a giraffe's, with more than seventy vertebrae that held up its tiny head. (We have seven vertebrae in our necks, the same number as giraffes, whose bones are superbig compared to ours.) Elasmosaurs would have made for perfect ferryboats, had they survived, able to transport dozens of people at a time on their broad

backs—as long as the passengers were not scared off by their jaws full of razor-sharp teeth. Nonetheless, the creature's long neck apparently fooled fish that might have steered clear of its body mass, only to get attacked by its head, which swooped in from so far away. The twisting neck also confused predators, since the beast was able to move its head like a snake, snipping at attackers from all sides. In addition, the way its flippers were aligned, an elasmosaur's design made it capable of doing swift 360-degree underwater rolls. Because of its massive weight, the enormous giant likely never ventured far out of the water and so laid its eggs at the shoreline or a quiet cove.

Where Did They Go?

Elasmosaurs were not true dinosaurs but were more akin to turtles. They preferred cooler water temperatures. However, they vanished during the "K-T extinction," a period sixty-five and a half million years ago when a countless number of earth creatures died off in a relatively short amount of time. Exactly what happened then is not certain, but it is theorized that a rapid succession of catastrophic events took place, including volcanic eruptions and massive asteroids striking the earth, which upset ecosystems worldwide. Sunlight filtered dimly for scores of decades, killing off many plants. The supply of smaller fish that elasmosaurs ate diminished as sea plants died out. With its massive body, elasmosaurs required pounds and pounds of fish each day. Even though it had many skills, the elasmosaur's jaw was small, which meant the creature could only eat prey of a certain size; this was one factor that led to the species dying off in a relatively quick amount of time. Since elamosaurs were strict carnivores requiring fresh fish, there simply was not enough food available to support their colossal bulk.

Loch Ness Monster

Some people believe a few elasmosaurs survived, living in deep cold-water lakes and passing the eons nearly undetected. At various times throughout history, accounts of dragon sightings described beasts with elasomosuarlike qualities. The Loch Ness monster of Scotland, nicknamed Nessie, supposedly resembles the extinct elasmosaurs more than any other prehistoric beast. Written reports of such a creature located around the Highlands area of Scotland are dated to the seventh century and persist to the present time, even if the creature has eluded sonar instruments, submarine hunts, and satellite tracking.

Scotland Stirred by Mysterious Loch Ness Sea Monster

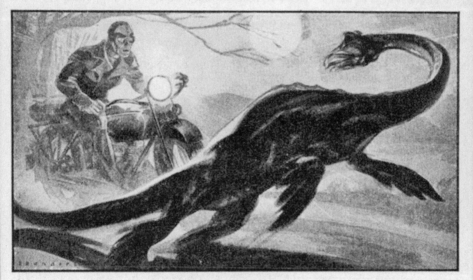

This is an artist's conception of what Arthur Grant saw early one morning as he drove down a road alongside Loch Ness, Scotland. Grant dismounted and started to investigate, but the strange animal snorted and plunged into the water.

SCOTLAND is aroused over reports made by several reliable persons that they have seen a sea monster in the vicinity of Loch Ness.

Arthur Grant, veterinary student, was riding home early one morning on his motorcycle when he viewed the creature, which he described as being about 15 or 20 feet in length. He jumped from his motorcycle to look at the animal, but he said it snorted wildly and splashed into the loch.

Scientists, discrediting the prehistoric sea monster theory, are inclined to believe the frequently seen animal is either a deep-sea eel or stray shark.

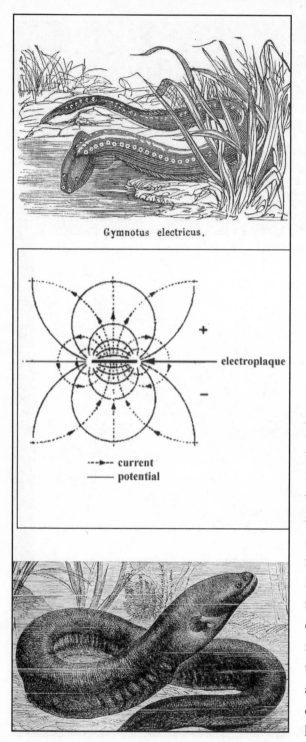

Gymnotus electricus.

electroplaque

--▶-- current
——— potential

ELECTRIC EEL
Nature's Most Shocking Fish

Despite its name, the electric eel is actually a fish, not an eel. It is related to the catfish. True eels belong to the order known as Anguilliformes, of which there are more than 800 species. The electric eel is the only member of its own genus called *Electrophorus*. It has a tubular and serpentinelike body, as thick as a weightlifter's forearm, growing to 6 feet long and weighing 45 pounds. It is found in South America, particularly the Amazon basin, preferring murky and muddy waters or the stagnant inlets of rivers and lakes. It has no scales; it is black, with a slash of red or yellow on its underside. It has a flat head wider than its body, with a blunt, square jaw. An electric eel has ribbonlike fins on its underbelly, from its tail to the base of its neck, which help it swim either forward or backward with equal ease. The eel also has lungs and needs to take a gulp of air every ten minutes. With bones that run along its entire length and are connected to its inner ear, the eel has an acute sense of hearing and

can detect the faintest sounds, even the lapping tongue of a mouse at the water's edge nearly 30 yards away. However, it is virtually blind and relies on electricity to "see."

How It Generates Electricity

The eel produces an uncommon form of bioelectricity in order to navigate, find prey, and then stun or kill it. It is able to emit both high and low-frequency charges. Nearly four-fifths of the eel's internal anatomy is dedicated to housing three distinct electricity-producing organs. On the molecular level, all living cells generate minute electrical signals. Atoms within molecules have varying numbers of electrons and protons, which in turn determine if a cell has a positive or negative charge. For the muscle in your arm to move, electrical signals are transmitted to release stored energy. Electric eels have specific electroplaque cells that are positively charged on one side and negatively on the other. These cells are stacked in a linear fashion like thousands of minibatteries packed into a flashlight. When sensing prey, the eel's brain signals for a rapid dissemination of sodium. This chemical reverses the negative parts of the electroplaque cells, turning them all positive to produce a burst of high-voltage electricity. The timing and release, and how it all comes together in an instant is complex but similar in concept to how batteries store energy and then discharge their power with the flick of a switch.

Can It Kill People?

Electric eels' synchronized flash of energy measures more than 600 volts. Sticking a fork into an electrical outlet will give you a shock of 120 volts. However, the eel's voltage is just powerful enough to stun a person and can kill you only if hit multiple times, or if you are attacked by a swarm of eels. Because the electic eel lives in water, the charge does not have a continuous current, as an electric outlet does, and dissipates rapidly, though it remains strong enough to shock prey without electrocuting the eel itself. People who have died from contact with electric eels did so from the shock of being stunned, suffering a heart attack, and then drowning.

The eel uses its biggest voltage to ward off predators. Electric eels do

not have teeth, so they primarily attack and subdue small frogs and fish they can swallow whole in one gulp.

Eel Mystery

Exactly how this primitive creature from the dark, muddy waters of the Amazon perfected its alternating frequency of electricity remains a puzzle to scientists. The energy-producing biobatteries of electric eels are so effective that doctors are attempting to use this natural mechanism to power artificial human organs and implanted medical devices. An experiment in a Japanese aquarium used the electric eels' power to light its Christmas tree. In the wild, these eels have few predators willing to take a jolt in exchange for a meal; they live for about fifteen years.

More than 500 creatures can produce some form of bioelectricity. The electric eel's closest relation, the thin-bodied knifefish, found in freshwater throughout Central America and South America, uses a similar method for producing electricity, though only for navigation. Like sci-fi aliens, knifefish encase themselves in a force field of electrical charges. A knifefish's low-frequency static bubble registers disturbances and fluctuations to its energy field, equipped as it is with an array of sensors located on its skin. It can "see" potential prey and avoid running into obstacles by using electricity.

skull bones

2 knife fish

ELEPHANT
Largest Land Animal

There are no land animals alive today bigger than an elephant. Of the two species of elephants, African and Asian, the African version is somewhat larger, with the adult male or bull growing 13 feet from toe to head and weighing 14,000 pounds. That is as much as the total combined tonnage of a pickup truck, an SUV, a van, and a compact car. While humans have a 3-pound brain, the elephant's weighs 12 pounds. This is proportionally smaller than ours when compared to body mass, and the elephant brain doesn't take up the capacity of its entire skull the way ours does. However, an elephant's brain, situated at the back of its head, away from its forehead (used for ramming and pushing), is highly developed.

Can They Ever Forget?

Elephants have demonstrated that they learn from experience and are affected by environment and emotion. They have poor eyesight, so they cannot rely on sight alone to gather information. They communicate through low-frequency sound signals and can detect the most subtle scents.

The saying "an elephant never forgets" is more or less true, since elephants do have significant long-term memories. An elephant's memories, for reasons unknown, are semiselective; however, an injury or hurt inflicted years earlier can remain as a grudge for the elephant's entire life.

An elephant can identify and remember more than one hundred individual members of the herd by their distinct infrasound voices or the ultra-low-frequency humminglike sounds an elephant makes, which are inaudible to humans.

Mother Knows Best

Elephants live in family units of a dozen to twenty with an elder female acting as leader of the herd. Elephant offspring stay with the mother and don't go out on their own until they are fourteen years old. During their adolescence, the young elephants follow the matriarch's direction, lining up behind her in single file to go to the feeding grounds.

Many males are literally shunned (unless a female is in heat) and lead solitary lives. An elephant gives birth to usually only one offspring every three or four years, since an elephant's pregnancy lasts a very long twenty-two months. A sow can have babies until she is fifty years old. When the ruling female dies, her oldest daughter takes over as matriarch.

Bull elephants roam in their own bands and are not welcomed to interfere with the daily decisions of the mother of the herd.

An Elephant's Toolbox

Elephants have the largest ears of all animals, which are needed to detect low-frequency signals but also serve as giant fans to help them stay cool. (Blood is cooled by the flapping ears, then circulated back through the body, lowering the animal's overall temperature.) The pads of their feet are also used for listening and can register the slightest ground movement. Nerves in their toenails tell the elephant the exact direction from where the noise is coming. The elephant's trunk—part of its upper lip—has more than 100,000 muscles and is its most versatile tool. It can be a trumpet, a sensitive scent detector, a shovel, and a siphon to suck in water, or it can be used to give itself showers, to dust itself, to knock down trees, to carry heavy items, and to scoop food to feed itself and to bring water to its mouth. The trunk weighs over 300 pounds and seems heavy even for elephants, since they often rest from its load by draping their noses over their tusks.

Long Live the Elephant

Lions or tigers can attack young elephants, but less so if they are not separated from the herd. As they grow into adults, the elephant has few natural enemies, except, of course, humans.

Top Ten Longest Pregnancy or Gestation Times

Manatee: 13 months; Camel: 14 months; Rhino: 15 months; Velvet worm: 15 months; Giraffe: 16 months; Walrus: 17 months; Dolphin: 19 months; Elephant: 22 months; Alpine salamander: 26 months; and certain sharks can be pregnant for 42 months.

An adult elephant eats almost 500 pounds of grasses and plants each day, though it deposits as waste more than 80 percent of what it consumes. These piles of manure help more plants to grow and serve as a wide-ranging seed disbursement program. The paths elephants clear by their heavy-footed migrations act as natural firebreaks and create water troughs for other animals.

Jumbo

The elephant embodies the word *jumbo*, which is synonymous with oversized. Actually, it was circus showman P. T. Barnum who gave his trained pachyderm the name. The African elephant Jumbo weighed 13,000 pounds and stood at 13 feet. Sadly, Jumbo died in 1885 when hit by a train. It was said that Jumbo raced onto the tracks trying to save his tiny friend, Tom Thumb, when the elephant was struck by the locomotive. Jumbo's bones are stored at New York City's American Museum of Natural History.

Woolly Mammoth

skull

Asian elephants are related genetically to the extinct woolly mammoth. However, mammoths were heavier and packed with blubber, which helped them keep warm during the Ice Age. The mammoth also had a long fur coat, smaller ears than modern elephants, and massive upwardly curved tusks that reached 12 feet in length. The long tusks were needed to clear snow from the frozen landscapes of Asia, Europe, and North America where it roamed from about 120,000 B.C. until only four thousand years ago, when the last of its kind faded away. It was not equipped to handle the climate change, dressed as it was for the icy world in which it once thrived. Featured prominently in cave paintings, the mammoth was a prize catch for early man, and mammoth populations were drastically dwindled by hunters. Since they lived and died where there is still ice, many frozen mammoths have been found. Experiments are under way to reverse extinction of this species by attempting to clone them back to life.

(It's estimated that poachers kill as many as thirty thousand elephants each year for their ivory tusks.) Elephants not only display emotion when seeing an old friend and have a sort of greeting ceremony, but they also express grief. When a newborn dies, a mother might try to revive her baby, and she appears very troubled, shoulders slumped and seemingly glassy eyed, staying near the site for days. In the wild, an elephant can live for more than seventy years. By that age, the old elephant's teeth are worn and ground away, so that it can no longer chew food, and it ultimately dies of starvation. If an elderly or sick elephant falls during a herd's migrations, herd members will come and try to lift it off the ground, knowing it must stay upright and standing in order to survive. Its family will come back to the place where it died, chasing away hyenas and scavengers from the bones, mourning their loss for a day or so before moving on.

ELEPHANT BIRD
Fattest Feathered Friend

Gone the way of the dodo, this giant, 9-foot-tall, 900-pound bird lived on Madagascar for a few million years. Its egg, having a 3-foot circumference, was a big as a pumpkin—or one hundred times the size of a chicken egg. The bird resembled an ostrich, with a long neck and a plump body perched on thick, scaly legs, and it was also flightless. It was a plant eater, but strong enough to roll over a fallen tree trunk if it wanted to get at tender fern buds below. Like the dodo, the elephant bird had few natural predators and did not know enough to fear human settlers when people first arrived. Although its meat was tough and not regularly prized by hunters, it was the rats that had traveled with humans who knocked the elephant bird into the extinct category. Rats feasted on the bird's eggs, which it laid in ground nests. The last of these giant feathered beasts was observed during the mid-1600s.

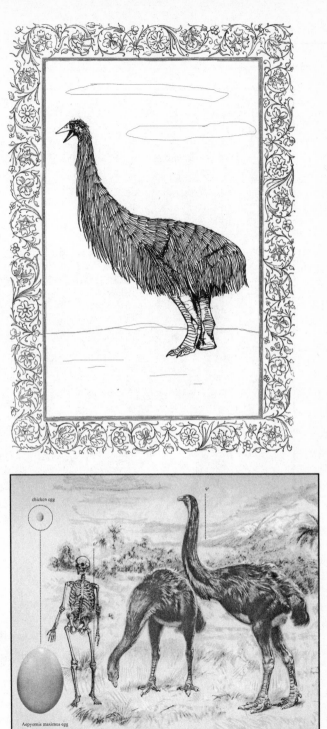

chicken egg

9'

6'

Aepyornis maximus egg

ENCANTADO
Legendary Amazonian Shape-Shifter

Found primarily in Brazil and the Amazon region, encantados are mythical creatures that camouflage themselves by assuming the forms of various other animals. In legend, the pink dolphins of the Amazon River were said to be encantados. Pink dolphins were blamed for creeping up on land at night and impregnating women. Various snakes were also described as encantados, especially ones that showed up at the most unlikely times, forgetting a snake's normally reclusive nature.

Where They Live
In the earliest stories about such creatures, these shape-shifting beasts came from a subterranean world, a realm compared to a hidden paradise. Despite dwelling in this perfect place where creatures were eternally happy, the encantados grew bored and wanted to experience human life, including suffering and death. They kidnapped people and then returned them unharmed. However, even if the missing person looked like the individual once kidnapped, they acted uncharacteristically and were eventually suspected of being only a human shell housing the encantado creature.

Oddly, encantados show up most frequently at exactly six o'clock at night and then vanish soon after, especially if they find no animal or human form to assume. According to Amazonian folktales, it is believed this small minute or two time slot is the only period in which they can transport back and forth from their underworld home. No one knows what an encantado looks like, since the few who have seen this beast as they actually appear are said to be rendered instantly insane. To this day, many rural inhabitants of the Amazon region will not venture out alone, or at all, during any evening near the six o'clock hour.

FAIRIES
Mischievous Mites

Stories about small flittering spiritlike creatures can be found in a variety of folklore tales spanning many cultures and historical periods. It is hard to imagine what a fairy exactly is, since no specimen has ever been captured. However, those who believe in fairies' existence classify them as mystical beings, perhaps even older than the sun. Fairies supposedly adapted to existing in physical reality, though they supersede the laws of physics. Nevertheless, most fairies are described as very small, the size of locusts, with thin waists or abdomens, featuring humanlike arms and legs, with either one or two pairs of transparent dragonflylike wings.

Most true fairies—also referred to as nymphs—seem to favor running water, such as fountains. They either stay concealed directly below the surface, at the edge of mist, or in the vapor cloud rising from the water source. However, fairies differ in physical forms and habits and correspond to the elemental, natural substance from which they derived, such as fire, earth, air, or water. An archaeological dig in the early 1900s reportedly found an ungrounded chamber in the Orkney Islands, in northern Scotland, in which miniature Stone Age weapons fashioned from flint were uncovered, leading many to speculate they belonged to fairies. Even so, fairies are mostly thought of as flying creatures.

In Irish folk legend, it was recommended to build houses that always had the front door and back door perfectly aligned so as not to disturb fairy flight patterns. That way, if a house unknowingly happened to be built in a fairy thoroughfare, the creatures could enter and exit without interference. Despite this consideration, fairies seem to have limited patience for the ways of mortals. In Germanic and Scandinavian folklore, these small creatures performed a far greater share of mischievous deeds than beneficial ones upon humankind and were often feared more than ghosts.

Fairies have green eyes and can bite, leaving a pain as hurtful as that of a bee sting. Those nipped by these creatures find two small teeth marks similar to a minisnakebite.

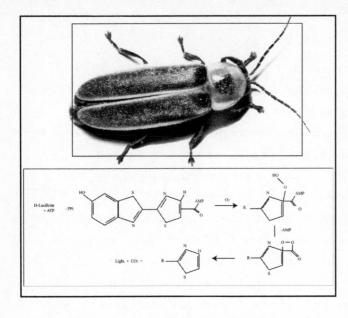

FIREFLIES
Lightning Bugs

Fireflies use their internally generated light to communicate, attract partners, warn predators, and mark territory. Seen at dawn and dusk during the summer in temperate and tropical climates all over the world, this popular insect is one of the most proficient at producing light; in its cylinder-shaped abdomen, chemicals and enzymes called "luciferin" and "luciferase" (named after Lucifer, the fallen angel) mix with magnesium ions that interact with oxygen. The glow is a nonradiant light, meaning it does not get hot the way a lightbulb does. Both male and female fireflies produce a yellow-greenish luminosity from birth and can control the internal on and off "switch" as they desire. Even when fireflies are larvae, this "lightning" or blinking occurs, which acts as a warning signal to tell predators, "Do not eat me, I am toxic."

How Many Times Does It Blink?

There are more than 2,000 species of fireflies, which are actually classified as beetles. An adult North American lightning bug has a life span of about two months. Its mission is to lay eggs into the crevice of tree bark or a likewise suitable and safe place before the first frost settles in. The larvae or offspring, which will never see their parents, will hibernate through the winter and emerge at spring. Adult lightning bugs can flick their lights up to forty times a minute or as few as once every five minutes.

Fireflies have been heralded in poetry and song for centuries.

In Japanese culture, fireflies were thought to be the spirits of ancestors. Europeans believed that if one flew in the window, it was bad luck and an omen of death.

Chinese folktales believed lightning bugs were created from the ashes of burning grass and that each insect was only given an unknown allotment of blinks before it glowed no more. In fact, a lightning bug's ability to illuminate does diminish as it grows older, though usually it is the brightest at the onset of summer.

One, Two, Three . . . Light!

Along the rivers that wind through jungle vegetation toward the Sea of China, tropical fireflies appear year-round. In Malaysia, a strange phenomenon occurs among South Asian glow beetles. At dusk, many begin a random flashing, as they do in most parts of the world, but on dark, moonless nights, a few fireflies perched on one tree suddenly begin to flash in unison. By midnight, all the fireflies in that tree, and the thousands more within sight, follow this spontaneous flash pattern and blink in breathtaking synchronicity. The fireflies' behavior is not fully understood by science, but local Malaysian legend explains that the fireflies are mimicking the twinkling of the stars.

FLAMINGO
Pink Plumed Bird

Six species of flamingos are found in Africa, Southern Europe, North America (Florida), the Caribbean, and in Central America and South America. Flamingos have long, spindly, sticklike legs, pudgy bodies, and instantly recognizable S-shaped necks. They have wide down-turned beaks, with brushstrokes of black on the ends that have a design ideal for scooping up and shoveling through mud and sand. They eat algae, insects, and small crustaceans, especially brine shrimp. Flamingos prefer to wade into the water cautiously on their long legs and then stop when

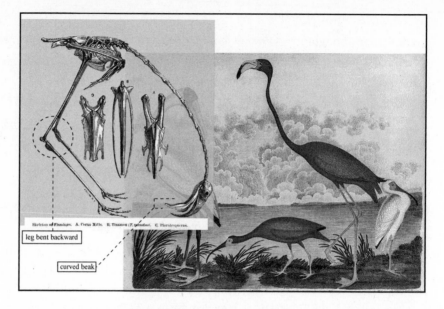

Skeleton of Flamingo. A. Coras Mills. B. Tinamou (T. robustus). C. Phoenicopterus.

leg bent backward

curved beak

a few inches deep. A flamingo observes the water around its legs to see if any tiny air bubbles are rising to the surface, indicating that its steps may have disturbed shrimp or small crabs. Then it uses its curvy neck to its advantage, thrusting it underwater until its head is submerged upside down. The flamingo always takes a deep breath, holds it, and closes its eyes while sucking up a beakful of sand. Each scoop of water, silt, and dirt is filtered out of the holes located at the back of its beak, sort of like how miners pan for gold. Tiny barbs on the roof of the flamingo's mouth hold on to shrimp, water bugs, or healthy pieces of algae. Its legs are bony and hard. If a bigger fish tries to bite a flamingo, or if the patch of sand it was mining seems scarce of tasty morsels, it takes a few more steps and flies to another spot.

How It's Built

The tallest flamingos grow to 4½ feet and weigh around 30 pounds. A flamingo prefers to wade in estuaries or at shorelines, feeding at low tide, and rests much of the remaining time on only one foot, while the other leg is tucked to its body. This way, since the flamingo's legs are so long and uninsulated, it can conserve heat in colder temperatures, and not become so hot in the sunnier parts of the day.

Most flamingos are pink, of course, but some can be a light red—though all are born either gray or white. The flamingo's diet of shrimp helps produce the pink-colored feathers. Naturalists can discern if food is plentiful based on the vibrancy of the flamingo's coloring. If a flamingo is eating only algae, it will usually wear a duller-colored coat.

The knee of a flamingo is more like an ankle that folds upward. It bends exactly opposite to how our knees work.

Pink Colonies

Flamingos are social birds and gather in vast mating colonies numbering in the thousands, transforming the landscape into a moving ribbon of feathered pink. Flamingos can fly as far as 30 miles to attend these reunions, but they are awkward gliders and must flap their wings continuously in order to stay airborne. They also need a running start of a few paces before taking to the air.

The flamingo has no real mechanism for defense, except for a thick, blunt beak; yet, perhaps due to its bright color, which nature often uses to signal toxicity, it has few natural predators. In the wild, flamingos live twenty-five to thirty years.

Flamingos are considered to be clean birds, since many are observed always preening themselves, as if always trying to look as pretty in pink as possible. What they are actually doing is spreading oil on their feathers, which is supplied from a gland near their tails. If they do not spend nearly three hours a day grooming, their feathers will become waterlogged and make it difficult to fly.

FLEA
Perfect Parasite

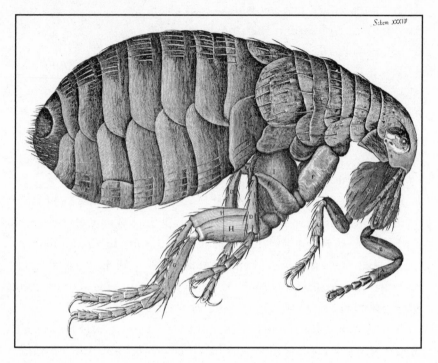

Throughout its one-hundred-million-year history, this minuscule insect, a parasite that sucks the blood of warm-blooded animals, has caused considerable grief to the animal kingdom—humans included. However, that is its nature: its purpose is to find a warm-blooded host from which it can obtain the nutrients it needs to survive.

The name *flea* derives from a Latin word meaning "dust," and the insect is seemingly as small as a speck of lint—usually only ⅛ inch in size. Ancient naturalists believed the flea to be some type of malicious dirt that somehow came alive. Although fleas go through metamorphism similar to a butterfly, their life transformation has never been romanticized, particularly since they need a meal of blood to lay eggs and start the cycle.

Because they feed from the bloodstream of multiple hosts, fleas are notorious disease transmitters. They spread tularemia, tapeworms, and numerous other pathogens. Fleas are especially noted as the infamous

carriers of the deadly bubonic plague, which killed one hundred million people worldwide during the Middle Ages.

Best in Show

Despite its, perhaps deserved, bad reputation, the flea is a remarkable creature in many ways. In fact, if there were award ceremonies among insects, the flea's unique skills would actually assure wins in many categories. For one, a flea can jump 7 inches into the air and broad jump across 13 inches, which would be equal to us leaping from the sidewalk to the top of twenty-five-story building and long jumping horizontally for a distance of 450 feet (greater than the length of one and a half football fields!). Not only that, it can repeat this leaping feat more than thirty thousand times in a row without needing a break, and do it by jumping left for one hop, and alternating to a right-sided hop for the next. It needs these skills, of course, to be able to hop onto passing animals to get its next meal. As for durability, a flea's hardened body allows it to survive being stepped on, put into scalding water, or practically frozen.

Fleas can go as long as one hundred days without eating or locating a suitable host, and a newly hatched flea can begin laying eggs within a month, producing more than two thousand of its kind in a lifetime.

A flea's body is comparatively as strong as tank armor, and a flea can only be physically killed by being smeared or getting pinched in half by human fingernails.

The Hopping Dracula

A flea's flat body is covered with tiny hairs, which serve as anchors and help it to cling better than Velcro when its host tries to scratch it off. The female flea is a thirsty creature, drinking about fourteen microliters of blood every day—more than fifteen times its body weight. If it were a human-sized vampire, it would need to drain the last drop of blood from 450 victims each month. The flea has eight different complex mouth

parts that all work in unison to bite and draw blood. It has two sawlike teeth that cut the skin and a needle part called a "labial palp" that is inserted into the opening like a syringe. It also has a sort of minipump in its stomach that draws in the blood of its host. In addition, the flea uses saliva as a lubricant before biting—this is the cause of itchy irritation, and how it spreads diseases. If a flea happens to find an ideal environment with high humidity and numerous hosts, it might live for a year and a half. On average, however, the flea's life span is about three or four months.

"Spontaneous Creation"

It once was commonly believed that many forms of life instantaneously emerged from inanimate matter. For more than two centuries, medieval scholars accepted the notion that fleas simply sprang into life from dirt, for instance, or that a rock could become a turtle. Bees and maggots were born from rotting meat, and an earthworm could change into an eel if it so desired. It wasn't until Italian naturalist Francesco Redi published *Experiments on the Generation of Insects* in 1668 that the idea of spontaneous creation came under question. Redi placed meat and dead fish in glass jars, some covered while others remained opened. The open jars produced maggots, and ultimately it was understood that larvae hatched from flies' eggs, instead of springing alive on their own. Redi went on to dispel many superstitions by using the scientific method. For instance, he proved that poisonous snakes did not get their venom from drinking wine. As Redi's health failed later in life, his friends were surprised that he was not afraid of dying. Redi said he had "never observed that death could be kept away through fear." He died in his sleep in 1697.

FLYING FISH
Aquatic Aviator

More than 60 species of marine fish have the ability to breach the water's surface and "fly"—even if they should actually be called "gliding" fish. Ancient naturalists once thought flying fish left the waves each night, finding the oceans too dangerous in the dark, and slept ashore. However, none can stay out of water for extended periods or, for that matter, perch on a branch as a bird might.

Flying fish have modified pectoral fins, which do resemble the shape of bird wings and span nearly as long as their 12- to 18-inch bodies. Flying fish are torpedo-shaped, with some having four pectoral fins used for "flight." These fins are retracted while swimming and held out perpendicularly while in the air.

The flying fish's wings seem to shimmer and beat, but since the membrane is so thin, it is the vibration of air passing over the wings that creates this illusion. A flying fish does not flap its fins, but it does flap its tail.

Aerodynamically designed similar to airplanes (which also do not have flappable wings), a flying fish propels itself by the motion of its tail and by using wind currents, adjusting direction and descent by shifting the angle of its wing-fins. In order to become airborne, the fish swims at speeds of nearly 40 miles per hour and then rockets out of the water. By using its momentum and its desperately wiggling tail—which beats seventy times per minute—the fish catches an updraft and flies. At this point, its tail becomes motionless, and its wings become like the fabric

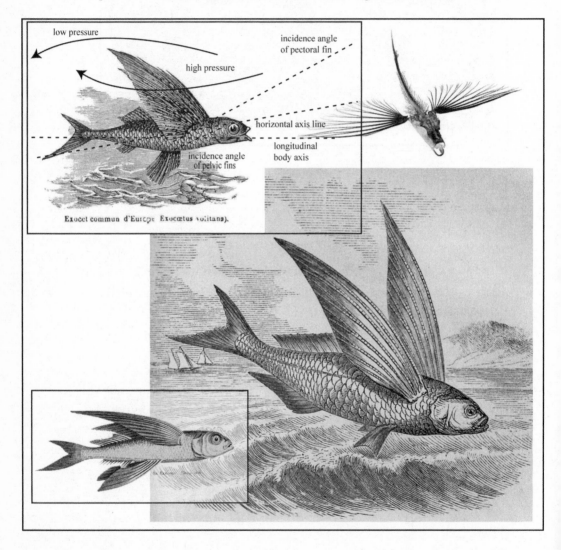

Exocet commun d'Europe Exocœtus volitans).

of a hang glider. When there is a literal "tail wind," flying fish can glide for more than 1,000 feet and reach altitudes of as high as 20 feet, though usually they only travel for 39 feet or so and stay about 1 yard above the water. Flying fish are found in all the world's oceans, though the majority prefer tropical and subtropical climates.

Why Fly?

Flying fish are tender and meaty animals that many large predatory fish and marine mammals, from bluefin tuna to dolphins, desire. These fish travel in schools, sometimes numbering in the hundreds or more, eating plankton and smaller fish. Swimming with others has its advantages, since the odds of being eaten on any given day are statistically diminished. However, when danger strikes, it is up to the individual fish to swim with all it has toward the surface. Once airborne it removes itself from the fray, betting that it will reeenter the water away from predators. The flights into the terrestrial realm last less than a minute, but the fish cannot breathe while in the air. Furthermore, there is the disadvantage and uncertainty of where it will land. Some flying fish end up on the deck of a boat or stranded ashore. In addition, while airborne there is the threat of birds waiting to snatch them from the sky.

In Caribbean folklore, many stories tell of how flying fish aspire to one day remain fully airborne. Others say they fly merely for a glimpse of the world that a fish never normally sees. If it makes it into adulthood, a flying fish lives for about five or six years.

Most flying fish leave the water when under attack, but they have also been known to take flight when there is no danger, seemingly just for the joy of it. They are attracted to light, particularly sunlight. However, they are also known to fly in the beam cast from boat lights.

FOX
Cunning Canine

There are twelve species of true foxes, all biologically related to wolves, coyotes, jackals, and dogs. The red fox, the most widespread today, originated in the southwestern part of North America about ten million ago. Today its north-south range extends from Central America up to the Arctic Circle, and it has spread east and west across the globe, as far as North Africa and Eurasia.

The fox predates the dog as the first canine that man had tried to domesticate. In fourteen-hundred-year-old graves unearthed in Jordan, archaeologists have found pet foxes buried alongside people. However, the dog eventually won out as

The prehistoric ancestors of dogs and cats, wolves and bobcats were primitive carnivorous creatures called "miacoids" that lived about fifty million years ago.

favored pet, presumably because the fox has a tendency to be skittish and displays a degree of aloofness similar to that of a cat. In addition, a fox passes a foul-smelling gas when excited. Although foxes are social animals, they do not have the pack mentality of wolves, instead preferring to gather in smaller family units. A "skulk" of foxes (as their packs are known) usually includes one male (a reynard) and one female (a vixen), which live in burrows along with their offspring, or kits (also called "pups" or "cubs"), of the last few breeding seasons. Young males are not driven off as is the case with many animals, but rather the "teenage" foxes can stay with the family, though they are expected to babysit and care for the newest litter of kits.

Pluralizing Animals

Groups of animals are oftentimes given colorfully descriptive names. The "skulk" of foxes derives from a verb meaning "to move stealthily." Here's a list of what some animal groups are called:

- A shrewdness of apes
- A cloud of bats
- A sloth of bears
- A wake of buzzards
- A bask of crocodiles
- A murder of crows
- A congregation of eagles

- A seething of eels
- A tower of giraffes
- A bloat of hippopotamuses
- A cackle of hyenas
- A mischief of mice
- A prickle of porcupines
- A rhumba of rattlesnakes

Size and Shape

Foxes are differentiated from canines by their narrow muzzles and flat heads that feature a distinct raised ridge above the eyebrows. Foxes have slighter builds as well, ranging in size from the desert fennec fox, which is 20 inches long, weighs 3 pounds, and is only 8 inches tall, to the red fox, which is 30 inches long, weighs 30 pounds, and stands at 20 inches in height. This does not include the fox's bushy tail, which is often longer than half its body. Like a cat, a fox uses its tail to aid in balance. It also serves as a fluffy blanket that it wraps around itself to keep it warm and comfy.

Clever as a Fox

The fox has made an age-old reputation for itself, appearing in folklore and myth as a creature with a sneaky and devious streak, and one that is wily, sly, and often hard to outwit. With its ability to adapt to various environments, the red fox has crossed paths with humanity throughout the ages. In Latin, foxes were called *vulpes,* a word for a weaver who whorls wool strands in a roundabout way so as not to allow the wool to become knotted. Foxes were said never to run in a straight line, but always made windy paths and took unexpected shortcuts. A fox's agility—it can leap a 6-foot-high fence or escape through any hole its head can squeeze into—has added to its wily reputation. In addition, a fox can hear sounds as inaudible as a squeak of a mouse from 300 feet, and its sense of smell is nearly as keen as a dog's. Foxes use scent to mark territory and communicate through growls, barks, and yelps.

CANIS (Vulpes) BENGALENSIS CANIS AUREUS. Sykes. BENGAL FOX.

Since they are not powerful predators or pack hunters, foxes usually feed on small rodents, reptiles, birds, fruit—and domesticated livestock, a practice that has earned foxes a bad name among farmers. Chicken coops must seem like fast-food restaurants to them. The fox's behavior has spawned more than a half-dozen idioms, such as "sly as a fox" or "clever as a fox." Foxes' persistence in raiding livestock, despite all sorts of means invented to catch them in the act, also makes "crazy like a fox" seem apropos. In English, the fox has even established itself as a verb, for "to fox" means to trick or deceive.

Life Cycle

Foxes can live for ten years in the wild, but most do not make it past two or three years. Although they can dig their own tunnels and live

Fox eyes work well in daylight, possessing binocular vision, but a fox also sees in darkness as well a person wearing night-vision goggles.

in burrows consisting of a few chambers, they prefer to take over burrows already made. They are not the best at housekeeping and do not keep their burrows clean, which is one factor that spreads numerous life-shortening illnesses among the species. In addition, foxes get tapeworms, roundworms, and mange, a disease caused by mites. Foxes rank third among smaller animals, after raccoons and skunks, for acquiring rabies. Since foxes are considered pests, they more frequently die from extermination by poison and traps. In addition, the fox has long been sought for its pelt, but has proved a difficult catch for even the most experienced trappers. Today, more than 20 million foxes are raised on farms to supply the demands of the fur trade. In the wild, however, as clever as they may be, foxes too often fall victim to speeding cars and become roadkill.

GIANT BARB
Gargantuan Goldfish

The goldfish in your aquarium and the 10-foot-long "giant barb" both belong to the same carp family, called Cyprinidae, which consists of an astonishing 14,000 species.

Giant barbs favor temperate climates and are found in North America, Africa, and Eurasia, though they are most numerous in Asia. The giant barb, also called the "Siamese giant carp," is the largest of its family and is among the biggest freshwater fish in the world. Barbs are native to rivers in China and Southeast Asia. Even though they are called giant "barbs," they have none; rather, the name comes from the little whiskers (actually called "barbells"), which grow from the chins or corners of the mouths on many carp and catfish. Siamese carp is an apt name since the fish usually live in pairs like the famous Siamese twins. However, these pairs of either brother or sister fish can grow to over 10 feet and weigh more than 600 pounds. They have large black-and-white scales and enormous heads with bulging eyes. They are most exclusively bottom feeders and migrate up and down the Mekong River system. Giant barbs lay eggs in clusters. The wisest barbs, who learn how not to be caught by fishermen, live for around forty years, though possibly longer. In one survey, tagged specimens released as yearlings were hooked twenty-five years later. Even with programs aimed at replenishing, there are not many of these giants left in the wild.

Hard to Floss

Goldfish and barbs are all gums and lips. They do not have teeth in their mouths. Barbs' grinding teeth are situated farther down the throat.

GIANT CLAM
Most Mammoth Mollusk

Most clams look like two oval shells connected by a hinge. Clams are called "bivalve mollusks" and are part of a huge group of invertebrates that account for more than 85,000 distinct species. Nearly 25 percent of all marine life is some type of *mollusca*. Clams come in all sizes, from the 2-inch littleneck clam to the so-called man-eating size. The "giant clam," as the largest species is called, grows to the size of a boulder, measuring 4 feet wide and weighing as much as 500 pounds.

How Clams Work

Clams have two identical shells made of hardened calcium joined by a ligament or hinge, which is operated by a pair of muscles that open and close both shells at will and by involuntary reflexes. All clams have no heads, eyes, or ears, but they do have hearts, mouths, stomachs, kidneys, reproductive organs, and anuses. The soft body and organs of the giant clam are supplied nutrients and oxygen by an open circulatory system, which consists of a free-flowing watery, yellowish blood. The clam opens its halves and takes a whopping gulp of seawater. The clam's gills function like those of a fish, seizing oxygen from water, but they also serve as its primary food collector. Tiny hair-thin feelers on its gills collect plankton and then sweep what's usable toward the clam's mouth.

Marine Farmers

The giant clam is found in the Indian Ocean and among the reefs of the South Pacific. This clam has

a wavy shell, forming five or six vertical folds on each half. However, instead of just siphoning water to bring the clam its nutrients, it figured out a way to grow its own algae farm inside its shells. After time, a perfect habitat is created for the exact algae it needs for nutrients, which are encouraged to grow along its upper folds and down the sides of its interior shells. It tends it own crop by opening its halves wide during daylight to allow the algae to photosynthesize in sunlight.

How Clams Meet

The only time the giant clam's shells' opening and closing schedules are modified is during mating. Since giant clams cannot move, they found a unique way to breed. Male and female clams are roused into action by a spawning chemical, which functions as a hormone. This special excretion is randomly discharged into the water by one clam, oftentimes correlated to the phases of the moon, and thus starts a chain reaction for other clams in the vicinity to do the same. Male clams then broadcast millions of sperm into the water while females release as many million eggs simultaneously. The clams attempt to catch this mixture and snap shut their shells, repeating this pattern at two-minute intervals for more than three hours.

Man-Eaters?

It was once believed these giant clams were like underwater Venus flytraps that snapped shut at a touch and sought to eat humans for lunch. Yet despite hundreds of years of rumors, there have been no verified deaths by the jaws of giant clams. They do react to stimuli and close if sensing a harmful invader, but most are too slow in closing their massive halves to catch a diver.

GIANT CLAMS TRAP SEA DIVERS IN GRIP OF SHELLS

Shells of huge clams found off the coast of Papua often weigh more than 400 pounds. Divers who accidentally step into

Copyright, Frank Hurley, through International
Giant Clam in Coral Reef Off New Guinea; Powerful Crushing Lips Partly Open

the open lips of the monsters are not infrequently held with such force that they cannot release themselves and are drowned. The shells close with such force that they serve as gigantic traps.

The U.S. Navy manual once contained a section about giant clams, advising that if trapped by one, a diver should search for the clam's hinge and cut oneself free by severing it. Giant clams are herbivores, but if an irritant does get into a clam, a hard casing is formed around it, which is how pearls are made by some species of clams. However, no human-sized pearls have ever been found inside giant clams.

Life Cycle
Once fully grown, giant clams have no predators. They can die from pollution or when bashed and uprooted during intense storms. However, clams are long-living creatures. A quahog clam found near the coast of Iceland was determined to be 405 years old—the oldest-known clam of record. Giant clams generally live for about 100 years.

GILA MONSTER
Lethal Lizard

Native to the southwestern United States and northern Mexico, the group name for the Gila monster is "lounge," and it is scientifically classified in the genus *Heloderma*. This lounge lizard—sort of like the human version that hangs out much too long in dark nightclubs—spends most of its time underground in shallow burrows or below shady rocks. A Gila monster's skin is like a tight, black-leather suit, colored with out-

The Gila belongs to a rare group of lizards that produce venom.

rageous designs of pink, yellow, and orange. It grows to about 20 inches and weighs 4 pounds. Gilas have stocky bodies and thick tails, which is where they store most of their needed fats (aka nutrient reserves) and moisture. A Gila only eats occasionally and can go a few months before needing to exert itself to find food. It favors making raids on other animals' nests to steal eggs. It will also go after small newborn mammals and birds or munch on dead animals.

Deadly Bite

Unlike snakes that strike and subdue with poisonous fangs and have venomous glands near their upper jaws, Gila monsters' venom is a modified saliva secreted from their lower jaws. It's powerful enough to kill smaller prey, but not often fatal to humans. The Gila grabs its prey with a steel-trap-like clamp of its teeth and then drools its paralyzing toxins into the wounds. If the small prey doesn't die right away, the Gila will let the animal go and trail it until it eventually succumbs. This adaptation makes sure the Gila exerts the least amount of energy, not wanting to chase and run unnecessarily in the hot climate where it lives.

Cure in Bad Breath

As recently as the late 1950s, biologists thought the Gila had no venom, but instead produced a poisonous gas with its breath. An article in *Scientific American* (1907) stated that the lizard got its poison by eating food that turned rotten in its stomach, because it had no apparent anus (in fact, it does have one). The authors surmised the lizard was dangerous to humans because its decayed teeth held particles of dead meat that turned putrid and rancid in the sun: "A bite has the same effect as the cut of a dissecting knife used on a cadaver, in other words, the inoculation of a deadly poison." The Native American Pima and Apache tribes believed the Gila held an evil spirit that was capable of causing death with a glance, while other tribes, such as the Yaquai, thought its hide had healing powers. Today, the ingredient in the Gila's ancient saliva has been found by modern science to treat a number of blood diseases, particularly diabetes.

Gila monsters are so named because they were first discovered near the Gila River in Arizona, and because they possess a certain monstrous appearance to go along with their deadly bite. In fact, the species dates back sixty-five million years, when there were numerous lizards that also had venomous saliva, and has remained nearly unchanged. Hundred-thousand-year-old fossils display Gila monsters that look exactly as they do today, proving the "lifestyle" the Gila developed was a winning one throughout all types of climatic changes. This "walking fossil" can live up to thirty years.

GORILLA
Premier Primate

Native to the tropical and subtropical regions of Africa, the adult male gorilla usually stands at about 5 feet 8 inches and weighs in at 400 pounds. The Eastern Lowland gorilla is the world's largest primate, capable of growing to nearly 600 pounds. Even though extremely obese humans can exceed 1,000 pounds, these cases are exceptions. The gorilla still owns the crown of "king of primates"—though its endangered-species status and humans' expanding waistlines put its title in jeopardy.

Gorillas have long been the subject of myth and legend. It was once thought that gorillas always gave birth to twins, for instance, and that

the mother ape loved one baby and despised the other. The favored one was carried and cradled in its mother's arms, while the shunned twin had to crawl up the mother's back and cling tight for survival. However, during dangerous situations when the mother needed to flee and reached for vines to escape, the baby she loved had to be let go and inevitably fell and died, while the shunned twin lived on. Many such folktales were told of the fabulous beasts that resemble humans, which we now know have nearly the same (approximately 96 percent) DNA as we do. In reality, single births are the norm among gorillas, and the baby stays with the mother for three or four years. She will not get pregnant again until the firstborn is ready to leave her care.

The Gorilla Diet

Gorillas primarily eat vegetables, fruits, fungus, and more than 200 different types of plants; however, they will munch on insects, including termites and ants, as a sort of dessert. An adult male will eat more than 50 pounds of food each day. Gorillas are nomadic and move daily to a new area to feed, never fully depleting a food source at one location. They wake at dawn and eat until 10 A.M., then nap while the children play. They start moving to a new place at noon, eating as they go, and then stop at 5 P.M. to eat again before preparing new bedding for the night.

Gorilla Society

Gorillas live in troops of between five and more than forty, and they have one male leader who settles arguments, guides the group to feeding sites, and appoints lookouts. A good leader is like a benevolent dictator and is usually the

most experienced and strongest. He uses his massive presence to protect his troop from predators and to frighten younger males looking to de-

throne him. A gorilla will rise on two legs, pounding its chest with clenched fists while roaring and baring sharp canine-looking teeth. He may charge or grab a branch and thrash it about in a display of fury. Although a gorilla usually prefers peace, when this type of intimidating diplomacy fails, his bite is more powerful than a lion's, and the leader will defend his troop-family with his life.

A mature male has forearms so strong he can rip a tree and its roots right out of the ground and snap a tiger's backbone over his knee.

Gorillas have no natural enemies in the wild, except humans. A typical ape troop consists of the dominant male, a few younger, nonthreatening males, and mostly females with their offspring. Among the females, the ones living in the group the longest mostly have say among other females, though occasionally a new bride the leader takes into the troop gets preferential treatment until she becomes pregnant and gives birth.

Naming of the Largest Primate

Around 500 B.C., an explorer named Hanno sailed from Spain leading a score of ships along the coast of Africa. He came upon what he thought were a hairy tribe of savage humans, which local interpreters called "gorillae." Hanno captured three female gorillas, but they were too ferocious for transport. The name *gorilla* derived from ancient Greek writings about this encounter and mistakenly meant "tribe of hairy women."

Life Cycle

Like us, gorillas have unique fingerprints, but they also have one-of-a-kind nose prints. There are about 35,000 still living in the wild and some 600 in zoos. Mountain gorillas living in higher altitudes are susceptible to pneumonia, and populations in the jungle forests get colds, sore throats, and respiratory illnesses during rainy seasons. Sometimes they get serious tooth decay and infections that are enough to kill them. In old age, gorillas often get arthritis and move slower, but the family compensates and helps them, rarely leaving them behind. They also get parasites, namely tapeworms, and other digestive tract infections.

Young males are in more danger than juvenile females, because when a new ruling male takes over a troop, he might decide to kill other males, seeing them as potential threats to his dominance. Females never kill their

If Not Us, What Animal Could Rule?

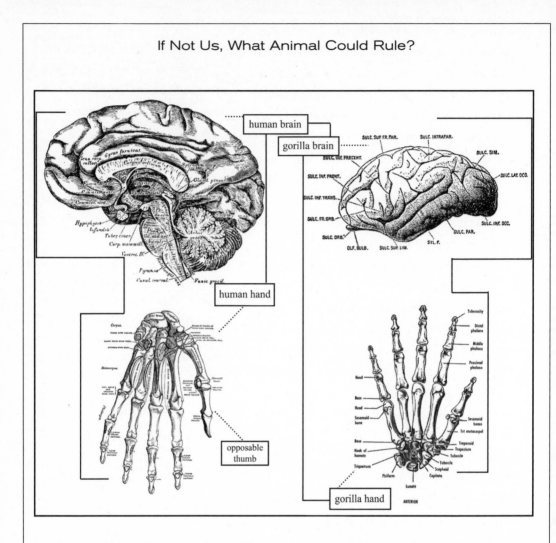

As one of our closest living animal relations, gorillas differ from us in two major anatomical ways and actually never had the chance to dominate the earth as we did. The thumbs of most primates cannot grip the way human hands can, and all primates lack verbal skills. Language is the thing that truly separates us. As physicist-philosopher Stephen Hawking noted: "For millions of years, mankind lived just like the animals. Then something happened which unleashed the power of our imagination. We learned to talk and we learned to listen. Speech has allowed the communication of ideas, enabling human beings to work together to build the impossible. Mankind's greatest achievements have come about by talking, and its greatest failures by not talking."

young, and a female displays deep emotion if her baby dies. Some might carry the lifeless infant for weeks, sometimes lifting its head or raising the lifeless baby's arms as if trying to bring it back to life. The average life span of a gorilla is between thirty and fifty years, though some wise old gorillas have lived to eighty.

More than 30 percent of all gorillas never live to five years old, primarily due to accidents.

GRIFFIN
Mythological Eagle-Lion Hybrid

According to legend, the griffin had a lion's body, with the head, wings, and sharp talons of an eagle. Though most closely associated with the myth and lore of ancient Greece, griffins were first depicted in Egypt in the third millennium B.C. Wherever they are spoken of, griffins had a ferocious reputation. They were said to prey on horses and tear humans to shreds whenever encountered. However, somehow griffins were also trained to guard royal treasures and tombs. Thought to be from a divine beast, a single griffin feather could make the blind see. Kings supposedly sought its large ostrich-sized eggs as a rare delicacy that were used, by some accounts, to make special medicinal and healing omelets. Griffins were relatively small—6 feet long and 2 feet high at the shoulders— though they moved as fast as lightning. The creature chose one mate for life, and if either partner died, the other would remain single until death.

Stanford University folklorist Adrienne Mayor recently has suggested

that the griffin myth was inspired by the ancient discovery of well-preserved fossils of the dinosaur *Protoceratops,* a hornless relative of the *Triceratops* that featured a sharp beak and large claws. Today, the griffin remains alive as one of the most frequently used symbols in crests and on coats of arms, owing to the creature's popularity during the Middle Ages.

GROUNDHOG
Nature's Weather Prophet

Many animals have the intuition and ability to anticipate impending changes in the environment. Their internal chemistry can detect the change of light, or the shortening of days, triggering hibernation, for example. Many tropical birds can perceive fluctuations in barometric pressure and sense when a hurricane is coming. Some snakes are even capable of predicting ground tremors before they happen and reportedly emerge from hibernation to die freezing on the ground rather than be crushed in an earthquake.

In Canada and the United States, the groundhog—also known as a woodchuck or "whistle pig"—has been regarded as a weather forecaster for more than three hundred years. On February 2 (considered the middle of winter by the old Julian calendar), the groundhog is said to emerge from its burrow to predict the amount of time left until spring. If it sees its shadow, there will be six more weeks of winter, while if no shadow is cast, it is an omen that milder weather will approach sooner. Originally

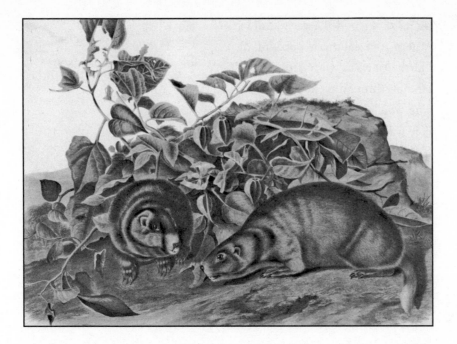

thought most reliable if measured at the noon hour, the groundhog's predictions, however, as monitored in thirteen different Canadian cities and recorded since 1934, show that the animal weatherman is correct less than 35 percent of the time.

But It Must Chuck Wood

"How much wood would a woodchuck chuck, if a woodchuck could chuck wood?" is an English-language tongue twister, first noted in a 1689 book of lexicons. *Chuck* now means "to throw," but when it implied chewing, the answer to the tongue twister would be "a lot," since a woodchuck will actually eat tree bark, even if it prefers softer leaves, roots, fruits, and many types of vegetation. The woodchuck is a rodent and part of the ground squirrel family. It grows to less than 2 feet long and weighs approximately 20 pounds. Woodchucks live in burrows, usually at

In ancient Rome, the bear, badger, and hedgehog were all hailed as forecasters of weather whose habits were taken seriously by generals in planning strategies for battle.

the edge of wooded areas found in eastern and southern portions of North America, with a range extending through western Canada. The woodchuck can climb a tree if it wants and swims quite well. It lives an average of six to eight years, neither throwing nor chopping wood as a beaver might, or knowing, apparently, that it is the celebrant of Groundhog Day.

The most famous groundhog, Pennsylvanian Punxsutawney Phil, was brought to Washington, D.C., in 1986 to meet President Ronald Reagan, and after starring in a movie, Groundhog Day *with actor Bill Murray, Phil made a guest appearance on* The Oprah Winfrey Show *in 1995.*

Suspended Animation

The groundhog will enter its burrow at the first signs of frost after foraging and storing considerable fat during spring and summer. It tunnels deeply, to where temperatures never get below freezing. Woodchucks have the ability to shut down their metabolisms to a mere whisker above death and enter a true hibernation, much more so than bears or other mammals. They will usually awaken involuntarily through the hibernation period, not to check the weather, but to make sure their burrows remain secure, and they can immediately return to the hibernation state. They usually end their winter rest at around the beginning of March, unless it is unseasonably cold.

Revenge of the Woodchuck

On August 20, 1911, a Pennsylvania man named J. J. Stomer was hunting woodchucks. He had bagged six then took a rest to read the newspaper, laying his rifle next to a bush. When he heard rustling in the undergrowth, he saw a woodchuck emerge. As he tried to reach for the weapon, the woodchuck scampered across the trigger and discharged it, killing the hunter.

Era	Period	Group	Formation	Symbol	Description
Mesozoic	Cretaceous		Kootenai Formation	Kk	Kootenai widespread basal conglomerate overlain by interbedded mudstones, sandstones and lacustrine limestones
	Jurassic		Morrison Formation		Morrison lenticular discontinuous sandstones, variegated shale and siltstone thin lacustrine limestones and irregular coal shales.
	Triassic		Dinwoody Formation	Trd	...ands combination of shaley reous mudstones and silt... limestones the colors is distinctive ...brown col...
Paleozoic	Permian		Shedhorn Sandstone	IPs	...fine grained sandstone with ...chert that is variably cemented by ...carbonate
			Phosphoria Formation	IPp	...atic to carbonaceous shale and ...shale with beds of chalcedony, silt c...
			Park City Formation	IPpc	...ands and carbonates ...bedded light colored ...interbeds of limestone
	Pennsylvanian		Quadrant Formation	IPQ	...r and planar cross ...ones with some ...laminated sandstone
	Mississippian	Snowcrest Range Group	Conover Ranch Fm	Msc	...dolomite and interbedded ...carbonate ...siltstone and quartz...
			Lombard Limestone	Msl	...bonate mudstone and packstone
			Kibbey Sandstone	Msk	...interbedded siltstone and sandston...
		Madison Group	Mission Canyon Fm	Mmc	...n Massive velloey to gray ...tone grainstone & wackestone ...as thin bedded carbonate
			Lodgepole Fm	Mml	...w wackestone and calcareous siltstone
	Devonian		Jefferson Formation	Dj	...son Upper dolomite member is a dark ...own to black dolostone ...wer limestone member displays irregular & ...ted distribution consists of a dense ...brown dolomitic limestone
	Silurian				
	Ordovician		Bighorn Dolomite	Ob	Bighorn light gray to yellow massive dolostone that only occurs in the southern end of the Snowcrest Range near Dillon
	Cambrian		Pilgrim Limestone	Cpi	Pilgrim Siltstone grainstone boundstone sandstone conglomerate & dolomite
			Wolsey Shale	Cw	Wolsey Shale fissile shale siltstone & minor interbedded limestone
			Flathead Sandstone	Cf	Flathead Crossbedded silica cemented quartzose sandstone deposited as nearshore sands
Precambrian	Proterozoic		Belt Supergroup (Missoula Group)	PCb	Rocks of the Missoula Group are comprised of generally undifferentiated sandstones and mudstones sedimentary structures are indicative of deposition in large scale fluvial systems
	Archean		Undifferentiated Metamorphic Basement Rocks	PCm	Archean and Paleoproterozoic metaplutonic and metasedimentary basement rocks that underlie the Mesoproterozoic rocks of the Belt Supergroup west of the McCartney Mountain

legs

tentacles

1"

1"

HALLUCIGENIA
Evolution on Acid

From what strange dreams of nature were the first creatures formed to produce a wormlike animal with seven pairs of pincer legs, six sets of tentacles across its back, and a blob of a head without eyes, ears, or mouth? Meet the hallucigenia. This tiny inch-long animal had a psychedelically purple and Day-Glo yellow-orange tubular body, as well as multicolored legs and tentacles. Its shape seemed improbable for locomotion, lopsided as it was, with stick legs that were actually curved spines, designed to making walking a clumsy endeavor.

It is not known if the creature had small, chewing mouths at the end of each leg, or if the food it captured was handed off from one pincer to the next like a baton in a relay race and then inserted into an eating hole somewhere near its blobish head.

Hallucigenia, so named for its bizarre and dream-like quality, emerged during what paleontologists called the "Cambrian explosion," five hundred million years ago, when new creatures were appearing in staggering numbers. This prehistoric period seemed guided by an experimental artist scribbling out sketches and weird animal designs at a furious pace, tossing page after page of biological blueprints into the wind, sea, or land and waiting to find out what anatomical feature worked best. Hallucigenia might have developed or converged into arthropods and spiderlike animals, though no creatures that remotely resemble it exist today. However, today cutting-edge robotic engineers are using the multilegged hallucigenia as a model for mechanical devices able to crawl over all surfaces without toppling.

Evolutionary Convergence

Certain animals that have no genetic connection independently develop similar characteristics, such as the wings of birds and bats. Scientist Simon Conway Morris, who named the hallucigenia, said, "all organisms are under constant scrutiny of natural selection [and] the organic substrate we call life [is] really a search engine to discover particular solutions."

HALCYON
Bird of Spring Break

Waves cease for 7 day nesting period, followed by 7 days of flying lessons for chicks.

ANCIENT GREECE
NORTHERN PART.

Even the ancients appreciated a spring break. The Greeks viewed any unexpected week or two's reprieve from winter to be miraculous and attributed the nice weather to a bird called the "halcyon" that laid its eggs on the shore. They thought this unusual bird rarely came ashore and normally lived far out at sea. However, it always chose a week in midwinter for hatching its offspring. It took seven days for the mother halcyon to sit on her eggs, at which time, winter's crashing waves abruptly ceased.

When an unseasonably warm spell occurred, sailors and all the ancient populations shook their heads knowingly, and referred to them as the "Halcyon days," and were sure winter's rage would not return until the halcyon chicks, nesting on some secret coastline, were old enough to fly. "Halcyon days" is a phrase that is still used to describe any unexpected pardon from the daily grind—or a nostalgic longing for the easy, carefree days gone by.

Was It Real?

Descriptions of this mythical bird seem to fit a real bird called the kingfisher, which has the genus name *Halcyon*. Kingfishers are generally medium-sized, colorful birds with long, thick bills. Certain species of kingfisher inhabit coastal regions and use their pointed bills to spear fish. They also dig out burrows near the waterline

to lay eggs. The brief hatching period attributed to the ancient halcyon does have some basis in the habits of many shorebirds, which tend to have shorter incubation periods than those of many terrestrial bird species. The ancient halcyons were immortal, but the kingfisher usually lives for about seven years.

Lovebirds

The legend of the halcyon grew from tales in Greek mythology about two lovers, Alcyone and Ceyx, who adored each other more than Zeus, thus angering the chief god. Accordingly, Zeus killed Ceyx by sinking his ship with a lightning bolt. When Alcyone heard of her lover's fate, she tossed herself into the sea. But their deaths were pitied by the other gods, who decided to transform the lovers into birds—the halcyons. Since Alcyone's father was the god of the winds, he honored his daughter each year by commanding the winter winds to cease and the waves to calm as the halcyons' eggs hatched.

CEYX and ALCYONE.

HARPY
Hazardous Hovering Hag

According to Greek myth, harpies were unpleasant creatures with bloated eagle bodies with broad wings and sharp, fingerlike talons. A harpy's features were entirely birdlike, except for a human, female face. Harpies were fast fliers and appeared from nowhere to wreak havoc. In rare accounts, a harpy was attractive, though it was usually described in most legends as being extremely ugly.

Whenever harpies are mentioned in literature or mythology, they are always cruel and violent. Phinas, a king who revealed too much information about godly secrets, was sentenced to attend a lavish all-you-can-eat buffet. However, the moment he tried to take a bite, harpies stood guard and snatched the food from his hands. The poet Dante had harpies tormenting persons who had taken their own lives in the fourth circle of hell. The victims were encased in an oak tree, but just as the leaves bloomed, hovering harpies swooped in and ate the buds, so that the entrapped souls remained hungry forever. After Shakespeare used harpies to describe women who were nasty and malicious by nature, the phrase "to harp on" came to mean to dwell incessantly on the same thing.

Fig. 18.

Fig. 18 —. Harpy Skeleton

HELICOPRION
Buzz-Saw Shark

This prehistoric sharklike fish stands out in the catalog of strange creatures for having a disk-shaped lower jaw with teeth arranged in a spiral pattern, looking nearly identical to the blade of a circular saw. At 15 feet long, the helicoprion prowled the world's oceans 225 million years ago. It had a pointed snout like a shark, but its bottom jaw featured a coil of vertically aligned teeth. As new teeth grew, older ones didn't fall out but were pushed back like the steps of a circular staircase, until some of the fish had a lower jaw as wide as a 3-foot saw blade. It seemed to use its peculiar jaw structure as an effective killing technique—sort of like a chainsaw massacre of the ancient oceans, plowing through schools of fish, dicing and slicing as many as it could strike and then circling back to gobble up its wounded prey.

HELICOPRION

EDESTUS

Scissor-Mouth Shark

Another prehistoric shark, called the "edestus," also held on to its teeth, as opposed to shedding them and growing new ones as do modern sharks. This beast was equally as ferocious as the helicoprion, though it grew a longer and longer jaw and snout to accommodate each new season's crop of razor-sharp incisors. Its deadly mouth eventually looked like a pair of giant serrated scissors, similar to the type used to cut fabrics, but it was powerful enough to fashion its prey into bloody tidbits.

HAMSTER
Domesticated Rodent

Saved from near extinction by its cuteness, the golden hamster now is among the top five favorite pets in the United States. This is quite an accomplishment for a short-tailed rodent weighing approximately 8 ounces and standing less than 6 inches tall on its hind legs—especially considering it was first domesticated only in the 1930s and introduced in the United States in 1938. Hamsters were rarely observed in the wild, naturally living in remote, semi-desert regions of Asia, Africa, and Central Europe. Many thought the animal a tailless mouse, although it was eventually identified as a unique species in 1839. Little was heard of the hamster until nearly one hundred years later, in 1931, when a zoologist wanted to know if this species

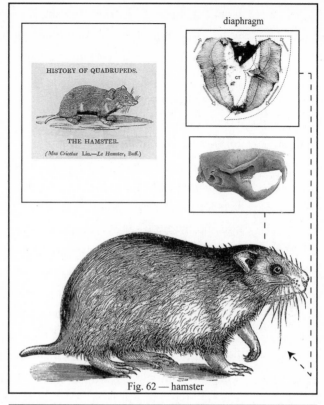

Fig. 62 — hamster

Hamster Ban

In 2008, during the Zodiac Year of the Rat, owning pet hamsters became a hugely popular fad with Vietnamese youth. Fearing an explosion of runaway hamsters wreaking havoc on crops and acting in precaution against the spread of diseases, government officials banned owning hamsters. Many boys and girls kept their pets in secrecy, and an underground hamster culture grew.

still existed and went into the Syrian Desert in search of the tiny beast. He captured a litter, but only a brother and sister survived. This single pair, however, came to provide the ancestral breeding stock for generations of pet hamsters to come. Nearly all hamsters sold as pets are de-

scendants from the first brother and sister pair captured more than eighty years ago. More than 1,000,000 golden hamsters are sold annually, but only 10,000 hamsters (excluding escaped pets) are left living in the wild.

The Wild Hamster

Fossils indicate hamsters first appeared in the Middle Miocene epoch (16 million to 11.6 million years ago) and developed unique survival skills. Hamsters are burrowing animals and can make elaborate underground sanctuaries more than 30 feet in length, with rooms for sleeping, chambers for socializing, and other compartments for food storage. A hamster adds numerous escape routes and can squeeze into any cracks as long as its head fits. The rodent often nudges a rock over the exits to dissuade unwanted visitors, but also uses the entry stone to collect morning dew, lapping the few droplets of water it needs to make it through the day.

Hamsters are fussy about keeping their fur clean and groom themselves regularly. In the wild, hamsters spend infrequent time aboveground, emerging at sunset and dusk, though sometimes they gather food during the day. They have entirely black bulging eyes, which makes them farsighted and virtually blind in full light. A hamster cannot see objects up close, like a hand thrust in its face, and it will bite at such objects as a reflex. Hamsters do not hibernate, but when subjected to extreme heat or cold, they lower their heartbeats and metabolisms so as not to need food or water for a few days, hopefully until the severe weather passes.

Life Cycle

Owls, foxes, and snakes are hamsters' natural enemies in the wild. Pet hamsters are susceptible to a number of diseases, including stones in the bladder and numerous kinds of cancer, which especially afflict the females of the

Saddlebag Cheeks

Hamsters are diligent hoarders, and some wild hamster burrows were found to have more than 50 pounds of stored edibles. Hamsters have elastic-like cheeks that are used to carry foods while foraging. A hamster's cheeks can expand to such an absurd size that it would be equivalent to a person stuffing two soccer balls in his or her mouth. In Arabic, the Syrian or golden hamster was called "saddlebags" for its ability to pack its mouth pouches so well.

species. Starvation from neglect is an all-too-common demise among caged pet hamsters. Hamsters also get an intestinal disease called "wet tail." In addition, they may die of salmonellosis acquired after consuming tainted packaged seed mixtures, and they can transmit the bacterium to humans who don't wash hands after handling their hamsters. A sick hamster will let its fur go unkempt, and its bright eyes will become dull.

No permits are required to bury a deceased pet hamster in your backyard. Band-Aid tins and Ovaltine jars often served as coffins for children's deceased pet hamsters during the 1960s and 1970s, but now there are pet cemeteries and crematoriums available to give hamsters full rites, including headstones or urns. Hamsters usually live no more than two to three years, though some have reportedly lived up to five or six years.

Alternative Power

With a million hamster wheels spinning on any given night, it's been speculated that the collective energy of hamsters could light a small city, if all were hooked to the power grid.

Double Dipping

Hamsters, like rabbits, have stomachs that are not quite cable of digesting certain grasses and grains on the first eating. As a matter of course, they practice "coprophagia," a term meaning they eat their own feces or droppings. They do this to get the nutrients that were missed on the first go-through. Hamsters seem to feel no embarrassment when chewing on their own pellets.

autohemorrhaging sinuses in the eye sockets

spikes/horns running along the spine and edges of its sides for defense

can inflate and appear doubled in size

HORNED LIZARD
Minister of Defense

Mistakenly called a "horny toad," this curious-looking creature is, in fact, a lizard and not a toad. The horned lizard does have the brownish coloring of a toad and squats close to the ground, but it has four similar-sized, scale-covered legs and a thinly tapered tail—and it does not hop. It also has distinctive spiky thorns that run along its spine and at the edges of its sides, with three or four larger horns crowning its head, giving it a gladiatorial appearance.

There are 14 species of horned lizards in total, with most types found in North America, predominately in desert or semi-arid climates. They grow 4 to 8 inches long. When threatened, the most unusual of the species can instantaneously inflate itself, puffing up into a spiked ball that is twice its normal size. When that fails, it can squirt blood from the cor-

ner of its eyes, thoroughly freaking out the most persistent coyotes or wolves. The horned lizard can spray streams of red blood (which is foul smelling to boot) up to 4 feet.

Life Cycle

A horned lizard primarily eats ants and makes a zigzag line from mound to mound. This food choice leaves the reptile wide open to many attackers, including snakes, roadrunners, hawks, and carnivorous mammals.

Even with all their defenses, food is scarce in the desert, and horned lizards are easy marks at birth and remain vulnerable to predators until they grow and develop their unique military protections. Some species of horned lizards lay more than forty eggs at a time to enhance their species' survival rate. The new hatchlings immediately bury themselves under sand and receive no guidance from their parents. Horned lizards can live in the wild from five to eight years.

Strong Medicine

The great cataloger of Mexico's animals and plants, Spaniard Dr. Francisco Hernandez, was amazed when he observed the horned lizard, and he shocked European audiences when his writings about the creature were published in the mid-1600s. Native people of the North American Southwest and Mexico had long held the horned lizard in high esteem. Shamans and medicine men chanted about the character of the lizard to an ill person and sometimes placed one of the scaly specimens alongside the sick. It was thought that the tough and resilient spirit of the horned lizard would cure the infirm. When missionaries arrived in Mexico, they also liked the horned lizard and thought it was a holy beast that wept sacred tears of blood.

HORSE
Civilizing Steed

There are 75 million horses in the world, grouped into more than 400 different breeds. Horses were first domesticated about four thousand years ago by nomads of the Asian steppes. The earliest horse ancestor was a fox-sized animal that appeared fifty million years ago. Many evolutionary breaks and branches occurred until the long-legged genus *Equus*—which today consists of horses, asses, and zebras—appeared a

mere five million years ago. Horse history and its evolution are the most documented of animals, since, before the invention of the engine, the horse was entwined with civilizations' rise and fall. Those who had horses ruled, and it was a well-known proverb that you could judge a man by looking at his horse.

HEAVY ENGLISH DRAUGHT HORSE

A Horse Is a Horse

Horses come in all sizes and are specialized at various skills. One of smallest horse breeds, the Falabella, measures around seven hands or about 30 inches from it hoof to its shoulder (called its "withers"). The largest, the Belgian Brabant, stands at seventeen hands and weighs more than 2,000 pounds. The towering Brabant, incidentally, eats 60 pounds of hay each day and drinks 20 gallons of water, and it is strong enough to pull a load four times its weight, or as much as a school bus filled with kids.

One horse breed, called Przewalski's, is thought to be a remnant of the true wild horses that once roamed the Mongolian—a kind that were never domesticated. The last wild ones were seen in the late 1960s, though at-

Horse "Hands"

Horses are still measured in "hands," equivalent to about 4 inches, or the distance from the tip of the outstretched thumb to the top of the pinky finger. This is an ancient measurement system, probably established by Egyptians making pyramid calculations and eventually applied to the commerce of horse trading.

tempts to reestablish a free-range population are under way. In the wild, horses roamed in herds of about twenty, led by a dominant male or "stallion." A female horse is called a "filly" or "mare" and the young are called "foals." Horses' baby or "milk" teeth fall out between the ages of three to five years, and they keep their mature teeth for the remainder of their life. Before record keeping, the age of a horse was gauged by examining its teeth. Horses are naturally herd animals and prefer to be around members of their own kind. Horses usually get along with other livestock, but many are known to dislike the smell of pigs.

Gift Horse

"Don't look a gift horse in the mouth" is an idiom from the days of horse trading, when the wear and tear of a horse's teeth indicated its age and how useful it would be for working the field. If someone gave you an old horse for free, it was impolite to look at the teeth of the gift horse before accepting it. Doing so would be similar to checking out the price tag of a birthday present before accepting it.

Horse Sense

Since horses have been a part of our culture for so long, many phrases have been inspired by our dealings with them. The term "horse sense"

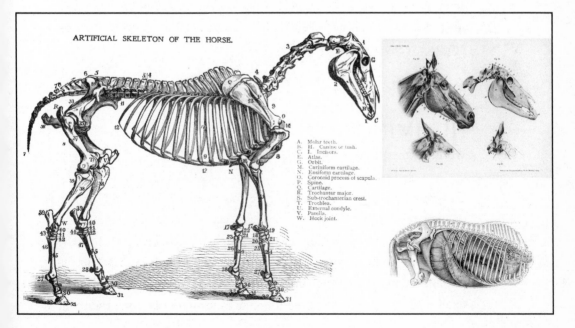

ARTIFICIAL SKELETON OF THE HORSE.

A. Molar teeth.
B. H. Canine or tush.
C. I. Incisors.
E. Atlas.
G. Orbit.
M. Cariniform cartilage.
N. Ensiform cartilage.
O. Coracoid process of scapula.
P. Spine.
Q. Cartilage.
R. Trochanter major.
S. Sub-trochanterian crest.
T. Trochlea.
U. External condyle.
V. Patella.
W. Hock joint.

refs to one who has a common-sensical knowledge and originally referred to a person adept at looking at a horse and discerning its qualities and flaws. The Greek writer Xenophon published a treatise in the fourth century B.C., "The Art of Horsemanship," which taught "horse sense" and included practical techniques to avoid buying a bad horse. Like many animals, there are no two horses that are the same, as each individual displays various preferences and personality quirks. Horses have a unique intelligence and possess exceptional long-term memories. Yet they can also be spooked by nearly anything, often by the sight of such ordinary objects like a plastic bag tumbling in the wind. They then run recklessly to avoid whatever they think of as dangerous, since fleeing has always been their primary defense to avoid mishap. Horses live, on average, for thirty years.

The famous TV "talking horse," Mister Ed, starred in a sitcom during the 1960s. The blond palomino, a gelding by the real name of Bamboo Harvester, displayed an uncanny ability to act, completing such tasks as turning on a light switch, unplugging wires, and stomping its feet on command. But like many actors, he was also temperamental and refused to work when he didn't feel up to it. To get Mister Ed to appear to talk, a grainy treat with the texture of peanut butter was spread on the horse's gums.

HUMMINGBIRD
World's Tiniest Bird

The immortal gods drank nectar. So too does the hummingbird, the smallest species of bird in the world, specialize in drinking the sweet, syrupy resin secreted by flowers as its primary food. The gods had the drink delivered by doves as they lounged on their cloudy cushions in the sky, but the hummingbird works incredibly hard to get its daily fill. The small bird must sip a dew-drop amount from more than one thousand

2 inches

Bee hummingbird

flowers in a four-hour period just to sustain its supercharged metabolism, needing to consume half its body weight by this labor-intensive method every day. There are more than 340 different types of hummingbirds found throughout North America and South America, and all are usually as colorful and iridescent as the shades of flowers from which they feed. The smallest, the bee hummingbird, is the size and weight of a walnut, or about 2 inches long, while the largest, the giant hummingbird, measures about 8 inches, though this bird is also extremely thin boned and bodied, weighing only ⅔ of an ounce.

A hummingbird can fly up, down, and backward as well as hover by doing a figure-eight motion with its wings. It can migrate for distances of thousands of miles, reaching cruising speeds of 30 miles per hour and can also achieve short sprinting flights of nearly double that rate. The humming-

The hummingbird is named from the sound its wings make, flapping at an eye-blurring speed of more than fifty times per second.

bird's tiny heart beats more than one thousand times per minute. In addition, it takes a hyperventilating rate of breaths needed to maintain this effort, inhaling and exhaling more than 250 times every sixty seconds.

Flower Dance

Orioles, finches, and even woodpeckers might take a dip of flowery nectar, just as hummingbirds, likewise, might alter their diets by eating bugs while hovering at an open petal.

The flowers hummingbirds feed on have indeed adapted to this prolific pollinator, with some plants evolving new petal shapes and different carpels (the part that holds the nectar at the base of the petals) to accommodate hummingbirds. Similarly, hummingbird bills have modified to various lengths and curves so the birds can get nectar from their favorite flowers more easily. The flower and the hummingbird have been in an evolutionary dance, both altering as the climatic music changed with each environmental shift. The hummingbird, as tiny as it is, however, is a feisty bird that earnestly protects its flower patch against all kinds of other birds, rival hummingbirds included. This little bird has no problem going face-to-face with a mighty hawk, if necessary, nearly always outmaneuvering it with its hovering, aerial skills, and dronelike speed. Sometimes a group—called a "charm"—of hummingbirds, are seen taking a momentary break in bushes near flower fields, but the bird is never observed on the ground; the feet of a hummingbird are good only for perching and of no use for walking.

Recent finds in Germany revealed a thirty-million-year-old hummingbird fossil. The question of why none remain in Europe or Asia is unanswered.

—

Ecuador is the hummingbird capital of the world, with more than 160 different species found in that country alone. The rufous hummingbird migrates the farthest, traveling 3,000 miles from Alaska to Mexico each year.

Life Cycle

The task of nectar hunting does not afford the hummingbird immortality, as it did the mythical gods. At the end of each day, its frantic working life sends the bird into a sort

of hibernation, much more profound than sleep, called "noctivation." Each night it touches the borderline of death, when its metabolic rate is slowed by as much as 95 percent.

In this state, the hummingbird's lungs move almost undetectably and the bird can be touched and picked up, seeming lifeless. In the morning, its arousal back to life takes nearly twenty minutes before it returns to normal and begins its day of searching for nectar. Hummingbirds live on average from three to five years. One hummingbird will flap its wings approximately 210,240,000 times during its lifetime.

HYDRA
Many-Headed Mythical Monster

This multiheaded serpent lived in the swamps near Lake Lerna in ancient Greece and was believed to be real by the local populations for more than two thousand years. If it was a dinosaur of some sort, no fossils were found to prove it, yet the Greeks thought this beastly anomaly was an

offspring of various gods or Titians. Nevertheless, according to ancient sources, this reptilian creature had a hefty body covered with scales and a long, curling snake-type tail. It also had two clawed feet, or four feet in some versions, and was either the size of a baby elephant or as massive as a dragon. In addition to an ensemble of sharp-toothed mouths, it emitted a foul, poisonous breath.

How to Kill a Hydra

In stories, the hydra became a nightmarish symbol of any seemingly insurmountable problem that only got worse no matter what you did. Legend said the hero Heracles finally defeated it by compartmentalizing the problem. Although he kept an eye on all the heads, he cut one off at a time while instructing his assistant, Iolaus, to shoot a flaming arrow at the neck wound, cauterizing (or sealing) it with burned flesh to prevent a new head from blooming. The final hydra head could not be resolved with any weapon, so Heracles pulled it off with the brute force of his hands and buried it beneath a rock.

One of the hydra's unique qualities was instantaneous regeneration. If a hydra head was cut off, not one, but two heads grew back to replace it; depending on accounts, the hydra could have anywhere from nine to one hundred heads.

Autotomy

Lizards and lobsters can spontaneously self-amputate a limb, a tail, or a claw when under attack in a process known as "autotomy." This adaptation helps a lizard to escape, as it hopes a predator will seize its wiggling tail and allow it time to flee. Some lizards have the ability to regrow their lost body parts, especially their tails. A lizard can regenerate its tail as many times as it is cut off, though each new tail grows back shorter and shorter. The original tail consists of vertebrae that are an extension of the lizard's spine, but the vertebrae do not grow back in the regenerated versions—instead, a similar-appearing cartilage manifests. How this happens, biologically, remains a mystery. As for head regeneration, the hydra is the only beast said to accomplish such a feat.

HYENA
Merry Matriarchal Marauders

Hyenas are found in Africa, Arabia, and India, adapting to a variety of terrains, from grasslands to mountains. Their range once spread though Europe and much of Asia. There was even an extinct type that lived in North America at the end of the last Ice Age. Hyenas are similar to many doglike species that form social packs for hunting and catch prey with their teeth rather than by claw, yet their evolutionary trail shows they have more genetic similarities to prehistoric cats.

Although branded with a reputation as being scavengers, hyenas are clever and determined hunters, obtaining more than 95 percent of their daily food on their own. Nonetheless, even lions frequently abandon their kill without a fight when surrounded by a large group of hyenas. There are three species of hyenas; they all have small heads with short muzzles and bone-crushing teeth, dark fur around their eyes, ears that stand up-

right, and long, thick necks, giving them a distinctive silhouette among animals. The largest, the spotted hyena, grows to nearly 5 feet long and weighs as much as 200 pounds.

Females Rule

The mama hyena rules the clan, which can have as many as 80 members in one cackle. All are singularly focused on protecting their territorial rights. A female earns rank by fighting and rules according to the power

Gender Bender?

SKELETON OF SPOTTED HYÆNA.

For centuries, hyenas were thought to be capable of changing their sex or were considered to be hermaphrodites (containing both female and male reproductive organs). In part, this misunderstanding was due to the prevailing role of the female, which many early naturalists assumed was a male—but they were at a loss to explain how the pack leader was capable of giving birth. Dominant females have extra supplies of hormones that make them aggressive, but also make their sexual organs form into odd, elongated shapes that appear extended somewhat similar to males' private parts. Giving birth through this curious narrowed birth canal gave rise to myths claiming the male hyena gave birth.

of her jaw and her cunning. Even the lowest-ranked female in a hyena clan is above the strongest male. When it comes to dining, hyenas will even mortally injure one of their own if they think another is trying to skip the line in the established hierarchy. Hyena clans are fluid, and alliances change frequently, but all will rally when called to protect their dens—especially when ganging up on lions and big cats.

Why Does a Hyena Laugh?

Hyenas, as social animals, developed a complex system of vocal communications that enable them to excel at working together. Their infamous laugh—more like a cackling giggle—is used when they are either frustrated or nervous. They also make an extremely loud whooping sound that can be heard for miles and is employed as a siren, calling all hyenas to gather for an attack. This war cry arouses their adrenaline, and few can resist it. A hyena's rank determines the type of laugh: the less-dominant ones laugh more frequently and at a higher pitch.

Are Hyenas Evil?

African legends about hyenas often associated them with demons. Witches were believed to be the only ones able to train hyenas. Evil sha-

mans could summon these beasts to do their wicked deeds. Other cultures considered hyenas as couriers to the spirit realm. Hyenas were said to rob graves to snatch the souls away to hell. But not all thought hyenas possessed evil magic: among the Maasai people of Kenya and Tanzania, it was customary to leave their dead out in the open, and they believed it honorable for a human carcass to be devoured by hyenas.

Life Cycle

Laughter is often said to be the best medicine, and for this animal, it seems to increase its life span; that is, if it survives birth. Nearly 60 percent of firstborns suffocate in the birth canal, and only about half of the young make it through the first year. Afterward, their powerful social network provides a long life in the wild. Among hyenas, to be born from a governing female is sort of like the passage of royalty among humans, because this high status will ensure protection from other hyenas and access to more food. Hyenas live for about twelve years, though some reach the age of twenty or older.

The Sacred Ibis

IBIS
Sacred Snake Snatcher

The ibis, a long-legged shorebird with a sickle-shaped, down-turned bill, was hailed in the Bible and in Egyptian writings as the perfect animal to rid an area of snakes. Ibises are experts at catching any number of amphibians, reptiles, and crustaceans; they usually wade in a group (or a "siege"). As if telepathically connected, all become motionless simultaneously. Sometimes a few ibises wade farther upstream in order to drive fish toward ibises waiting nearby along riverbanks, shorelines, and in estuaries, where they normally feed. In ancient times, snakes were no minor ecological problem and accounted for tremendous fatalities; oftentimes, areas overrun with snakes were abandoned from settlement. The ibis, as a deliverer from these creatures, rose in status until the bird was made sacred within Egyptian mythology. In the story of Noah's ark, the ibis

was among the first birds released, perhaps to catch any snakes remaining after the Great Flood.

There are nearly 30 different types of ibises found in the Americas, Europe, Asia, Africa, and Australia. They nest in colonies and sleep in trees at night. All are strong and graceful fliers, and they are not usually territorial. In fact, ibises often feed alongside other wading birds. They particularly like to hunt near taller herons, as both birds help one another in some ways. A group of foraging ibises frequently drives food toward the

The African sacred ibis is white, with a black onyx head, beak, and legs. There are black tips at the end of its white wings and on the tufts of its tail feathers. This majestic bird has a 2-foot-long body with wide wings spanning nearly 4 feet. In Egyptian theology, a principal deity, Thoth, was often envisioned as a man with the head of an ibis. The god had many roles, from the inventor of writing to judging the dead. The bird was considered so holy it was frequently preserved as a mummy. In one vast, ancient burial ground, or necropolis, near the city of Memphis in Egypt, archaeologists found more than half a million mummified ibises.

solitary heron, while the taller bird's height advantage gives the ibis flock an early warning system when raptors or birds of prey are about. The ibis, depending on its environment, is food for carnivorous birds, big cats, or crocodiles. On average, ibises lives for around twenty years.

The American white ibis was chosen as the mascot of the University of Miami since it was cited by the public relations committee as a brave bird. When hurricanes approach, the white ibis is the last to seek shelter—which may not be the best idea—however, it is the first bird to return, signaling the storm has ended.

IBONG ADARNA
Songbird with the Rudest Surprise

According to local legend, there once was a bird living in the Philippines that was extremely rare—and dangerous. Even so, the ibong adarna, as the bird was called, was sought for its healing powers, because it was believed to be a curative for depression. The bird, about the size of an eagle with a long peacock tail, always sang seven exceedingly melodious songs, all in a row. After each song, the bird's feathers changed into entirely different colors. Anyone who heard the music fell into a sound sleep. To avoid capture, the bird then perched above the sleeping suitor. It would find the right position, aligning itself just so on a branch and then defecate on the person's face. Its excrement was of a chemical concoction that induced a long-lasting coma. The bird's spell could be reversed with a mere bucket of water thrown into the face to wash off the bird's droppings. Despite extensive hunts for this magical bird, none have been spotted in modern times.

ICHNEUMON
Dragon Slayer

In medieval lore, the ichneumon was an expert dragon tracker that hunted the monsters in their lairs with the steadfastness of a bloodhound. Descriptions of the beasts are similar to those of weasels or otters, which are also slender and agile furry mammals. The ichneumon seemed to have an inherent hatred of dragons and prepared for battle with the giant beasts by covering itself with mud. It would wait as one layer of mud hardened and then repeat the process until its coat was as thick as armor. The ichneumon then stalked a dragon and waited until it was in a deep, snoring slumber. It killed the mighty dragon by climbing onto its head and then burrowed into the beast's nostrils, weaving itself into one and then coming out head up from the other nostril. This method suffocated the dragon while it slept.

The ichneumon also slew crocodiles in an equally creative manner. It waited until the reptile opened its mouth to allow birds to enter and pick its teeth clean. The ichneumon then snuck in and crawled down the croc's throat, burrowing and chewing through the reptile's intestines until the beast died. It then emerged unscathed from the crocodile's nether region.

What Was It Really?

It seems more likely that ichneumons were inspired by actual mongooses, noted as expert killers of danger-ous snakes. Although not related to weasels, they look alike and are found in Asia, Africa, and Europe. The

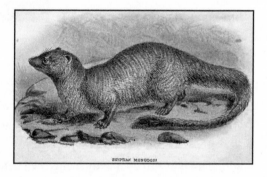

EGYPTIAN MUNGOOSE

Indian mongoose is legendary as a cobra killer and a likely source of ich-neumon folktales. A mongoose is quicker than a cobra strike, and it uses cunning and trickery to defeat the venomous reptile. The mongoose has

also a natural built-in resistance and immunity to snake toxins. However, it doesn't eat the snake but usually attacks in a preemptive assault, in order to hunt for its diet of rats and small rodents without competition, or to avoid worrying about getting caught unaware. Mongooses grow from 1 to 4 feet long and would have easily qualified as the medieval dragon slayers of old.

There's a superfamily of insects, named Ichneumonoidea, that contains more than 80,000 species. Ichneumon wasps have long and thinner bodies than bees and have veiny wings. They have what appear to be very long stingers, but they are actually the females' egg depositors. The wasp pierces the body of any number of insects and lays its eggs inside. As its larvae grow, they feed on the host until they kill it.

INKANYAMBA
Zulu Monster

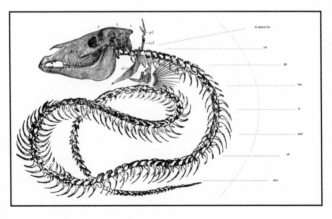

This fabled creature is a 30-foot eel with fins protruding from its horse-shaped head. Like many cryptids—creatures that lack scientific explanations—this one lives in a specific location, namely Howick Falls in South Africa. Zulu folklore describes the inkanyamba as swift and ferociously carnivorous, known to snatch people and animals from the shoreline in the blink of an eye. It usually only surfaces from its deep underwater caverns during the summer months and especially during torrential rainstorms.

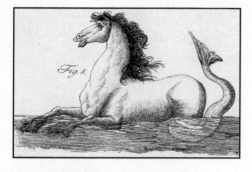

Fig. 5.

Since such a creature was found among prehistoric cave paintings, alongside depictions of known animals, this evidence gives rise to the possibility that some type of large eel once existed in the area. There is an eel called an "anguilla" that grows to about 6 feet. There is also a living specimen of an eel-like creature, called a "hagfish," which is found in African waters. The hagfish, which is neither a true eel nor a fish, does, in fact, have a slimy and snakish anatomy. It has a skull with two brains, but lacks a spine, and yet despite these oddities, it has never been seen leaving the water or swimming in the clouds.

During hard downpours, the inkanyamba can rise out of the water and ride in the clouds of the storm, gobbling up people miles from its normal waterfall environment.

IMPALA
Spring-Loaded Savannah Sprinters

This swift antelope lives in the African savannah and gathers in huge herds, numbering in the hundreds. The impala stands about 3 feet at the shoulder and weighs 100 pounds. The males have long and sharp spiraled horns, which are used as part of their defensive tools—and for dueling when challenging each other during mating season.

When outlying members of a herd see danger, such as stalking lions, an impala calls out in a dog-sounding bark to warn the others, signaling an adrenaline-charged stampede. The herd can go from a standstill to speeds of more than

Impalas, like many grazing herbivores, epitomize nature's law that there is often greater safety in numbers.

50 miles per hour in an instantaneous explosion of leaping antelope. They use this bark sparingly and seem to have an unwritten code to never "cry wolf" without good reason.

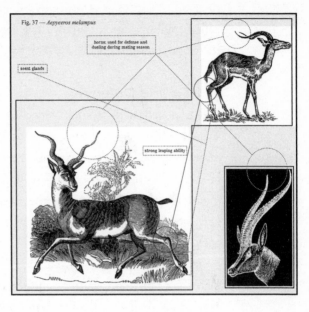

Fig. 37 — *Aepyeeros melampus*

horns: used for defense and dueling during mating season

scent glands

strong leaping ability

Spring-Boarding

The characteristic that distinguishes the impala among antelopes is its remarkable broad-jumping capabilities. Just as a lion is about to grab it, the impala can leap for a distance of 30 feet. The impalas' seemingly patternless leaping and bounding to the right or left totally confuses would-be predators, yet there is a hidden organization in this pinball type of motion among the fleeing herd. While in midflight impalas release scents to signal to others the general directions they all are to follow, thus keeping the herd moving on a similar course. But with such a springy-footed skill, impalas often leap for the fun of it and can jump up into the air as high as 10 feet. They often use this agility to jump over instead of walking around bushes that might seem too prickly. An impala lives on average for about twelve years.

ISOPODA
Pillbug

Isopods are truly ancient creatures that have remained nearly unchanged for three hundred million years. They are crustaceans with hard shell-like bodies and usually have seven pairs of legs. More than 5,000 species of isopods live primarily in the ocean, but a nearly equal amount traverse

the land. A common terrestrial version, known as woodlice (though also called "pillbugs" or "roly-polys"), is found in temperate climates all over the world; woodlice are easily seen by upturning a stone or a fallen tree.

The Round Defense

When poked with a stick, woodlice roll themselves into a perfectly shaped pill-sized ball. In reality, they are not an appetizing food for many, since the bulk of their bodies consists of a hard exoskeleton, which holds their form together just as skeletons define and hold the structure of internal organs and tissues of other animals. Pillbugs do not need to find new shells and instead shed theirs as they grow by molting and growing back larger ones.

In addition, pillbugs have no way to regulate their body temperatures and internally assume the temperature of the environment around them; however, they can also hibernate when cold weather approaches. Pillbugs are not poisonous and carry few diseases harmful to us. They prefer the dark world under tree bark and eat decaying vegetation, living on average for about three years.

A pillbug needs a lot of moisture and dampness to survive and dries out quickly, turning permanently into a dried ball of a bug when conditions become arid.

JACKALOPE
Horned Hare Hoax

In antiquity, animals were often described as having a mixture of parts borrowed from completely dissimilar creatures. The griffin had a lion's body and an eagle's head. The chimera was also lionlike, though it had a snake's head on its tail and a goat's head growing from its spine. North America has its own assorted-parts animal: the jackalope, a jackrabbit with a rack of miniature antelope antlers.

Where Is It?

The vast majority of sightings of this elusive creature are near Douglas, Wyoming. The first record of such a hybrid critter was in 1829 when it was supposedly discovered by a trapper. The original specimen was displayed stuffed and mounted in a local hotel until the 1920s. The jackalope has since eluded capture, although numerous replicas of the creature are sold as tourist souvenirs. The supposed animal is hard to find, since it sheds its antlers in summer months, blending in with the normal jackrabbit population. It only grows horns during winter. Jackalopes spend the coldest months at higher altitudes and use their antler adaptation to break the ice to forage for grasses buried beneath the frost line.

Rabbits are susceptible to a virus that manifests as large, bony tumors on their heads, and this condition is the likely origin of the jackalope legend. Nevertheless, the state of Wyoming issues

Jackass or Jackrabbit?

There are more than 50 species of jackrabbits, which are actually classified as hares; rabbits are of the same family but a different genus. Hares are generally larger than rabbits, have longer hind legs and ears, and usually run much faster and hop farther than rabbits. Jackrabbits got their name in the same confusion about how animals can be a mix of parts. Many thought hares were actually rabbits with jackasses' ears, hence, "jackrabbit."

hunting licenses for antlered jackrabbits, good for one day only, every June 31, from midnight to 2 A.M.

Historically, Buddha is said to have made references to horned rabbits, and there are European illustrations of a horned rabbit from the 1500s.

JACULUS
Legendary Living Lance

This winged serpent was thought to be some type of small, legless dragon. It was described in old natural-science books as a beast that preferred to dwell in trees, camouflaging itself to look exactly like a branch. It then shot down from its perch with the force of a spear and killed by impaling its victim with its stiffened body and sharp head, rather

than with venom or by claws. The creature could strike at prey below, but it was equally proficient at shooting itself up into the sky as if propelled by an engine to pierce and skewer whatever might fly above. The lance snake got its name from a Greek weapon, the javelin.

There is a species of rodent that lives in North Africa and in arid regions of Asia also named a jaculus. It has long legs and hops similarly to a kangaroo. The serpent the ancients described most resembles a species of snake still in existence, called a "fandrefiala snake," found in Madagascar. In Malagasy

mythology, the serpent was feared and said to dangle from trees and then spear people or livestock passing below. Sometimes called the "perinet night snake," the reptile does have a spear-shaped head, but it cannot skewer anything with its skull, nor is it venomous.

JAEKELOPTERUS
Biggest Bug Ever

The jaekelopterus was an 8-foot proto-insect that lived in rivers, lakes, and estuaries about 390 million years ago. It belonged to a group of extinct creatures called "eurypterids," which would later develop into scorpions and spiders.

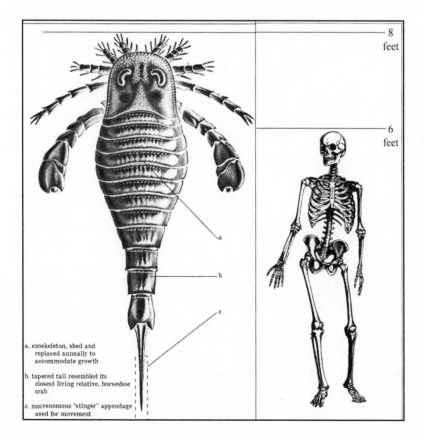

8 feet

6 feet

a. exoskeleton, shed and replaced annually to accommodate growth

b. tapered tail resembled its closest living relative, horseshoe crab

c. nonvenomous "stinger" appendage used for movement

It couldn't swim but could crawl with eight pairs of tiny legs, which were not long enough to provide much mobility. It had lobsterlike front pincer-claws. The creature was too cumbersome to leave the water and was forced to shed its hard exoskeleton, or shell, for a larger one each year while underwater. Vulnerable as it was without its armor during these periods, this creature was highly efficient and survived across the globe for one hundred million years. It had a hard, tapered tail like that of a horseshoe crab (its closest surviving relative), but the tail was not poisonous like a scorpion's. Its stingerlike appendage was used as rudder or as a pick-like lever to push itself out of a wedge.

Supersized

During the era of the jaekelopterus's reign, there were no large-toothed fish to offer competition, so it was the primary predator and was allowed to grow to tremendous size. When creatures around the jaekelopterus began to grow bigger, as happened with most arthropods—especially ones that made it through the evolutionary strainer—the insect became smaller or vanished. Arthropods are a tremendously large group of animals and include all insects, scorpions, spiders, and lobsters with over 1.1 million known species living today. It's estimated that there are 10 million extinct types and an unknown number of yet unnamed arthropods waiting for discovery. This giant great-granddaddy jaekelopterus paved the way for making this animal group the most populous in the world, with nearly 75 percent of all animals being some type of arthropod. The lobster is the largest arthropod remaining, but back then, millipedes also grew to 6 feet and dragonflies had 5-foot wingspans.

Where They Went

The jaekelopterus lived during the Permian period, when all the continents were connected and surrounded by one humongous ocean called Panthalassa. Something dramatic happened about 250 million years

ago that practically wiped the living organism slate clean, killing off 95 percent of all marine and aquatic animals and marking the end for more than 70 percent of all land beasts. It was the largest extinction event known to science. Thousands of volcanoes on land and under the sea erupted serially, coating vast areas with lava and eventually causing the planet's temperature to rise by five degrees. It took thirty million years for ecosystems to recover from this shock.

Who Has the Most Legs?

Centipedes and millipedes are distant relatives of the jaekelopterus, though they are now known as "myriapods" and are part of the beetle family. Centipedes, commonly called "hundred-leggers," and millipedes, "thousand-leggers," do have more legs than seem to be needed, but neither lives up to its name. Most centipedes generally have about seventy legs. No millipedes have one thousand legs. An inch-long millipede called the *Illacme plenipes*, found in California, holds the record at 750 legs.

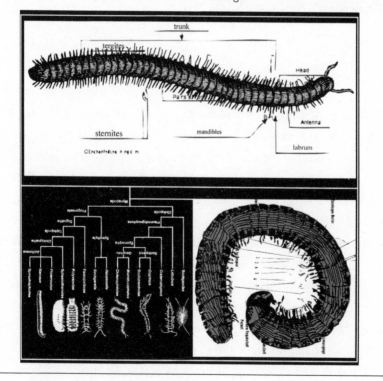

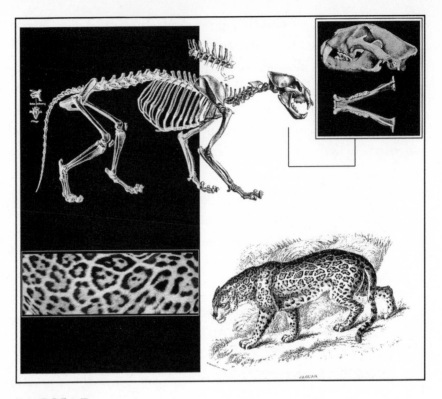

JAGUAR
"God of the Night"

Jaguars are the third largest of the big cats, after tigers and lions. They are found from Arizona in the United States to the tip of South America. This cat's ancestral link originated in Asia, crossed the Bering Strait about two million years ago, and roamed throughout North America. Fossils of a distinct modern-day jaguar that had established its dominance mostly in Central America and South America are dated to approximately five hundred thousand years ago. Strictly carnivorous, the jaguar can be as long as 5 feet from head to tail base and weigh up to 300 pounds. It normally has blond and orange fur with black, rosebud-shaped spots. However, more so than with other big cats, jaguars can also have entirely black fur, with the spots barely visible. They are solitary animals, highly territorial, and mark their boundaries of over 50 square miles by clawing trees and defecating at perimeters. Unlike tigers and lions, jag-

uars like water and are skilled swimmers, catching prey on land or in rivers with equal ease.

In rivers, they hunt turtles and will eat fish or caimans. On land, they are ambush hunters, preferring to wait in a tree and pounce from above, eating capybaras, deer, peccaries, tapirs, and occasionally humans.

The jaguar has a straightforward and deadly method of killing—it always goes for the head and crushes the skull with one powerful bone-crunching bite.

Totem of Power

For the Mesoamerican cultures, including Mayans, Aztecs, and Native American tribes, the jaguar was a mystical beast. The Mayans hailed the cat as "the God of the Night," ruling over the Mayan underworld. "Jaguar" is derived from *yaguareté,* a word in the indigenous Guaraní languages of central South America that means "the fiercest beast." Numerous Andean cultures had cults that worshipped the jaguar.

The Mayans made totems of jaguar images to represent Tezcatlipôca, an all-powerful god, while rulers assumed names that contained the word *jaguar* in their titles. The Aztecs had an elite division, like Navy SEAL commandos, which called itself the "Jaguar Knights." These warriors wore jaguar skins and were experts at using an ancient weapon called an "atlatl." This was a handheld spear-chucking device that launched a sharpened missile with deadly accuracy and at a speed of more than 90 miles per hour, killing, as was said, with the surprise of a jaguar.

The cat's teeth held magical powers and Aztec warriors dressed in jaguar skins to harness the cat's seemingly supernatural strength.

Life Cycle

As apex predators, jaguars can only be killed by humans. In the wild, these big cats live for about fifteen years. Females have somewhat shorter life spans, especially after giving birth to litters of one or four cubs every

three years. A female is most vulnerable while her young stay with her until they are weaned after about two years; she frequently has to protect her offspring from being killed by their own fathers. Wild jaguars also die of age-related diseases. For example, one of the last jaguars living in U.S. territory, a sixteen-year-old animal tagged with a monitoring collar, died in 2009. When found, the cat was euthanized because it suffered from painful kidney failure.

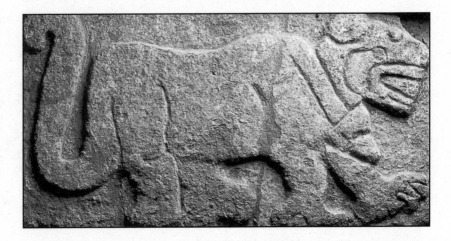

How Does It Roar?

Big cats, of the genus *Panthera*, emerged as dominant hunters around 3.5 million years ago, with lions, tigers, leopards, and jaguars all sharing a similar ancestor. The jaguar also comes in third in the battle of roaring cats and makes a cry that is more like a strong cough. Cougars, bobcats, and snow leopards cannot roar at all, since they lack a flexible bone in the throat, called the "hyoid bone," which enables the big cats to roar. Among all the predatory felines, lions win the roaring contest, yet, while this advantage is a frightening one, none of the big cats can purr or meow like a housecat.

Alien Big Cats: Phantoms That Are Out of Place

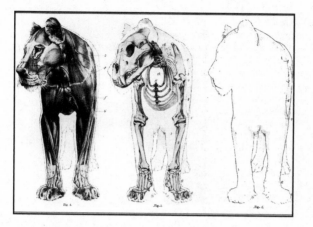

Alien big cats, also called "ABCs," or "phantom cats," are actual cougars, jaguars, or other large felines that appear in regions far from their known natural habitats. Most are runaway pets or escapees from a zoo, circus, or private ownership. However, cryptozoologists (alternative scientists who study extinct animals and creatures described in mythology) have gathered evidence and recorded numerous sightings of ABCs that may not have been pets or runaways. In 2009, for example, a "black panther with red eyes" was seen near an industrial sector in Bommelscheuer, Germany. A woman jogging through the area one quiet Sunday morning stopped in her tracks. She saw a panther stalking from rooftop to rooftop and notified police. Search dogs, thermal imaging scans, and police helicopters failed to capture the animal, which seemed to have simply vanished. Witnesses in other areas throughout Germany also reported seeing a black panther, even when zoos reported no animals missing. In Maui, Hawaii, mystery cats have been seen since the 1980s, even if searches by the U.S. Forestry Service and experienced trackers could not find them. In January 2001, a leopardlike cat was witnessed slowly strolling across an intersection in Maui before disappearing into the mountains. Phantom cats were observed in Britain, the Netherlands, New Zealand, and near Sydney, Australia. In India, mysterious hulking gray leopards that appear suddenly and then are gone are called *pogeyan,* meaning, "The cat that comes and goes like the mist."

Where the Wild Things Are

Reported sightings and vanishings of dangerous wild animals to police in the last three years

black cat	115
big cat	111
hoax	15
wild cat	14
lynx	14
leopard	14
cheetah	13
panther	12
lion	12
unknown	11

The Eurasian lynx, a variety of leopard, was, in fact, once native to Great Britain, though it was thought extinct for more than twelve thousand years. Even if the phenomenon of ABCs is dismissed by many as improbable, sighting of big phantom cats continues.

JELLYFISH
Bountiful Brainless Blobs

There are approximately 2,000 different types of jellyfish found in all the world's oceans. These gelatinous, gooey creatures have been carried by currents for more than five hundred million years, surviving any number of worldwide ecological shifts.

Jellyfish are not actually fish nor are they like most other invertebrates, since they have no bones or exoskeletons at all. Jellies are often classified as zooplankton, the tiny water-dwelling creatures seen under a microscope, though jellies are tremendously larger.

They survive in all waters, but thrive more in the ocean, dwelling both near the surface or in the darkest depths. Jellies mostly have umbrella-shaped bodies, which contain more than 95 percent water. The dome of the jellyfish is often called a "medusa," after the tentacle-headed figure in Greek mythology. The jellyfish lacks digestive or respiratory systems; it has no circulatory system, nor a brain nor a nervous system, yet it does have what's called a "nerve net" that reacts to stimuli and touch.

Some jellies have as many as twenty-four eyes and can detect light, which guides them toward the surface or away from it. However, a jelly's vision is always out of focus, since it lacks a brain to interpret what it sees. A jellyfish has a mouth and tentacles, some containing poisonous venom that paralyzes and kills its prey. This adaptation relates to its unfocused eyesight, since, not being able to understand what it is seeing, a jellyfish would rather stun a potential food source than take the chance of eating something still alive that might be harmful. Food is passed to a jelly's mouth, which lies below its dome. It distributes nutrients to its other body cells by diffusion and absorption. Some jellies can contract a muscle to give them propulsion, through an undulating and pulsing motion, while others are carried to wherever the currents take them. Jellyfish are proficient predators, eating plankton, fish, and crustaceans. To know what creatures looked like in the prehistoric world is to observe a jellyfish, which represents the most numerous and visible of marine living fossils found on the earth today.

The largest jellyfish is the lion's mane, which can weigh as much as 1,000 pounds and have 120-foot-long tentacles. One of the tiniest, the Irukandji jellyfish, which is smaller than 1 inch wide, has a sting toxic enough to kill a person, with venom one hundred times deadlier than a cobra.

How They Work

Surviving without a brain seems alien to us, but jellies have perfected a thriving and abundant existence by using an array of techniques and chemical reactions. Their eyes, for example, contain a substance around the edges called "gypsum crystal," which keeps them right side up even in the darkest light. The tentacles have cells that upon touch release small barbs of poison and work without direction from a cerebral source.

How they mate is perhaps even more the stuff of sci-fi. With some jellies, the male sperm swims into the female's mouth and fertilizes the eggs. The eggs incubate in a chamber until the larvae swim out. These larvae, called "polyps," or strange growths (the same word is used to describe odd growing things inside a human body), attach themselves to the ocean surface or to stationary objects. In some species, the polyps merely float, but all fundamentally turn plantlike at this phase. The polyps take root and grow a stem and small upward-facing tentacles that gather passing food. The polyps then bud more identical polyps until the cluster of these premature jellies is large enough to break free and swim away as full-grown adults.

Life Cycle

Some jellies stay in the polyp stage for a year or

Immortal Jelly

The jellyfish species *Turritopsis nutricula* is found all over the world and is a small one with a bell-shaped dome less than ½ inch wide. It has a reddish color and as many as eighty tentacles. This unusual creature has seemed to solve the great dilemma of all living things and developed a way to rejuvenate itself when facing old age. As an adult, this jellyfish lives a solitary life, but when sensing deterioration, it has the ability to trigger its cells to begin a process called "transdifferentiation." This biological process is rare in nature, as when a cell changes into another form and assumes an altogether different function. (One example of transdifferentiation is observed in salamanders, such that if an eye lens is damaged, a different cell can transform into a new salamander eye cell.) This jellyfish uses all its cells to transform its medusa body back into a polyp. Its tentacles are retracted and reabsorbed until becoming a polyp, the plantlike plankton form that it was at birth. This would be the equivalent of an elderly person who, as he or she got feebler, went to bed and then began shrinking, until turning into an infant once again. This jellyfish comparatively becomes a baby, toddler, child, and adult—ad infinitum, thus achieving biological immortality.

two and then live as spawning adults for as little as a few hours. Some jellies remain as adults for a few months, though for most, the polyp or budding stage occupies the majority of their lives. Since full-grown jelly-fish are food to many large marine species, especially turtles, they usually meet their end by being eaten or washed ashore.

JENNY HANIVER
"Devil Fish"

The sea was long held as a mystery and was rightfully feared for its unpredictable power. During the early period of ocean travel and commerce, sailors would entertain land-lubbers with tales of exotic creatures they encountered. One such monster, the Jenny Haniver, was thought to be a demonic fish by many, though it turned out to be a hoax perpetrated by the sailors themselves. It be-came a thriving side business for seamen to catch stingrays or skates and dry out the car-casses, but not before first sculpturing the fish into humanoid shapes. In the 1500s, science books actually claimed there were marine creatures that looked like bishops, and al-though it had fins and scales, the bishop fish bore a flap of fish skin that resembled a large hat worn by pontifical clergy. Jenny Haniver was even given a Latin-sounding scientific name, *Satanius Aquas,* and thousands of vari-ous creations were sold as tourist souvenirs, touted as baby mermaids and devil fish.

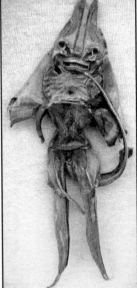

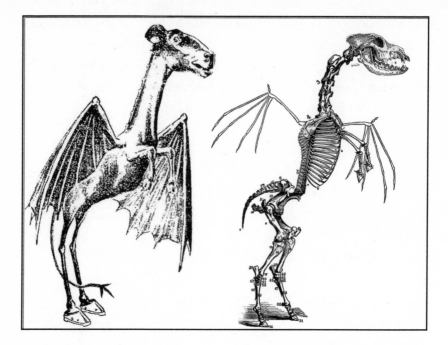

JERSEY DEVIL
Phantom of the Forest

In the eerie quiet of the one-million-acre Pine Barrens region of southern New Jersey, a part furry, part feathered unidentified flying beast has appeared periodically for more than 250 years. The creature stands upright on two sticklike legs and has feet that resemble hooves. It is about 3 feet tall and has small arms and five-fingered clawlike hands.

It has a doggish head, some say resembling a collie, and it makes a yelp or bark that is quick and echoes like an owl hoot. It appears primarily in August, although its odd hoofprints have been found in snow, especially on snow-covered roofs. It flies at speeds of more than 60 miles per hour, with a violently flapping *whooshing* sound, but the Jersey Devil is also apparently adept at running. When once pursued by professional trackers, and nearly captured, it was said to fit under an 8-inch gap below a fence and leap 5

Hairless, skinlike membrane wings are attached at the Jersey Devil's spine, which fold up like an accordion or when extended reach a 5-foot wingspan.

feet over barriers with unearthly agility. It nests in abandoned chimneys, under crawl spaces, and in rocky caverns. The Jersey Devil is an omnivore and has been seen eating livestock and small animals, as well as raiding vegetable gardens and fruit orchards.

Sightings

Stories of the Jersey Devil's origins are conflicting, with some believing it was borne by a woman named Leeds, or by one Mrs. Shrouds of Leeds Point, New Jersey, who was either a witch or gave birth to a deformed creature, sometime around 1735. Historically, it was common to attempt to make sense of the unknown by attributing an anomaly to demons. However, descriptions and sightings throughout the last 250 years, by more than two thousand witnesses, including reports made by police and government officials, portray the Jersey Devil as a unique beast and without a single humanoid characteristic. Evidence of its continued existence persists into modern times.

What Is It?

The Pine Barrens is a designated national biosphere reserve and has numerous species of flora and fauna found nowhere else in the world. The sandhill crane, native to the area, matches the size of a Jersey Devil, though the bird does not normally attack and maim livestock. Another theory purports that perhaps Jurassic period creatures might emerge from prolonged hibernation at unusual times. The pterodactyl, a flying reptile, had some of the features of the Jersey Devil, but it was thought extinct sixty-five million

The famous 1812 war hero Stephen Decatur spotted a Jersey Devil and shot a cannonball at it. Another dignitary, Joseph Bonaparte, king of Spain, encountered the beast while on a hunting trip in the area in 1820. In the 1930s, the New York Times *reported on the Jersey Devil disrupting a crew of berry farmers in southern New Jersey. A reward to capture the beast was posted in the 1960s.*

years ago; the pterodactyl had a 60-foot wingspan. There are otherwise no fossil records of any creature that matches the characteristics of the Jersey Devil.

Nevertheless, sightings have decreased dramatically since the early 1970s after the Oyster Creek nuclear power plant was built in the vicinity of the Pine Barrens. Some claim that radioactive fallout is curtailing the activity of the Jersey Devil or may have caused it to perish.

KANGAROOS
Jumping Jacks

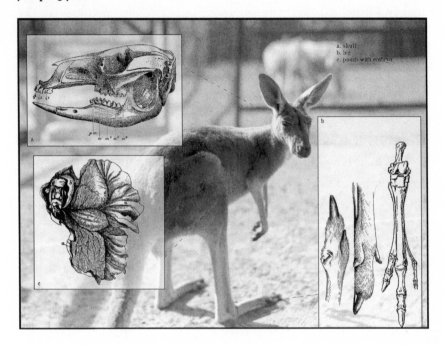

a. skull
b. leg
c. pouch with embryo

Found only in Australia, the kangaroo got its name from Aborigines who called the jumping marsupial *gangurru,* though today kangaroos are commonly known by many Aussies simply as "roos." In Aboriginal mythology, kangaroos were created during "Dreamtime," when mythical beings took the forms of landscapes and animals. Ten-thousand-year-old cave drawings depict the 4 larger species of kangaroos exactly as they appear today. The animals were often considered sacred totems among Aborigines, who honored them with specific dances.

There are more than 50 types of kangaroo-related animals known as *macropods,* or large-footed marsupials—the red kangaroo being the biggest, standing nearly 7 feet tall and weighing as much as 200 pounds. Earlier settlers and visiting Westerners were shocked to see such a creature. It was described as having a deer's head, standing upright like a human, and capable of hopping for distances of more than 30 feet like an overgrown and furry frog.

How They Got Down Under

Although their present form is uniquely Australian, the earliest kanga-roos and their marsupial ancestors were once tree-dwelling opossumlike creatures that originated in the Northern Hemisphere and migrated to South America about 120 million years ago. Ancestral kangaroos then ventured to Australia when three principal landmasses—Australia, Ant-arctica, and South America—were joined.

Roos by the Numbers

To hop is an efficient mode of travel, covering long distances while con-serving energy. Kangaroos reach speeds of 40 miles per hour and can soar 10 feet above the ground. They have short, thumbless forelimbs, but do have knife-sharp claws on their feet.

The only time kangaroos' legs move independently is when kicking. A kangaroo's clawed-foot jab is powerful enough to slice the jugular or knock unconscious any attacking predator.

Their front limbs are used for grabbing plants, tending their young, and boxing, a skill they display when sparring with rivals during mating. Like camels, kangaroos have fatty deposits to reg-ulate hydration and can go without a sip of water for months. Their thick tails are used for balance, as a spring, and like a brake when they want to slow down. Kangaroos are strict herbivores and have adapted to the varied Australian climates, ranging from deserts to mountain ranges. They sleep most of the day in groups of ten or more, called a "mob," led by a dominant male, and they forage at twilight and dawn. Eastern gray kangaroos are the most abundant, with a population estimated at about 2 million.

Jack and Jill and Joey

The male kangaroo is called a "buck," "flyer," "boomer," or "jack." The females are called "jills," and the babies "joeys." Kangaroos are very fam-ily orientated, and the mothers seem especially happy when breeding and caring for their young. Like most marsupials, the kangaroo fetus leaves the birth canal before it is fully developed, no bigger than 1 inch long.

The blind, pinkish baby crawls up and into its mother's pouch, where it feeds from her teats.

The female can become pregnant soon after the joey is born, though the fertilized egg waits to develop until the baby in the pouch is old enough to leave at about nine months. The mother allows the baby to return to her pouch to drink milk. It might also go for a ride with her for as long as a year and a half, even if in the mother's bulging belly pocket it looks like a toddler too big for its stroller. Amazingly, her teats produce different types of milk required for the joeys at various stages of development; during her adult life, she is usually tending to three offspring of diverse ages, ranging from infant to two years old.

Unlike most wild animals—though similar to many humans—the mother kangaroo cares for offspring that are of different ages.

Life Cycle

Dingoes—wild Australian dogs—are kangaroos' greatest natural enemy, after humans. Toxoplasmosis, a disease transmitted by parasites, affects kangaroos, as does hantavirus, a pathogen usually spread by rodent feces.

In addition, since kangaroos prefer to venture about in the dark, frequently grazing on grassy areas alongside roadways, about 200,000 kangaroos are killed each year by vehicles. The animals freeze in the glare of headlights, just as deer do, or become confused and leap into the path of a car rather than bounding away.

Longevity among kangaroos varies depending on species and environmental conditions, such as the severity of droughts or floods. All told, the kangaroo's average life span is about twelve years. Some have been known to live as long as thirty years.

One recent viral epidemic, called "chorioretinitis," caused fifty thousand kangaroos to become blind, with the hapless beasts stumbling about until dying prematurely.

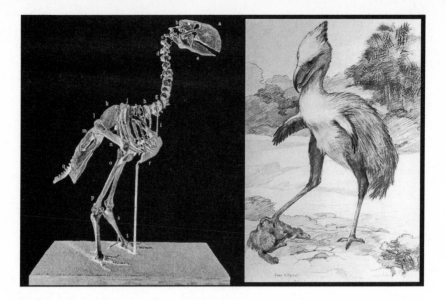

KELENKEN
World's Deadliest Bird

Fifteen million years ago Argentina was a tropical Petri dish and virtual laboratory producing the strangest beasts. The continents had drifted to their present positions, with regional ice ages occurring around the globe, but in South America massive flightless birds remained the prevailing predators. One of these creatures, the kelenken, looked like an ostrich with a hawk head. Its skull was the largest of any known bird, measuring more than 2 feet long, in addition to having an 18-inch, pickaxe-thick beak. The feathery 500-hundred-pound bird was 10 feet tall and quick on its feet, leaping up onto boulders, plowing through dense foliage, and reaching speeds of nearly 30 miles per hour to catch its food. It was strictly carnivorous.

Terror Birds
A number of carnivorous flightless birds were also known to live in North America (now Texas and Florida) during the same era, and some species still existed by the time the first humans arrived there, approximately

fifty thousand years ago. Australia had the giant *Dromornis stirtoni*—or "thunder bird"—during prehistoric times, weighing more than 1,000 pounds, even if this bird was a mellower beast, eating only plants. The large ground birds had filled the niche as apex hunters when dinosaurs like the tyrannosaurs vanished into oblivion. The kelenken did not fade away as much from climatic shifts, but rather it had the predator-prey tables turned on it when the big carnivorous cats appeared. Nature's court of justice, or

The kelenken snatched prey while running and then shook it violently back and forth until it became stunned and lifeless. Sometimes it would pound its quarry to stillness with a few raps with its colossal head and beak.

the random principles of evolution, made these large flightless birds easy marks. However, a number of evolutionary clues suggest that some of the kelenken's traits (especially the structure of its beak) were passed on and survive in present-day falcons and eagles.

Duck of Doom

During the same geological epoch, the Middle Miocene period of about fifteen million years ago, an enormous duck flourished in the wooded areas of Australia. A bird named *Bullockornis*, dubbed the "Demon Duck of Doom," stood about 8 feet tall, had webbed feet, and looked remarkably similar to an oversized goose. However, unlike modern ducks and geese, this extinct bird preferred meat.

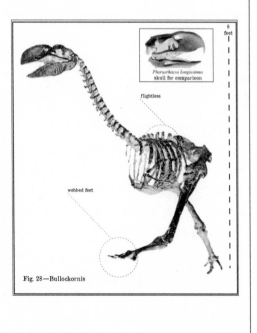

Phorusrhacos longissimus skull for comparison

flightless

webbed feet

8 feet

Fig. 28—Bullockornis

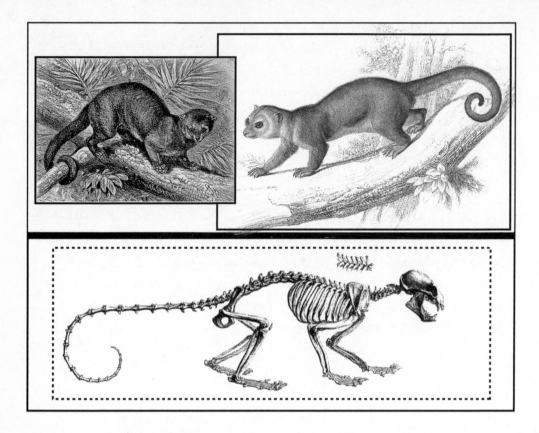

KINKAJOU
"Honey Bear"

This mammal of the Central American and South American rain forest regions is called a "honey bear," or sometimes a "sugar bear," though it looks more like a mixture of a weasel and a monkey. However, this tan-furred, long-tailed, 2-foot-long animal is more closely related to raccoons than to bears. It does have a sweet tooth, and after a dinner of fruit, ants, insects, bird eggs, or lizards, it likes to use its 5-inch-long tongue to lap the nectar from tropical flowers. Kinkajous often have their faces smeared with pollen when they dip their tongues into the next flower, and they therefore act unknowingly as indispensable pollinators of the rain forest.

The kinkajou is rarely observed, since the animal is extremely stealthy and secretive. It usually ventures out only after sunset, foraging until

midnight, and then again just before dawn. The honey bear wraps its tail around a tree branch and dangles from it like a bungee cord. The tail cannot grasp items or act as a fifth hand, but it is strong enough to pull its body weight

In the wild, the kinkajou honey bear wouldn't think of raiding a beehive and is never seen actually eating honey.

back up onto a branch. The animal is, however, very dexterous with its fingers and can carefully peel the skin from a mango if it so desires. Honey bears live in small family units and bond by regularly grooming each other. They find their way to one another in the darkness by scents and by barking and screaming, which sounds eerily like the cry of a woman in distress. Kinkajous fall prey to cats, snakes, and raptor birds, but not often, since they are keenly alert and agile. More so, they are frequently sought by humans for their thick pelts or captured to be transformed into pets. The kinkajou lives in the wild for about twenty years. The oldest-known zoo specimen is over forty years old.

Do They Make Good Pets?
Kinkajous are cute, and many are captured as pets. They are normally laid-back and low key, seemingly docile, but they freak out easily, spooked by loud urban noises and sudden movements. They are especially grumpy if roused from bed during the day and will screech, lunge, claw, and bite. A kinkajou has long incisors that make a deep wound. Once caged, kinkajous get an array of diseases, especially roundworm, which can transmit to the pet owner.

KOALA
Fussy Feeder

The koala lives mainly in the eastern regions and parts of the southern coast of Australia. The eighteenth-century settlers thought the animal a

miniature bear. It looks like one, but it is a marsupial, meaning its babies are born premature—by mammal standards at least—and finish maturing in the mother's belly pouch. The cuddly-looking, 20-pound stuffed toy–size beast has been around for nearly fifty thousand million years. Koalas were a bit bigger back then, when Australia was more than half covered by a rain forest and food was plentiful. They used to eat all kinds of foods, but as the rain forests receded, eucalyptus tree forests came to dominate. The koala adapted its entire digestive system in order to eat the new leaves of this usually indigestible and toxic plant and made this tree its exclusive food source.

One-Food Diet Plan

Koalas do not need to drink water. They get all their nutrients from eating more than 1 pound of eucalyptus leaves each day. They sleep eighteen hours a day, eat for three, and depending on the mating seasons, hug and groom for the remaining two hours, before nodding off for another long slumber. The time required to digest eucalyptus leaves might contribute to the fact that three-fourths of the koala's life is spent asleep.

At some point in their adaptation, koalas acquired a specialized bacterium in their stomachs, which actually draws the nutrients from the eucalyptus leaves by fermentation, the same way grapes are turned to wine. The mother must pass this bacterium to her young by gagging up a big gob of it called "pap," and spitting it into the newborn's mouth. Sometimes she passes this bacterium along by feeding the young handfuls of adult droppings or feces, which the toddler koalas consider special treats. If this transfer does not happen, the newborn koala will die of starvation, being physically incapable of digesting eucalyptus leaves. This internal fermentation process might also explain why koalas have very strong and repugnantly repel-

Check Expiration Date

There are more than 600 different kinds of eucalyptus trees, of which only 30 are acceptable to the fussy koala. Even among the trees it does like, a koala smells the leaves first, making certain the buds are not older than one year. Eucalyptus leaves that are older than that are toxic even to koalas.

ling odors. It also seems to affect their brains. Compared to the size of their skulls, koalas have one of the smallest and oddest-shaped brains in the animal kingdom. Almost half of a koala's head is filled with water, engulfing a small brain about the size of two shriveled almonds. Eucalyptus does not provide much of the protein or energy needed to maintain an active mind.

Do They Make Good Pets?

Sharp fangs, claws, and unpredictable behavior make koalas a questionable choice for a pet. Although in the forest, they are observed in groups, koalas usually like to keep to their own branches and prefer to be left alone. It is not easy to know when or why they will become irritated or what provokes them.

Life Cycle

A few centuries ago koalas numbered in the millions. Now, there are less than 50,000. In the wild, their natural enemies are primarily eagles and dingoes. Today automobiles and habitat loss are major threats. Koalas have been known to live for thirty years, but they are a species susceptible to diseases. In 2009 CNN reported an alarming number of koalas have been afflicted with "koala AIDS," and the Australian Koala Foundation predicts the species could go extinct within three decades if nothing is done.

Book 'Em

Koalas have two thumbs on each hand. The second thumb is where we have our pinky finger. They also have fingerprints that are nearly indistinguishable from human prints.

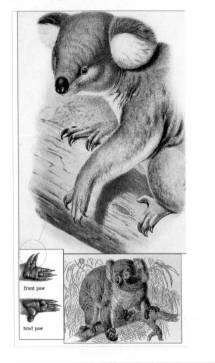

front paw

hind paw

Koalas seem docile and laid-back most of the time, but they can become vicious and attack with a biting lunacy when provoked, acting like teddy bears gone "Chucky."

KOMODO DRAGON
Largest Living Lizard

Komodo dragons are found naturally on only four Indonesian islands, where they flourish amid rugged terrain riddled with earthquakes and volcanoes that is reminiscent of a prehistoric world. The creature has remained unchanged for at least four million years, yet it went undiscovered by Western scientists until 1910. The Komodo has since gained infamy as the deadliest and largest lizard on the planet. Belonging to the genus of monitor lizards, Komodos have stout bodies with short, strong legs, and thick, powerful tails. The Komodo can grow to a length of nearly 10 feet and weigh more than 300 pounds.

King Killer

The Komodo has sixty scalpel-sharp teeth. Its mouth is literally a cesspool of biotoxins, containing more than fifty poisonous bacterium, including the deadly staph. Although unaffected by its own noxious saliva, a Komodo keeps these germs active by its own bleeding gums and from eating dead carcasses and chewing on feces. In addition, it produces snakelike venom from glands in its lower jaw.

The lizard has a 2-foot yellow, forked tongue that flicks and darts as the Komodo's head sways from side to side, detecting the scent of its prey.

Strictly carnivorous, the Komodo prefers to wait in concealment, its brown scales serving as perfect camouflage, until its prey is close. It then strikes its victim at either the throat or the gut, attacking anything from small mammals to a massive water buffalo. After it bites, it jerks

back, tearing flesh and inflicting heavy bleeding. If the animal manages to get free, the Komodo trails slowly behind, knowing its victim will soon die of sepsis, or blood poisoning. If the meal is small enough, it swallows its catch whole; but it can gorge on over 200 pounds of larger prey, such as a horse, in one feasting. That is the equivalent of a 100-pound person consuming 80 pounds of hamburger meat at a single meal.

At Peace with Itself

Komodos never seem bothered or hurried. They lounge in a shady burrow or sun on a rock if they wish, apparently with leisure. They have no natural enemies. When they decide to hunt, which is about once a week, rarely are they unsuccessful, displaying a degree of intelligence unusual among lizards.

They are mostly solitary hunters, but when needing a decoy, two dragons might work together to distract or lure prey into an ambush and then take turns eating the kill. When eating a kill or scavenging carrion, nothing much goes to waste. They leave only the fur and intestines. However, Komodos see nothing wrong with turning on a weaker member of their own kind and eating it as well.

Dragon Family Life

Among monitor lizards, with more than 30 species distributed worldwide, the new hatchling knows instinctively to fear its parents. The adults see their newborns as nothing more than food. A Komodo hatchling, for example, will bolt for the nearest tree and stay branch-bound for four years. The parents are too heavy to climb the tree to eat them, and only when the young are large enough, after feeding on insects, do they come down to begin their solitary life as a master predator. Monitor lizards' name derives from the Latin *monere*, meaning "caution," since they often survey the terrain ahead with outstretched necks, monitoring the surroundings. "Komodo" derives from the island where these lizards were first found, Komodo Island, part of an archipelago known as the Lesser Sunda Islands. As a species, the Komodo was once widely spread throughout Asia and Australia, abundant for more than twelve million years, but most died

Komodos can recognize numbers, and when tested by scientists, they display the ability to count in a rudimentary manner.

———

On the beach, Komodos measure human footprints left in the sand, unafraid of tracking even people, and they will enter a tent and hide under a pile of gear or wait under the crawl space of a bungalow.

———

In 2009, two Komodo dragons ganged up on a fruit picker in Indonesia and killed him. Although total deaths attributed to Komodo dragons are rare, the reptile has no fear of humans and treats us as any other prey when in their habitat.

out approximately twelve thousand years ago, except those on the isolated island habitats where they are found today. The Komodo dragon can live for more than thirty years.

Do They Make Good Pets?

There are about 7,000 members of this instinctively vicious species left in the wild, but some people have attempted to treat the Komodo as a pet. Like many animals, these lizards have individual temperaments, but some Komodos have been taught tricks, such as jumping through hoops to get food. Others have been leash trained, and certain lizards were said to be docile around children, at least while kept well fed. Most are quick to become belligerent, however, and ultimately cannot be fully trusted not to maim, or even kill, their owners.

Virgin Dragon Birth

In 2007, one British zoo-bound female Komodo, which had never been housed with a male, laid eggs that hatched. In what's called "parthenogenesis," the mother's genes fill in the gaps that normally would be supplied by the male in order to complete the full genetic code, allowing for a normal, nonmutant live birth. The hatchlings were not clones of the mother, even if all the newborns were females. Virgin births are not entirely unheard of among animals: scorpions, boa constrictors, bonehead sharks, and some insects have them, though no mammals have reproduced asexually, except perhaps once, as alleged in the Bible.

KRAKEN
Giant Squid

In the frigid North Atlantic waters between Iceland and Norway, 50-foot giant sea monsters reportedly regularly attacked medieval ships. These beasts had eight tentacles and bulb-shaped heads with two round eyes that were each bigger than a person. The few survivors of these surprise savage assaults described how the creatures' eight massive tentacles engulfed the wooden vessels, entangling and gripping them from mast to bow before plunging them, with all hands on deck, to the seafloor. The mere surfacing of a beast was equally dangerous, since moments after it breached the water, it created an instant whirlpool, which likewise sunk ships.

Krakens, as these real-life sea monsters are called, have been recorded in Scandinavian writings since A.D. 1100. They were even studied by early biologists, mentioned in the book *Natural History of Norway* in 1752. According to these speculative reports, the kraken, unlike a roaming octopus, anchored itself to the bottom of the ocean and resided there as an underwater beastly king. Larger fish would come to it, driving smaller schools of fish within its reach, and in so doing spare themselves from being devoured. Subsequently, there was always an abundance of fish found where a kraken lurked. Norwegian fishermen used to remark after a bountiful haul that a kraken was likely below. When the kraken grew too enormous to remain tethered to its underwater throne, it shot up to the water's surface, latching onto ships, or whatever it could seize in desperation, knowing that its reign was finished and that it would die shortly afterward.

Colossal Octopus

In 2002, the largest octopus ever recorded was captured off the coast of New Zealand. It had 13-foot-long tentacles, but it was not nearly as enormous as the krakens of old. Squid, a different species than octopuses, grow larger. One was found, again off the coast of New Zealand, that was 33 feet long and weighed 992 pounds. Squid or octopuses that attacked wooden ships might have mistaken the vessels for small whales; octopuses are carnivores and will try to eat whatever looks like a meal. They use their tentacles to hold their prey while they then tear it apart piece by piece. As for its own es-

cape, an octopus will release an inky dark fluid to conceal its whereabouts while fleeing. Both squid and octopuses have eight arms, but squid have fins while octopuses do not. Octopuses, like the kraken king, live solitary lives, while squid prefer to roam in schools. Both have a short life span of usually no more than five years.

KUMO
Mythical Monster Spider

Long before Godzilla and Mothra, Japan was plagued by a huge arachnid, a hairy spider that according to folklore was bigger than a human and had

eight eyes as huge as headlights. Its coloring was muted gray, mixed with browns and blacks, such that, when stationary, it often appeared as a heap of discarded clothing or rags. It did not weave webs to trap prey but instead hid in abandoned houses or at wayside shelters. When unwary travelers entered, the kumo remained still until the people fell asleep. It then encased the person in a tightly bound web thicker than rope. The kumo did not devour its victims immediately but rather drained blood from them in rationed amounts.

The legend of the kumo appears in a number of morality tales; it apparently attacked humans who needed to learn a lesson, such as when a greedy old man was captured and only released when he learned to become more generous.

Meet the Largest Real Spiders

Spiders have existed for some three hundred million years. Among living species, the giant huntsman spider is considered to have the longest legs. Found in Southeast Asia, the huntsman has eight limbs that each measure 12 inches. The Goliath bird-eater spider lives in the South American rain forests and also has large legs, nearly 1 foot long, but it is thicker bodied than the huntsman and about the size of a personal pan pizza. It is fond of eating hummingbirds, bats, and rodents. It does not build webs; rather, it ambushes prey and then paralyzes it with a venomous bite.

LAGARFLJÓT WORM
Glacier Eater

Searching for the Lagarfljót Worm

A giant worm lives in a lake in the eastern region of Iceland, according to local folklore. It was first observed in A.D. 1345 and has been seen periodically through the twentieth century. More than 300 feet in length, it coils near the shoreline and only rarely slithers at the surface. Even though it has sharp teeth and can emit a foul gas, it seems to be a herbivore, since it is not known to attack animals or plague human populations in the vicinity. It is a thin lake monster, only about as thick as a man's thigh, and is said to have both gills and lungs, able to live underwater or on land. Many consider it as an omen that something momentous, either good or bad, is about to happen whenever it does make an appearance. The colossal creature survives in the Lögurinn Lake, which is pure but murky from silt deposits and erosion. The lake is a basin for water flowing from melted glaciers carried by the Lagarfljót River. Even if an entire class on a school trip recently reported observing it slithering upstream, taking ten minutes to pass, the "worm" is likely grasses and weeds whorled together

```
┌─────────────────────────────────────────────────────────────┐
│                      Lake Monsters                          │
│                                                             │
│  Among creatures unexplained by science, lake-dwelling     │
│  beasts are the most common, with more than one hundred    │
│  various creatures located worldwide. The worm of Iceland  │
│  is unlike the long-necked lake monsters, such as the Loch │
│  Ness creature. The Ogopogo of Lake Okanagan, British      │
│  Columbia, is another fabled worm monster about 15 feet    │
│  long, with fins on its head and body that when swimming   │
│  resemble limbs. Champ of Lake Champlain, New York,        │
│  allegedly is about 30 feet long, with no visible head,    │
│  though it has humps along its back.                       │
└─────────────────────────────────────────────────────────────┘
```

by currents, or optical illusions caused by bursts of methane gas, which is found in high concentrations on the lake bottom.

What Is It?

The Lagarfljót worm is often suggested to be a giant eel. There are nearly twenty known species of freshwater eels, though none of such gargantuan size, even if some marine types reach 8 feet in length. An eel is mostly tail, with the majority of its organs located close to its head. Under unique conditions, an eel's tail can grow to unlimited lengths.

LANTERN SHARK
Glow-in-the-Dark Shark

The lantern shark has developed a counterintuitive camouflage technique, employing light as a means to deceive and confuse would-be predators.

The lantern shark is one of the smallest sharks known to exist and grows to no bigger than the length of your arm. It swims mostly throughout the Atlantic Ocean, although it is sometimes seen in the Pacific Ocean near Japan and off the coast of Australia. Its favorite food is fish eggs.

It produces a hormone and chemical called

"luciferin" in its belly that reacts with oxygen to create a blue-green light, similar to glow-in-the-dark sticks. This makes it blend in with the natural light in the ocean and go undetected by larger fish. Among living things, the production of a cold light source, which does not give off much heat, is known as "bioluminescence." Sailors once thought the shark's strange light was from ghostly sea lizards that feasted at night on souls lost at sea. In fact, lantern sharks seem to gather near hydrothermal vents, hotspots in the ocean where water is heated from underwater volcanoes or from shifting tectonic plates.

Samuel Coleridge's poem The Rime of the Ancient Mariner *alludes to creatures similar to the lantern shark:*

> Yea, slimy things did crawl with legs
> Upon the slimy sea.
> About, about, in reel and rout
> The death-fires danced at night;
> The water, like a witch's oils,
> Burnt green, and blue and white.

LEAFY SEA DRAGON
Master of Camouflage

Fig. 34—Sea Dragon *Phycodurus eques*

Looking like seaweed can have its advantages, especially if you are a small, fragile seahorse living among the rough-and-tumble reefs along Australia's southern and western coastline. Leafy sea dragons are covered with body protrusions that appear nearly identical to leaves; if it remains motionless among a patch of seaweed, it is practically impossible to spot. It even found a way to propel itself in a slow-motion manner, resembling a floating weed, by having only tiny movable fins on its head and another dorsal fin near its tail.

What Color Is Your Mood?

This seahorse grows from 8 to 18 inches and eats lice, plankton, shrimp, and small fish that it catches easily with a long, dragonlike snout. Predators or prey can rarely see it, not only because it looks like a plant, but also because it has the ability to change color at will to match the hues of its aquatic environment. A certain diet can affect color changes, but the leafy sea dragon can also turn a different shade when stressed, rang-

ing from brown, pale pink, blue, green-yellow, and reddish. It chooses different color combinations when feeling content or for mating, and it can even make itself transparent when, perhaps, it does not want to be bothered by anything.

The downside of hiding in plain sight and a go-with-the-flow lifestyle occurs when a sudden wave flushes a seahorse from the reef, making it impossible for it to return to the habitat where it is most suited. Unlike other seahorses that have gripping curled tails, the leafy sea dragon cannot anchor itself during turbulent conditions, and it is either blown out to sea or washed ashore. Leafy sea dragons, if very lucky, live in the ocean no more than three to five years.

Tricks of Camouflage

Some animals have fur that changes color depending upon the season. For example, the arctic fox sheds its summertime darker coat to one of snow white as winter sets in. Environmental temperature changes and shortening of daylight trigger an animal's hormones to help make its natural camouflage more adaptive. For fish, reptiles, and color-changing amphibians, many have cells called "chromatophores," each containing a certain color pigment. Another master of marine camouflage, the cuttlefish, has minuscule muscles surrounding each of its chromatophore cells. It can willfully constrict the muscles attached to the color cell of its choosing, changing its skin the way an artist squeezes paint from a tube.

LESOTHOSAURUS
Chicken Dinosaur

This two-legged little dinosaur looked like a featherless chicken scurrying about, and, according to its hipped-bone structure, it was probably an early ancestor of several bird species. It was about 3 feet tall and ran on two legs. It usually traveled in large packs or flocks, darting about from boulder to shadow in a frenzied manner. Its nervous and swift-footed disposition was a necessary adaptation since it was a bite-sized nugget to many of the large carnivorous dinosaurs that were about. Lesothosaurus was a herbivore that became extinct about sixty-five million years ago, when it is theorized that asteroid impacts darkened the sky and polluted the earth's atmosphere for at least a decade, likely killing off the lesothosaurus's favorite plants.

LEUCROTA
Speed Demon

This mythical hybrid beast lived in India. Its badgerlike head had a wide mouth that could open from ear to ear like the Cheshire cat's. It was as long as a donkey but the height of a dog, with deer legs and a lion's tail. Leucrotas lacked teeth and instead had hard, bony-ridged planks that served as jaws to mash and saw its prey into pieces.

The leucrota reportedly plagued humans' attempts to domesticate animals and clear forests, both necessary for early agriculture. Second-century Roman writer Claudius Aelianus claimed to have seen the beast during his travels and related how it had the ability to imitate human speech, including the inflection and accent of the speaker. In one incident, woodcutters were clearing an area while leucrotas hid secretively

in the brush. The beasts listened to the men for many hours. By evening, the leucrotas moved off some distance and began calling out a man's name. As the woodcutter followed, they backed away, leading him deeper into the forest until he was alone, at which point the leucrotas devoured him.

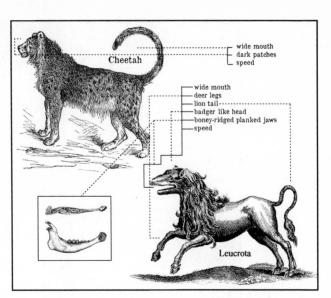

wide mouth
dark patches
speed

Cheetah

wide mouth
deer legs
lion tail
badger like head
boney-ridged planked jaws
speed

Leucrota

What Was It?

There is, of course, no animal with planked teeth that can speak in a human voice. However, a clue found in ancient records related to the leucrota's speed, said to be the quickest among beasts, which matches that of the cheetah. A yawning cheetah appears to have a wide mouth, and the black fur marks under its eyes—like the cheek smudges worn by athletes to cut down glare—gives it a different look than most cats. Cheetahs are the fastest land mammal, reaching 60 miles per hour. They are daytime hunters, and, for this reason, they need speed to survive, rather than stealth like most feline predators. Cheetahs are found in Africa and southern Asia and might have been the leucrotas the ancients feared. However, the cheetah's body is vulnerable, designed as it is for speed and not for tangling with lumberjacks. In fact, most of the game cheetahs kill is rapidly absconded by hyenas and lions, which the small cat relinquishes without a fight. Cheetahs live for about twelve years.

To trick hunting dogs, leucrotas mimicked the sound of a man vomiting, and when the dogs went toward it, thinking their master was in distress, the beasts ate the dogs. The leucrota was devilishly difficult to capture and thought to be the fastest-running animal of all.

LION
King Carnivore

Prehistoric ancestors of the modern lion first appeared in Africa more than seven hundred fifty thousand years ago. Various subspecies spread throughout Europe, Asia, and North America. However, by the end of the last Ice Age, around ten thousand years ago, most of the prehistoric strains, including the European cave lion and the North American lion, had disappeared. During those earlier millennia, the lions were adaptive predators, reaching a worldwide sprawl that was comparable among animals to that of primitive man. If not always the apex predator in the days of saber-toothed tigers and giant bears, the lion was indeed formidable and feared as a powerful and aggressive beast. The Northern American lion, the biggest lion of all time, grew to 11 feet and weighed 700 pounds,

while the modern version is still massive at 6 feet, topping the scales at 500 pounds. Now, lions live naturally only in sub-Saharan Africa and in parts of India.

Lioness Club

Most predatory cats are solitary hunters, but the lions' success, in part, rests on their intricate social network and group hunting. Lions live in family units, called "prides," consisting of ten to twenty females and their cubs, under the dominance of one or two

males. The lionesses hunt more often than the males and use ambush methods, sometimes employing decoys to drive prey to where other lions are waiting. They even learn to communicate in the field, using the tufts of hair on the end of their tails as pointers, sort of as silent walkie-talkies to give directions and information on the progress of the prey. The male lions are responsible for marking territory, up to 100 square miles, with the scent of their urine or by physically marking trees and keeping away intruders. For this, even though the lionesses usually acquire the food, the males are given the right to eat first. Sometimes, however, the females clamp down on the catch and refuse to give the male his traditional first bite. Mealtimes are not relaxing for the pride, as fights, clawing, and even death occur over dinner.

Hairdos Only Last So Long

The males have distinctive manes, and usually the ones with the thickest and fullest hair are considered most attractive to females. The male lions' reign is in constant jeopardy, challenged frequently by young males. Their rule of the pride usually never lasts more than a few years, at best, until they are driven out or killed in battle by a stronger, younger lion, re-

gardless of how good-looking their manes might be. Most of the pride consists of related females, male and female cubs, and older sisters and aunts. The young male lions are driven away at around three years, and it is not uncommon for brother lions to hunt together for life, until they can together usurp a lion of another pride. The old dethroned lions turn to a life as solitary hunters and usually die shortly after; as they grow feeble and old then are even attacked by predators, especially hyenas.

The lionesses enjoy lifelong stability, or at least more so than males, although they might suffer the murder of their cubs when a new ruling lion takes over.

A number of old lions become man-eaters, finding humans, which they normally avoided, as easier prey. In 2004, an elderly lion, nicknamed the "Cunning One," was blamed for eating forty-three people in a village in Zambia. Tanzania reports at least one hundred human deaths at the jaws of mostly older lions each year.

What's for Dinner?

Lions have strong front legs jointed in such a way that they can catch prey by the neck and clutch it in a sort of headlock. They flip it over to break the animal's neck. They also frequently kill their prey by suffocation and merely enclose the animal's mouth or snout in their powerful jaws until

it stops breathing. Sometimes they go for the jugular vein, but, in all cases, they do not like to struggle with their meal or fight with it for too long. Leaping on a running animal's back and going for a death-defying ride is the most dramatic but the least favorite method of acquiring meals.

When in the midst of a hunt, the lioness jumps horizontally to over 30 feet, and leaps as high as 12 feet into the air. As for speed, lions run no faster than 30 miles per hour and only for a distance of less than 50

Legends say the lion uses some sort of telepathy that calms its prey, telling it that its death will be fast and less painful if not resisted. More likely, though, is that the weaker animal is immobile from shock or counting on some miracle of camouflage not to be noticed.

yards before becoming winded. Many animals, once cornered by a lion, run like mad, while others freeze as if hypnotized by the lion's gaze.

The lion has sharp 1½-inch-long claws, which are retractable and spring open with the swiftness of switchblades. The lion's teeth include front incisors that are 5 inches long. Lions can eat 40 pounds of meat at one time, and then usually do not eat again for four or five days. After these feasts, lions often sleep for eighteen to twenty hours each day.

Last Roar

Lion cubs have the highest mortality rate, compared to other large cats, with fewer than two in ten surviving the first year. Many die from teething, an apparently painful process, as their large teeth move into place. While teething the young are unable to eat. They are also the last in line at all meals, and when food is scarce, many frequently starve, or, as mentioned earlier, they are eliminated by a new male that takes over a pride. In the wild, lions live for about twelve years. The elderly or infirm are shunned, and themselves fall prey to predators when unable to keep up with the pride or they are cast out from the group.

Lions are strong, but they could be called lazy, preferring to lounge for nearly a week, or more, in between meals.

———

A lion's roar is truly bloodcurdling and so powerful that its exhale is strong enough to turn a cloud of dust into a minitornado. The roar is audible for nearly 3 miles.

LIOPLEURODON
Mighty Marine Marauder

This aquatic reptile once dominated the oceans that covered Europe about 150 million years ago. Its skull was the size of a tall man, over 6 feet long, and it had a long snout filled with shredding teeth. It had paddle arms for propulsion and an enormous bulging body, which extended another 30 feet to its tail.

Liopleurodon ferox

It liked to lie in wait, camouflaged in green-algae-covered lagoons, and lunge from the water to munch on shore-feeding dinosaurs. However, even though it had to breathe air, its hugeness made it a prisoner of the sea. It was too cumbersome to leave the water, or it would be beached and suffocate under its own tremendous bulk. As voluminous as it was, when hunting in water, the liopleurodon swam swiftly and caught prey with rapid surprise attacks. It had developed pulsating nostrils that were highly developed to detect scents even underwater. The last liopleurodon disappeared along with all the great dinosaurs, around sixty-five million years ago.

LLAMA
Andean Spitballer

Llamas once roamed the North American plains, but when the last Ice Age began to subside about ten thousand years ago, they migrated to the Andes Mountains of South America and made that area their exclusive natural range. It is hard to know how the original llamas behaved since like the alpaca, a smaller llama relative, the animals were domesticated by the Incas. An undomesticated relation of both llamas and alpacas is another high-altitude cameliod beast called a "vicuña"; all these animals have similar traits and are famous for their unusual ability to spit a considerable distance, with a fair degree of accuracy.

The High Life

Few animals have successfully adapted to living in altitudes as high as planes fly, where air is nearly 50 percent thinner than it is at sea level. Llamas have large concentrations of oxygen-carrying proteins in their hemoglobin, which make them capable of living at heights of 13,000 feet. Llamas are plant-eating herd animals that prefer to group among related family members. They usually have one male as leader of the herd, but this status changes easily; they do not like to get into serious confrontations among their own kind, although they do bite each other when an argument arises over vying for a mating partner. Female llamas give birth to one baby at a time after an eleven- to twelve-month gestation.

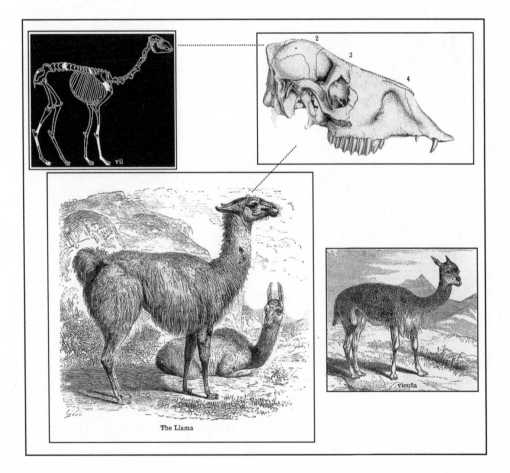

The Llama

vicuña

Llamas give birth only from 8 A.M. to noon, when it is the warmest in the high mountains. During and after labor, other females will gather around the new mother with her calf and form a circle to block the wind and protect the newborn from predators.

———

Llamas spit to keep younger members of the herd in line, and females might spit at males that are being too aggressive when they wish to be left alone.

———

In the wild, leopards, cougars, and condors (when llamas are very young, old, or ill) are their natural enemies. Llamas live on average for about twenty-five to thirty years, but some have lived for as long as forty years.

Llamas grow to about 4 feet tall at shoulder height and reach 6 feet to the top of their head. They can weigh about 280 pounds.

The Incas' Llama

The natives of Peru and the Andes first domesticated llamas over four thousand years ago. There were no horses or donkeys, and the llama became the only means of transportation moving cargo. During the Incas' reign, llama and vicuñas were prized for their wool. The hairs of the animals were considered so valuable that laws permitted only royalty to wear vicuña wool garments. The llama was such a valuable creature to the people of the high countries that the dead often had llama statuettes buried beside them in their graves, supposedly to help in the afterlife.

Spit Speech

Llama spit is partially digested food it draws up from one of its four stomachs. Since llamas can regurgitate easily and rechew food called "cud" in their mouths, they have a wad always ready for disposal. When they do it, the sound is more like a cough than a spit. The spit's intensity ranges from a large amount of nauseatingly foul-smelling goo to as little as a small spray.

In general, a llama spits to convey annoyance. How angry it is determines how down deep in its stomach a llama reaches, knowing that hocking up spit from its digestive tract has the most atrociously putrid smell and taste, thus making a stronger statement. Happier llamas can hum to each other; they communicate alerts to the herd by making a braying signal.

LONGISQUAMA
Evolutionary Enigma

The first flying vertebrates appeared about 225 million years ago. One lizard from that era seemed to be caught in the cross fire of evolution and apparently had no wings, but it did feature a series of long feathers that grew out of its spine. This would appear to be a futile adaptation that would only serve to knock it down sideways in a strong wind. Perhaps its plumage served as a camouflage to make it look like a walking fern plant? The spine feathers might have been a deterrent and offered a mouthful of gagging fluff to whatever predator that wanted to eat it. The longisquama was unusually small for dinosaur times, at only 6 inches long. Nevertheless, what appear as feathers in fossils might be elongated reptile scales, subsequently not making the odd lizard a precursor of flying animals after all, but rather a mysterious evolutionary dead end.

LOVEBUGS
Insect Honeymooners

Swarms of attached insects invade the Gulf Coast regions of the United States and throughout Central America each May and again in September. They fly as couples in a meandering way, joined at the abdomen. The insects emerge in such numbers that they darken the sky, as if it is raining black soot. More than several hundred thousand can fill an air

Lovebug *(Plecia nearctica)*

space no larger than a football field, all the way from the ground to more than 1,400 feet up into the sky. They do not bite or sting but do have an acidic blood that corrodes paints, clogs car radiators, and smears windshields in a mass as thick as glue.

The lovebug is a member of the march fly family, which contains about 700 species, and spends most of its early stage of development undetected, living inconspicuously in grasses and among marsh reeds. It has a narrow black body with a red middle part below the head, or thorax. Females are about ⅓ inch long, while the males are smaller, measuring ¼ inch in length. Although both flap wings during flight, the females do most of the work and face forward while the male looks in the opposite direction, seemingly going along for a ride he cannot escape.

Locked in Embrace

Lovebugs go through a complete metamorphosis, from egg, larva, pupa, and adult. The larva stage lasts the longest, from around six to eight months, hatching from the three hundred or so eggs laid under decaying vegetation. The pupa, or miniature adult phase, extends for about a week. However, when temperatures reach more than 68 degrees and the days have more light, the adult males climb to the top of reeds and wait for the females, which soon come forward in swarms.

> *The lovebug is so odd, most think this natural phenomenon is a result of a bioexperiment gone bad.*

Buxom Bugs

The larger the female, the more desirable she is to the males. The swarming females are gripped by the tinier males, and held on to with all their might, until the males can manage to attach themselves to the females'

abdomens. The male does this to deposit sperm into a female's peculiar reservoir and fertilize her eggs. If a pair mates toward evening, they wait as a couple until daylight before flying away attached. They may disengage and mate again, but most couples stay irrevocably conjoined for a few days. The adult female will separate only when she is ready to deposit her eggs, but afterward, she dies within seventy-two hours. The male lives a bit longer, for approximately ninety-two hours, before sheer exhaustion ends his brief but passionate existence. Lovebugs have few natural predators due to their acidic flavor. Not many birds think of them as food; even most spiders pass on a meal of lovebugs.

LOVELAND FROG
Creature from the Black Lagoon

In the dark rivers of central Ohio in the United States, according to local folklore, there lives a 3-foot-long creature that walks upright, has the skin of a frog, and bears facial features similar to a human's. Its face is slightly distorted, however, and has a wide mouth without lips, though its eyes and nose are humanlike. It has wrinkles, skin folds, or hardened ridges instead of hair. It also has use of its hands since it was spotted once carrying a portion of a steel pipe. It lifted the metal bar high and was strong enough to strike it against a rock to cause sparks. It lives primarily in water, but probably is amphibious, as it is believed to be the cause of small and unexplained campfires found along riverbanks, where it tries to warm itself during cold spells. It has never been seen in winter, when it's

suspected to be hibernating. In the spring and summer, it emits a strong odor similar to almonds, which is assumed to be a scent it uses to mark trails or perhaps to attract others of its species during mating season. It is extremely shy and does not seem to want to harm anyone, and it has been frequently shot at when encountered by chance. No specimens have been captured alive, and no carcass of the Loveland frog has been found, though many believe it still exists.

Lizard People

World mythology has numerous references to reptilian humanoids. The earliest stories of creation found in Babylonian texts describe a race of ancient aliens that came to colonize the earth. In artwork, these beings are depicted as humans with reptilelike features. The Chinese have a similar mythology depicting "Dragon Kings," humans with reptile bodies. In Native American folklore, oral histories describe how a meteorite, or some huge celestial object, fell, which caused many to seek refuge underground, living in a labyrinth of tunnels. In South Carolina, there are reports

of a "Lizard Man of Scape Ore Swamp," who is 7 feet tall and lives in drainage pipes and lagoons. Proponents of the Loveland frog, and those who claim to have sighted other humanoid reptiles, theorize that such creatures were products of genetic material transported by meteorites. Others say these creatures are castaways from the ancient aliens and were abandoned when their race left the planet, considering the earth inhospitable. It's said they now live in tunnels and sewers scattered around the world.

MANTICORA
Human-Lion-Scorpion Mix

When humankind first inhabited the earth, many terrifying creatures were here before us. In 400 B.C., a learned doctor and diplomat in the Persian Court, Ctesias, wrote twenty-four books in which he cataloged various ancient animals that oral history was still able to remember. He described a man-eating "manticora," a beast with a lion body and a humanlike face. Some said it had either blue or gray eyes and three rows of teeth in its human-looking mouth, and its jaws could open incredibly wide. It spoke in a shrill, whistling, or sometimes flutelike, voice, which the voracious beast used to confuse people or entice them closer. It was very strong and could leap considerable distances, both horizontally and vertically with apparent ease. It also had a spiked tail, tipped with a scorpion stinger. Some witnesses encountered it in Africa, while others said it lived in India.

Incredibly, sightings of the beast persisted into the twentieth century. One manticora was reportedly hit with clubs and driven away by villagers of Ugijar, Spain, during the 1930s. A genus of tiger beetle is also called *Manticora*. In African folklore, the beetle is an evil creature and capable of bringing about unavoidable doom, if not death. As for the beastly manticora, no one knew why the manticora so hated humans, or if it was a nightmarish and imaginary invention. Not every living thing left a fossilized record.

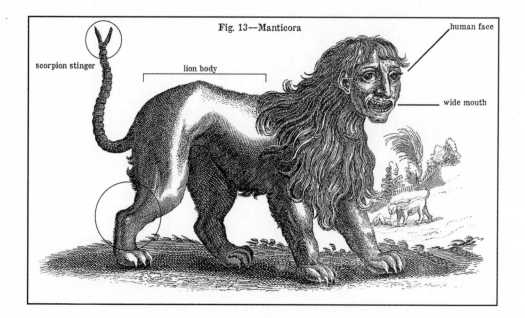

Fig. 13—Manticora

scorpion stinger

lion body

human face

wide mouth

> *The absence of fossil evidence for intermediary stages between major transitions in organic design, indeed our inability, even in our imagination, to construct functional intermediates in many cases, has been a persistent and nagging problem for gradualistic accounts of evolution.*
> —Stephen Jay Gould

MEGACHASMA
Newly Discovered Shark

8-foot shark

6-foot diver

No one had ever seen this 18-foot shark, *Megachasma pelagios,* until 1976, though it has been cruising the Pacific, Atlantic, and Indian Oceans for eons. It has a huge mouth that it keeps open while it swims, scooping in jellyfish and plankton. Only around 50 of this megamouth have been observed since its discovery. It is related to a primitive shark genus that lays eggs, which incubate inside the mother until ready to hatch. How this large shark remained elusive and unidentified puzzled ichthyologists (shark scientists), though a similar creature was depicted in medieval woodcuts. The megamouth shark, or one similar, was shown transporting Neptune, the god of the sea. Some say that when the first of these elusive sharks was captured, entangled in the anchor of a U.S. Navy ship near Hawaii, its magical invisibility was breached. Scientists believe that only about 40 percent of marine species are identified; the unnamed are assumed to be small creatures, such as different types of crustaceans or krill. For large species such as the *Megachasma* to go undetected is rare.

MEGALODON
Largest-Ever Marine Predator

This enormous shark had a jaw and mouth that in themselves were bigger than some studio apartments. It was literally the length of a house, at more than 60 feet long, and weighed 70 tons, which is more than three times the size of its likely descendant, the great white shark. Its triangular teeth were 7 inches long. In medieval days, when the creature's fossilized teeth washed ashore, or were unearthed while hoeing fields, people thought these specimens were actually dragon teeth and valued them as prized possessions.

When It Ruled

In its day, sometime after the giant marine lizards and dinosaurs disappeared, the megalodon shark came to dominate the seas and was probably the largest marine predator that ever existed, ruling from twenty-five million to about one and a half million years ago. Then, all the oceans were warmer and connected, not blocked by the Isthmus of Panama, which allowed the monster predator to terrorize and roam the world. At that size, it preferred deep-sea waters and fed on whales. It came close to shore during breeding and gave live birth to offspring that were 8 feet

long and equipped to eat at arrival. As these sharks had no natural predators, their extinction most likely had to do with temperature increases in ocean waters.

Though megalodons are thought extinct, there have been infrequent eyewitness sightings during the twentieth century: one in 1918 and another in 1938, with more recent claims of this beast surfacing off the coast of Indonesia. Although it's unlikely that the megalodon survived, the fact that less than 10 percent of the ocean has been fully explored leads some to think it possible that some of these beasts may be still breeding in ocean trenches or that a subspecies of megalodon still lurks, one that adapted to cold water and intense deep-sea pressure.

> *It is not the strongest of the species that survives,*
> *nor the most intelligent that survives. It is the one*
> *that is the most adaptable to change.*
> —CHARLES DARWIN

MERMAID
Magical Maritime Maiden

Many ancient cultures shared stories about encounters with a creature that had the tail of a fish and an upper body resembling a woman. John Smith, the famous English settler remembered for his relationship with Pocahontas, saw a mermaid in 1614, saying the creature had long, green hair and she was "not at all unattractive." Explorer Henry Hudson also spotted one,

In 1842, circus ringmaster P. T. Barnum fooled many when he displayed a "mermaid" carcass, which later proved to be monkey bones sewed together with a fish body. In 1910, many saw a mermaid briefly sunning herself off the coast of Ireland, and in 2004, a partial carcass of such a creature was found washed ashore in India after a tsunami, though results from studying it proved to be inconclusive.

writing that she had long black hair and a sparkling tail similar to a dolphin's. Christopher Columbus sighted three, but, in his opinion, they were not as beautiful as legend described, saying, "in the face they looked like men." The Bible describes how during the time of the Great Flood, certain sea-women, sea-men, and even sea-dogs survived by growing fins and becoming half fish. Some evolutionary theories described how our earliest human ancestors had ties to the sea, the primal cauldron of all life. New studies propose that humans descended from a type of aquatic ape and not terrestrial primates. That mermaids were apes whose legs fused to make it easier to survive in water instead of on land is improbable, though in nature's imagination nothing seems entirely unfeasible.

Magical or Mischievous?

Composite descriptions picture this form of sea-dwelling primate as breathing air and not having gills. Native human pearl divers can hold their breath for ten minutes and reach depths of 150 feet without scuba equipment. The longest record for such a feat was nineteen minutes and twenty-one seconds, achieved by a Swedish free-diver in 2010. To get to the gates of an underwater metropolis, where such creatures exist, would require even longer breath-holding capabilities, in addition to anatomical adaptations that could withstand extreme underwater pressure. Even so, not all stories of mermaids and mermen considered them as friendly, and it seemed many used their brief appearances as lures to trick sailors. In some mythologies, mermaids relished human flesh, causing ships to wreck on rocks and then devouring the floundering sailors.

Sirens' Song

In ancient Greece, many believed in a creature similar to a mermaid, but it seemed more like an ugly bird-woman than a beautiful mermaid. This species, called a Siren, had incredible auditory abilities and could sing a mind-altering song, which apparently affected men's hormones. In Homer's epic poem *The Odyssey,* he tells of how the hero Odysseus lashed himself to the mast of his ship so as not to be lured by the Sirens' hypnotizing song, thereby avoiding certain death. It was known that no man who heard the Siren's song could resist its pull. The upper portion of a Siren was humanish, but everything from the torso down was a full-feathered bird with talons, including a pair of wings at the waist. Sirens lived in remote coastal regions, predominately around the Mediterranean Sea, and preferred to nest in high, rocky perches. They were omnivores but preferred to eat large fish and animals, including men. The song the bird-woman sang was so alluring that all who heard it were driven to find its source, doing so without reason, risking all. The Siren could also sing another melody that put a person immediately to sleep. In either event, the Sirens used this trickery to subdue their human prey.

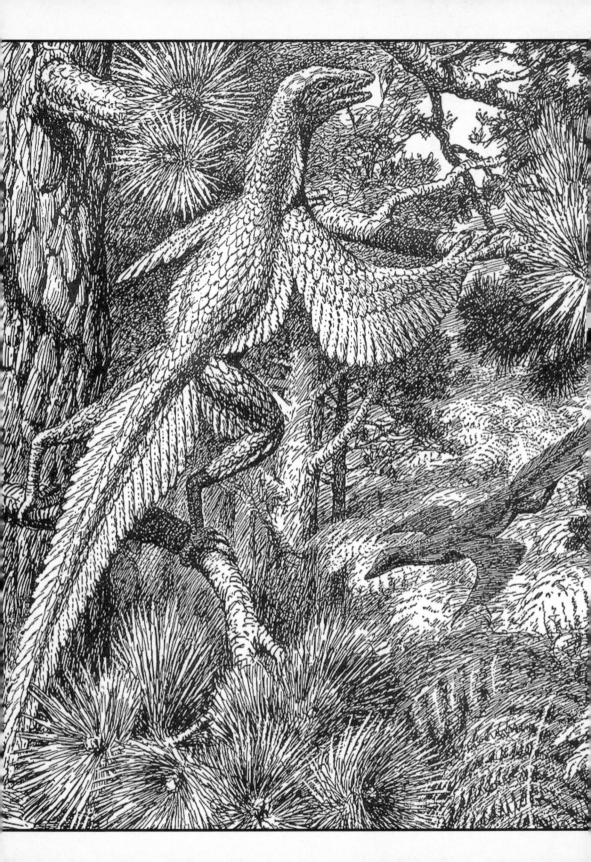

MICRORAPTOR
Four-Winged Bird Prototype

This small, 3-foot, 2-pound flying dinosaur had four wings. Alive 120 million years ago, the microraptor had a number of unique anatomical attributes that offer one of the best examples of how lizards could have transformed into birds. From numerous fossil evidence of this species, we know that these creatures were once exceedingly abundant in their time. This flying dinosaur was entirely covered with long brilliantly colored feathers, even on its legs.

A pair of wings was set where birds typically have them, while the second pair grew from its legs. Aerodynamically, it was suited for gliding, though probably not built for swift departures, and it got tangled in branches and thick primeval vegetation easily. The way its wings were situated, similar to a Wright Brothers biplane, the microraptor probably had to hop up to a high branch and jump off before using its four wings to lift into the air currents. It is no wonder they were such a quick food source in the ancient days, and a model, for birds, at least, that was eventually shelved by nature's blueprint department.

"Great Chain of Being"

Before the 1800s, most people believed that all animals once created still existed somewhere. The notion of extinction was unheard of, and people believed that beasts and creatures of the past were merely hiding in some still unexplored portion of the earth. Extinction was not accepted as a reality until 1796 when naturalist Geroges Cuvier proved that not all beasts, as proved by fossils, evolved into something better. He made popular the notion of geological "catastrophism," which is when short-lived and violent natural events caused the disappearance of species. For centuries, when theological ideas influenced science, many believed in the "Great Chain of Being," from the Latin term *scala naturae,* or the "stairway of nature," which espoused that every species was created exactly as it appeared and never changed.

MINOTAUR
Mazed and Consumed

A man with a bull's head once lived in Greece. According to mythology, it was captured and housed in a specially designed maze. The beast was explained as having been transformed due to various gods' trickery or from gods or humans breeding with animals. The minotaur stood at 7 feet tall; it was carnivorous, or possibly an omnivore, but it was primarily fond of eating children, which were sent into the beast's labyrinth as sacrifices.

The minotaur was eventually killed by a hero named Theseus. He famously found his way out of the beast's maze by tying a string to the entry door and unfurling the twine as he went.

For countless centuries, many people believed such a creature once existed. In ancient times, physical abnormalities caused by birth defects often resulted in the person being treated as inhuman, or demonic. Descriptions of this beast appear so often in literature that the legend of such a thing might have stemmed from an actual per-

son who had an odd-shaped head, similar to a bull's. Many ancient stories of hybrid beasts were told and retold to teach lessons in morality. As an imaginary beast, the minotaur symbolized death, among other subconscious fears, and its maze was a metaphor for life's uncertainty, though navigable by following a string of a solution, whichever one that might be. There is no evidence the minotaur actually existed, and if it did, it was likely a one-of-a-kind mutation that sparked people's imaginations.

MOLE
Master Miners

The mole's ancestor, a mouse-sized mammal, survived by going underground during the Oligocene epoch, some twenty-five million years ago, as the earth went through profound climatic changes. Polar ice caps were forming, and tropical rain forests receded, which allowed grasslands, large savannahs, and deciduous forests to flourish. In general, many mammals got bigger during this period, but the mole found its strategy for survival in the subterranean world, becoming a powerhouse tunneler, with natural tools specialized for digging and thriving in the dark.

How They Look
There are 20 species of moles found in North America, Europe, and Asia. They range in size from the smallest, the American shrew mole, which is only about 3 inches, to the biggest, the Russian desman mole that grows to 9 inches long. Moles are cylinder shaped with soft, thick fur. They have tiny ears and long, lobe-shaped snouts. A mole's nose contains a

thing called an "Eimer's organ," which contains as many as one hundred thousand nerve fibers. The mole's nose serves as its primary sensory tool and helps it "see" underground. All moles have eyes, but, in some species, they are covered with flaps of skin that allow them to perceive light from dark, but for all intents render them blind.

Super Mole

Moles are such powerful diggers, with a tunneling strength and speed of excavation that finds few rivals in the animal kingdom. Moles have long, hard claws, which move from the center to the side as they plow through soil. When a mole digs, it breaks the ground with its claws and by moving it head and claws in unison, it pushes the dirt below its body. With its hind feet it pushes and kicks the loose soil toward the hole opening at the surface. A mole can tunnel for four hours at a time, but it then needs four hours of deep sleep before resuming.

Moles dig tunnels through hard ground at a rate of 15 feet per hour, or in softer terrain as rapidly as 1 foot per minute. A carbon-dipped bit used to drill water wells averages only 10 feet per hour through bedrock. The mole can move backward or forward with equal ease. It is a virtual biodigging machine, capable of exerting tremendous force with its tiny body. If we

Moles bore well-engineered tunnels with narrow diameters, which require no support to prevent collapse.

had the mole's comparable strength, we could punch a tunnel through an office building of drywall and cinder-block walls with our bare-handed fists like a superhero.

Tunnel Mystics

In ancient times, Celtic fortune-tellers sought to read the maze made by mole tunneling, studying directions of its paths for supernatural clues. In reality, moles burrow in a route of the least resistance. They might follow a fence line or zigzag to avoid buried boulders or impassable obstructions. They make two types of tunnels: temporary paths near the surface to forage in the search for earthworms and insects, though these tunnels are rarely used more than once. Deeper down, they make permanent highways that many moles might share, though when in mating season, some are blocked or claimed with a scent made by a male or boar mole, to warn others to find a different underground route to take. A mole also leaves scents to mark tunnel rights or as a calling card to attract potential sows his way. Moles

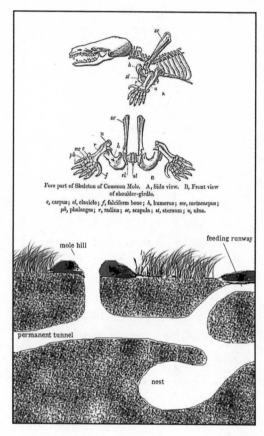

Fore part of Skeleton of Common Mole. A, Side view. B, Front view of shoulder-girdle.

c, carpus; cl, clavicle; f, falciform bone; h, humerus; me, metacarpus; ph, phalanges; r, radius; sc, scapula; st, sternum; u, ulna.

might be seen gathering in groups, called "labours," during this period and afterward give birth to two to six moles per litter. After two months, the young moles are capable of burrowing and finding earthworms on their own.

Life Below

Moles prefer solitude, and many of their tunnels are only wide enough for one. They also carve out living chambers and even storage rooms.

Since mole tunneling requires so much energy, an 8-inch mole must eat 50 pounds of earthworms a year. If it does not eat something every eight hours, it dies of starvation. The mole also has twice as much blood as animals of similar size, and it's loaded with hemoglobin, which helps the mole require less oxygen underground. The mole has unique saliva that can paralyze an earthworm and yet keep the invertebrate alive. Sometimes a mole merely bites off the earthworm's head so it cannot tunnel away after it is captured. Moles collect their catch in a chamber, called a "larder," which often contains more than one thousand worms, still warm and ready to eat.

Star of the Show

The star-nosed mole has a strange pink appendage with tentacle-like fingers at the tip of its nose. This semiaquatic species is also the fastest mammal at gobbling up bugs. With its incredibly sensitive nose, it finds insects so quickly and devours larvae at an eye-blurring recorded speed of 220 milliseconds. How fast is that? In the time it takes you to say, "Wow!," the star-nosed mole just ate ten bugs.

Life Cycle

When underground, moles are safest, though sometimes they die in burrows if the tunnels are washed out during a flash flood or from snow melts. Many moles are semiaquatic, such as the odd-faced, star-nose mole, yet they can drown if trapped in a muddy hole for too long. While coming up to the surface to dump excavated soil, they fall prey to birds, larger mammals, and reptiles. Moles live from four to seven years.

MONGOLIAN DEATH WORM
A Sandy Surprise

The Gobi Desert is one of the world's largest deserts, located at the southern portion of Mongolia and northern China, covering an area nearly 1,000 miles long and 500 miles wide. It has no sand dunes, unlike the Sahara Desert. Temperatures there reach 115 degrees, and sudden windstorms are strong enough to knock a man down. The Gobi was once an inland sea and an incubator for many early life forms. Noted as a treasure

trove for fossils, the Gobi is teeming with dinosaur bones and eggs that are still well preserved. Prehistoric tools one hundred thousand years old have been found there. The Gobi was also ground zero for the bubonic plague, a disease that originated from this primeval cauldron in the 1320s and went on to wipe out nearly half of Europe's population. A strange creature from the past, known as the Mongolian death worm, is said still to lurk there, burrowed under a thin layer of sand, waiting in silence to strike an unwary traveler dead for one misplaced step.

Thick as a Sausage

Although numerous expeditions have searched for the death worm, none have been captured or photographed. Locals, however, think it's real and describe the animal as growing from 2 to 5 feet in length. It is as thick as a sausage, resembles a cow's large intestine, and has a blood-red-colored body. The Mongolian death worm has a blunt head, without visible eyes, and an oval mouth with extendable pincers, in addition to a spiked, two-pronged tail.

Distant Relatives

If the death worm once existed when the Gobi Desert was a sea, then there is an animal called a "bobbitt worm" that shares some similarities. Bobbitts live in the ocean at depths of 130 feet and remain motionless when buried under sand. When something touches a bobbitt worm or it senses nearby activity with one of its five anten-

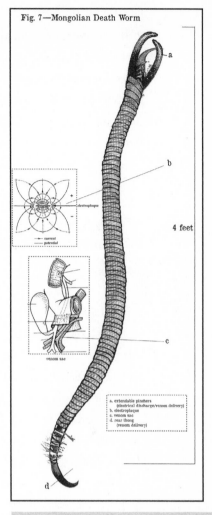

Fig. 7—Mongolian Death Worm

4 feet

a. extendable pinchers
 (electrical discharge/venom delivery)
b. electroplaque
c. venom sac
d. rear thong
 (venom delivery)

The death worm can discharge a harsh yellowish spit that is highly acidic, capable of melting metals and said to be instantaneously lethal to humans. If its prey is out of reach, the death worm can emit an electrical charge strong enough to stun and disable.

nae, the worm bursts into action like a loaded spring lock. It has powerful teeth that are sharp enough to bite a passing fish in half. Bobbits do not have acidic saliva, but they grow up to 10 feet and can live for over one hundred years. As for possible land-dwelling relations, worm lizards have a similar appearance to death worms. Worm lizards look like fat earthworms but are actually limbless reptiles. They burrow, as do death worms, and ambush prey, though are neither venomous nor capable of emitting electrical charges.

MOSASAUR
Ancient Rulers of the Shore

This half-snake-, half-alligator-looking reptile was unfathomably big, growing nearly 60 feet long. Mosasaurs were insatiable meat eaters that were last known to prowl the primordial shorelines sixty-five million years ago. These sea lizards (also called "tylosaurus") were not dinosaurs, yet they perished from the planet at the same time dinosaurs did. Mosasaurs were apex hunters, meaning they devoured other predators, like sharks, and even ate smaller versions of their own kind.

With spikelike, backward-facing teeth on the roof of its mouth, the mosasaur locked on to and forced its wiggling catch down into its throat. Resistance was futile once prey was tracked and chased by these sea monsters. There is evidence that mosasaurs lived in family units like

whales and protected the young, which were born alive and usually in pairs. Because these reptiles needed to come up for air regularly, the young mosasaurs were ready to swim within minutes after birth.

Like snakes, mosasaurs had lower jaws with extending hinges and their skulls were flexible, which allowed them to open their mouths wide enough to swallow huge animals with one gulp.

Lights Off

When we think of mosasaur and dinosaur extinction, many imagine that it occurred from one sudden catastrophe, even if evidence points to a series of events as the most probable cause. Dinosaurs were not roaming and foraging or swimming one day and then suddenly all keeled over the next, as if their plugs were pulled from the socket or their batteries ran out of power. Asteroid impacts of the magnitude that occurred during this period did, in fact, wipe out in a fireball all living things within a range of at least 500 miles. But for the rest of the animals, death was slower, and most species became extinct piecemeal. As food supplies dwindled, reproduction cycles were interrupted, or viruses took their tolls, certain animals died out over time in a process that for some took several centuries to complete. There were carcasses everywhere, this is certain. However, for those animals that were carrion eaters, and for those that adapted to become scavengers, this period was not an era of death but one of considerable abundance. There were probably a few long, giant-necked mosasaurs searching the oceans, calling out in their signaling cries, and looking for others of their kind, but finding none, until the last was gone.

60 feet

Fig. 13 Mosasaur

MOSQUITO
Out for Blood

Mosquitoes have been sucking blood from other creatures for as long as there have been animals. The earliest ancestor of this parasitic insect, whose name comes from the Portuguese words meaning "little fly," is as old as four hundred million years, yet one fossil trapped in amber from eighty million years ago displays a species with nearly the same anatomy as that of a modern mosquito. There are more than 3,500 species of mosquitoes found throughout the world.

There are an uncountable number of mosquitoes alive at this moment. Under ideal breeding conditions, two mosquitoes will bring into being four generations of their kind in only fourteen weeks. The offspring will mate again and again, each producing more offspring, until as many as fifty million mosquitoes are eventually produced from that

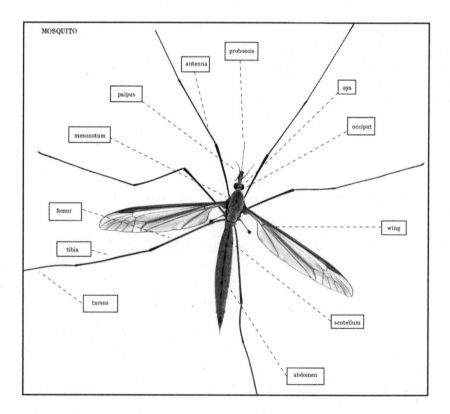

MOSQUITO

proboscis

antenna

eye

palpus

occiput

mesonotum

femur

wing

tibia

tarsus

scutellum

abdomen

original pair during one summer season alone.

Prehistoric High Tech

Mosquitoes are adaptive insects, with more intrinsic skills than many high-tech warfare devices.

Only the female mosquito hunts for blood while the male drinks nectar and sap from plants.

A mosquito has a chemical sensor that can detect carbon dioxide from the exhaled breath of warm-blooded animals; it smells the faintest traces of lactic acid, an ingredient of sweat, from a distance of more than 100 feet. Visually, a mosquito can detect movement and differentiate its target from stationary backgrounds. It cannot see objects in fine detail or generally move fast enough to see a hand ready to slap it. It does sense heat given off by living animals and homes in on its intended host with precision.

Once a mosquito lands on its victim, its piercing needle or biting component, called a "proboscis," is so sharp and thin it cannot be felt when inserted into flesh. Blood from the last victim, along with anti-coagulant saliva, is injected to allow new blood to be sucked up by the process of capillary action. It will drink about five microliters of blood or until its belly is at the bursting point. One female can bite as many as one thousand different animals in its lifetime, without preference, such that it might inject its needle into a rat, or a bird, or a person all in one night. Since it feeds on a variety of species, it is a deadly carrier of diseases. The mosquito has killed more people worldwide than the combined totals of all wars or catastrophes in history.

Life Cycle

Mosquitoes have four life stages; the female can only produce eggs after a blood meal and deposits them in water, where they float to the surface and form a cluster. If laid in winter, eggs survive until spring, but, in the summer, they will hatch within a few days. Each egg then turns into a larva, appearing as a wiggling worm, which breathes air though a snorkel-like body part. It remains as such from five to fourteen days, before form-

ing into a pupa, or miniature adult, taking another two days to dry off. The adults then live from one to two months. Many fish, birds, amphibians, and reptiles are sustained by mosquitoes, but the insect multiplies too fast for its predators to make even the slightest dent into its numbers.

What Are They Good For?

Although many agree this is one creature that would not be missed if permanently eliminated, the mosquito possesses many unique anatomical features that might someday prove beneficial to us. In fact, a painless hypodermic needle has been designed in an attempt to duplicate a mosquito's proboscis. A straight pin or hypodermic tip, for example, when pressed into skin literally stabs nerve ends and causes pain. A hypodermic tip that has a jagged edge, as does the mosquito's needle nose, disturbs less surface area. This affects a smaller amount of nerve endings, and, therefore, is less painful. The mosquito, however, also slightly vibrates its nose while inserting its needle. The mosquito has two serrated maxillae with jagged edges that are used to pierce the skin. Once these breach the skin, then a straight needle, called a "tubular labrum," descends between the chambers to suck up blood.

NARWHAL
Nature's Oddest Dentistry

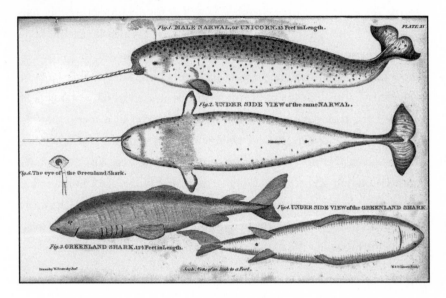

Fig.1. MALE NARWAL, or UNICORN. 15 Feet in Length.
PLATE II
Fig.2. UNDER SIDE VIEW of the same NARWAL.
Fig.5. The eye of the Greenland Shark.
Fig.4. UNDER SIDE VIEW of the GREENLAND SHARK.
Fig.3. GREENLAND SHARK. 12½ Feet in Length.
Scale, ⅜ths of an Inch to a Foot.

The narwhal, named from the Viking root word *nár*, or "corpse," has a grayish-white color that is strikingly similar in complexion to that of drowned sailors. For centuries, the animal was thought to be a fish or the sea's beastly version of a unicorn, due to its 10-foot-long spiraled tusk. It is now classified as a whale, a cousin of the beluga whale. It roams the frigid arctic waters around Greenland and northern Canada, and it has adapted to life hunting for fish at depths of more than a mile below the ice caps and glaciers. A narwhal male can weigh 3,500 pounds, as much as a small truck, and grow to 16 feet.

Fussy Eaters
Narwhals have a limited menu of sea life they consume, including codfish, halibut, some shrimp, bottom-dwelling crustaceans, and only a specific squid. Their tusks make chewing food difficult, and they must swallow whole whatever they catch. Narwhals socialize in pods of ten to one hundred, gathering in larger numbers to migrate with seasonal changes. They travel closer to shore in the summer and out to deeper oceans in winter.

About That Tusk . . .

Early naturalists believed the narwhal used its tusk as a spear to impale prey or as a weapon against enemies, as well as for dueling with other narwhals. Some guessed the tusk worked like a pick to open breathing holes through the ice. The tusk is actually a tooth, a left incisor that grows so long it pierces right through the narwhal's upper lip. The primary purpose of the narwhal tusk seems to be as an ornament used to show status. The length of the tusk determines social rank and serves as a sort of natural scepter or kingly crown, similar to how the lion with the thickest mane often acquires the most lionesses for his pride. The tusk also might have another function and serve as an environmental probe. As a tooth, it has nerves and can gauge temperature, the same way drinking an icy slushy might be sensitive to our teeth. In addition to registering coldness, it measures salinity, helping the narwhal find better places to hunt or breed.

Life Cycle

Having adapted to the coldest waters, the narwhal species is now threatened by warming global temperatures. Already at the top of the world,

Throughout history, many believed the narwhal tusk had magical powers. In the sixteenth century Victorian Queen Elizabeth purchased one for the equivalent of two and a half million dollars in today's money, enough money to build a lavish castle. Worth more than gold, drinking cups made from narwhal tusks were thought to neutralize all poisons and stymie assassination attempts, which was a constant threat to ruling monarchs in the ancient world. The British scepter is made from a tusk, as is part of the Danish royal throne. The narwhal tusk's magic, or true purpose, has yet to be fully understood.

narwhals can swim no farther north for colder waters. Besides being assailed by humans, narwhals are attacked by polar bears and killer whales. Their tusks cannot defend against bears, though they might aid in deflecting a killer whale if a narwhal can see the predator coming. A narwhal's average life span is around thirty to forty years, but some have lived for more than fifty.

NEPHILIM
The Titans

Many cultures have myths that tell of a great flood and cite this landmark event as a reason why many of the humanlike races that coexisted with us are no longer around or were destroyed. One humanoid species said to exist during those antediluvian times was a race of giants, mentioned in the Bible as nephilims (from the Hebrew word meaning "tyrant" or "bully"). The ancient Greeks called them *gegantes,* or "titans."

According to biblical references, a nephilim was nearly three times bigger than the average person, standing at around 17 feet tall, with a waist that was 6 feet wide. Similar to human design, nephilims walked upright and lived in small tribes. Even if they seemed to share our basic anatomy, all parts were supersized: a fossilized humanlike giant lemur bone, the upper

NEPHILIM SKULL & FEMUR

HUMAN SKULL & FEMUR

SIZE RELATION OF HUMAN & NEPHILIM SKELETAL STRUCTURES

part of the leg, was unearthed in the 1950s, in Turkey. It measured over 4 feet and was offered as proof that giant humanoids once actually existed. Other giant and humanish remains were found on the Solomon Islands. Because of their size, nephilims were threatening to humanity and could simply crush people in their grips. In the prehistoric world, with its long list of supersized animals, such enormous humans might have existed, in theory.

Elephant skull

nasal cavity resembling ocular cavity

One-Eyed Giants

Cyclopes were also a gargantuan race of mythical humanoid creatures, but they were more monstrous, having one eye. Ancient Greek and Roman writers described the cyclops as either having an extra eye placed in the center of the forehead, or with only one enormous eye above its nose. Cyclopes were also thought to be expert builders, and when medieval societies encountered monuments or structures constructed with huge stone blocks and of unknown origins, they frequently assumed the buildings were the handiwork of the vanished cyclops race.

What Were They?

During ancient times, people inflicted with physical abnormalities, such as gigantism, were thought of as nonhuman and descendants from another species. There is no medical term for people having only one eye, yet a few throughout history have been born that way. Legends of giants, and particularly the cyclops, most probably stem from when early civilizations unearthed and discovered extinct elephant skulls. A prehistoric dwarf elephant that was a quarter the size of African elephants, with a head only twice as large as a human skull, once roamed the Mediterranean islands. The large nasal cavity from which the elephant's trunk grew

seemed to be one large eye socket on the head of a cyclops. The dwarf elephants in this region disappeared at around 6,000 B.C.

The Other End of the Spectrum: Miniature Humanoids

According to ancient African legends, there was once a race of very tiny humanoid creatures, called "abatwa." These minibeings were smaller than ants. They were hunters and gatherers and used poisonous arrows to kill prey. There were frequently observed napping on blades of grass they strung up to work as hammocks. They also learned to control ants and often lived inside ant colonies without harm. No fossil evidence of the abatwa race has been found, perhaps due to their minuscule size.

NINGEN
Japanese Human-Whale

In waters north of Japan, there supposedly lives a whalelike creature that has a humanized face. *Ningen,* a word for "human" in Japanese, is 30 feet long, but not as thick and wide as most whales. However, it has what appears to be a mask of human features, including two large eyes, a nose, and an opening that could be a mouth in the middle of its melon-shaped head. It is a deep-dwelling beast, living in the farthest reaches of the Arctic Circle. Instead of front fins, it has long, jointed arms that are floppy, with dangling skin, as well as tentacles

or claws that appear similar to long fingers. No specimen or carcass of the beast has been found, though there have been numerous eyewitness accounts spanning a few centuries. For instance, U.S. Navy correspondence from 1835 described a similar creature breaching the surf around the South Pole. The boldest theories speculate that the creature dwells in a deep abyss. Or that it might have found the legendary tunnel that connects the North Pole to the South Pole by some undersea labyrinth through the earth's core. Other reports have testified that the whale-man can pull itself from the water and stand upright on floating glaciers, though since it is entirely white, it blends unnoticeably against snowy backgrounds. When spying a passing ship, the ningen can camouflage itself by kneeling or hunching over, and it is easily mistaken for a block of ice.

NUDIBRANCH
Solar-Powered Sea Slugs

For original shapes and for featuring unusual patterns of fantastic colors, the small, inch-sized, soft-bodied marine mollusk called a "nudibranch" takes some of nature's highest honors. There are more than 3,000 different species of this sea slug, which look like miniature sculptures of hand-blown glass. Nudibranchs are found around the world's coasts and tropical shorelines.

15. LAILA COCKERELLI MACFARLAND
Dorsal view, about 6.5 times natural size

16. TRIOPHA CARPENTERI STEARNS
Dorsal view, about 1.5 times natural size

17. TRIOPHA CARPENTERI STEARNS
Lateral view, about 1.5 times natural size

A nudibranch starts life encased in a shell, which it sheds at maturity when an oblong body emerges decorated with variously colored appendages and tentacles. It has open gills, which look like feathers, that run along its back and at its tail. Some species eat algae and store it in the outer tissues of their bodies. They do not kill the algae, but rather use it as internalized minisolar panels. As the algae survives through sunlight and photosynthesis, the plant provides sugars and nutrients to the sea slugs. Nudibranchs also eat sponges and barnacles, but despite their bizarre beauty, most are cannibals and prefer to eat other sea slugs best of all.

With such odd colors, these abstract-shaped and psychedelically colored creatures are said to be living gems escaped from Neptune's treasure chest.

Do Not Touch

In addition to their quirky looks, nudibranchs' mating patterns are equally strange. Since they do not trust each other and rarely touch for fear of being eaten, mating is done from afar.

Each nudibranch is technically both a male and a female, a hermaphrodite, with reproductive organs of both sexes. It can deposit jellylike eggs if it wishes when acting as a female or fertilize another's batch of eggs it encounters while performing its male role. It cannot, however, both lay and fertilize its own eggs.

NUDIBRANCHIA

A Sluggish Life

Slow moving, always plodding along in their inch-by-inch manner, nudibranchs are usually small—from less than ¼ inch to 1 foot—but some can get bulky and bloblike, weighing 3 pounds. Predators, except other nudibranchs, are few. Their bright colors broadcast their toxicity, and they are rarely eaten. Nudibranchs live on average for about a year.

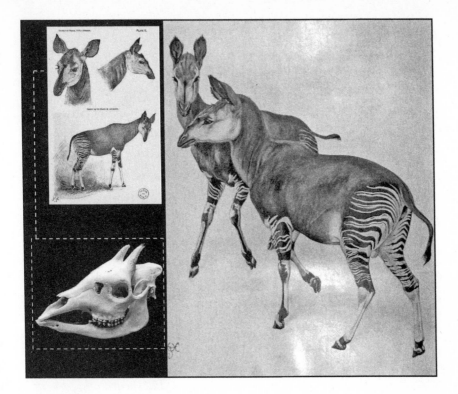

OKAPI
Hermits of the Rain Forest

An okapi has a giraffe head on a huge, Clydesdale-sized body. It looks like it stepped in a can of zebra paint, with white stripes on its fore and hind legs, and more on its rump. Okapis were thought to be part of the antelope family (of which there are 90 species in Africa), but they are actually more closely related to giraffes. Okapis have long black tongues and find nourishment from a variety of things not often considered edible, such as red river clay and many plants and fungi known to be poisonous to humans. They even seem to enjoy eating charred bark from burned trees or the bits of carbon found in extinguished campfires. The okapi has highly sensitive hearing, which can detect the slightest twig snap from a distance of 200 yards. It is surprisingly agile, despite its bulk, which makes it an elusive beast that few have ever seen. An okapi has a very gentle disposition and is a committed pacifist, never fighting even if

attacked. For centuries, many thought the okapi was the legendary African unicorn.

Hide and Seek

In the 1870s, Henry Morton Stanley, the famous explorer of Africa, cited an unknown animal that locals referred to as "atti." In his travelogue of his journey through the rain forest, as he searched for "Dr. Livingstone, I presume," Stanley encountered what most believed to be a mixed offspring of a giraffe and a zebra. In local folklore, stretching back to tales told in the time of Egyptian pharaohs, okapis were believed to possess supernatural powers. Western scientists thought the creature an invention and ridiculed those who said otherwise. The verification of the species' existence did not take place until 1901. English explorer and colonialist Harry Johnston was the first to obtain proof that the animal was real. He was obsessed with finding the legendary beast mentioned in Stanley's accounts.

Although Johnston never saw an okapi alive, he sent a partial carcass of one to London. The specimen was reconstructed and mounted for display in the Natural Museum of History, making international headlines; "A Newly Discovered Beast," declared the *New York Times* on September 8, 1901. The okapi amazed the world with the fact that such an animal avoided contact with civilization for so many centuries.

After Harry Johnston intervened and prevented a band of African pygmies from getting put into crates and shipped off to a circus sideshow, the small-statured tribesmen expressed gratitude by offering to help Johnston find the long-sought okapi.

Life Cycle

No one knows how long okapis live in the wild, where leopards are among their most natural enemies. The animals survive for thirty years in zoos, even if legend says that they were once capable of living for hundreds of years, or longer. Some believed that "atti" were unaffected by time and could become ageless, though only if they allowed no human eyes to gaze upon them. This legend stems from the animals being rarely

seen in the rain forest—they perfected their camouflage to the point of disappearing. Estimates count current population at 15,000, mainly in the Republic of Congo, and there are more than 150 living in zoos.

OPOSSUM
The Living Dead

Algonquin Indians called the largest marsupial found in the Northern Hemisphere "apasum," meaning white beast. All marsupials originated in North America, but most became extinct there about twenty million years ago. Some had spread to South America and finally Australia. About three million years ago, the common Virginia opossum, which had evolved independently while in South America, migrated northward once again when the continents were reconnected by a land bridge.

Opossums range in size from the 3-inch mouse opossum to the Virginia opossum that is about the size of a large house cat. All have patchy fur, called "awn hair," that varies in color from gray to bleached white. They have pointy snouts and long, hairless tails that are used for helping with balance. However, the tail is not strong enough to support the animal's body weight hanging from a branch, which is often how cartoon versions of the animal are depicted: opossums of all sizes all hanging happily in a row. In reality only the very young can use their tails for clinging to a branch. As omnivores, opossums will eat almost anything, though they are not terribly aggressive and prefer to eat dead animals, garbage, wild fruits, insects, birds, amphibians, or any small prey not likely to give them too much of a fight or require a chase.

Laid-Back
The opossum gives the impression of taking things in stride, of not being hurried or nervous. Even in birth, the opossum seems to be resigned to acceptance. As marsupials, the young are born after two weeks of gestation and must crawl, without help, up into the mother's pouch in order

to survive. She might give birth to twenty or more joeys (the same name for young kangaroos) during her lifetime, but less than half make it to the teat for a first meal. If successful, the young will remain in the pouch for two to three months. The toddlers then spend the next nine months going wherever the mother goes by clinging with all their might to her back as she scampers about and forages. She never seems to mind this extra load, and if a baby falls off, she will give it some time to catch up, though seems to accept the loss if the joey repeatedly fails to hold on. Only 10 percent of her offspring survive the first year. Opossums live in abandoned burrows or tree hollows, but do not take the time to dig their own. They are nocturnal and sleep during the day and for sizable portions of the night.

Practicing Dead

When confronted, an opossum will hiss and bare its teeth to bluff away an attacker, but if things look grim and its chances of scaring away its pursuer seem unlikely, a strange involuntary biological mechanism takes over. Hormones kick in that make it wobble and immediately keel over on its back. Its lips will curl, and foamy bubbles emerge at the gums. Its eyes roll upward, its eyelids become half-closed, and its limbs go stiff as a foul gas passes from an anal gland. For all intents, it seems the opossum has either died of fright or is infected with some truly dreadful disease. This trick suddenly makes it very unappetizing to a potential predator. "Playing dead" is more than method acting—the opossum can be prodded, poked, and handled as if a corpse, but it will not rouse. It can remain in this state from forty minutes to four hours.

Locked In

It's not certain if the opossum's mind shuts down while playing dead, or if it can still hear. It might be similar to what's called "locked-in syndrome," or "waking" coma. When this happens in humans, they are unable to speak, move, or react normally to stimuli, yet their brains are alert and active. Five thousand patients each year fall into a waking coma on the operating table as a result of anesthesia failure. Inadequate anesthesia may cause the patient to feel the pain of surgery without the ability to signal to the doctors, move, or communicate. The opossum rendered into its locked-in mode surrenders its fate to chance.

Life Cycle

Opossums are prey to hawks and owls and larger carnivores that can catch them if they are not given an opportunity or time to feign death. Since opossums eat roadkill or dead animals, many find themselves flattened alongside the carcasses they were trying to eat. They are fre-

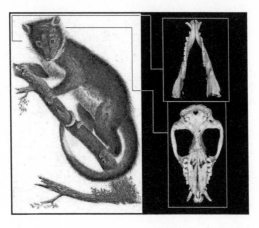

quently struck by vehicles. Snakes are not a threat to opossums, since they have a unique antivenom quality in their blood that has evolved through the millennia, making them impervious to the bite of rattlesnakes and pit vipers. However, the animal is afflicted on a cellular level by an accelerated rate of aging, a condition called "senescence." Soon after achieving maturity, at about one year, the opossum turns elderly and begins literally dying from old age. Opossums live for about two and half years, no matter how ideal are their environmental conditions or access to food supplies.

ORPHAN BIRD
Good Eggs Rise to the Top

The orphan bird was a popular entry in medieval bestiaries. It reputedly was about 3 feet tall, with a heronlike body. It had a 4-foot wingspan and striped feathers that looked like a red, white, and black flag. The orphan bird's head was fashioned with a curved beak similar to a hawk's, though the bird also had a colorful array of tail feathers, which pointed upward like a peacock's plume.

It was called an "orphan bird" due to its unusual method of egg lay-

ing. Unlike most birds, the female incubated her eggs in a feathery depository near her tail feathers until about ready to hatch. At that point, she flew out to sea and cast her eggs on the surface of the

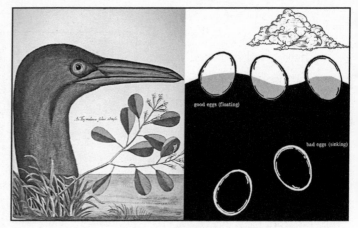

water. The orphan bird had a unique method to predict the future character of its offspring, by using a floatation test to separate the bad ones from the bunch. Within minutes, she knew immediately which eggs held good chicks or which ones were bad. Eggs that were suspected to hatch chicks likely to give the mother bird problems in the future sank rapidly, while eggs containing chicks of a better disposition floated to the top.

Although there are no records of any bird that laid eggs on the ocean, or a bird matching the physical descriptions of an orphan bird, some shorebirds, such as gulls, might have nests close to the water. Perhaps a few eggs occasionally wash to sea. However, put a freshly laid chicken egg in water and no matter if it's good or bad, it will sink. The story of the orphan bird was told for centuries as a morality tale. It represented a secret wish of many parents who often wondered if there was a way to know how their offspring would turn out: Will the unborn cause more grief than joy? In nature, a number of birds lay eggs, and for reasons unknown, decide to abandon them without attempting incubation.

The orphan bird coddled the eggs for a day or more at sea until the good hatchlings swam to her wings and remained safe nestled in her plumage. The potential troublemakers were orphaned to the bottom of the sea.

OSTRICH
Largest Living Bird

Found in Africa's savannahs and arid regions, the mighty ostrich has wings but cannot fly, not even if its life depended upon it. It can run fast, at speeds of more than 40 miles per hour and maintain that pace for an hour at a time. The wings might be outstretched, as if it's trying to fly, but the ostrich does this for balance and uses the wings like rudders. An ostrich can also "gallop" or take strides that cover more than 15 feet. The biggest ostrich, from toe to head, stands nearly 10 feet tall and weighs 350 pounds.

An ostrich's long legs are so powerful that it can kick a predator with such force as to cause serious injury or death. The ostrich kicks forward and eyes the target it wishes to strike, though it remains poker faced, giving scant clue of its intentions. Ostriches live in small herds of around ten, led by a dominant hen, and move about frequently eating plants, insects, and reptiles. Sometimes ostriches gather in large numbers, with one hundred or more seen together during periods of migration. They do not drink water regularly and get most of what they need from plants.

Head in a Hole

The odd-looking bird has fostered many legends, including that it had a stomach so durable it could eat iron. Ostriches do ingest stones, however, to help grind food in their gizzard stomachs. Ancient observers believed the ostrich could grab

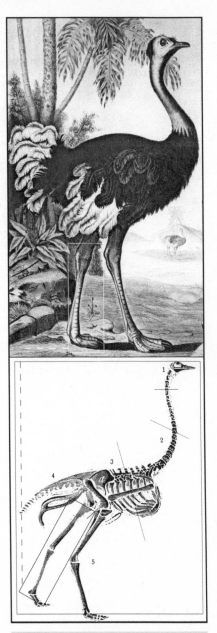

Ostriches have the largest eyes of any land animal, measuring more than 2 inches in diameter.

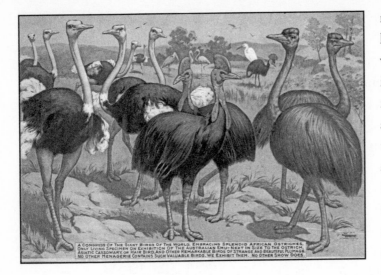

A CONGRESS OF THE GIANT BIRDS OF THE WORLD, EMBRACING SPLENDID AFRICAN OSTRICHES, ONLY LIVING SPECIMEN ON EXHIBITION OF THE AUSTRALIAN EMU-NEXT IN SIZE TO THE OSTRICH, ASIATIC CASSOWARY OR HAIR BIRD, AND OTHER REMARKABLE BIRDS OF STRANGE AND BEAUTIFUL PLUMAGE. NO OTHER MENAGERIE CONTAINS SUCH VALUABLE BIRDS. WE EXHIBIT THEM. NO OTHER SHOW DOES.

rocks with its feet and hurl the stones backward at its pursuers as it ran to escape. The most persistent myth still cites that an ostrich puts its head in a hole when trouble brews, foolishly thinking it is sufficiently camouflaged or that it somehow unbelievably turns itself invisible.

The bird does try to minimize its unmistakable silhouette when sensing danger by huddling close to the ground. It hopes to hide below the savannah grasses. While biding its time in this hunched position, an ostrich may probe its head in the sand, not to hide, but rather to see what edible morsels it might find.

The Big Egg

Among all living animals, the ostrich lays the biggest egg. It weighs over 3 pounds, with a yolk equal to two dozen chicken eggs, and has a width about the size of a honeydew melon. After courtship and a mating dance, where the male opens his wings and shakes his head around and around, the parents breed. They are very particular and demand privacy, preferring to be out of sight from other members of the herd for such events.

All the ostriches of the herd lay eggs in a common pit, but the dominant female examines each before covering the eggs with sand. She knows which eggs were laid by which hen. The matriarch might discard eggs laid by females she does not like or who had spent too much time with the herd's male and are potentially threatening to her leading position. She rolls those eggs out of the nest and damages them. Twenty to thirty eggs can occupy one nest, while the ones deemed unworthy are left to rot in the sun. The egg pits are attended by females during the day,

while males take turns to protect the pit at night. When the eggs hatch after about forty-five days, the males stand near to defend against predators, while all the females gather to nurture the chicks communally. Even with all those watchful eyes, usually no more than one hatchling from the nest will live longer than a year. Vultures, hawks, lions, cheetahs, and jackals—nearly everything that eats meat in the wild—eyes the ostrich as a meal. If an ostrich survives to adulthood, reaching maturity at about two years, it can have a life lasting forty to forty-five years.

OWL
Swivel-Necked Hooter

The large forward-facing eyes of the owl are set closely on its face, making it an easy bird to identify. Owls' staring gaze and eerie hoot in the night have both frightened and intrigued people throughout history and contributed to myths and superstitions about the owls' mysterious powers. In ancient Greece, the bird was a solemn and respected icon and adopted as the favorite of the goddess Athena. Images of the owl's eyes adorned coins and were said to watch the dealings of commerce wisely. The owl's poor reputation, which persisted well into the twentieth century, dates back to the Romans, who believed the owl was a potent omen predicting curses and death. Battles were postponed or fought, and travel altered, if an owl was seen or heard. In the Middle Ages, the owl was tied to sorcery and witchcraft. The

ATHENIAN HORNED OWL.
from Edwards

bird was thought to be an evil creature of the night that lived near tombs, and, with each hoot, it caused the death of someone within hearing range. Either evil or wise, the owl's reputation changed frequently—its powers ranging from weather prediction to curing diseases. For centuries, many English children were given a concoction of raw owl eggs, said to make one immune for life from drunkenness.

There are more than 200 different types of owls found worldwide, except in Antarctica. They range in size from the elf owl, as small as a sparrow, to the more than 2-foot-tall Eurasian eagle owl. Whether the owl is mystical is a matter of opinion, but it is supremely adapted as an efficient bird of prey.

Mysterious Eyes

An owl has three sets of eyelids: one lid blinks from the top, another goes up when sleeping, while the third sweeps from side to side, like windshield wipers, to protect and moisten the owl's distinctive eyes. This allows it to keep its eyes open for long periods, appearing as if not blinking.

An owl's eyeballs are not round, but are shaped more like oval tubes, and have rapidly reacting retinas that can indicate a wide range of light, giving it incredible night vision.

The owl cannot roll its eyes to look up, down, or sideways; it can only stare straight ahead.

Rubber Necking

Because of its fixed eyes, the owl has a neck as flexible as rubber. It contains fourteen bones, double that of a human's neck. The owl can turn its head more than 270 degrees (ours can turn 150 degrees comfortably without the risk of snapping).

The owl can flip its head upside down while standing straight up, or it can twist it to angles that appear as if its neck were attached to its head by

a rubber band. Its neck is long, hidden by more than one thousand feathers. Its wing feathers are shaped differently than most birds', with tiny combs at the end that make for a silent and stealthy flight, so the owl is inaudible to prey. The design also allows for swift takeoff and for balancing while carrying its catch in its talons. An owl flies low to the ground, and due to two large ear holes on either side of its head, it can hear a mouse stepping on a leaf from a distance of more than 75 feet.

Owl in the Family

As a solitary hunter, the owl does not find the night forest frightful or eerie. Its senses interpret sounds and sights that would be too intense and almost hallucinogenic for us to imagine. When mating, owls nest together, with both parents taking turns to sit with eggs and teaching the hatchlings the tricks of owlhood. The young leave after about three months to find their own territories. Smaller owl species are attacked by larger birds of prey and carnivorous cats. In the wild, owls live for about ten years, but captive ones have lived as long as thirty, trading freedom for a longer life.

An owl can look almost completely backward, but it cannot spin its head totally around, Exorcist *style.*

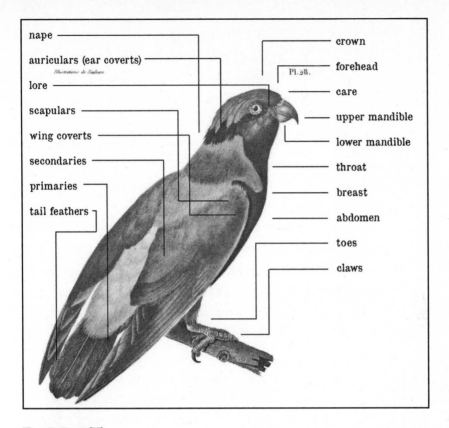

nape

auriculars (ear coverts)

Illustrations de Zoologie

lore

scapulars

wing coverts

secondaries

primaries

tail feathers

crown

forehead

Pl. 28.

care

upper mandible

lower mandible

throat

breast

abdomen

toes

claws

PARROT
Most Brilliant Bird

Parrots come in more than 370 different species, ranging in size from the 3-inch green pygmy parrot, native to New Guinea, to the brilliantly blue-feathered hyacinth macaw of South America that is nearly 4 feet long.

The world was once much warmer than it is today, and a variety of wildly colored plants and flowers made the parrot's multicoloring superb for camouflage. Fossils of birds that look like modern parrots date to about seventy million years ago, with some specimens unearthed in both Europe and North America.

Parrots evolved when South America, Africa, and Australia formed a supercontinent, called Gondwana, about two hundred million years ago.

Public Speaking

One of the most verbally prolific parrots of note was an African gray named Alex. Studied by scientists for more than thirty years, Alex had acquired a 150-word vocabulary.

Parrots eat grains, nectar, and plants, but some also hunt insects, invertebrates, and small animals. Most are monogamous and stay together even when not in breeding season. Parrots have one of the best vocal capabilities among birds for imitating human speech. They are not melodious singers, but they continuously squawk among themselves and mimic sounds. A parrot has a small cerebral cortex, the part of the brain considered as a measure of species' intellectual capabilities. However, parrots can solve puzzles and use words correctly or at least associate an object defined by a particular sound. The parrot does not have vocal cords but produces the sound by altering the shape of its trachea, or throat, and manipulating airflow to achieve the word or recognizable sound.

President Andrew Jackson was always on trips and away from home. To keep his wife company he bought an African gray parrot, named Poll. The bird outlived them both and was removed from Jackson's funeral service for cussing obscenities in both English and Spanish. President McKinley also had a parrot he took to the White House. The bird was named Washington Post and could whistle the song "Yankee Doodle."

DEATH OF GENL ANDREW JACKSON.

Life Cycle

Depending on their diet, among other environmental factors, many parrots are genetically endowed to live long lives. Pet parrots frequently outlive their owners; some birds, especially macaws and cockatoos, reach the age of one hundred years old or more. In the wild, a parrot's average life span is around twenty to thirty years, due to predation and accidents, but cases of individual birds reaching long lives is still common. Other animals' longevity, like turtles', is attributed to a slow metabolism, but parrots, who are inquisitive,

have a high metabolic rate. They are always flying and foraging, squawking and socializing, displaying a childlike curiosity that might contribute to their longevity. Parrots are also quick to snap at whatever is annoying and prefer to avoid problematic situations, either other people or parrots—another trait recommended for a long life.

Alexander the Great conquered the known world, and on his return from India in 325 B.C., he brought back one of his most prized treasures, a bird that could imitate human language. The parrot was a must-have for many monarchs thereafter and an especially favorite pet during Roman times.

PENGUIN
Ruler of the Ice

Native mainly to Antarctica and surrounding islands, the penguin has made a home in the coldest part of the world. Unable to migrate or fly off to warmer climates because of wings useless for flight, the bird stands out in the aviary world for its strange and, to some, admirable life, considering it has been relegated to living in the harshest environment on the planet. There are at least

18 different species of penguins, all living in the bottom portions of the Southern Hemisphere. None can fly, though all are speedy swimmers, using their wings like fins, and masters of endurance. They hunt shrimp, small fish, and squid.

This cold-weather bird has been around for forty million years, and it was once capable of flying. Why it devolved into a flightless bird remains

Penguins can dive to depths of 500 feet, traveling for more than 150 miles in one day in search of food, a journey that can take fifteen hours.

a mystery, but, with not much food available aboveground in such cold climates, it is likely the wings were of better use for aquatics. The emperor penguin stands the tallest at 44 inches and can weigh almost 100 pounds. The equally regal king penguin is second largest and has been recorded to dive 771 feet.

At the Rookery

Penguins usually gather in large colonies during October to lay eggs. Some species make nests from rocks, and both parents take turns guarding and hatching the egg. The emperor penguin has no rocks to use and instead the male rests the egg on its feet. Male penguins form a large circle to block the wind and remain nearly stationary until the egg hatches nine weeks later. In the meantime, the females walk more than 30 miles to the sea to find food and then hike back in time to regurgitate it to feed the new hatchling. Most penguins mate for life, but some only stay faithful for one breeding season. Penguins' main enemy is the ferocious leopard seal, though other birds also prey on penguin hatchlings. An emperor penguin can live its uncomplaining life, despite such incredible cold and hardship, for more than twenty years. The current world population of penguins is estimated at 100 million.

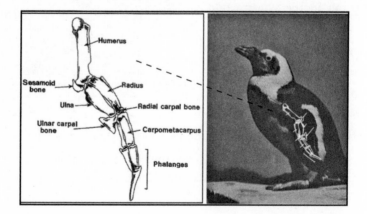

PEREGRINE FALCON
World's Fastest Flier

Among birds of prey, which include eagles and hawks, falcons are in a class of their own. There are 37 different types of falcons, which are generally smaller than other raptors, though due to falcons' distinctive tapered-wing design, they are the flying aces and the best stunt pilots among birds.

Falcons are found in Europe, Asia, and North America, favoring wooded areas and grassy plains, while the peregrine falcon spans the globe, with the exception of polar ice caps. Called the "wandering falcon" (*peregrine* comes from the Latin word meaning "wanderer"), the bird favors cliffs, and rocky ledges, though it has also adapted to city life and can be comfortable among skyscrapers.

Peregrine falcons reach speeds during descending flights, called "stoops," of over 200 miles per hour, making them the fastest animals in the world.

Sky Hunters

The female peregrine, which is larger than the male, is about 15 to 20 inches tall, about the size of a crow, with a 3-foot wingspan. It weighs about 1½ pounds and has dark-colored, helmet-shaped feathers on its

Once the speedy peregrine eyes a bird in flight, the target's chances of escaping its midair attack are less than 50 percent.

head and a white neck. It has a speckled cream breast with a bluish-gray or brownish body, with a zebra-striped pattern to its wing feathers. Peregrines prefer to catch their prey in midflight, eating mostly other birds, which is the reason some cities are encouraging their nesting as a form of natural pigeon control. A peregrine's beak is sickle-shaped and yellow with a black tip. The legs of a peregrine are yellow and end with razor-sharp black talons.

The peregrine's dramatic hunting tactics include snatching a bird with its talons midair and tumbling toward earth until its prey is subdued with a wound to the neck. Sometimes it stuns the bird with a closed-fist talon punch. The falcon will come back for the dazed prey once it falls to the ground. Either way, the falcon will carry its catch back to the nest or another high place—it rarely eats on the ground. If the male scores a meal, the female mate might come by, flying upside down, and like aircraft attaching to refuel while in flight, the falcons will transfer the catch in midair.

Falcon Education

Falcons do not put much effort into nest building, and when they can, they evict other birds from nests or occupy abandoned nests. Peregrines choose a mate for life, and the female is the dominant of the pair. Three or four eggs are produced each year. The female sits on them for most of the day during the monthlong incubation, while the father takes over the night shift. Since their nests are not soft-lined, one or two eggs usually crack, and the parents promptly eat it to avoid spoiling the remainder of the eggs. After hatching, the chicks stay nest-bound for five or six weeks, but once

fledging falcons are capable of flight, the parents take them out to teach them how to hunt. Although the young birds instinctively know many maneuvers, the parents will have them practice their distinctive midflight attacks on dragonflies and large insects.

Life Cycle

Other large birds of prey, especially bald eagles and owls, actively hunt young falcons. Foxes, raccoons, and other mammals also present a danger, sniffing out the ground nests, such that most hatchlings do not live past the first year. Once they make it to two or three years old the chances of survival are greater, and a peregrine falcon can live for fifteen years in the wild.

PERSIAN THREE-LEGGED ASS
Walking Water-Purification System

On islands in the Arabian Sea, off the coast of Yemen, there was a huge horselike beast, measuring 15 feet at the shoulder, that spent its days thrashing about at the shoreline. According to myth, it had white fur, two hind legs, and one front leg. It had a short horn or bump on its snout, and four pairs of eyes: two eyes were on its head and another set on its back. Legends said the Persian ass had the job of purifying the world's water. Since no fossils exist, the creature is consid-

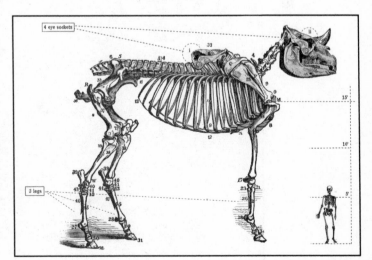

ered as fantastical, even if cited as a real animal in Egyptian and Greek writings.

There was a beast that lived in the region, an extinct animal called an "indricotherium," which was a hornless rhino with long, horselike legs that stood 18 feet at the shoulder. It trashed about in the water to cover itself with mud in order to rid itself of bugs—not to purify water. Incomplete indricotherium fossils found during ancient times might have made it seem as if the animal had one less leg than normal.

PHOENIX
Born in a Blaze

About as large as an eagle, though taller and plumper, the phoenix was a unique bird described in diverse sources, including Egyptian, Chinese,

Persian, and Greek folklore, and in ancient texts regarding natural sciences. It reputedly nested at the tops of palm trees and ate herbs, such as frankincense and gum plants, or other herbs not normally consumed by birds. It had reddish-golden breast feathers and a purple tail, which fanned upright similar to a peacock's. Few observed the bird, although it was identified by its melodious song that sounded similar to a flute.

The mythological phoenix had a longer life span than any known bird, lasting from five hundred to one thousand years.

At the end of its long life, the bird made a nest of the driest twigs and arranged it near a rocky outcropping. It then stood in the center of the kindling and struck at the rocks with its beak until a spark was produced, setting the nest ablaze. The bird spread its wings but did not fly and allowed itself to become entirely engulfed in the flames. Soon after the fire cooled, usually after the first rain, a new and fully grown phoenix emerged out of the ashes. Mythology described the bird as nearly immortal, each new version a clone of the original.

Why Burn?

It is not known if the dying bird laid an egg below the ground, covered it with twigs, and then used the heat to incubate its offspring. Some said that since only elderly phoenix gave birth, it knew it was too frail to defend its hatchling. To give its chick a chance of survival, the fire was meant as a ploy to keep away predators. Even if no actual birds have been known to willfully self-immolate, or burn themselves, numerous ancient records attest that such a bird once existed.

PIGEON
Urban Bird

There are more than 300 species of pigeons and doves, ranging in size from the 8-pound New Guinea crowned pigeon, to the tiny finchlike New World ground dove. Pigeons are usually the bigger birds, while

doves are less stout bodied and smaller. Pigeons live everywhere, with the exception of Antarctica and the North Pole, having adapted as well as humans and populating all types of habitats.

The typical pigeon, commonly called a "rock pigeon," is the most numerous and recognizable, since this species prefers urban life more than any other type of bird. Rock pigeons consider buildings to be just another stone ledge or cliff (their natural habitat for millions of years). Pigeons are highly abundant in India and urban parts of Asia where many see the birds as reincarnated spirits. People in all countries often feed pigeons for good luck and to earn positive karma. Of course, it is impossible to know what pigeons actually think of us and whether they like us. Perhaps they

look down from their perches upon city traffic and consider it a noisy inconvenience occupying their terrain.

The rock pigeon weighs just less than 1 pound and stands about 1 foot tall. It has a nearly 2-foot wingspan and prefers a circling flight pattern but is capable of flying to great heights at a near vertical ascent, due to a strong, muscular skeleton. Rock pigeons are usually gray feathered with a bluish tint; their heads are a shade darker, with green and purple iridescent color collars around their necks.

On the ground, they walk in a bobbing fashion, moving their portly bodies forward, but leaving their heads behind to catch up. Since they have monocular vision and see a different view out of each eye, they bob-walk to orient and gauge depth to the surroundings so as not to trip. Pigeons are vocal and like to talk, or "coo," while nesting, hanging out, or when about to feed.

There are 1.5 million pigeons living in New York City alone and another 28 million in European cities.

Billions to Zero

Once far exceeding rock pigeon numbers, the passenger pigeon was a wild dovelike bird with a population of more than 5 billion living in the United States when European settlers first arrived. When passenger pigeons flew, their numbers would block out the sun for more than twelve hours. One migration of them covered an area a mile wide and formed a trail for 30 miles long. However, in 1914, only one lone passenger pigeon remained, a twenty-nine-year-old bird, named Martha, housed in the Cincinnati Zoo. All hoped that this last specimen of this species, by some miracle, would lay an egg. She did not and soon died, entering the record book as the last of her kind. The passenger pigeon—due primarily to a slaughter style of overhunting—suffered the most rapid man-made extinction of a species in modern times.

WWI HEROES

"President Wilson" lost a leg at Verdun

These pigeons were all wounded while carrying messages

They Winged Their Way Through Skies of Steel

"Cher Ami," saviour of the Lost Battalion

Airmail

Pigeons' ability to find their way back home, no matter how far removed, has made them famous since ancient times. The Sumerians, as early as 3,000 B.C. discovered the wild pigeons' homing instinct and began to breed the birds. During the fifth century B.C., pigeons were used to establish the first communication network and carried messages throughout the Middle Eastern empires. In the Bible, a dove was the messenger bird that told Noah to anchor his ark at the end of the Great Flood. In the Middle Ages, pigeons were the most reliable way to send secret information between castles. Queen Elizabeth of England had lofts of special pigeons, and she kept one step ahead of her enemies with the aid of messenger birds. In the 1700s, the European House of Rothschild financiers gained incredible fortunes by employing pigeons to receive and transfer information faster than the Rothschilds' financial rivals. During World War I, pigeons brought messages across enemy lines, and some individual birds were actually awarded Medals of Honor for their bravery.

In parts of India, pigeons were official mail couriers for centuries, disbanded from service only in 2004.

Quantum Pigeons

The pigeon homing instinct remains a mystery to science. Pigeons have been known to find the speediest route back to their homes from distances of more than 600 miles. Some think a pigeon retains an "odor memory" of its home and tracks airborne scents. Pigeons also look for landmarks, such as lakes or mountains, and even remember intersections of highways to find direction and change course.

They may even have a way to gain flight information by observing the position of the sun, flying in a path until they are realigned to where the sun is at the same angle as it would be at their home perches. Pigeons, perhaps, use infrasonic, low-frequency sound waves that are emitted by the constant seismic movement of the earth to find their bearings. Pigeons might even instinctively apply a form of quantum physics and demonstrate a principle known as "Bell's theorem," which concerns the behavior of atoms and what is called "nonlocality pairs." This quantum theorem is considered unexplainable, yet attempts to clarify how atomic particles that once interacted continue to influence each other even if they become disjoined. Bell's theorem assumes that these atoms remain connected and will eventually find each other to reconnect, regardless of distance or separation by time or space—sort of like a pigeon's inherent bond to its roost. In addition to the homing instinct, the pigeon is considered smart and can recognize photographs of different humans, pointing out the image of the person who feeds it from among a stack of pictures. The pigeon is one of the only birds that can recognize itself in a mirror.

> *It has been proposed that pigeons have internal compasses and read the earth's magnetic fields to know how to return home.*

Weighty Droppings

City pigeons consume almost anything and are estimated to produce about ½ pound in droppings per bird, per week. Pigeons' droppings are heavy and more acidicly corrosive than other birds' droppings. Some contain diseases, such as *E. coli*, encephalitis, and salmonella. Pigeon pooh weighs 18 pounds per cubic foot. If not removed, droppings can cause roofs to collapse. If pigeon waste clogs an awning's support tubes, for example, the weight of droppings causes structural failure. In the Middle Ages, pigeon feces were considered prized fertilizers and better than cow or horse manure. Elizabethans hired night watchmen to guard pigeon coops and prevent thieves from stealing the droppings. In the sixteenth century, pigeon dung was used as an ingredient in gunpowder, while today many are trying to find a way to recycle the bird's waste, with one inventor turning it into a potent soap.

Life Cycle

Each female pigeon produces about ten squabs (babies) a year. The eggs hatch in about eighteen days and the young remain in the nest for nearly two months, fed by both parents until strong enough to fly and feed on their own. In the wild, pigeons are prey for many predators, though their rapid breeding cycles give this species a greater edge for survival. In the city, cats, hawks, and rats are their enemies. City pigeons live rough-and-tumble lives; with diets consisting of junk foods, and being exposed to the elements, they usually live from three to five years. Coop-kept pigeons and woodland pigeons live, on average, fifteen years, depending on the species.

PLATYPUS
Nature's Combo Platter

When the first platypus was discovered by naturalists in the eighteenth century, a specimen was shipped from Australia to London for classification. Scientists suspected the creature was a fake and that it was likely an otter or beaver that somehow had a duck's bill sewn to its head. It seemed that its webbed feet were taken from a seabird and attached by glue. The platypus, one of the strangest

mammals, is native to eastern Australia and Tasmania, belonging to the oldest-known genus of *Monotreme* mammals, of which only four additional species remain. It lays eggs like a lizard, but feeds its young milk. This combo special of an animal weighs about 3 pounds and grows to 2 feet long. It has thick, brown fur and a wide tail, with a birdlike beak for a mouth and nose.

All the body parts of this semiaquatic animal, as mixed as they seem, have made the platypus highly effective for surviving dangerous waters and at acquiring its favorite food of insects and worms, which it finds at the bottom of rivers. Its odd duck bill is one of its main anatomical advantages and the secret to its long-lasting success as a species.

The male platypus has sharp spurs on its heels that contain venom as deadly as a rattlesnake's.

—

The platypus bill is equipped with forty thousand nerve endings that detect electrical impulses emitted by the muscle movement of creatures as small as water bugs and grubs.

Diving for the Bottom

Since the platypus must gather food from the murky riverbed, where there is no natural light, it had to resolve a problem of navigation. It can only hold its breath for about two minutes and dives with its eyes totally closed, its ears sealed with a flap, and mouth clamped tight. In this total darkness, it has adapted by using its duck bill to find its way underwater and to locate food.

Sensors in the platypus's bill function like motion detectors in a house alarm system, measuring water pressure fluctuations caused by animals and registering objects in the creature's path.

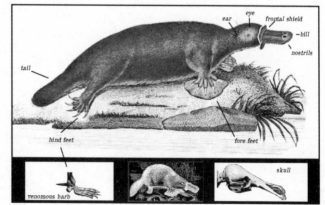

But more important, the bill indicates exactly where to find worms, for example, that are buried under mud at the bottom of rivers and lakes. In the two minutes the platypus has while holding its breath, it pinpoints the source of electrical charges made by living insects and, with its shovel-like bill, collects worms, shellfish, grit, and rocks. The platypus stores each mouthful in its cheek pouches until it can return to the surface and sort out what is edible after each dive.

The Other Egg-Laying Mammal

The platypus and the echidna are the only egg-laying mammals. Native to New Guinea and Australia, the echidna looks like a small porcupine, covered with spiked, stiffened hair-needles. When threatened, it is capable of rolling up into a ball about the size of a cantaloupe. It has a small version of an anteater's snout and sharp claws. Unlike the platypus, it is terrestrial and eats ants and termites by digging at mounds and collecting the insects on its long, sticky tongue. The female lays one egg and carries it in her pouch; it hatches after only ten days. The baby echidna, called a "puggle," does not need to crawl its way to the pouch as marsupials must do. Hatched inside the birthing pouch, it nurses milk from mammary pores, staying there for nearly two months. The mother then digs a burrow and hides the growing puggle, coming back every few days to give it more milk, doing so for another seven months. Named after a Greek mythological monster that was half woman, half snake, an echidna lives for around fifteen years.

Waterfront Homes

Platypuses dig burrows on the water's edge, constructed with openings so small they must struggle to fit inside. This design is made purposefully—it helps the platypus squeeze the water from its fur. Platypuses build temporary burrows to camp in and other, more permanent ones, for sleeping and storing food. A special birthing burrow is made for the female to lay her annual deposit of two eggs. She remains secluded, cuddling the leathery eggs against her furry body and tail until they hatch in about ten days. When the pups emerge, she feeds them milk that seeps from a gland—not a teat like most mammals have. After a few months, the young platypus is able to swim, and, like its parents,

prefers a solitary life, only coming together at times of mating. When courting, a male will latch on to a female's tail and together they swim around in circles, never uttering a sound. The aquatic dance might go on for hours, round and round, until something seems right between them, and they then choose each other as mates.

Life Cycle
On land, where they are not as agile as in water, platypuses are prey for eagles, hawks, owls, and foxes, although their keen sense of hearing and hind feet stingers help them fend off foes. On the riverbanks, pythons and water rats are also enemies, especially to the young, and while in the water, crocodiles try to snatch platypuses when they can. Feeding primarily at night, the platypus hopes for the cover of darkness to increase its chances of survival. If fortunate, it lives to around fifteen years.

PRONGHORN ANTELOPE
Prairie Ghost

Although not truly an antelope and instead the sole surviving member of its own family called *Antilocapridae*, a pronghorn is distinguished for its forward-pointing, grappling-hook-like horns. It lives at high altitudes, 10,000 feet above sea level. Even where oxygen is at diminished levels, and when most people would be gasping for breath, the pronghorns have remarkable speed, able to sprint from 0 to 50 miles per hour in seconds.

In addition, they have incredible balancing agility and intense muscular control; they can easily perch on a rocky precipice or navigate sure-footedly through rough terrain. Athletes envy the metabolism of the pronghorn, an animal that withstands temperatures ranging from 50 below zero Fahrenheit to the scorching heat of more

Among the fastest land animals, pronghorns come in second behind only cheetahs.

than 120 degrees. It has concentrated red blood cells that can deliver oxygen to its muscles instantaneously. The secret of pronghorns' Olympian skills lies at the cellular level, since their body is packed with supermitochondria, the energy-converting part of cells, which make pronghorns aerobic prodigies. They range from central and western Canada, through the Rocky Mountains and New Mexico to Texas. Pronghorns weigh up to 150 pounds, are on average 4 feet long, and measure to 40 inches at the shoulder. They live for about fifteen years. Nearly extinct by the 1920s, the pronghorn population has rebounded and is now estimated at about 750,000.

The Phantom

Native Americans compared the pronghorn to a spirit, seen one minute, vanished the next. It is also a genetic ghost, in that it is the only one of a dozen types of ancient antelopelike animals that evolved exclusively to the changing climates and prairies of North America about twenty million years ago. All but the skillful pronghorn are gone.

QUACKERS
Elusive Sea Monsters

Unidentified things in the skies are called UFOs, but the ocean also has a category for mysterious sightings of marine beasts called USOs, or unidentified submerged objects. As technology advances, undersea realms and marine landscapes that were havens and retreats for creatures unnerved by encroaching civilization are now prodded and probed. In the Arctic and North Atlantic Oceans at depths never before observed, submarines registered unusual froglike noises, emitted by a creature that travels faster than any known man-made vessel, reaching speeds of 150 miles per hour before disappearing and leaving only a quack, or "ribbit," sound in its wake. Giant squid, due to their lack of exoskeletons, often avoid sonar detection and emit a sound identified as a "bloop." Orca whales also make audible undersea noises while mating, but do so close to the surface.

The quacker noises might be some counterintelligence technology, but the beast encountered was 60 feet long and resembled a torpedo-shaped shark.

Renderings made from sonar signals created by the elusive quackers seem to resemble the long extinct basilosaurs, an elongated species of a whale, which once roamed the world's oceans until thirty-four million years ago. Fossils of this creature were as long as 160 feet, with fins resembling paddles. It had a snout-shaped mouth with numerous sharklike teeth. In recent times, further investigation into the source of the frog sounds has driven the basilosaurlike beast, or whatever it is, only deeper into its underwater chambers. However, no specimen of the quacker has been located or positively identified.

QUETZALCOATLUS
Gigantic Gliding Dinosaur

The first giant lizard that had powerful wings, *Quetzalcoatlus* cast ominous shadows during the dinosaur era, with some having 39-foot wingspans, bigger than some airplanes. The reptile belonged to a group of beasts known as pterosaurs. There were more than fifty different species. All had flaps of skin tissue that attached from their claws, ran along their bodies, connected at their feet, and served as wings, somewhat similar to bat anatomy. Pterosaurs had long, drawn-out, narrow heads, with rudder-type crests protruding from their skulls, with pointed, spikelike

beaks and numerous sharp teeth. They had fur instead of feathers and attained flight by springing back on their legs and leaping into the air. Once up, they beat their wings furiously and were able to reach estimated speeds of over 75 miles per hour and soar for hundreds of miles. Most were carnivores, while some were scavengers, although the enormous *Quetzalcoatlus* found in North America apparently specialized in hunting fish. Their growth rate after hatching

Quetzalcoatlus

was supercharged, going from a flightless creature to one sturdy enough to fly within days. Pterosaurs lived from 220 million years ago, until 65 million years ago.

Still Flying?

No creature fits the descriptions of a dragon better than the pterosaur. The odd facts about this creature stem from cave drawings, particularly one drawn on a cliff face in Utah, made by Anasazi Indians in around A.D. 200—which was an exceedingly long time from when the flying reptiles were supposedly extinct.

Other pterosaurlike creatures supposedly have been seen in a wide range of locations, from Cuba and North Carolina to parts of Australia. In the mid-1800s, French workers were digging a tunnel. When they split open a boulder, a large birdlike beast emerged, spread its wings, groaned once, and then died. A local university identified it as a pterosaur, and a photo appeared in the 1856 edition of *Illustrated London News*. It is now known that a number

In the last twenty years, beasts resembling Quetzalcoatlus were allegedly spotted in Papua New Guinea, where flocks of similar mysterious creatures come out at night so regularly natives gave them a name, "ropens."

of animals can "turn off" and enter various degrees of hibernation. Although it is extremely unlikely that any living thing could hibernate for sixty-five million years, nature and its rules are anything but constant.

QUETZAL
Best-Dressed Bird

If all the birds in the world entered a beauty pageant, the quetzal, a tropical bird found in the Central American rain forest, might take the crown. The bird is 16 inches tall and a lightweight at about 8 ounces, with the male having a bright red breast, green wings, a shocking yellow beak, and a fluffy, chartreuse-hued crest. At mating season, the male grows a 3-foot rainbow-colored tail to score itself winning points in the bird beauty contest. The quetzal lives in tree hollows carved out with its beak and eats fruits, nuts, insects, and small lizards or frogs.

The bird was depicted frequently in Mayan and Aztec art, but people were forbidden to capture or to put the bird in cages, since it was said to lose its beauty and die of sadness if so imprisoned. If a person was found trying to tame one, the Mayans treated the offense with capital punishment. Today in Guatemala, the currency is not called dollars or pesos, but "quetzal," in honor of the bird's worth.

The Mayans and Aztecs venerated the quetzal as a goddess, and it was considered more precious than gold, representing a free-flying omen that brought good fortune to their civilizations.

QUINOTAUR
A Fishy Tale, Half Full of Bull

This fanciful beast became "extinct" by the eighth century and was rarely mentioned afterward. It was a mixture or a cross between a bull and a fish. Its bovine head had five horns, dark brown fur, and a large drool-dripping black nose. It dwelled in coastal regions near France. It was an amphibian and could disappear underwater and swim considerable distances before resurfacing. However, since its upper abdomen also had legs and hooves similar to those of a bull, it foraged on land, which must have been no easy task since it was forced to drag the lower, fishy part of its body about as well. When out of water, quinotaurs were most vulnerable to attack and reportedly were hunted to extinction. Ancients explained that it was borne from the union of a god and a human, but what this creature could have been remains unknowable. There are no related fossil records, and its existence relies on mentions of its habits in various mythologies, which seem similar to stories told of the Greek minotaur, though with a fishy twist.

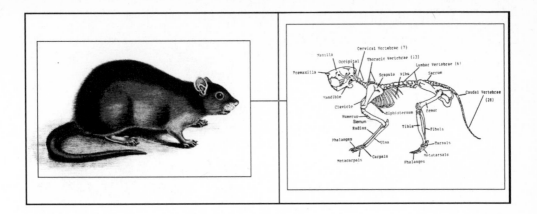

RAT
Rodent Ruler

Rattus is the imperial-sounding Latin name bestowed on the genus of more than 50 species of true rats. A rat is a small to medium-size rodent, about 5 to 10 inches, weighing about ½ pound, with a naked, thick tail, which is usually longer than its body. The two most famous rats are *Rattus rattus,* the black rat, commonly known as the house rat or roof rat, and *Rattus norvegicus,* the brown rat or Norway rat (though it originated in Asia and not Norway), which is commonly known as the city or sewer rat. Together, the black and brown rats have gained worldwide domination among their genus, with populations as large as humanity's. In other words, for every one of us, no matter where we reside, there is at least one rat living closer to you than you might think. The history of rat expansion parallels humankind's history, because we usually transported them, even if unknowingly, to everywhere we went. Rats proved equally capable of adapting to all environments.

The biggest true rat was recently discovered living in a volcanic crater in New Guinea. Called the Bosavi woolly rat, it grows to the size of cat and weighs 4 pounds.

Social Life

In the wild, rats live in burrows and colonies that consist of one male and five or six females, each with its own chamber. However, since the male breeds with them all, the colony size grows dramatically and rapidly. Females can give birth to six to twenty-four pups every three four pups every three

to four weeks, and they are able to get pregnant as soon as they are three or four months old. Males can be aggressive and chase off their male offspring soon after they are weaned, at five or six weeks. In urban environments, where space is limited, rats share common territories, and colony sizes reach into the thousands.

Rats enjoy being close to other rats and like to pile up for warmth, often sleeping side by side. They share food but are cautious, smelling the mouth as well as the butt of another rat to see if the food is good or if it is tainted with poison before they eat from the common bounty.

In New York City, there are 12 rats for every person, or 96 million rats, running through buildings and the subterranean network of tunnels and pipelines below the streets.

Mind-Boggling Rats

Rats learn through trial and error and do not forget easily what they learned. They can jump 3 feet straight up into the air, without a running start. They can fall 50 feet and seem none the dazed, though their depth perception is highly developed and they rarely stumble unless

pushed. They can swim for three days without stopping, fit into an opening smaller than a quarter, and can gnaw through wood, sheet metal, cinder blocks, and even a piece of glass if it has the slightest crack. A rat moves its whiskers, which are more sensitive to touch than our fingertips, back and forth nearly fifty times per second. Rats have hearing that is more acute than ours, detecting frequencies in the range of ultrasound. Their eyesight is poor, however, and they cannot focus or adjust to light quickly, seeing in only blues and greens. Instead, a rat views its world as an array of aromas and smells. A rat can sniff a speck of another's urine and know who it is, how stressed that rat is, if it is a male or female, and where it has been.

Every surface has a unique scent, from a shag rug to a tile floor, and rats follow the way to a food source or return to home by using their noses. Even though they lick themselves and prefer to keep their coats groomed, rats live in extremely filthy places. Since the beginning of civilization, rats have been humans' nemesis because of where they travel, and they are known to carry at least seventy diseases. Black rats were hosts to fleas that carried bubonic plague during the Middle Ages, killing millions of

Rat King

Within a colony, rats are somewhat equal, and there's no one boss rat that sits in its lair growing enormous while others serve it the best morsels. However, a phenomenon called a "rat king," associated with overcrowding, does occur; when rats are living in a compact environment, their tails may get entangled and knotted. Sometimes more than a dozen get so entwined and are further glued together with excrement and dirt. These enmeshed bunches grow from pups to adults in this predicament. Nevertheless, they go about hunting, foraging, and sleeping together as a unit. This situation has been observed in mice, but since mice will practice partial self-cannibalism (that is, eating their own tails when food is scarce), entanglement seems more prevalent among rats. The largest configuration of a rat king was found in Germany in the early 1800s, which consisted of thirty-two rats knotted together. Judging from their size, it seemed they were joined soon after birth and survived in this condition for at least a year.

people. In general, rats score high as vectors for the transmission of diseases from animals to humans.

Mouse vs. Rat

Mice have been on earth longer than rats, though in antiquity it was believed they were the same animal. The Romans called the mouse *Mus minimus*, or little mouse, while the rat was *Mus maximus*. Mice have triangular heads with pointier noses, are generally much smaller at the size of a sparrow, have thin tails, and have ears that are larger proportionally than those of

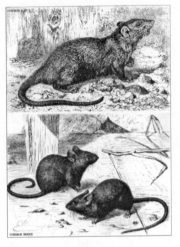

rats. Mice are generally better climbers and scurry up a ninety-degree-vertical wall. They can cross a wire while holding on upside down, which is a feat a rat finds difficult. In general, mice do not infect human food supplies as much as rats do, and they are overall less destructive. Mice also live longer, for about five years, while rats survive about two years. However disturbing, mice will eat their dead, while rats—due to their sniff-before-taste instinct—generally will not eat a fellow rat carcass, especially if it died from illness or poison.

RAVEN
Black Jester

Permanently dressed in stylish black, the raven is the largest of the more than 5,000 types of passerine, or perching, birds. The common raven is found in Europe and the Northern Hemisphere, growing up to 30 inches, with some having large wingspans of nearly 4 feet. Weighing no more than 4 pounds, ravens are generally much larger than their cousin,

the crow, although they look quite similar. However, even if they look alike, ravens and crows will never share the same territory. There are other genuses of ravens found in Asia, Africa, and Australia.

No Opportunity Lost

Ravens are social and congregate in flocks, with many pairing for life, breeding together season after season and joining to protect their territorial rights. Ravens are omnivores and are adaptive to woodland or urban life, having a history and role alongside humans throughout the ages. They will hunt for small animals but prefer to eat carrion, insects, and grain. They are clever and known to raid the food supplies of all sorts of animals.

Scarecrows meant to chase ravens from crops are rarely taken seriously and frequently attract the birds rather than repel them. Ravens will roost in branches, using their perches to keenly observe where other birds and animals bury their caches of food. They can remember exactly where a cache was hidden and wait for as many as a few hours to unearth it.

Raven Mischief

Ravens are talkative and have more than thirty different calls used to communicate within the flock, ranging from danger warnings, cries to notify where carrion is found, or calls to update each other when working together as lookouts. Ravens team up when attempting to at-

Ravens will alert and attract wolves when the birds locate the remains of a large animal in the forest. They lead the wolves to the carcass and then let the canines do the hard work of tearing through the hide.

In the Middle Ages, the raven was associated with witchcraft, and many considered the birds to be people who had been transformed by a curse or alchemy. Some were thought to be demonic tempters, tricking people into foolery. The birds were often seen as harbingers of death or bad luck, primarily attributed to their dark feathers and for coming close to people, unusually curious and unafraid for wild creatures.

tack nests of other birds, and they are willing to share food supplies, as long as there is enough for themselves first. Probably considered bullies in the minds of smaller birds, ravens are often chased away by any number of birds that are protecting their territorial rights and their nests filled with eggs. Ravens seem to take it in stride, rarely aggressively fighting back, as if accepting that they were busted and moving on to look for an easier opportunity to get food.

All in the Game

Ravens are always looking for fun, and even when they steal a morsel from another raven, they are usually never overly mean-spirited. Instead, they spend time figuring out ways to rob all sorts of things for amusement and as play. Ravens will snatch wristwatches that people might take off for a minute while washing their hands, or pilfer silverware from a picnic table, and even swoop in to grab golf balls right off the fairway. Ravens will slide down a snowbank as if sledding or play games of tag and a version of musical chairs, trying to outwit each other from their perches, hopping from branch to branch, seemingly just for the fun of it.

Some of the braver ones will taunt dogs and cats, landing directly in the animal's view, and caw with laughter when the dog or cat tries in vain to chase them. When among serious threats in the wild, such as coyotes and wolves, the birds keep a cautious distance.

Life Cycle

The raven's intelligence and mischievous disposition affords it a relatively long life. Adult ravens have few natural predators. By working in teams and with their elaborate system of communication, ravens are rarely fooled by carnivores or birds of prey. Their nests, though, are raided

by owls and martens, and young ravens might be captured by an eagle. Smart and cautious, even when coming upon a dead animal, ravens let other birds take the first bite to make sure it is not a trap. Ravens live for about twenty years, but the best pranksters of the flock have been known to live up to forty years.

In flight, ravens sometimes play a game of chicken, heading straight for each other to see which will veer first. They might bump into another raven as if for a joke, to see how it recovers in flight and reacts to the prank.

REINDEER
Santa's Sleigh Team

Reindeer live in the sub-Arctic and Arctic regions of North America, Europe, Russia, and Asia. The males or bulls reach shoulder heights of 7 feet and weigh over 600 pounds. They have thick fur, ranging in assorted colors of white, gray, or brown. Both sows and bulls have antlers. Some males grow racks more than 4 feet wide and over 3 feet in length, which make reindeer antlers one of the largest among animals, only second to moose. Reindeer use their antlers to fight enemies, to battle for dominance during mating season, and to scrape through ice to get at their favorite foods of moss and lichen.

In Finland, some reindeer breeds have been domesticated and trained to pull sleds, but none, except for Santa Claus's legendary herd at the North Pole, can allegedly fly. It is easy to guess how such a tale originated since reindeer run very swiftly, reaching speeds of 40 miles per hour as they seemingly glide above depths of powdery snow.

A reindeer's hooves change with the season, getting wide and spongelike during the summer thaw and shrinking to where only the hard hoof edge is exposed during winter—a seasonal modification that makes the hoof like a cleat and prevents the reindeer from slipping on ice. Reindeer are social animals, herding together in vast numbers, sometimes exceeding one-half million. These enormous groups partake in punishing biannual migrations traversing more than 3,000 miles. Reindeer are excellent swimmers and ford, en masse, icy rivers and lakes during these epic journeys.

About That Famous Red Nose . . .

Although reindeer do not have glowing noses like the fictional Rudolph the Red-Nosed Reindeer, they do have a specific heating adaptation to keep their nostrils red-hot, as it were. Features called "turbinate bones"

widen the inside of a reindeer's nostrils to increase the surface area and warm the air before it enters its lungs.

Their eyes can see through foggy nights, but reindeer are especially attuned to see minute distinctions in the winter landscape. This helps them to identify predators' tracks in the snow, or see other animals' signs, such as urine stains, which warn of impending attacks. Reindeer are prey to wolves, bears, eagles, and wolverines. A reindeer lives for about twenty years.

The reindeer's eyes can see ultraviolet wavelengths, similar to what we see using a backlight.

RHINOCEROS
Living Tank

There are five types of rhinos found in Africa and southern Asia. They are immense vegetarians, eating only grains and grasses, weighing 10,000 pounds and standing 6 feet at the shoulder. A rhino is coated with a plate of armorlike skin more than 2 inches thick. Rhinos have one or two horns, which are made of the same proteins that form our fingernails, growing 3 inches a year. Some rhinos have produced horn lengths of over 5 feet. They have little upright ears that produce excellent hearing, as well as a keen sense of smell. Their heads are massive, yet they have small brains for such a large beast.

When they charge, achieving sprinting speeds of 35 miles per hour, their force has been known to derail and knock a steaming railroad locomotive right off the tracks.

Ancient Tanks

Rhinoceroses trace their most similar-looking modern ancestor to about fourteen million years ago, though rhino relatives were perfecting their techniques for survival for some fifty million years. Many types diverged and evolved, with one notable variety: the woolly rhino, standing over 11 feet tall, was fur coated and so hardily adapted to the Ice Age of Europe; the last woolly rhino lived until about eight thousand years ago.

Loves the Spa

Rhinos enjoy wallowing in mud and wading into rivers. Due to their bulk, they are not too adept at swimming, trying to keep their heads

above the waterline lest they sink and drown. Even so, they can't resist a puddle of mud and love to get covered with it. Dried mud acts as an insect repellant and as a sunblock to keep them cooler.

The tick bird serves as the rhino's personal groomer, eating parasites and bugs. Due to the rhino's massiveness and short tail, it cannot bite or swat away pests, and it relies on the small bird for the task. The tick bird, however, also sneaks a little blood from the rhino, picking at the rhino's wounds for moisture and nourishment. Although the bird never lets a rhino's scab heal, the large animal tolerates its presence, seemingly more concerned and annoyed by ticks and insects than the damage the tiny bird can cause.

The big, ornery rhino does have one friend. It allows a small bird, called a "tick bird," to perch on its horn.

Life Cycle

Rhinos have had the misfortune of being considered valuable in traditional medicine, such that they have been hunted for their horns and bones for centuries. Chinese traditional medicine, in particular, still believes the rhino horn cures a wide array of illness and has "lifesaving" powers. This demand accounts for thousands of cases of illegal poaching and rhino deaths each year, while in reality the rhino horn has no proven medical benefits. As for predators, other than humans, the rhino has few, as its reputation for being quick to anger is well known among all the animals. If left alone, a wild rhino can live for about forty years.

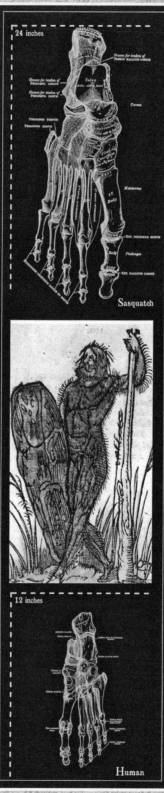

24 inches

Sasquatch

12 inches

Human

SASQUATCH
"Bigfoot"

THE BRIDGEPORT TELEGRAM

BRIDGEPORT, CONN., MONDAY MORNING, AUGUST 29, 1927

"WILD MAN" SOUGHT BY N. J. OFFICERS

"Big Hairy Man," Minus Clothes Scares Boy and Group in Woods.

SALEM, N. J., August 28.—There's a wild, wild man roaming around the countryside here, it appears, and police are trying to capture him.

Thomas Smith, aged fifteen, started the hunt today when he told Sheriff J. Enos Robinton that the tires of his bicycle had been slashed by a "big, hairy man without any clothes."

The boy said he was in the woods about two miles north of here. The man jumped out of the woods, wrecked the bicycle, and chased the boy.

Edward Jones and Cooper Wilson, farmers, came forth with their own story about this "Borneo" specimen. They were with some other men in the woods, they said, and had to take refuge from "a man that's either crazy or wild."

Police are checking up on a long-haired, bearded individual who might, they think, have escaped from a lunatic asylum.

Sasquatch is an unverified species of gorilla, primate, or hominid that is estimated to be 10 feet tall and weigh 500 pounds. Its range is extensive, from China to the Russian steppes to the United States. The most reliable sightings occur in the Pacific North American wilderness areas.

Accounts of this beast describe it as having a low-browed forehead, big eyes, and a prominent barrel chest. It is covered with 3- to 4-inch-long brown hair (though uneven and not as thick as a bear's), except for portions of its face, palms, and soles of its feet. According to tracks, Sasquatch, commonly known as "Bigfoot," has five toes and long toenails or claws on enormous feet that measure up to 24 inches long and 8 inches wide. It travels standing perfectly upright, though it uses its long arms and knuckles, which extend to its knees, on occasion for balance. Claw marks on trees suggest that Sasquatch is an agile climber.

> Sasquatch *derives from a Native American word for "wild man" and is a creature that features prominently in many tribes' oral histories.*

Why It Remains Concealed

Since no specimen has ever been found, most scientists believe Bigfoot is a hoax, though some argue that perhaps it is a Neanderthal hybrid

or some otherwise extinct hominid that somehow managed to survive. Although many modern apelike creatures reside in tropical climates, Bigfoot has adapted to upland terrains. It is reputedly nocturnal and an omnivore, favoring fish, particularly salmon. Species normally require a large breeding stock to sustain a population; however, it is unclear how Bigfoot procreates or how long it lives. Current sightings could be of specimens that are hundreds of years old, the last remnants of a once robust population.

One hypothesis for the occasional nature of Sasquatch encounters centers on its hibernation habits, particularly its possible ability to go into prolonged torpor (temporary metabolic shutdown) or even enter the deathlike "tun" state of metabolic stasis.

Bigfoots are experts at camouflage and apparently have exceptionally honed senses to have eluded capture. Since no Bigfoot corpse has been found, some suspect the creature must have strong familial or tribal units that ritualistically dispose of one another's bodies. Others point to the fact that the lush Pacific Northwest ecosystem—categorized as a rain forest by ecologists—would quickly decompose and reclaim any dead remains, thereby helping to preserve Bigfoot's mystery.

Yeti of the Himalayas

This legendary creature is physically similar in virtually all aspects to Bigfoot, with the exception of having snow-white hair, rather than brown. The Yeti (Tibetan for "rocky place bear")—or more commonly, the "Abominable Snowman"—dwells at high altitudes in the Himalayas. Locals say the beast forages for food by using stones or boulders as tools. It communicates by a series of whistling sounds. The Yeti has slightly smaller feet than Bigfoot; the largest footprint observed measures 13 inches long, though it's proportionally wider, at 9 inches. The wider feet apparently help in walking and climbing in its snowy terrain, acting like snowshoes.

SATYR
Hard-Partying Man-Goat

These legendary half-man, half-goat creatures supposedly originated in Ethiopia and wooded areas around the Mediterranean, but they were also found along the southern European coast and the British Isles. Some stood as tall as a full-grown human, while other strains were shorter than 4 feet. Satyrs had curly, thick hair covering most of their bodies, except their chests; some had long, bushy tails but others were tailless. All sported goatees or pointy beards. They were often depicted either with flaming reddish-orange hair or brown fur. With a flat nose and donkeylike ears, a

Satyrs were portrayed as being perpetually drunk. They also seemed to organize epic parties, which people reportedly were enticed to attend and where they lost their inhibitions.

satyr's face was humanlike; its lower portion was entirely goat or that of another hoofed animal.

Such a creature intrigued poets and storytellers; images of satyrs, with both human and goat characteristics, were depicted in ancient Greek art dating to around 500 B.C. and continued to be described in various Roman texts. It is the only creature from Greek mythological records that is also mentioned in Hebrew writings. The prophet Isaiah warned people not to go near the ruins of Babylon, believing the partying satyrs dwelled there: "Wild beasts of the desert shall lie there; and their houses shall be full of doleful creatures; and owls shall dwell there, and satyrs shall dance there." The satyrs were considered "goat-devils" for encouraging lascivious behavior, and thus creatures to be avoided.

Satyrs were said to be born from, or were themselves, deities, which was a standard way ancients explained unusual or odd creatures. Nevertheless, satyrs were astute, could play a flute, and were capable of speaking numerous languages. The god called "Pan," a patron of shepherds and fertility, was often said to be a satyr. In the British Isles, the northern variety of satyrs reportedly also had horns and was even more enigmatic than the Greek version.

Faun of the Forest

Like satyrs, fauns were a legendary group of goat-people that inhabited forests and usually were helpful to lost travelers. While satyrs were always male, fauns could be faunas or female, as well. (*Flora* and *fauna* are words we use to describe plants and animals, respectively, and were the names of Greek goddesses overseeing aspects of nature.) According to the *Daily Telegraph*, in 2009, a goat in Zimbabwe gave birth to a creature with a human head that had the body of a goat, including a tail. It is the only example of a faunlike creature born in recent times, but it died a few hours after birth.

SAWFISH
Power-Tool Mouth

The sawfish, sometimes called the "carpenter shark" (though related more closely to stingrays than sharks), has a 6-foot-long saw blade snout, with as many as twenty-five teeth on both sides. There are 8 types of sawfish, with some growing to lengths of over 20 feet. Mostly found in tropical waters near the coasts of the Atlantic, Indian, and South Pacific Oceans, sawfish are nocturnal bottom feeders. They sleep in estuaries or in shallows during the day, remaining motionless, parked on the bottom lethargically for hours on end.

It duels with its blade cautiously, since, in contrast to shark teeth that are continually replaced, once the sawfish's teeth fall out, or are knocked loose, it cannot regenerate more. The sawfish must wait ten years to reproduce and most never reach that age, since they are frequently tangled in fishing nets due to their odd-shaped noses. Young sawfish are eaten by dolphins, crocodiles, and sharks. If luck prevails, a sawfish can live for thirty years.

The sawfish's bill is primarily used to sift sand and hunt for buried crustaceans, but if the sawfish sees a fish swim by, it leaps into Zorro mode and slashes the prey with its snout.

Union Workers

In ancient Greece, legend had it that if you cut a piece of wood with the snout of a sawfish and used the head of a hammerhead shark to drive in the nails, the structure would withstand gale force winds and never wash away in a flood.

SKUNK
Stinkiest Species

Twelve species of skunks are found in Southeast Asia and the Americas, ranging in size from the 18-inch, 1-pound pygmy spotted skunk to the heavy-duty 36-inch-long, 20-pound hog-nosed skunk. Skunk fur can be black, gray, or brownish, but all skunks have white stripes. Most famously, skunks emit one of the worst odors known to nature from two glands located at their anuses. Since a skunk has neither good eyesight nor big teeth for defense, it has perfected chemical warfare as its best deterrent against predators. Most carnivores, from bears to wildcats, give the small mammal a wide berth after experiencing a skunk's stench.

The skunk's odor contains sulfur and other chemicals that produce a smell worse than that of rotten eggs and burning rubber combined.

It can shoot its spray up to 6 feet, projected along with a farting sound. The emission is strong enough, at close range, to cause a sort of pepper-spray-induced temporary blindness. The smell can linger on an attacking animal's fur for more than a week. Skunks use this weapon sparingly and generally just mist the air with it rather than releasing a thunder-clap burst, since they only carry enough of the spray for four

or five uses. It takes about a week for a skunk's glands to manufacture another dose.

Can They Stand Their Own Smell?

Unsurprisingly, skunks are solitary animals. Their gas is not poisonous, but probably due to experiencing one too many juvenile sprayings, adults would rather forage alone. They only come together for mating, and sometimes they gather communally while wintering in burrows.

Skunks are omnivores, eating plants, earthworms, small frogs, mice, and fish. They are clean animals and groom themselves regularly.

Young skunks, like many human children who think farting is grossly amusing, frequently spray each other for the fun of it.

They move from burrow to burrow, living in tree hollows or tunnels abandoned by other animals. Skunks, even with their chemical defense, have short life spans, usually about three years. Birds of prey, such as owls, which cannot smell, are the skunk's greatest enemy. In addition, since skunks are not fast runners and have poor vision, many end up dying as roadkill.

Stink and the Bigger Brain

The first "proto" mammals were small creatures, with even smaller brains and a less defined area of the cerebrum to detect scent. At a time when daylight was the most dangerous time for small creatures to be about, the ones that survived adapted by venturing out at night to hunt for food. Without light, mammals needed to rely more on scent detection, which spurred the development of larger brains to interpret the world through smell.

SPIDER
Web Weaver

Lycosa fatifera.

Spiders have been weaving webs since the dawn of time, or at least for 140 million years, the age of a fossilized web preserved in amber that displays a pattern used by spiders today. Spider silk is one of the most remarkable fabrics found in nature, made of interwoven proteins, consisting of an assortment of amino acids; the spider produces strands comparatively stronger than titanium alloy that can stretch and flex with the elasticity of a rubber band and without breaking.

Spider silk is formed from spinneret glands on the bottom of the spider's abdomen; the earliest arachnids used the silk to protect their eggs, and then as guidelines that helped them find the way back to their nest. Eventually, they learned how to build the silk into a web to catch prey. Some spiders can make eight different types of silk, specialized for various tasks. To build a web, a spider doesn't shoot out its first strand like Spider-Man does, but rather makes a long, nonsticky one called an anchor thread. Some spiders just let the strand blow until it attaches to something, and then they traipse across, first securing the local end by encircling it around a branch or effectively tying it into a knot. From this main line, a spider adds bridge lines and various other threads, more and more of them, until a full web is constructed. All 35,000 different species of arachnids found throughout the world create silk, but not all are web weavers.

Web Rules

There is no monument to the first spider that came up with the idea of making an intricate web, just as the original architect or engineers of the pyramids receive no credit. However,

If clothing was made from spider silk, a person wearing such clothes could withstand a round of machine-gun fire or get run over by a car without effect.

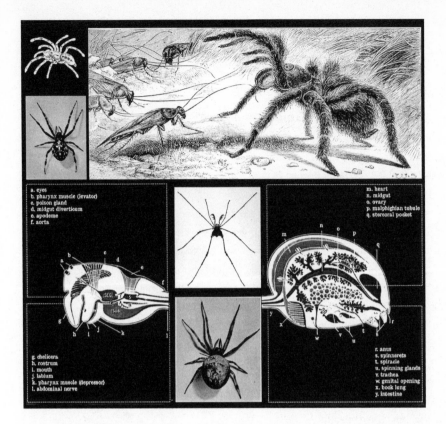

the golden orb weaver spider is singled out as a champion and master of insect web design. These weavers grow to about 2 inches; are reddish, brown, or yellow in color; and have long legs with ends pointed inward like knitting needles, which helps them weave better than ground-walking spiders whose leg ends are usually turned outward.

Orb silk strands contain an acid that gives the orb weaver's web a golden hue, and an advantage in fooling bees and other insects into thinking its trap is merely rays of sunlight. It takes much energy and use of its dietary proteins for a spider to make its webs, such that it often recycles the silk by eating a web that is no longer adhesive or has portions damaged by wind or rain. Inside its circular web, a spider sometimes makes irregular zigzags that are shaped like letters of an alphabet, as

The orb weaver spider can make a circular web 3 feet wide, with radiating support cords that are over 10 feet long.

if the spider is writing in some secret code. A lady golden orb weaver lives for about one year. Right after mating, the bigger female turns on her male partner and eats him.

Spider Aviators

Many insects are caught in the wind and transported to incredible heights, usually against their will. In the 1920s, entomologist P. A. Glick charted insects' migration by using an airplane to discover exactly how high bugs flew. He attached gluey fly-paper strips to his biplane so they trailed behind like advertisement banners, and was amazed at the diversity and volume of specimens that each mission yielded. He counted more than twenty-five thousand insects in any given air column, which on a typical day was no wider than 50 feet and ranged in height from 20 feet to over 15,000 feet above the earth. At the highest altitudes, he regularly observed the ballooning spider. The adolescents of this species seem to seek the thrill of flying and fashion a sort of parachute to become airborne. On the windiest days, they crawl to the tip of a branch and extend their bodies, casting their web strands toward the sky. They ride the thermal currents, sometimes for days, at over 10,000 feet high, traveling more than 300 miles. But they are not lost forever, and when wishing to return, they make differently designed chutes that glide their descent safely back to earth. Some seem addicted to this behavior; once back on the ground, and after catching a quick meal, they make a balloon web again, and keep returning time and again to the heights.

SNAILFISH
Deepest-Dwelling Fish

Born into darkness, where light never shines, the hadal snailfish does not know that the sun exists. It lives in abyssal sea trenches, canyons in the ocean floor that are 25,000 to 35,000 feet below sea level. It holds the record as the deepest-living fish yet discovered. There are almost 200 types of snailfish: all are tadpole-shaped, scaleless fish

that grow from 2 to 30 inches in length and weigh up to 25 pounds. They are found in oceans from the Arctic to Antarctica, yet the deep-sea hadal snailfish have never been captured alive and were not known to be real until 1955. They live in extremely harsh conditions at the bottom of the deepest marine trenches around the world, hellish places where the molten core of the earth peeks through.

The snailfish's eyes are black orbs not meant for seeing as we know it, since the creature lives in total darkness and has no need to detect light. Instead, the snailfish has sensors on its head to navigate, sense vibrations, and find food in these dark, rock-bottom pits. In waters where nothing of its size or complexity was thought to exist, the snailfish swims vibrantly in schools. Snailfish feed on microshrimp and the few organisms that can tolerate sea trench conditions of total darkness and crushing water pressures. It is unknown how long snailfish live; when they die, they do not float to the top—this is certain—but are likely recycled or consumed.

SPONGE
Oldest Living Animal

Aristotle, the famous classical Greek philosopher and naturalist, correctly surmised that sponges were actually animals, not plants as they were often considered. Sponges are ancient creatures; the oldest, the Antarctic sponge, was alive when its namesake continent separated from South America about 140 million years ago. There are more than 10,000 different kinds of sponges inhabiting all the world's oceans, in depths of a few feet of coastal water to more than 5 miles below the surface. The earliest known fossils of such organisms date to the extremely distant past—more than six hundred million years ago.

Rock Steady

A sponge does not mate, but rather creates a perfect clone of itself (with identical DNA) when a piece of itself is broken off by currents. The "offspring" clings and grows wherever it happens to settle. Sponges do not have nervous systems, nor digestive or circulatory systems, or, in fact, any organs. They live an immobile existence, anchored forever to the spot on the seafloor where they were originally deposited.

Sponges rely on ocean currents to bring them food (bacteria and plankton) and oxygen and to flush out their waste.

A sponge body has thousands of tiny porous cells, which collect whatever passes by in the current. It also has unique cells called "choanocytes" that have small, whiplike tails; these cells go about delivering the nutrients through-

out the sponge's body. The sponge has a flexible skeleton made of a nonliving gelatinlike substance, and fibers made of protein and calcium called "spicules" that give it shape.

Chemical Warfare

As simple as sponges are, they seem to know when it's necessary to protect their anchored spot. Even if the question "Do sponges have consciousness?" stirs debate and, perhaps, remains definitively unanswerable, the organism, nevertheless, seems quite aware of its surroundings. In fact, the sponge has developed a complex process to ward off attackers. These weapons, more than anything, have allowed sponges to survive for millions of years even as the earth has changed all around them.

As stationary creatures, sponges rely on their ability to produce various chemical reactions that deter predators from eating them or to hinder getting smothered by plants or organisms that try to grow near them and invade their space. For example, they produce chemicals toxic to starfish and emit other noxious mixtures that act like virtual weed killers. Sponges use these weapons to inhibit coral from spreading, effectively making a no-grow zone around their base. They have an array of antibiotics that kill many types of microorganisms and antifungal chemicals as well. Scientists are even turning to the ancient sponge as a holder to one of the keys that might explain puzzling questions about longevity.

Chemicals produced by sponges are being studied and are believed to help fight human diseases, such as AIDS, cancer, tuberculosis, and many bacterial infections.

Life Cycle

The Antarctic sponge has one of the longest lives among all animals. In the frigid water, with fewer predators than tropical sponges must face, Antarctic sponges have the leisure to grow slowly, less than a fraction of an inch every ten years. One type of sponge called a "glass sponge" has a body that resembles transparent crystal. Some are large enough for a scuba diver to stand inside their cone-shaped forms and become thoroughly concealed. By measuring the size of a sponge, similar to counting the annual rings of a redwood tree, scientists have determined that some Antarctic sponges have been alive for more than fifteen hundred years.

SUGAR GLIDERS
Superman Marsupial

These tiny marsupials live in Australia, Tasmania, and New Guinea. The sugar glider has a body no bigger than 5 or 6 inches long with a bushy tail of equal length. It has large round eyes, small mouselike ears, and a

white furry head with black stripes. The unique feature of a sugar glider is a flap of thin skin called a "patagium," which attaches from its big toes and extends up to its little fingers, making it look as if it's equipped with a superhero's cape. When stretched out, the patagiums become like wings and are used for gliding long distances. The sugar glider, when the wind is blowing can easily glide the length of a football field and go from goalpost to goalpost in about five seconds. This marsupial eats insects and loves the sap from eucalyptus and gum trees.

Do They Make Good Pets?

Sugar gliders make for happy pets, provided you have a giant fenced-in aviary, because in the wild they feel happiest when gliding around at night hunting for bugs and sipping on sap. In a cage, they will accept mealworms for dinner. But they can never be house-

Every Animal Has an Invention

Shamans and medicine men of the past knew that nature held the secrets to ease many of humanity's ills. From the smallest microbe to the largest beast, each has a unique secret, perfected by nature's process of trial and error. Technology also helps in the creation of new inventions and designs by duplicating efficient animal adaptations. For example, the flying squirrel provided the inspiration behind the Wingsuit, a special jumpsuit worn by parachutists that allows them to glide in the air for longer times and with greater accuracy than a traditional chute. With outstretched fabric arm flaps and another patch of cloth between a jumper's legs, the "squirrel suit" lets humans fall during a jump like a guided missile at speeds of 100 miles per hour or as slow as only 30 miles per hour. However, landing with ease while wearing a Wingsuit is still a dangerous hit-or-miss proposition for humans.

broken and drop excrement wherever they are allowed to roam. In addition, they like to bite, hiss, grunt, and bark throughout the night. Sugar gliders communicate in nature with hormonal scents, which to us smell anything but sweet.

A Glider's Life

Sugar gliders use their soaring talent when searching for food, swooping from tree to tree, and escaping quickly from predators. However, their gliding makes them conspicuous, such that owls, foxes, snakes, and monitor lizards will eat them when they can. Sugar gliders live for about ten to fifteen years.

THRASHER
Nature's iPod

Thrashers are North American songbirds possessing the world's largest repertoire—they know how to sing as many as three thousand different tunes. Brown thrashers are found in Canada and the United States, predominately east of the Rocky Mountains during the summer; they migrate to the southern United States for winter. A flasher is not the flashiest of feathered birds, with a light reddish-brown colored body and wings, and a white-speckled and black-striped breast. This drab color allows it to remain concealed while it sings among hedges and undergrowth. It has an above-average height for a perching bird, at about 11 inches, and a wingspan of 1 foot. Its beak is dull, and it has yellow eyes with large black pupils. Some of the thrasher's notes, chords, and musical phrasing are as complex as many masterpieces of classical music; its ability to sing puts it at the top of the charts when measured by the complexity of its vocalization. One of the great tricks of the brown thrasher is its ability to mimic other birds, and it has the ability to keep learning new songs its entire life.

Other Copycat Birds

Like the brown thrasher, the starling, a small iridescently speckled black bird, mimics fellow birds' songs, but it can also replicate other sounds. For example, if it lives on a farm, the starling can make a decent impersonation of sheep. If it lives in the city, it can make sounds that replicate a bus door swishing open or a police car's siren. The mockingbird is the best copycat among bird singers, capable not only of precisely mimicking the songs of many birds, but also insect and frog sounds. The lyrebird of Australia is another marvelous mimicker, likely the most versatile worldwide; this bird can replicate a wide range of sounds from chain saws, car engines, and rifle shots to crying babies.

Birds Sing for Rights

Thrashers build nests close to the ground and compete for territory with their archrival, the catbird, which also mimics songs. The two birds can imitate each other's voice, and when fooled by the other, they will fight to the death over nesting rights. Marking an area by song is a common characteristic among many songbirds. Certain rifts and types of song tell other birds that they are here, healthy enough to sing, and able to defend their space.

Most birds sing at dawn, in the morning hours, since their songs are their only property deeds and must be renewed daily. Dickcissels, sparrowlike birds, will spend nearly 70 percent of their day singing, as if the little birds need to keep speaking out to have their rightful claims heard. The tiny red-eyed vireo, weighing less than one-third of an ounce, will belt out as many as twenty thousand songs a day. Birds sing to warn other birds that they must be taken seriously. The skylark, for example, sings in flight, especially when eyed by a predator. Its song shows that it is exceptionally strong: not only is it able to fly and sing at the same time with such a vengeance, but it is also willing to give a fight of equal bravado.

The sandpiper sings for five minutes straight while flying across what it claims as its territory, as if marking boundaries by song.

How Birds Sing

Birds of the same species sing the same songs and seem to learn how to perfect variations from their fathers, since males frequently croon more than female birds. Some species are capable of learning melodies only during their first year and are called "close-ended learners," while open-ended learners, such as thrashers, can pick up new musical numbers throughout their lives.

Some birds, like the Henslow's sparrow, learn only one song, while the sedge warbler uses more than fifty distinct melodious harmonies that are long-winded and musically complex; this bird never repeats the same exact version more than twice. Songbirds have an organ called a "syrinx," or voice box—two membranes at the bottom of their windpipe that

vibrate when air passes through it. Birds with better muscle control around the syrinx can sing better songs. They also learn how to time and control their breaths. The canary, for example, takes as many as thirty short breaths a second, so as not to impede its musical number.

Birds Sing for Love

The most melodious bird songs are for love. A song's complexity or sheer volume and persistence is meant to court and impress a potential mate with a display of virtuosity. Among songbirds, the males are usually most proficient, though the females are the judges and critics of their skill. Just as hip-hop songs might appeal to city dwellers, and a country song might seem just right while driving a lonely road bordered by cornfields, birds produce sounds to suit their surroundings. The "love songs" signal to a mate that they are well adapted to the ins and outs of their terrain.

What Makes a Hit?

Female birds are often attracted to complicated songs, and they might make the rounds checking out various males' skills before making a decision. The nightingale, one of the few birds that sing at night, has over three hundred different love songs in its playlist. It shows the female that it is alert at all hours and a good potential father to protect the nest. The marsh warbler, a bird native to Europe, migrates in winter to Africa, though it mimics the songs of African birds when its looks for a mate back at home. Its song promises

The female alpine accentor, a sparrowlike bird of Europe and Asia, is one of the few female birds that sing. She mates with several males and has a bunch of "fathers," none of them certain of their paternity, helping her nurse and care for her eggs.

the female that it is an accomplished and experienced traveler, and likely to secure an exotic trip next winter. The brown thrasher male starts by blasting out his loudest song at the top of a tree. Once he has a female's attention, he returns to the underbrush and sings softer melodies.

Life Cycle

Snakes, hawks, and owls look to thrashers as a meal. The catbird is an enemy to the thrasher's eggs, breaching the nest and breaking them whenever it can. Nearly half of all thrashers, even when hatched, do not make it past the second year. But if a thrasher does learn the tricks of survival—and a few songs—it can live for about twelve years.

TIKBALANG
Filipino Horse-Human

The tikbalang is a legendary creature that lives in the forest and remote regions of the Philippines. It is a large beast standing over 6 feet tall that bears a head similar to a horse's yet has a human body. It has long arms and human hands, though its legs are proportionate to a man's and its feet are hoof shaped, giving it a stiff, upright posture. The tikbalang's hair grows like a horse's mane, in a Mohawk style, but it is made of bristles, similar to a porcupine's quills.

Tikbalangs prefer to stay in heavily overgrown areas and congregate under bridges. It seems they eat bamboo, since most sightings have occurred in bamboo thickets. Besides traditional methods of camouflage, the tikbalangs avoid detection

by blocking footpaths and roadways to confuse travelers, sending unwanted visitors in directions away from their hiding spots. When it rains while the sun is shining, many in the Philippines say a tikbalang is breeding somewhere. In some legends, the creature befriends individual humans and speaks to them. Historic records claim that some natives had captured tikablangs and domesticated them. If one is lassoed, a would-be tikbalang tamer has to ride on the creature's backside as the beast dodges and leaps through the forest. If one manages to stay straddled, the tikablang will eventually concede defeat and let the person ride it whenever it wishes. In most accounts, a tikablang does not harm humans, and some of the younger ones occasionally break the species' rules of strict secrecy to watch children at play. Sometimes the beast might briefly join in activities, such as fetching a foul ball, before vanishing into the forest.

TOAD
Toxic Wart Wearer

The toad seems like a stoic little creature, sitting on a stone in the forest, patiently waiting for an insect or grub to pass within reach of its long, sticky tongue. It rarely appears nervous or fidgety, though it will make a

concerted effort to hop away if prodded or provoked. There are more than 300 species of toads, classified as amphibians, found in all parts of the world, with the exception of polar regions.

One reason the soft-bodied toad has the luxury of appearing calm in a natural world filled with larger predators has to do with its internal chemistry. The wart-covered skin of the toad contains a milkylike alkaloid secretion called "tryptamine," similar to toxins found in some poisonous mushrooms, which causes hallucinations in humans and death to animals that ingest it.

Hallucinogenic Venom

A North American toad, *Bufo americanus*, is famous from coast to coast, especially after its psychoactive venom was classified as an outlawed substance by the U.S. Drug Enforcement Administration, which warned people that "toads may not be licked."

tryptamine

Frog vs. Toad

Toads are actually land-loving frogs, and both are amphibians, meaning that the first parts of their lives are spent exclusively in water. Hatched from eggs, frogs and toads are tadpoles in their youth, resembling a fish with a bulbous body and long tail, and only grow arms and legs as they mature. How long frogs and toads stay as tadpoles depends on the pond or stream where they were born. Environmental factors and water temperatures, as well as differences among various species, dictate whether a tadpole will remain in its fishlike form for as little as a month to more than a year. Once adults, frogs stay close to the water of their birth, while toads will head to drier ground and prefer never to be fully submerged again.

FROG TOAD

Catching Warts

For centuries, mothers have warned children that handling toads will cause warts to grow on their hands or faces. However, even though a toad is considered an unattractive creature and, when attacked or handled roughly, can produce a poison that might cause a person severe pain, seizures, and cardiac failure, it will not give that person warts.

Life Cycle

Old toads, both the European and American variety, have been known to live up to forty years, though on average most frogs and toads live anywhere from two to fifteen years, depending on the species. Frogs have far more natural enemies than toads, although many snakes and some birds seem to be unaffected by toad venom.

TUBEWORM
Dwelling in Diabolical Depths

On the ocean floor, where tectonic plates shift, raging bursts of superheated water erupt at temperatures exceeding 500 degrees Fahrenheit. No living thing should reasonably be able to live at such extreme temperatures. These hydrothermal vents spurt forth hydrogen sulfide and a slew of toxic minerals. The water is cooled rapidly by the freezing currents that occupy ocean depths, but these regions can often remain a bubbling cauldron and killing zone for distances of 200 yards. Hydrothermal vents or underwater hotspots, similar to "Old Faithful," the

geyser in Yellowstone National Park, vary widely in volume and intensity. However, right at the cusp of many of these vents, where water is near the boiling point, colonies of giant tubeworms have claimed this inhospitable ocean real estate as their own.

Blind Chemists

Living without sunlight, giant tubeworms have harnessed a complex assembly of bacterium partners to help turn hydrogen sulfide, a chemical that would burn the skin off your arm, into usable oxygen and nutrients.

The worm lives inside a protective sleeve made of a substance that is hard like a lobster shell and is topped with a bright red flowerlike plume at top. The red of its "head" comes from oxygen-rich hemoglobin, or red-blood cells, which acts as its processing plant to exchange chemicals that feed the bacterium that lives inside of it. Without arms, eyes, a mouth, or even its own digestive system, the tubeworm has perfected a process called "chemosynthesis." The bacteria that live inside its tubular frame do all the work, turning the toxic soup of chemicals into life-sustaining nutrients that not only ensure the tubeworm's survival but also allow it thrive.

A giant tubeworm grows to lengths of more than 7 feet. Inhabiting an environment more akin to some alien planet, it has no predators and can live for more than 250 years.

TROLLS
Nordic Neanderthals

A legendary race of primates known as trolls, called "jötunns," or monsters, in Norse mythology, are described as heavyset beasts, about 7 feet tall (despite their reputation for being short) and covered with fur or long hair. According to Scandinavian folklore, they had humanlike faces and limbs, but with lobe-shaped noses, and larger, cuplike ears that were located higher up on the side of their heads than humans' ears. Myths

that they lived under bridges and collected toll for safe passage were later
made popular in German folklore as stories of bridge-dwelling trolls fea-
tured a dwarfed version of the original oversized Scandinavian troll.

Trolls lived in isolated mountain ranges and inhabited caves. They
were extremely powerful, with muscular forearms, and could toss heavy
boulders for long distances. The early human inhabitants of the area
passed on oral legends about the species, which were said to be carnivores
and not afraid of hunting men or eating them. The origin of the creature
was unclear, though various mythologies reasoned that trolls were born
out of the armpits of a giant. It has been speculated that troll mythology
grew from early human encounters with Neanderthals, which also once
inhabited Northern Europe.

Encounters with Trolls

Our earliest relations broke from apes about fifteen million years ago.
None of the earliest hominids closely resembled us physically, though
they were bipedal beasts with problem-solving brains. It was not until
about 500,000 years ago that Hominidae began to appear, which acted
and appeared more like modern humans. The well-documented *Homo
erectus,* a low-browed, brutish species seemed to vanish about 300,000
years ago, and by 195,000 years ago, creatures more like ourselves came
on the scene, sharing the hominid stage for a time with Neanderthals.

What other small bands of hybrid, humanlike creatures flourished in isolated pockets throughout the world is unknowable. Yet it is possible that legends and mythologies grew from oral histories concerning our encounters with humanlike species during our long migratory history.

Fossil evidence clearly indicates that *Homo sapiens sapiens,* or modern man, encountered Neanderthals, a separate species from us that vanished only about thirty thousand years ago.

TULLY MONSTER
Pole-Eyed Beast

Tullimonstrum is an extinct mud-dwelling creature that existed about three hundred million years ago when North America was partially covered under a shallow sea. (Fossils of the "tully monster" were first found in Illinois.) In that era all the landmasses were so lopsidedly rearranged that nearly all the midwestern states were situated at the earth's equator. Nevertheless, this creature had one of the most improbable body designs ever

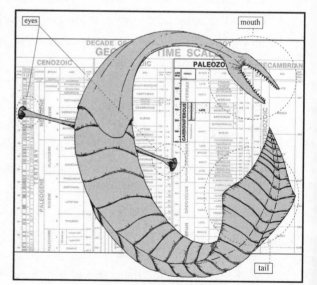

constructed, with a headless, sluglike body, two fins, and a long nose with a pincer on the end that contained eight tiny teeth. In addition, it had some form of rudimentary eyes located at the base of its polelike fins. As bizarre as it was—its design was never replicated—it seems reasonable, as biologists speculate, that this animal may have eventually developed into some variety of worms. As of now, the tully monster is classified as an animal, but thus far it belongs to its own phylum.

The Order of Life

In the mid-1700s, Swedish scientist Carl Linnaeus devised a system that classified all living organisms into categories and lists, a system that is still used in biological sciences today. He divided forms of life into a descending list in which they first belong to a kingdom, then a phylum, class, order, family, genus, and finally a species. Considered a genius and the Einstein of his time, Linnaeus grouped organisms by physical similarities. His list intrigued many and began the serious scientific inquiry into man's origin, sparking a search to find where we fit into this all-inclusive directory of living things.

TURTLE
Armored Ancients

Turtles live both on land and at sea, but all are reptiles distinguished by their bony shells, extensions of their ribs that serve as shields for their backs. The bottom or belly of the turtle shell is called a "plastom" and is actually an elongated collarbone. The two halves of the turtle shell are connected by muscle hinges that allow it to close tighter. This adaptation helped make the turtle one of oldest types of reptiles, existing from 215 million years ago, well before lizards, crocodiles, or snakes appeared. They lived alongside dinosaurs and then outlived them all.

Today, there nearly 250 different species of turtles. The leatherback

The largest known turtle of all time was the Archelon, which died out sixty-five million years ago and measured 13 feet long and 16 feet wide.

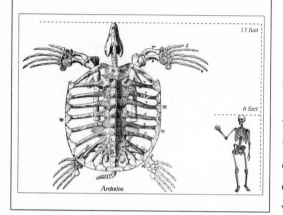

Archelon

sea turtle ranks as the largest, with a 6-foot-wide shell and weighing 2,000 pounds. The smallest is the South African padloper tortoise, growing to only about 3 inches. The meanest of the bunch is the snapping turtle, of which there are 2 species, the common snapping turtle and the alligator snapping turtle. Both have sharp hawklike beaks and can bite off a human finger with one chomp. They are even more than bullies to their own kind and are cannibalistic. The snapping turtle will devour a smaller member of its species without a second thought.

Portable House

Tortoises—land-dwelling turtles—generally have larger spaces inside their shells than their aquatic relatives, allowing them to fully draw all their limbs and their heads inside. Tortoises have eyes facing downward, while those of aquatic turtles face upward.

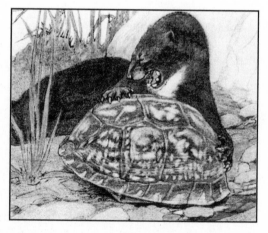

A turtle's beak is rigid, and the only part of its body that it can move fast is its head, a necessity for catching swift prey. Some turtles, like the Florida softshell turtle, are carnivores; many are omnivores; and some eat only plants. Aquatic turtles can hold their breath for as long as seven hours. Even turtles living in arid regions need access to freshwater, while marine turtles have adapted to drinking seawater by eliminating excess salt through their tear ducts.

All turtles lay eggs, and even sea turtles must breach the protection of the ocean to deposit their eggs on the shoreline. Young turtles are orphaned from birth and have no parental care or guardianship. The turtle never sheds its shell, which remains its permanent abode, growing larger as it matures. Aquatic turtles have light-weight shells, while tortoises' shells are usually thicker and heavier, but a lifesaving burden.

Life Cycle

Marine turtles are sometimes preyed upon by sharks, though most have few other natural enemies once fully grown. At birth, turtles are at their most vulnerable, especially sea turtle hatchlings, which must make it to the shore-line from their beach mound nests. Seabirds and shorebirds pick off the hatchlings as easy late-night fare; so do fish and crabs. Tortoises are at-tacked by raccoons, snakes, coyotes, and birds of prey. Despite the signifi-cant mortality among the young of many turtle species, nature seemed to give the slow steady turtle the benefit of longevity. Averaged across all species, the turtle has a life span of about fifty years, but some have lived more than two hundred years.

All turtles have tremendous night vision and see in more colors than humans.

—

English General Robert Clive had a massive pet tortoise, "Adwayita," received as a gift while he was in India in the late 1700s. It was transported to a London Zoo in 1875. The tortoise died in 2006 of a cracked shell at 250 years old.

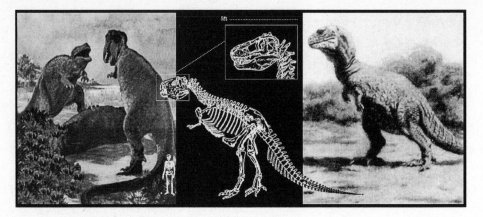

TYRANNOSAURUS REX
Largest-Ever Predator

The most well known of all dinosaurs, T. rex was the largest land carnivore that ever existed. Its Latin name means "King tyrant," and it's a highly appropriate one considering the dinosaur grew to over 40 feet long and weighed 7 tons. Its legs alone measured 13 feet to the hip, and it had a 5-foot skull with a mouthful of 12-inch teeth. There were at least 30 species of *Tyrannosaurus,* found in Europe and Asia, though the largest of its kind roamed the landscape of what is now western North America. As a species, the T. rex only had about a million-year reign. However, during its heyday, it was hard to outwit, since it had excellent vision and a keen sense of smell.

It did not walk upright all the time, with its head held up high, Godzilla style, as generally depicted, though it could stand up to fight and scan the horizon. Instead, it leaned forward as it ran with its heavy tail counterbalancing its massive skull. The tail pointed straight out and was perpendicular to its legs. It certainly was a meat eater, but it seems this hulking monster did not like to pick a fight as much as originally believed. Since its arms were small and awkward, it's unlikely that hand-to-tooth combat was its favorite

Although enormous, the T. rex's bones were nimble, and its joints were fused in such a way as to give it the agility comparable to much smaller darting lizards.

Jurassic Park

The novel and movie *Jurassic Park* about cloning dinosaurs from blood found in the bodies of insects is based on a factual premise. Dinosaur DNA still exists; many samples of prehistoric blood are preserved in the stomachs of mosquitoes that lived 140 million years ago, particularly specimens sealed in ancient amber or fossilized tree resin. Although no complete sequences of dinosaur DNA have been found, it is one day theoretically possible to have a T. rex or any number of dinosaurs reborn, or at least genetic versions duplicated.

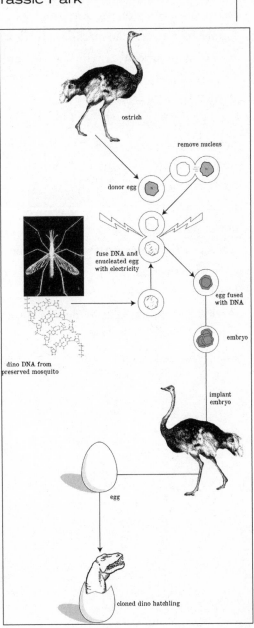

ostrich

remove nucleus

donor egg

fuse DNA and enucleated egg with electricity

egg fused with DNA

embryo

implant embryo

dino DNA from preserved mosquito

egg

cloned dino hatchling

mode of attack. It could be compromised easily and killed from below by gut punctures made by smaller dinosaurs during battle. It probably preferred to sneak up on other grazing beasts and then pounce and kill with tremendous force. The infamous T. rex was just an overgrown scavenger, preferring to pick the remains of what other dinosaurs had killed.

Why They Died

Very few juvenile fossils of this species have been found, suggesting the T. rex was extremely protective of its young. Apparently it kept its brood under fierce guardianship for four or five years. The full-grown T. rex had an average life span of about thirty years. The species died out at around the time of the K-T event sixty-five and a half million years ago, but it was one of the last of the larger dinosaurs to disappear. As both a hunter and a scavenger, the T. rex survived slightly longer, but it was ultimately unable to avoid extinction. It is possible the T. rex was not able to digest bacteria-laced carrion, which was plentiful, and needed fresh meat, of which there was less and less available to meet its huge daily demand.

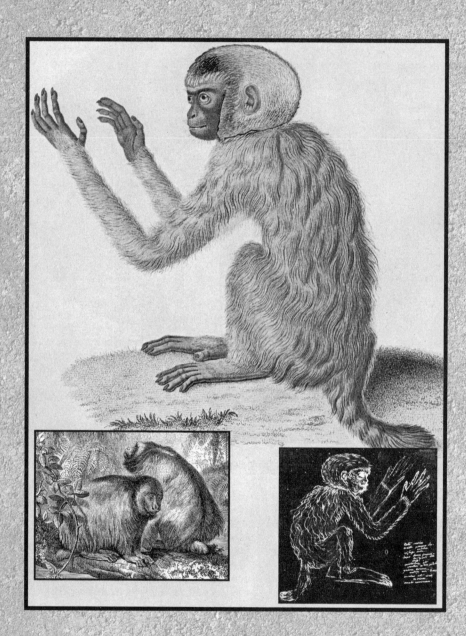

UAKARI
Masked Monkey

Found in the forest canopy of the Amazon, the uakari is a monkey with a completely hairless red face, which looks identical to a painted mask. Uakaris are quiet, lethargic monkeys and seem a bit melancholic. The four types of bald-headed uakaris have no fat on their faces, which gives their countenance a skull-tight appearance. Long, light-colored hair covers their bodies, growing shaggily from the top of their heads and hanging to their shoulders. Some have all white hair, while some are red-colored or blond. They weigh about 10 pounds and are just over 2 feet long, preferring to live in the treetops. The uakari has a paddle-shaped tail, yet it is capable of making 6-foot leaps as it forages, eating mostly fruits, nuts, insects, and small animals.

Little Buddahs
Amazonian folklore tells tales of the creature as a force of both good and evil. Living as they do 1,000 feet above the forest floor, uakaris are rarely observed. They were often considered to be the reincarnated spirits of ancestors and so they were largely left alone. Still, other tribes hunted uakaris and dropped the monkeys from their perches with blow darts. They were revived with a pinch of salt placed in their mouths and kept as pets. Uakaris take to captivity with the same resignation and expressionless face they have when staring out from the tree branches. Besides humans, only birds of prey can snatch the monkeys from the ceiling of the rain forest. They are social animals and family oriented, living in groups of one hundred. Uakaris live for about fifteen to twenty years.

UMBRELLA BIRD
Useless in the Rain

UMBRELLA BIRD *cephalopterus penduliger*

This entirely black perching bird is almost 2 feet tall and lives exclusively in the rain forests of Central America and South America. It gets its name from an umbrella-shaped crest of feathers that crowns its head. However, this odd fluff is not any more watertight than other bird feathers—which are much more water resistant than animal fur. It unfurls the full dome of its "umbrella" mainly during courtship.

It could also be called a weird-wattle bird, since it also has a growth of flesh from its neck that dangles to below its feet. This wattle serves as a megaphone of sorts and helps the bird amplify its loud calls through dense foliage. If left alone, it eats fruits and nuts and lives for about twenty years. Although they are desired as pets, umbrella birds do not take well to cages and live shorter lives behind bars.

UNICORN
One-Horned Mystery

In 401 B.C. the Greek historian Ctesias voyaged to India, a place then thought to be a fabled land at the edge of the world. He was the first to mention a peculiar one-horned, horselike creature that lived there. He described it as a wild ass that was very swift footed and had a white, red, and

black hide, with a 2-foot horn in the center of its head. Others spoke of a one-horned beast in Africa that resembled a rhino. Some described the unicorn as being the size of a goat, with a beard, a spiraled horn, and the tail of a lion. Nevertheless, it was a rare creature and extremely difficult to capture, evidentially. It is probable that many of the early sightings of unicorns were actually describing a type of rhino, or perhaps some form of mutant one-horned deer or bovine. All the same, the ancients considered them to be absolutely real and inscribed detailed accounts of their behavioral traits.

Pliny the Elder wrote that "the ferocious beast" used its horn to assault enemies, though when trapped, the unicorn leaped from a cliff and landed on its horn, which seemed to absorb the impact from the fall. However, it was commonly believed that the unicorn's horn was especially designed to kill dragons.

The Vikings capitalized on the medieval craze for unicorn horns by passing off the spiraled tusks from narwhals as those of unicorns, selling them for their weight in gold. The king of Denmark believed he had a throne made from unicorn horns, though it was actually made from whale tusks.

Embellished with Time

From ancient times through the Middle Ages, unicorn folklore grew in detail. It was certainly a solitary animal and dwelled in forests. Wherever it grazed, flowers bloomed and it seemed to be eternally springtime. Unicorns frequently spent time gazing at their reflections in lakes, admiring their own beauty. The horns of the unicorns contained strong medicine and had unique healing powers that could neutralize all poisons. If one were able to take a sip of unicorn blood, it would guarantee immortality.

Cave paintings in Lascaux, France, and ancient drawings in Namaqualand, an area in Nambia and South Africa, depict one-horned beasts. Another early rendering discovered in Lago Posadas, Argentina, also displayed what appears to be artistic examples of one-horned creatures. If such a creature did exist, it became extinct by about 6,000 B.C.

Where Are They?

Unicorns became symbols of purity, strength, and an untamable spirit, and unicorn renderings were used on numerous royal coats of arms. Although no fossils of unicorns have been found, there are people who believe the beast has retreated to another dimension or resides in an astral plane. Sightings have dwindled during the last hundred years, but some cling to the hope that they will occasionally appear to the lucky and spiritually pure.

VAMPIRE SQUID
Tentacled Terror

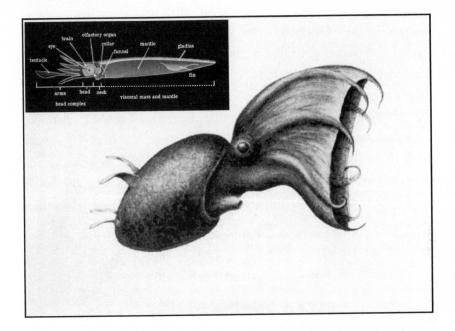

Living in the dark ocean depths, this small 1-foot-long squid has a web of skin that connects its eight tentacles together, causing it to look like a sinister creature with a black cape. Its big red eyes make it seem even more horrific. However, the vampire squid is no more bloodthirsty than any of its other larger squid relations, even if its joined tentacles give it a swooping and whirling motion as it swims.

Since it swims slowly with its permanently attached Dracula cape, the vampire squid makes up for this disadvantage by having an extremely strong clamping beak. The squid is hard to detect in the dark ocean, where it lives in depths of 3,000 feet, and because of its black color it does not need to chase after and track down prey. Once a small fish is seized in its vampiric grip, there is no escape. It uses its webbed tentacles like a net. This squid

Instead of ink that some squid disperse to conceal themselves, the vampire squid discharges a cloud of gooey mucus that chokes up visibility, blinding its pursuers in a mess of phlegm.

does not eat that often, having a very slow metabolism that helps it survive the cold water depths.

No one knew vampire squid existed until 1903 when one was first dragged up in a fisherman's net, and it is still uncertain whether they live in underwater sea caves or roam freely in the open ocean. When first encountered, people thought the creature escaped out of a portal from hell. However, when it was learned that these squid change colors, transforming from black to bright red or blue, twinkling like a Christmas ornament, their sinister reputation changed, if not their name. They have bioluminous lights, called "photophores," emitting from their skin, which flash in synchronized patterns to attract mates and for navigation. Fossils reveal the vampire squid has remained unchanged for more than three hundred million years, though how long it lives and how it dies remain mysteries.

VELVET WORM
Slow Slimer

Appearing as a cross between a worm and a caterpillar, the velvet worm is actually not related to either but rather is more closely linked to scorpions and primitive crabs. It grows to about 7 inches, has tiny pinhead-sized eyes, two flat and thin antennae, and it is soft bodied. The velvet worm moves slowly and sluggishly on about forty-two pairs of legs. It lives mostly in equatorial regions of the Southern Hemisphere, with other types found in parts of Africa, Asia, and Australia. It usually prefers being on the ground in tropical forests or under leaves where it hunts for smaller insects, which it captures by smothering the creatures with a gluelike slime the worm spits out.

The velvet worm's slime is shot from two portals below its antennae. Composed of proteins, the gooey substance forms a net, engulfing a small insect as if it were caught in a minipatch of quicksand.

If the velvet worm seeks larger

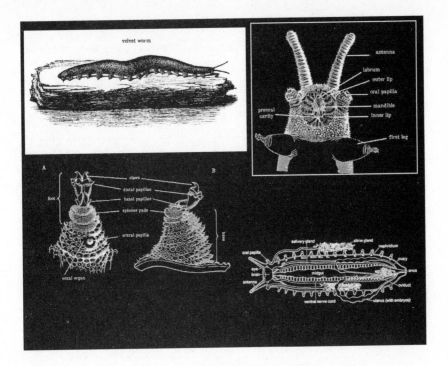

velvet worm

antenna
labrum
outer lip
oral papilla
mandible
inner lip
preoral cavity
first leg

A
claws
distal papillae
basal papillae
foot
spinous pads
oral papilla
coxal organ

B

salivary gland
slime gland
nephridium
oral papilla
ovary
eye-brain
anus
midgut
antenna
oviduct
ventral nerve cord
uterus (with embryos)

prey, the slime will tie up the bigger insect's limbs, rendering its victim immobile. The velvet worm has large lips it uses to suck at its sticky-trapped catch and then chews it with jaws or small mandibles deep in its throat. Its muscles to move its teeth back and forth to shred and grind up its food.

Slime World

Males transfer their seed by carrying sperm on their antennae, and when a female is encountered, a male inserts its entire head into her abdomen. Instead of starting life as eggs, young velvet worms are born alive. They are communal beasts, and the juveniles are not eaten by the parents, but rather are allowed to hitch rides on the females' backs.

By some unknown means of communication, velvet worms hunt cooperatively. Sometimes they appear to gather under a rotting log as if in a planning stage and then split up into assault teams to begin a foraging campaign, even if in a slow-

Although the brain of this creature is minuscule, the worm displays social behavior more akin to that of certain mammals.

motion fashion. Size is what determines the status among velvet worms, and when meeting, they measure the newcomer by tracing their antennae along the other worm's entire length. When hunting together, the dominant (i.e., biggest) female usually gets the first bite. The velvet worm can live for up to six years.

Worms Among Us

The word *worm* is generally used to describe any cylinder-shaped and wiggling, soft-bodied invertebrate. The earthworm is the most commonly recognized and abundant of the true worms, or annelids. The earthworm is literally a tube of muscular meat, with a brain and five hearts that pump its blood along a rudimentary circulatory system. All earthworms have both male and female organs, but they need a partner to play an opposing role in order to reproduce. However, if a worm is cut into parts, with the exception of its head, it can rejuvenate a segment. Worms have eyes, but only for sensing light or darkness. Instead, they can sense stimuli throughout their entire bodies. They breathe through their skin and need moisture to process the oxygen; a dried-out worm actually suffocates. They eat bacterium and decaying leaves, thus functioning as superior aerators of soil. Many animals, fish, birds, and amphibians have them on their most delicious lists, and worms are frequently devoured—one reason why they have a short life span. However, despite its defenselessness, a fortunate worm can live for six years.

WATER BEAR
The Most Imperishable Creature

Water bears, also known as tardigrades, are the most indestructible animals ever observed. Whether it is frozen at temperatures reaching only a little above absolute zero, a point where complete molecular motion ceases (-459.67°F), or stirred into a pot of boiling liquid, the water bear will survive.

Water bears have even been transported to the airless vacuum of outer space and subjected to blasts of deadly radiation that would literally disintegrate and mortally affect any living thing, and yet they still came away unscathed. This microscopic animal is found all over the world, though when not tested to the extreme, it prefers to live on patches of moss, fungi, or lichen in temperate climates. There are more than 1,000 varieties of water bears, belonging to a group of similar creatures called "extremophiles," with the smallest only observable with a microscope and the largest growing to less than .059 inches, or the size of a dot drawn with a pencil. All water bears have four pairs of legs with claw-toes and four-segmented, chubby bodies with blunt-shaped heads and look very much like Gummi bear candies. The water bear waddles in a bearlike stride when it walks.

Bury them under glacier-thick ice at the highest peak of the Himalayas, throw them in a desert for decades without a drop of water, or sink them to the lowest depths of the ocean— these practically imperishable creatures still will not die.

Suspending Time

The water bear has a still mysterious biological switch that allows it literally to turn itself off when environmental conditions become unfavorable. It enters extreme hibernation, called the "tun" state, which is defined as the cessation of all biological and cellular activity and imitates death. For the water bear, this condition is reversible, and it resurrects itself when better conditions return. The length of time it can remain in this standstill phase seems to have no limit. For example, a patch of dried moss was in a mu-

seum display for over one hundred years. Scientists found what appeared to be flattened water bear carcasses in the moss, but after water was added and the bears had absorbed enough moisture, they came back to life. Nevertheless, the tiny creatures that hold the key to the secrets of cryogenics, if left alone to live on their patch of moss in the forest, have normal life spans of only about one year.

WHALE
Largest Animal in the World

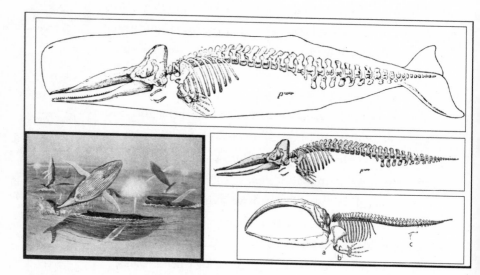

The more than 85 species of whales trace their ancestor to a mouse-sized land-dwelling mammal with four legs, belonging to a genus called *Artiodactyla*. It lived near the sea and probably got its food there, but it nested on land and had already evolved to adapt fully to terrestrial life for eons. The true missing-link creature that went from a land-based life to deciding that its best chance for survival was to return forevermore to the ocean is unknown. However, in the fifty million years since then the whale has not only survived countless geographical changes but now ranks as the largest mammal in the world and inhabits all the earth's oceans.

Carnivores vs. Harvesters

All whales breathe air and exhale through blowholes located on their heads, are warm blooded, and nurse their young from mammary glands with milk that is as thick as toothpaste.

Whales all have front flippers and flukes, or tails; they have layers of fat beneath the skin, called "blubber," and have four-chambered hearts as we do, and large, complex brains. They can be divided into two primary groups by their choice of food. The meat eaters, including the sperm whale, the killer whale, and belugas, all have teeth and are predators of fish, squid, shellfish, or other marine mammals. The baleen whales, so called because of the giant grids or filters, called "baleens," in their mouths that collect microscopic plankton and krill as they swim, include the blue whale, the bowhead, and the humpback. As for size and longevity, the baleen harvesters win, with the blue whale ranking as the largest animal that ever lived, measuring over 100 feet long and weighing up to 150 tons. (That is as much as five World War II Sherman tanks.) The carnivores live more socially and hunt in pods, while many of the baleen whales prefer loosely associated social networks, or a solitary life.

All whales carry their infants in wombs, ranging from nine to eighteen months, and give birth to a calf tail-first so the newborn will not drown.

Whale Language

The predators, like the belugas and killer whales, communicate by making clicking and clanging noises and with whistles, not only to coordinate

hunts, but also to recognize each other, greet friends, and when distressed or saddened. No one has ever cracked the code of what whale vocalizations actually say, but it seems they communicate the equivalent of status updates among their pods, for example: "I'm doing fine"; "Let's take a left turn"; "Shark!" Whales also use this elocution as sonar to interpret and calculate

Some whales have a feature called a "spermaceti organ" located on their foreheads or noses that helps them stabilize their buoyancy. This organ also serves as a sort of "third eye," which transforms sound waves into images. The word spermaceti *gives the sperm whale its name.*

size of prey or depths. A whale has the ability to hear the resonances through a section in its throat; then the sounds are sent to an inner ear. Many of the baleen whales sing in melodic voices but do not rely on elocution to evaluate prey as much as toothed whales; they emit sounds to help them map the ocean terrain and to locate each other for mating.

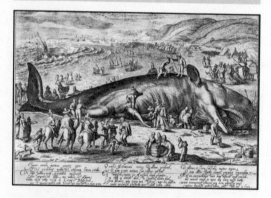

Why Do Whales Beach Themselves

The phenomenon of whale pods coming ashore to beach themselves has always seemed perplexing. Human-transmitted sonar signals may be one reason for the whales' disorientation, yet it may be that one or more of the whales is sick and dying.

Once a whale is beached, the weight of its own body taxes its organs. The whale has difficulty maintaining its body temperature, and it succumbs to heat stroke, chills, or pneumonia. Some whales seem to come to the shore arbitrarily, as if it would be more amicable to die there rather than end by shark attack, or sinking and drowning. Perhaps they come back to the edge of the sea from where their ancient ancestors first ventured to take one last look at the terrestrial world before they die.

Life Cycle

Life spans among whales vary per species, though generally baleen whales live longer than toothed whales; one bowhead whale, when measured by

a certain acid produced by the whale's eyes, and by dating a fragment of a broken harpoon still lodged in the animal, placed the age of this particular bowhead whale at 211 years old. Many of the baleen whales live to at least one hundred years while the toothed whale's life span is on average fifty years. Over the ages, man has been the whales' greatest enemy, though killer whales will eat other whales, and sharks will attack smaller

As social animals, whales care for their ill and often refuse to abandon a family member, even if it means following it to shore and causing their own deaths.

whales when they can. Beluga whales, who live in Arctic waters, can be unexpectedly trapped by ice packs, where polar bears become a danger to them.

Dolphins

Once thought to be the fastest fish in the ocean, the dolphin belongs to the same Cetacean family as do whales and porpoises. The name *dolphin* is derived from the Greek words meaning "fish with a womb." Ancient fishermen sought their help and called "Simo, simo," to ask to be guided to where schools of fish lay hidden. Roman literature includes stories of how boys trained dolphins to give rides on their backs, and even to this day the animal seems to have a particular affinity for children. In recent times, a lone boy crossing the Florida Straits from Cuba told how dolphins surrounded his makeshift raft, protecting him from sharks, and how the dolphins nudged his tattered vessel toward shore.

There are forty different types of dolphins. The marauding killer whale is the largest dolphin, though all are carnivorous. Dolphins live for about twenty years. The famous dolphin from the 1960s TV series *Flipper* was a female that died of a heart attack at age fourteen in 1972. She is buried under a leaping dolphin statue on the front lawn of the Dolphin Research Center in Grassy Key, Florida.

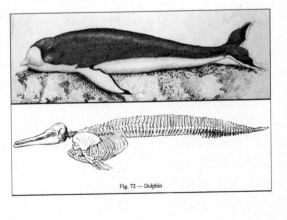

Fig. 72 — Dolphin

WOODPECKER
Nature's Jackhammer

A routine schedule that includes banging your head ten thousand times each day against a tree might seem a punishing existence, but for the enthusiastic woodpecker, with its uniquely designed anatomy, nothing seems to bring it more joy. There are more than 200 species of woodpeckers, found everywhere with the exception of Antarctica, Australia, New Zealand, and Madagascar; they range in size from the possibly extinct 20-inch ivory-billed woodpecker with a 30-inch wingspan, to the diminutive North American downy woodpecker, growing to only 6 inches tall. Woodpeckers eat insects and larvae found in trees, preferably the juiciest ones concealed beneath tree bark. Nearly all of a woodpecker's body parts, from its specially designed toes to the built-in shock absorbers in its head, make this bird equipped to excel at its task. The woodpecker specialized in finding a niche in the food chain, able to feed on insects few other animals can reach.

A woodpecker's beak is hard, as straight as a chisel, and as powerful as a drill bit, though more flexible, even if woodpeckers follow one of the basic rules of carpentry and always strike at a perfectly perpendicular angle.

Prevention of Headaches
It was once believed woodpeckers had coiled, automobile-like shock absorbers located in their necks that allowed them to drill their beaks into solid trees at a rapid-fire rate of twenty-one times per second without getting headaches. At the force in which they drum into bark, humans would suffer a concussion, immediate unconsciousness, or worse. Our brain floats in fluids while the woodpecker's brain practically occupies its entire skull, which prevents it from moving and shaking the way our brains would. In addition, the woodpecker has spongy tissue and muscles between the beak and the brain that absorb the pressure. The woodpecker's exceptionally long tongue—at

4 inches, or longer in some species—also plays a role; while pounding on wood a woodpecker's two-pronged tongue rolls up and is stored in the upper portion of its beak or nostril, serving as additional cushioning. The woodpecker's tongue is equipped with barblike fibers and has a bundle of nerve endings—a mini "ear" on the tip. After drilling a hole, the woodpecker probes with its tongue to locate a living insect that lies in hiding. The tongue can hear the bug's heartbeat and then curls around it like a little fist with fishhooks to pluck it out to eat. The red-bellied woodpecker's tongue is so long—three times the length of its beak—that it wraps around neatly a few times inside of its skull when retracted.

Vertical Climbers

Since the 1870s, when telephone poles came into use, people had to figure out a way to climb these branchless "trees" the way a woodpecker did. For balance and safety, a lineman scales a vertical pole by attaching stirrups with spiked heels and wears a belt-harness apparatus. The woodpecker has four toes like most birds, but instead of three facing forward and one behind, this expert aviary pole-climber has two spurred toes facing backward and the other two pointing forward. It also has a stiff tail feather assembly that adds stability and makes spiraling up or down a tree a matter of ease. It has no need for a harness. Once the woodpecker starts its drilling exploration into bark, it has another modification to prevent sawdust from choking it: the bird's nostrils have tiny feathers to trap dust better than a paper filter mask.

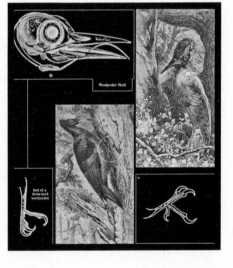

The Woodpecker's Rule of Three

Curiously, many species of woodpeckers want to do things in multiples of three. When the woodpecker flies, it flaps its wings three times, and then glides; three wing beats, another glide, and so on, following this pat-

tern whenever possible. It likes to make twenty-one, and not nineteen or twenty-two, drum beats per second with its bill. Since woodpeckers are not particularly vocal birds, they also drill into wood for audio purposes, signaling territory, or in a certain rhythmic scheme to attract other woodpeckers for mating, again in a pattern that is a multiple of three.

Life Cycle

Woodpeckers like to nest in holes they hollow out or find in dead trees, which are sometimes breached by rats, weasels, and snakes. They feed during the day and must keep looking out for hawks and other birds of prey. Many woodpeckers are antisocial and aggressive not only to other peckers but to birds lurking near trees that they view as their own, and they are infrequently ganged up on by ravens or other attacking flock birds. On average, and depending on the species, woodpeckers live from five to twelve years. Even with all the years spent head banging—for example, over thirty-six million times for a ten-year-old woodpecker—they do seem ultimately to lose the ability to drill and get food, and so they die, as it were, from a worn-out beak bit, and starvation, in old age.

The Most Famous Woodpecker

Woody Woodpecker was a cartoon character created by Ben Hardaway in 1940 for a film short that played in movie theaters before feature-length films, but Woody admittedly was not drawn from the specifications of any known woodpecker species. *The Woody Woodpecker Show,* a thirty-minute animated TV series, made Woody an internationally known character during the show's heyday from 1957 to 1966. Woody was hyperactive and had a crazy laugh; barbershops offered "Woody" haircuts that resembled the cartoon character's Mohawk hairstyle. The cartoon was revived starting in the 1970s and can even be found on cartoon channels to this day.

XIPHACTINUS
Most Gluttonous Animal

This fish once was found almost everywhere, from the shallow oceans that at one time covered the plains of North America to waters as far south as Australia, until it suddenly vanished around sixty-five million years ago. Shaped like a minisubmarine, this predatory fish grew to lengths of 15 feet. It had a protruding lower jaw, or underbite, with needle-sharp teeth that were designed to skewer prey. Its odd jaw also made it easy to scoop up schools of swimming fish and trap the bunch alive in its cage of teeth. So eager was this predator to get another meal, it often did not chew its food thoroughly, preferring to swallow it whole.

Although this indiscriminate attack-and-gobble approach helped it become a dominant and persistent sea marauder, it also proved a trait that seemed to kill it frequently in the end. The old saying "your eyes are bigger than your stomach" (describing a person

To other fish, the xiphactinus was death itself, an unstoppable maniacal kind; from its perspective, though, it was extremely adept at eating anything that happened to swim near it.

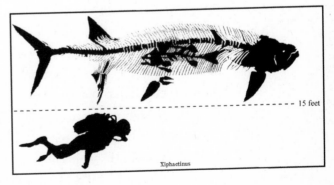

15 feet

Xiphactinus

who puts more food on a plate than he or she capable of eating) was exemplified by the xiphactinus. Many fossils indicate that this creature often died from ingesting fish much too large for its stomach to handle. Gluttony, so to say, helped it to survive as a species for nearly thirty million years, but individually, eating every meal was like playing Russian roulette. It never knew which of its prey would be its last meal. Many times, a large fish that had been eaten remained alive and thrashed about in the xiphactinus's gut, rupturing organs and causing death by internal bleeding.

YALE
Swivel-Horned Beast

The mythological animal known as a yale (also "eale") once prospered in North Africa and grew to the size of a horse, though it had a long swishing tail similar to an elephant's. Its face was thick with an upturned nose and bared protruding incisors identical to a wild boar's. Its most noteworthy feature was a pair of long horns, which could point either forward or backward. In fact, the yale's horns had an attaching joint that allowed them to swivel and fight off enemies no matter the direction. It was an omnivore, though it seemed to prefer grazing and seemingly was related to the antelope family. Its main competitor was the dreaded basilisk. The two beasts were natural enemies, hating

each other so that they seemed to cause the other's extinction, if either, in reality, had ever actually existed.

Yale vs. Basilisk

The basilisk was a Herculean chicken with a snake's tail. It had a sonic weapon and could kill creatures by emitting a piercing squeal. Some basilisks also had flame-throwing capabilities and destroyed other birds in flight by shooting small balls of fire from their mouths. The basilisk had such a strong odor that snakes died as it merely passed them in the woods. The beast is recorded in many ancient books about animals, yet it is hard to imagine what creature it could have been. In several texts, a basilisk resembled a type of snake or frilled lizard. Nevertheless, if your acreage was infested with such a beast, the ancients advised breeding weasels, since they could stifle basilisk outbreaks. In addition, the yale was sought to combat the littler beast, since the yale was impervious to the high squeals of a basilisk, nor was it affected by its flame-throwing abilities. The yales' swiveling horns caught many a basilisk off guard, but they were ultimately poisoned by the smaller beast's lethal bite.

YAK
Colossal Cow

The yak is a type of long-haired wild cattle found in the high regions of the Himalayans and related to prehistoric bison. Yaks are one of the biggest species of bovine, measuring 7 feet at the shoulder and weighing around 2,000 pounds. With short legs and stout bodies, many had been domesticated as beasts of burden. Yaks have horns that curve outward and grow to about 30 inches. Their fur is shaggy and long on top, with an extra layer of more dense and woolly hair underneath. This layered fur keeps the yak warm even in subfreezing temperatures. Having adapted to higher attitudes, the yak's heart and lungs are superlarge. With blood evolved to utilize thinner oxygen at such heights, the animal chokes and falls ill if taken to lower plains. In the wild, yaks are hunted by wolves and bears; they remain in herds of one hundred or more in an attempt to ward off full-scale attacks. Wild yaks will charge, especially if protecting a calf, but most will flee far and fast at the sight of a human. Yaks can easily withstand their chosen frozen world and live for about twenty years.

ZEBRA
Untamable Striped Steeds

Zebras belong to *Equus,* the genus including horses and asses. All 3 types of zebras are grazers and are found naturally in Africa. Unlike horses, zebras have short, bristly manes and tufted tails. They can weigh as much as 500 pounds and stand 5 feet at the shoulders. Zebras' well-known black-and-white-striped color scheme makes them stand out, to us at least. For color-blind or color-compromised animals, though, zebras' stripes serve as a type of camouflage known as "disruptive coloration," which in the evening and at dawn makes the zebras harder to detect by the animals that hunt them. All the carnivorous cats attack zebras, as do wild dogs and hyenas. Zebras' unique striping, along with their oily and shiny fur, helps reduce solar radiation, helping them stay cooler.

Zebras groom each other and develop strong family bonds. If one becomes lost from the herd, all help search for it and bring it back to the security among its numbers. Zebras like order and will often walk following a strict line and in single file, falling in place by an established hierarchy.

To us, all zebras merely look striped, but zebras identify each other and recognize old friends by their striped patterns. Each zebra has a slightly different striped arrangement, and when examined closely, the stripes are as distinctive as fingerprints. Zebras live relatively long and often reach the age of forty.

Humans have repeatedly tried to domesticate zebras and to ride them as horses. This was seriously attempted numerous times, especially in Africa where zebras are naturally less susceptible to disease than are horses. However, the zebra panics quickly and proved dangerously unreliable as a means of transport or for pulling coaches and such. Although apparently as intelligent as horses, zebras more forcibly resist attempts at domestication.

ZOOPLANKTON
Nature's Smallest Creatures

The billions of living zooplankton are essentially invisible to our unaided eyes. Most of these tiny creatures inhabit oceans and all types of bodies of freshwater throughout the world. Zooplankton come in hundreds of thousands of different shapes and sizes, ranging from protozoan amoebas to shrimplike krill. The mostly miniature world of zooplankton hosts a catalog of creatures designed from nature's eclectic scratchpad or from some data base of boundless imagination. There are the speck-size arrow worms with transparent bodies, bearing an assortment of weird, long fins on each side; or the 20-millimeter ctenophere, which looks like a circular drop of silicone, with comblike membranes that turn various colors as it swims; or the dinoflagellates, no bigger than .05 millimeters and resembling a high-flying balloon with a tail dangling as a string.

Others simply absorb whatever the waters provide. However, because they are so low on the food chain, their abundance, or lack of, serves to monitor planetary health. Affected as they are by the slightest changes in pH, salinity, pollutants, temperature,

zooplankton

and other factors, they are our microscopic sirens. When either appearing too abundantly or suddenly disappearing, zooplankton—derived from the Greek word *planktos* meaning "drifter" or "wanderer"—as the world's tiniest beasts can predict the rise and fall of us all.

Origin of Life

Were animals created from a godly chart exactly as they are? Or did they change and adapt as varying conditions arose? To this author's eye, it's a matter of irrelevance, when the sheer extraordinary abundance of life is celebrated. Scientifically, however, the study of how life transformed from inorganic material to something alive is called "abiogenesis," or "biopoesis." Geologists calculate the earth to be four and a half billion years old, and at formation, it was a sterile rock bombarded by a more than twenty thousand asteroid impacts. One billion years later there were numerous microbelike objects inhabiting the planet. There is no one prevailing view of how life came to arise on Earth. Some theories

explain how the environment was a mixture of chemicals, including, carbon, iron, sulfur, and excreta, which formed a "primordial soup." From this, amino acids, the "building blocks of life" were fused, catalyzed, or combined and brought to life by electrical charges or chemical reactions. Others suggest life began at undersea thermal vents, or originated when deposits of living organisms were transported from extraterrestrial sources, arriving on meteorites, or carried within the very matter that formed the earth. Some say God merely thought about it, and life all just came to be. Whatever evidence finally proves true, one fact remains: there are millions of species and trillions—actually, countless numbers—of creatures alive right now. However, each is an individual, considering itself, if it can, as an "I" or a "me," and doing what it's able, any way it can, to stay alive.

ACKNOWLEDGMENTS

Foremost thanks to my editor, Peter Hubbard, for his guidance and encouragement, especially by pointing the way to the medieval bestiary.

Much gratitude to artist Christopher David Reyes (aka Atolm) for his precise drawings and knowledge of prehistoric beasts and creatures of mythology. Very special thanks to artist Jesse Peterson for his incredible immersion in this project; he spent countless hours creating nuanced art, collages, and original visual designs support with my text. Gratitude, as always, to literary agent Frank Weimann, and to his attentive staff. Also, much thanks to the experts who answered my questions about animal specifics and to the helpful, patient, and kind zoologists and staff at the Staten Island Zoo, Staten Island, New York, and at Zoo Miami, Miami, Florida.

SOURCES

Adams, A. L. 1867. *Wanderings of a Naturalist in India*. Edmonton and Douglas.

Albright, L. B. 1994. "Lower Vertebrates from an Arikareean (Earliest Miocene) Fauna Near the Toledo-Bend Dam, Newton County, Texas." *Journal of Paleontology* 68(5): 1131–1145.

Allen, J., and Griffiths, J. 1979. *The Book of the Dragon*. Chartwell Books.

Andrewartha, H. G., and Birch, L. C. 1954. *The Distribution and Abundance of Animals*. University of Chicago Press.

Anhinga Trail, Everglades National Park, Florida, http://www.dongettyphoto.com/Florida/anhingafish.html (accessed July 9, 2011).

Auffenburg, W. 1981. *The Behavorial Ecology of the Komodo Monitor*. University of Florida Presses.

Baker, Steve. 1993. *Picturing the Beast: Animals, Identity, and Representation*. Manchester University Press.

Barney, Stephen A., ed. and trans. 2006. *The Etymologies of Isidore of Seville*. Cambridge University Press.

Barrow, Mark V. 2009. *Nature's Ghosts: Confronting Extinction from the Age of Jefferson to the Age of Ecology*. University of Chicago Press.

Baxter, Ron. 1998. *Bestiaries and Their Users in the Middle Ages*. Sutton Publishing.

"Beginnings 7," http://www.tlogical.net/beginnings7.htm (accessed July 11, 2011).

Bekoff, Marc. 2005. *Animal Passions and Beastly Virtues: Reflections on Redecorating Nature*. Temple University Press.

Bellairs, A. d'A. 1969. *The Life of Reptiles*: Weidenfield and Nicholson.

Berrill, N. J. 1975. *Reproduction of Marine Invertebrates II*. Academic Press.

Birkeland, Charles, ed. 1997. *Life and Death of Coral Reefs*. Chapman & Hall.

Blob, R. W. 1994. "The Significance of Microfossil Size Distributions in Faunal Abundance Reconstructions: A Late Cretaceous Example." *Journal of Vertebrate Paleontology* 14(3 suppl.): 17A.

Bothwell, Dick. 1962. *The Great Outdoors Book of Alligators*. Great Outdoors Publishing Co.

Brower, Kenneth. 1991. *Realms of the Sea*. National Geographic Society.

Brusca, R. C., and Brusca, G. J. 2003. *Invertebrates*. Sinaur Associates.

Bulloch, David K. 1991. *The Underwater Naturalist: A Layman's Guide to the Vibrant World Beneath the Sea*. Lyons & Burford Publishers.

Burnie, D. 2005. *Dinosaur Factfile*. Kingfisher Books Ltd.

Burton, M., and Burton, R. 2002. *International Wildlife Encyclopedia,* 3rd ed. Marshall Cavendish Corp.

Carr, C. E. 1990. "Evolution of the Central Auditory System in Reptiles and Birds." *American Zoologist* 30(4): 48A.

Castro, P., and Huber, M. E. 2005. *Marine Biology*. McGraw-Hill.

Caughley, G. 1966. "Mortality Patterns in Mammals." *Ecology* 47: 906–918.

Charig, A. J. 1989. "The Cretaceous-Tertiary Boundary and the Last of the Dinosaurs." *Philosophical Transactions of the Royal Society of London B: Biological Sciences* 325(1228): 387–400.

Charig, A. J., Greenaway, F., Milner, A. C., Walker, C. A., and Whybrow, P. J. 1986. "*Archeopteryx* Is Not a Forgery." *Science* 232: 622–626.

Chave, E. H., and Malahoff, A. 1998. *In Deeper Waters*. University of Hawaii Press.

Chempetitive Group, http://www.chempetitive.com/about (accessed July 11, 2011).

Cherry, John, ed. 1995. *Mythical Beasts*. British Museum Press.

Clark, J. M., Montellano, M., Hopson, J., and Hernandez, R. 1991. "Mammals and Other Tetrapods from the Early Jurassic La Boca Formation, Northeastern Mexico." *Journal of Vertebrate Paleontology* 11(Suppl. 3): 23A.

Clark, Stephen. 1984. *The Nature of the Beast*. Oxford University Press.

Clemens, W. A. 1970. "Mesozoic Mammalian Evolution." *Annual Review of Ecology and Systematics* 1: 357–390.

Clements, J. F. 2007. *The Clements Checklist of Birds of the World.* Cornell University Press.

Coleman, Jon T. 2004. *Vicious: Wolves and Men in America.* Yale University Press.

Coleman, W. 1971. *Biology in the Nineteenth Century.* John Wiley and Sons.

Conway Morris, Simon. 2003. *Life's Solution: Inevitable Humans in a Lonely Universe.* Cambridge University Press.

Cook, Albert S. 1919. *Phoenix and Physiologus.* Yale University Press.

Corbet, G. B., and Hill, J. E. 1980. *World List of Mammalian Species.* Cornell University Press.

Coulson, R. A. 1993. "The Flow Theory of Enzyme Kinetics: Role of Solid Geometry in the Control of Reaction Velocity in Live Animals." *International Journal of Biochemistry* 25: 1445–1474.

Crompton, A. W., and Jenkins, F. A. 1979. *Origin of Mammals.* University of California Press.

Curley, Michael J. 1979. *Physiologus.* University of Texas Press.

Dahmus, Joseph Henry. 1984. *Dictionary of Medieval Civilization.* Macmillan.

Daston, Lorraine, and Mitman, Gregg, eds. 2005. *Thinking with Animals: New Perspectives on Anthropomorphism.* Columbia University Press.

Desmond, A. J. 1976. *The Hot-Blooded Dinosaurs.* Dial Press.

Dickinson, E. C., ed. 2003. *The Howard & Moore Complete Checklist of the Birds of the World.* Princeton University Press.

Dixon, D., Cox, B., Savage, R. J. G., and Gardiner, B. 1988. *The Macmillan Illustrated Encyclopedia of Dinosaurs and Prehistoric Animals.* Macmillan.

Electroplaques, http://wn.com/electroplaques (accessed July 8, 2011).

Facts about bald eagle: eagles, as discussed in Britannica, http://www.britannica.com/facts/11/829593/bald-eagle-as-discussed-in-eagle (accessed July 8, 2011).

Florkin, M., and Scheer, B. T. 1979. *Chemical Zoology.* Academic Press.

Freeman, S. 2005. *Biological Science.* Pearson Prentice Hall.

Fudge, Erica, ed. 2004. *Renaissance Beasts: Of Animals, Humans, and Other Wonderful Creatures.* University of Illinois Press.

Fudge, Erica. 2000. *Perceiving Animals: Humans and Beasts in Early Modern English Culture.* St. Martin's Press.

Gaskin, D. E. 1982. *The Ecology of Whales and Dolphins.* Heinemann Educational Books Ltd.

George, Wilma B., and Brunsdon Yapp, W. 1991. *The Naming of the Beasts: Natural History in the Medieval Bestiary.* Duckworth.

Giant Anteater. Chicago Zoological Society (Oct. 2, 2008), http://www.czs.org/czs/Brookfield/Exhibit-and-Animal-Guide/Tropic-World/Giant-Anteater.

Gila Monster Superstitions, http://www.docseward.com/Superstition.html (accessed July 9, 2011).

Godin, A. J. 1977. *Wild Mammals of New England.* Johns Hopkins University Press.

Goldstuck, Arthur. 1999. *The Aardvark and the Caravan: South Africa's Greatest Urban Legends.* Penguin Books.

Gravity waves and hornworms, http://www.azcentral.com/news/columns/articles/0816clay0816.html (accessed July 6, 2011).

Green, J. 1968. *The Biology of Estuarine Animals.* University of Washington Press.

Greenwood, P. H., Miles, R. S., and Patterson, C. 1973. *Interrelationships of Fishes.* Academic Press.

Grizzly Man, Film Blather, http://filmblather.com/films/grizzlyman/ (accessed July 6, 2011).

Grzimek, B., 1972. *Grimek's Animal Encyclopedia*: Von Nostrand Reinhold.

Hallam, A., 1975. *Jurassic Environments*: Cambridge University Press.

Hamilton, W. J., Jr., and Whitaker, J. O., Jr. 1979. *Mammals of the Eastern United States.* Comstock Publishing Associates.

Haraway, Donna J. 2003. *Companion Species Manifesto: Dogs, People, and Significant Otherness.* Prickly Paradigm.

Hardy, Alister. 1965. *The Open Sea: Its Natural History.* Houghton Mifflin Co.

Harrison, F. W., and Kohn, A. J., eds. 1994. *Microscopic Anatomy of Invertebrates.* Wiley-Liss.

Hassig, D. 1995. *Medieval Bestiaries: Text, Image, Ideology.* Cambridge.

Hawking, Stephen. WGFT News. "It Doesn't Have to Be Like This." http://www.worldgathering.net/2009/news041.html (accessed July 16, 2011).

Henninger-Voss, Mary, ed. 2002. *Animals in Human Histories: The Mirror of Nature and Culture.* University of Rochester Press.

Herring, P. J. 1978. *Bioluminescence in Action.* Academic Press.

Heuvelmans, B. 1969. *In the Wake of Sea-Serpents.* Hill and Wang.

Hsu, K. J. 1986. *The Great Dying.* Harcourt Brace Jovanovich.

Ingold, Tim, ed. 1988. *What Is an Animal?* Unwin Hyman.

Jordan, D. S., and Kellogg, V. L. 1900. *Animal Life: A First Book of Zoology.* D. Appleton & Co.

Kalof, Linda. 2007. *Looking at Animals in Human History.* Reaktion.

Kalof, Linda, and Fitzgerald, Amy, eds. 2007. *The Animals Reader: The Essential Classic and Contemporary Writings.* Berg.

Karleskint, G., Turner, R., and Small, J. 2006. *Introduction to Marine Biology.* Brooks Cole.

Katona, S. K., V. Rough, and D. T. Richardson. 1993. *A Field Guide to Whales, Porpoises, and Seals from Cape Cod to Newfoundland.* Smithsonian Press.

Kingsolver, J. G., and Koehl, M. A. R. 1985. "Aerodynamics, Thermoregulation and the Evolution of Insect Wings: Differential Scaling and Evolutionary Changes." *Evolution* 39: 488–504.

Kohn, D. 1985. *The Darwinian Heritage.* Princeton University Press.

Leakey, R. E. 1981. *The Making of Mankind.* Dutton.

Lewin, R. 1983. "Extinctions and the History of Life." *Science* 221: 935–937.

"Life Is Do, Re, Mi . . .," http://singmelodies.tumblr.com/ (accessed July 6, 2011).

Lovejoy, Arthur O. 1936. *The Great Chain of Being: A Study of the History of an Idea.* Harvard University Press.

MacDonald, A. G. 1975. *Physiological Aspects of Deep Sea Biology.* Cambridge University Press.

"Making a Positive Impact," The Naked Scientists, http://www.thenaked-scientists.com/HTML/content/news/news/1334/ (accessed July 6, 2011).

"Marine Turtle: These Amazing Animals—Webverve InfoPool," http://www.infopool.webverve.com/environment/marine-turtle-these-amazing-animals.htm (accessed July 1, 2011).

Martini, Frederic. 1984. *Exploring Tropical Isles and Seas: An Introduction for the Traveler and Amateur Naturalist.* Prentice-Hall.

McCulloch, Florence. 1962. *Medieval Latin and French Bestiaries.* University of North Carolina Press.

McShane, Clay, and Tarr, Joel A. 2007. *The Horse in the City: Living Machines in the Nineteenth Century.* Johns Hopkins University Press.

Mech, L. D. 1970. *The Wolf.* Natural History Press.

Medawar, P. B., and Medawar, J. S. 1983. *Aristotle to Zoos: A Philosophical Dictionary of Biology.* Harvard University Press.

"Ocean Life: American Museum of Natural History," http://www.amnh .org/exhibitions/permanent/ocean/00_utilities/03c_landman.php (accessed July 5, 2011).

Minasian, S. M., Balcomb, K. C., and Foster, L. 1984. *The World's Whales.* Smithsonian Books.

Moore, J. A. 1964. *Physiology of the Amphibia.* Academic Press.

Newell, R. C. 1970. *Biology of Intertidal Animals.* Paul Elek Ltd.

Oster, G. F., Silver, I. L., and Tobais, C. A. 1974. *Irreversible Thermodynamics and the Origin of Life.* Gordon and Breach Science Publications.

"Painted Turtles, A Pet Owner's Guide to Painted Turtles," http://www.plus pets.com/reptiles/turtles/painted-turtles.aspx (accessed July 14, 2011).

Parker, Steve, and Parker, Jane. 1999. *The Encyclopedia of Sharks.* Firefly Books.

Payne, Ann. 1990. *Medieval Beasts.* New Amsterdam Books.

Perle, A. 1985. "Comparative Myology of the Pelvic-Femoral Region in Bipedal Dinosaurs." *Palaeontological Journal* 19: 105–109.

"Photo-Africa: African Wildlife, Nature & Environmental," http://photo-africa.blogspot.com/2008/06/weekly-high-five-3.html (accessed July 11, 2011).

Pokorny, V. 1963. *Principles of Zoological Micropaleontology.* Macmillan.

Porter, K. R. 1972. *Herpetology.* W.B. Saunders.

Raffles, Hugh. 2010. *Insectopedia.* Pantheon.

Rice, Tony. 2000. *Deep Ocean.* Natural History Museum.

Ritvo, Harriet. 1987. *Animal Estate: The English and Other Creatures in the Victorian Age.* Harvard University Press.

Robbins, Louise E. 2002. *Elephant Slaves and Pampered Parrots: Exotic Animals in Eighteenth-Century Paris.* Johns Hopkins University Press.

Roy, Tui De. "The Strangest Creature I've Ever Met." *National Wildlife Magazine,* June/July 2003 (Oct. 2, 2008).

Rutten, M. G. 1971. *The Origin of Life by Natural Causes.* Elsevier.

Salter, David. 2001. *Holy and Noble Beasts: Encounters with Animals in Medieval Literature.* Brewer.

Scott, W. B. 1937. *A History of Land Mammals in the Western Hemisphere.* American Philosophical Society.

Shepard, Paul. 1996. *The Others: How Animals Made Us Human.* Island Press.

Smyth, A. M. 1939. *A Book of Fabulous Beasts*. Oxford University Press.

Spath, I. F. 1938. *A Catalogue of the Ammonites of the Liassic Family Liparoceratidae*. British Museum.

Tarboton, Warwick R. 1990. *African Birds of Prey*. Cornell University Press.

"The Vulture as Totem," http://sped2work.tripod.com/totem.html (accessed July 1, 2011).

Thomas Nagel quotes: Quotations at Dictionary.com, http://quotes.dictionary.com/author/thomas+nagel (accessed July 6, 2011).

Walker, E. P. 1964. *Mammals of the World*. Johns Hopkins University Press.

Welty, J. C., and Baptista, L. 1988. *The Life of Birds*. Saunders.

Werner, Telesko. 2001. *The Wisdom of Nature: The Healing Powers and Symbolism of Plants and Animals in the Middle Ages*. Prestel.

White, T. 1960. *The Bestiary: The Book of Beasts*. Capricorn Books.

Young, J. Z. 1975. *The Life of Mammals: Their Anatomy and Physiology*. Claredon Press.

PHOTO CREDITS

Introduction: Jesse Peterson (http://www.jessepeterson.net), Joannes Jonstonus, zookeys, Ellenberger, Wilhelm, Hermann Baum, and Hermann Dittrich, Thomson, J. Arthur, David Walker, Idaho Public Television, Keppler, Udo J; Aardvark: Jesse Peterson, Birch, Reginald Bathurst, Library of Congress, G. F. Warren, Everybody's Cyclopedia; Aardvark: Jesse Peterson, Christopher David Reyes; Aardvark: Jesse Peterson, Library of Congress, Wardle, Arthur, Christopher David Reyes; Afanc: Jesse Peterson, Christopher David Reyes, Library of Congress, Anton; Ahuizotl: Jesse Peterson, Christopher David Reyes, The Brothers Dalziel; Ahuizotl: Jesse Peterson; Aja-Ekapa: Jesse Peterson, Christopher David Reyes, Tymms, W. R., The Art of Illuminating As Practised in Europe from the Earliest Times, Kojuma Zu; Aja-Ekapa: Jesse Peterson, Ellenberger, Wilhelm, Hermann Baum, and Hermann Dittrich; Albatross: Jesse Peterson, Leonardo Da Vinci, Goshen College, Pearson Scott Foresman; ABC's Jesse Peterson, Ellenberger, Wilhelm, Hermann Baum, and Hermann Dittrich; ABC's: Jesse Peterson; Ammonites: Ernst Haeckel, *Gentlemen's Magazine;* Amoeba: Jesse Peterson; Amphivena: Jesse Peterson, Tymms, W. R.: Amphiveana: Jesse Peterson, Christopher David Reyes, W. Ramsay Smith, J. S. Newell, *Popular Science Monthly,* Richard Lydekker, Louis Agassiz Fuertes; Andean Condo: Jesse Peterson, Stamp of Ecuador, The Brothers Dalziel, Pearson Scott Foresman; Angler Fish: Jesse Peterson, *Popular Science Monthly;* Ants: Jesse Peterson, Robert Hooke; Ant Lion: Jesse Peter-

son, Christopher David Reyes, Tymms, W. R.; Antarctic Sponge: Library of Congress; Antarctic Sponge: Jesse Peterson, Ernst Haeckel, Thomas Walton Galloway; Armadillo: Jesse Peterson, Henry Alleyne Nicholson, Tom Friedel, R. P. Labat; Armadillo: Friedrich Specht; Armadillo/Porcupine: Richard Lydekker; Archaeopteryx: Jesse Peterson, Case Western Reserve University; Aspidochelone: Jesse Peterson, Christopher David Reyes, Wieland, American Colony (Jerusalem) Photo Dept.; Aye-Aye: Chicago Field Museum; Aye-Aye: Mivart; Axolotl: Jesse Peterson, Popular Science Monthly; Axolotl Devolving: Jesse Peterson; Baboon: Jesse Peterson, Gustav Mützel, Rijksmuseum van Oudheden; Badger: Jesse Peterson, Bull, Charles Livingston, *The New Student's Reference Work;* Bagworm: Jesse Peterson, Richard Lydekker; Banshee: Jesse Peterson, Christopher David Reyes, Cloppenburgh; Jesse Peterson, *Scribner's Magazine;* Bats: Jesse Peterson, *Popular Science Monthly,* Henry Alleyne Nicholson, Ernst Haeckel; Bats: *Dictionnaire encyclopédique Trousset;* Bear: Gustav Mützel; Bear: Jesse Peterson, Jovan Zujovic; Bear: Jesse Peterson, Library of Congress; Beaver: Jesse Peterson, Lewis Henry Morgan, Bull, Charles Livingston, USDA; Beaver: Jesse Peterson, George Cuvier; Bee: Stelluti, Francesco; Bombardier Beetle: Jesse Peterson, Peter Halasz; Bongo: Jesse Peterson, Richard Lydekker, Ernst Haeckel; Bonnocon: Jesse Peterson, Christopher David Reyes, The Brothers Dalziel; Bonnocon: *Medieval Bestiary;* Butterfly: Nemos; Butterfly: Jesse Peterson, Merian Maria Sybilla; Caladrius: Jesse Peterson, Pieter Ven Der Borcht; Camel: Jesse Peterson, Utagawa, Kuniyasu; Capybaras: Gustav Mützel; Cats: Jesse Peterson, Karl Rothe, Ferdinand Frank, Josef Steigl, Cats: Jesse Peterson, George Mivart; Chameleon: Jesse Peterson, American Colony (Jerusalem) Photo Dept, G. A. Boulenger; Chameleon: Jesse Peterson, *Illustrations de zoologie, ou, Recueil de figures d'animaux peintes d'après nature;* Chupacabra: Jesse Peterson, LiCire, Lydekker, British Museum of Natural History; Beast of Bladenboro: *New Pocket Guide of the Year 1836, for Nature, Forest and Hunting Enthusiasts;* Cobra: Jesse Peterson, Jeffrey Parker, Pearson Scott Foresman; Cobra: Reptile Channel; Cobra: Jesse Peterson, Underwood & Underwood; Creto: Jesse Peterson, *Popular Science Monthly,* Niels Stensen, *British Museum of Natural History;* Cricket: Jesse Peterson, Pearson Scott Foreman, Suzuki, Harunobu; Cricket: Enrico Mazzanti; Crocodile: *Dictionnaire classique d'histoire;* Crocodile/Alligator: Jesse Peterson, Lydekker, *Illustrated London News;* William Dwight Whitney, Thomas Rymer Jones, Wilhelm Kuhnert; Deathwatch Beetle: Jesse Peterson, UF; Dodo: Jesse Peterson, Chan-

dler B. Beach; Dog: Jesse Peterson, Charles Darwin, Gilbert Gihon; Dolly: Jesse Peterson, Dimitry Bogdanov; Dolly: Williston, University of Kansas Museum of Natural History; Draco Lizard: Ernst Haeckel; Draco Lizard: Jesse Peterson, Gunther, Albert, Robert Hardwicke; Dragon: Library of Congress; Dragon: Art Illustrated; Dragon: Howard Pyle; Dung Beetle: Jesse Peterson, Hopkins, A. D.; Dugong: Jesse Peterson, *Popular Science Monthly, Dictionnaire encyclopédique Trousset;* Eagle: Jesse Peterson, Bain News Service, publisher, Physiognomonia; Elasmosaur: Jesse Peterson, J. Smit; Elasmosaurus: Wendel Williston; Loch Ness Monster: Inverness Courier; Electric Eel: Jesse Peterson, Trousset; Electric Eel 2/Knife Fish: Jaques Burkhardt; Elephant: Jesse Peterson, Lydekker, John Lockwood Kipling, Hanabusa, Itchô; Elephant 2/Woolly Mammoth: Jesse Peterson, Rouffignac Cave Painting, USNPS, Field Museum of Natural History; Elephant Bird: Jesse Peterson, Black Hills Institute for Geological Research; Elephant Bird: Jesse Peterson, Christopher David Reyes, Tymms, W. R.; Encantado: Jesse Peterson, Christopher David Reyes, Tymms, W. R.; Fairy: J. A. Fitzgerald; Fairy: Kate Greenway; Firefly: Jesse Peterson, Flamingo: Jesse Peterson, Library of Congress, Richard Owen; Flying Fish: Jesse Peterson, Trousset; Fox: Library of Congress; Fox: Jesse Peterson, nineteenth-century fox print; Fox: Jesse Peterson, John Edward Gray; Giant Bulb: *Suidôbashi surugadai;* Giant Bulb: Jesse Peterson, Cuppy Ph.D., Hazlitt Alva; Giant Clam: *Popular Mechanics;* Gila Monster: Jesse Peterson, *Scientific American;* Gorilla: *Everybody's Cyclopedia;* Gorilla: *Familiar Animals and Their Wild Kindred;* Gorilla and Man: Jesse Peterson, Buchanan, Henry Gray; Griffin: Friedrich Justin Bertuch; Groundhog: *Quadrapeds of North America;* Hallucigenia: Jesse Peterson, Christopher David Reyes, Geological Society of America; Halcyon: Jesse Peterson, Louis Figuier William & Robert Chambers, B. P. Holst, Frank Beard; Halcyon: Ceyx and Alcyone: William Woollet; Harpy: Gustave Doré; Harpy Skeleton: Jesse Peterson; Helicoprion: Jesse Peterson, Christopher David Reyes; Hamster: Jesse Peterson, Thomas Bewick, H. Alleyne Nicholson; Hamster: Jesse Peterson, S. G. Goodrich; Horned Lizard: Jesse Peterson, Sarah Cooper; Horse: Köllner, Augustus; Horse: Ellenberger, Wilhelm, Hermann Baum, and Hermann Dittrich; Horse: Jesse Peterson, Ellenberger, Wilhelm, Hermann Baum, and Hermann Dittrich; Hummingbird: Jesse Peterson, Worthington Hooker, William & Robert Chambers; Hummingbirds: Jesse Peterson, Whitney, William Dwight, Asa Gray; Hydra: Hydra Engraving, 1664; Hydra: Rosso Fiorentino; Hyena:

S. G. Goodrich; Hyena: Jesse Peterson, Richard Lydekker, Hyena: *Anzeige einer großen Haupt-Fütterung welche in der Menagerie des Unterzeichneten stattfinden wird,*1830; Ibis: Richard Lydekker; Ibis: Jesse Peterson, Cuvier, Lydekker, Theodor Jasper; Ibis: Thoth: Luxor Temple; Ibong Adarna: *Deutsche kunst und dekoration,* 1909; Ichneumon: Pierre Belon; Ichneumon: *Les observations de plusieurs singularitez et choses memorables,* Ichneumon Wasp, 1898; Inkanyamba: Jesse Peterson; Inkanyamba: Friedrich Justin Bertuch; Inkanyamba Anguilla: American Food and Game Fishes; Impala: Jesse Peterson, Pearson Scott Foresman, S. G. Goodrich; Isopoda: Jesse Peterson, Henri Milne-Edwards; Jackalope: Jesse Peterson, Hall, Sidney; Jaculus: *Medieval Bestiary;* Jaculus: Jesse Peterson, William & Robert Chambers; Jaeckelopterus: Jesse Peterson, Henry Gray, Ernst Haeckel; Jaguar: Jesse Peterson, Lloyd, Elliot Daniel Giraud; Jaguar: Atlantic Watershed Basalt Sculpture; Jaguar: Tula Pyramid; Jellyfish: Ernst Haeckel, *Mittheilungen aus der Zoologischen Station zu Neapal, zugleich ein Repertorium for Mittelmeerkunde;* Jenny Hanniver: Konrad Gesner; Jenny Hanniver: M. Violante; Jersey Devil: Jesse Peterson, *Philadelphia Evening Bulletin;* Kangaroo: Jesse Peterson, Matson Photo Service; Kelenken: Jesse Peterson, Charles R. Knight; Kelenken/Bullockornis: Jesse Peterson, Royal Ontario Museum; Kinkajou: Jesse Peterson, Richard Lydekker, Alcide d'Orbigny, Werner; Koala: George Cuvier; Koala: Jesse Peterson, Richard Lydekker, Gould; Komodo: Ouwens; Komodo: Jesse Peterson, Bronn; Kraken: Pierre Denys de Montfort; Kraken: Giant Squid, 1887; Kraken: Harper Lee; Kumo: Rehse Archiv für Zeitgeschichte und Publizistik, DLC; Lagarfljót Worm: Jesse Peterson, Richard Lydekker, *Illustrated Sporting News;* Lantern Shark: Jesse Peterson, Jackson; Leafy Sea Dragon: Jesse Peterson, Haeckel, William Buelow Gould; Leafy Sea Dragon, Arctic Fox: John Edward Gray; Lesothosaurus: Jesse Peterson; Leucrotta: Jesse Peterson, leucrotta, c.1800; Lion: Jesse Peterson, Richard Lydekker; Lioness cubs: *Illustrated London News;* Liopleurdon: Jesse Peterson, Llama: Jesse Peterson, E. George Squier; Longisquama: Jesse Peterson, Lydekker; Lovebug: Jesse Peterson, Insect colorplates, 1832; Loveland Frog: Jesse Peterson; Loveland Frog/Lizard People: Jesse Peterson; Manticora: *Medieval Bestiary;* Manticora: Jonstonus, Joannes; Megachasma; German engraving; Megachasma: Jesse Peterson, Christopher David Reyes, Kevfuture; Megalodon: P. J. Smit; Megalodon: Jesse Peterson; Mermaid: woodcut, c.1600; Microraptor: Gerhard Heilmann; Minotaur: Antoine-Louis Barye; Minotaur: Jesse Peterson, Tymms, W. R., Christopher David Reyes; Mole: John Ed-

ward Gray; Mole: *Mémoires du Muséum d'histoire naturelle;* Mole: Jesse Peterson, British Museum of Natural History; Mongolian Death Worm: Jesse Peterson; Mosasaur: Jesse Peterson, G. R. Levillaire, Charles R. Knight; Mosasaur: Charles R. Knight; Mosquito: Jesse Peterson; Narwhal: Narwhal, W. Scoresby; Narwhal: Pierre Pomet; Nephilim: Jesse Peterson, Henry Gray; Nephilim: Odilon Redon; Nephilim: Jesse Peterson; Ningen: Jesse Peterson, Christopher David Reyes; Pearson Scott Foresman, Tymms, W. R.; Nudibranch: Anna B. Nash; Nudibranch: Vaillant A. N.; Okapi: Jesse Peterson, Smithsonian report; Opossum: *Annales des sciences naturelles;* Opossum: Jesse Peterson, Buffon; Orphan Bird: Jesse Peterson, Seabird, 1800; Ostrich: Jesse Peterson, Library of Congress, Pettigrew; Ostrich: Library of Congress; Owl 1 & 2: Systematic Natural History; Owl: Engraving, 1902; Parrot: Jesse Peterson, *Illustrations de zoologie, ou, Recueil de figures d'animaux peintes d'après nature;* Parrot, Jackson: Library of Congress; Penguin: Welsh, Louise; Penguin: Jesse Peterson, Horydczak, Theodor; Peregrine Falcon: Johm Edward Grey; Peregrine Falcon; Conrad Susemihl; Persian Three-Legged Ass: Jesse Peterson; Phoenix: Friedrich Justin Bertuch; Pigeon: Bubley, Esther; Pigeon: Jesse Peterson, *The American Legion Weekly;* Pigeon: Charles Darwin; Platypus: Herford, Oliver; Platypus: Jesse Peterson, John Edward Grey, Whitney, William Dwight; Platypus, Echidnas: Jesse Peterson, *Voyage autour du monde par les mers de l'Inde et de Chine ex,* Brehms Tierleben; Pronghorn Antelope: Jesse Peterson, Clinton Hart Merriam, *Illustrated London News, Everybody's Cyclopedia;* Quackers: W. D. Munro; Quackers Basilosaurus: Jesse Peterson, Conrad Gesner; Quackers Basilosaurus; Jesse Peterson, Christopher David Reyes, Tymms, W. R.; Quetzacoatlus: Jesse Peterson, Christopher David Reyes, Williston; Queztal: A. H. Evans; Quinotaur: Conrad Gesner, Rat: Jesse Peterson, Lydekker; Rat: Griffin, Syd B; Rat: Naturkundliches Museum Mauritianum Altenburg; Rat/mouse: Jesse Peterson, Richard Lydekker, Raven: Jesse Peterson, White, The Rev. Gilbert; Raven: White, The Rev. Gilbert; Reindeer: Jesse Peterson, Lydekker, Jahrbich, Ellenberger, Wilhelm, Hermann Baum, and Hermann Dittrich; Reindeer: Jesse Peterson, *Sporting Adventures in the Northern Seas,* Deer Skull, Ellenberger, Wilhelm, Hermann Baum, and Hermann Dittrich; Rhinoceros: Albrecht Dürer; Rhino: Jesse Peterson, L'Univers Illustre, Lydekker; Rhino: Joseph Smit; Sasquatch: Wild Man Sought by N.J. Officers, Bridgeport Telegram; Sasquatch: Jesse Peterson, wildman engraving, Holland, 1572, Gray; Satyr: seventeenth-century engraving; Satyr: Jesse Peterson; Sawfish: Jesse Peter-

son, Lydekker, Alvin Davison; Skunk: Jesse Peterson, Brehms Tierleben; Spider: Trousset; Spider: Jesse Peterson, *Illustrated London News,* Lydekker; Spider: Jesse Peterson, André Garnerin; Snailfish: Jesse Peterson, *Bulletin of the Bureau of Fisheries;* Sugar/Glider: *A Hand-Book to the Marsupialia and Monotremata;* Sugar Glider Wing Suit: Len Shires; Thrasher: Jesse Peterson, Bull, Charles Livingston: Thrasher/Song: Jesse Peterson, Katsushika, Hokusai; Tikbalang: Jesse Peterson; Toad: Lydekker; Toad: Jesse Peterson; Bufo Calamita engraving, Henry Alleyne Nicholson, D. E. A.; Toad: Jesse Peterson, William & Robert Chambers, William Dwight Whitney; Tubeworm: Jesse Peterson, Lydekker, Ernst Haeckel; Troll: Theodor Kittelsen; Troll/Neanderthal: Herman Schaaffhausen; Tully Monster: Jesse Peterson, Christopher David Reyes, Geological Survey of America; Turtle: Horydczak, Theodor; Turtle: Jesse Peterson, Bureau of Fisheries, Sara Cooper, Lydekker, Williston; Turtle: Bull, Charles Livingston; Turtle: Jesse Peterson, Wieland; Tyrannosaurus; Jesse Peterson, Charles R. Knight, Vincent Lynch; Tyrannosaur Cloning: Jesse Peterson, after Craig Freudenrich, Ph.D.; Uakari: Jesse Peterson, Humboldt, Lydekker; Umbrella Bird: Jesse Peterson, Henry Walter Bates, Lydekker; Unicorn: Jesse Peterson, Ulisse Aldrovandi, Tymms, W. R.; Unicorn: Jesse Peterson, Joannes Jonstonu; Vampire Squid: Jesse Peterson, Carl Chun, Hoyle; Velvet Worm: Jesse Peterson, Sedgwick; Velvet Worm/Worms: Rudolf Leuckart; Water Bear: Jesse Peterson, Department of Biology, University of Wisconsin, Fairfax County Public Schools; Whale: Jesse Peterson, J. G. Millais, Meyers, Lydekker; Whales/Songs: Jesse Peterson; Whales/Beached: Jacob Matham; Whales/Beached: Nickerson; Whales/Dolphin: Jesse Peterson, Charles Hamilton Smith, Lydekker; Woodpecker: Christopher Plantini; Woodpecker: Jesse Peterson, Thomas Rymer Jones, *Illustrated London News,* Fannie Hardy, Ecksorm; Xiphactinus: Jesse Peterson, after Sternberg; Xiphactinus: Jesse Peterson, after Sternberg; Xiphactinus: Jesse Peterson, Christopher David Reyes, Tymms, W. R.; Yale: Jesse Peterson, *Medieval Bestiary,* Gray, Strangeway; Yale/Basilisk: Wenzel Hollar; Yak: Jesse Peterson, Lydekker, Kendall, Alice S.; Yak: Jesse Peterson, Lydekker; Zebra: Matson Photo Service; Zebra: Jesse Peterson, *Illustrated London News,* Lydekker; Zebra: Ulisse Aldrovandil; Zooplankton: Jesse Peterson, Haeckel, Robert Hooke, John Vachon; Zooplankton/Life Origin: Jesse Peterson, George Adams, Librairie Hachette, John Collier.